Bad Aboriginal Art

Edited by

Sandra Buckley

Michael Hardt

Brian Massumi

THEORY OUT OF BOUNDS

...UNCONTAINED

BY

THE

DISCIPLINES,

INSUBORDINATE

PRACTICES OF RESISTANCE

...Inventing,

excessively,

in the between...

PROCESSES

OF

HYBRIDIZATION

Bad Aboriginal Art

Tradition, Media, and Technological Horizons

Eric
Michaels

Foreword by Dick Hebdige • *Introduction by Marcia Langton*

Theory out of Bounds *Volume 3*

UNIVERSITY OF MINNESOTA PRESS

Minneapolis

The University of Minnesota Press gratefully wishes
to acknowledge the assistance of Paul Foss
in selecting this collection of essays.

Published by the University of Minnesota Press
2037 University Avenue Southeast, Minneapolis, MN 55455-3092
Printed in the United States of America on acid-free paper

LIBRARY OF CONGRESS CATALOGING-IN-PUBLICATION DATA
Michaels, Eric.
Bad Aboriginal art, and other essays / Eric Michaels ;
foreword by Dick Hebdige ; introduction by Marcia Langton.
p. cm. — (Theory out of bounds ; v. 3)
Includes bibliographical references (p.) and index.
ISBN 0-8166-2341-4 (pb : acid-free paper)
1. Walbiri (Australian people)—Communication. 2. Communication.
3. Knowledge, Sociology of.
I. Title. II. Title: Bad Aboriginal art. III. Series.
DU125.W3M53 1994
320.2'0899915 — dc20
93-5132
CIP

To the Yapa of Yuendumu, N.T.

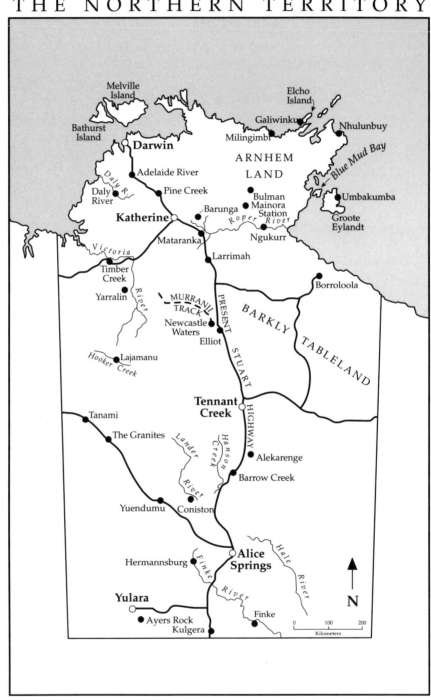

Melville Island
Bathurst Island
Darwin
Daly R.
Adelaide River
Daly River
Pine Creek
Katherine
Barunga
Mataranka
Victoria
Timber Creek
Yarralin
River
MURRANJI TRACK
Newcastle Waters
Elliot
Hooker Creek
Lajamanu
Tanami
The Granites
Lander
River
Yuendumu
Coniston
Hermannsburg
Finke
River
Yulara
Ayers Rock
Kulgera

Galiwinku
Elcho Island
Nhulunbuy
Milingimbi
ARNHEM LAND
Blue Mud Bay
Bulman
Mainora Station
Roper River
Ngukurr
Umbakumba
Groote Eylandt
Larrimah
Borroloola
PRESENT STUART HIGHWAY
BARKLY TABLELAND
Tennant Creek
Hanson Creek
Alekarenge
Barrow Creek
Alice Springs
Hale River
Finke

N

0 100 200
Kilometers

Contents

Foreword

Dick Hebdige

The Pueblo Indians are usually closemouthed, and in matters of their religion absolutely inaccessible ... the air was filled with a secret known to all communicants, but to which whites could gain no access. This strange situation gave me an inkling of Eleusis, whose secret was known to one nation and yet never betrayed. I understood what Pausanias or Herodotus felt when he wrote: "I am not permitted to name the name of that god." This was not, I felt, mystification, but a vital mystery whose betrayal might bring about the downfall of the community as well as of the individual. Preservation of the secret gives the Pueblo Indian pride and the power to resist the dominant whites. It gives him cohesion and unity; and I feel sure that the Pueblos as an individual community will continue to exist as long as their mysteries are not desecrated.

C. G. Jung, *Memories, Dreams, Reflections*[1]

What would it require, for example, consistently to associate the inventive, resilient, enormously varied societies of Melanesia with the cultural future of the planet? How might ethnographies be differently conceived if this standpoint could be seriously adopted? Pastoral allegories of cultural loss and textual rescue would, at any event, have to be transformed.

James Clifford, "On Ethnographic Allegory"[2]

ERIC MICHAELS's work with—to take a different example—the inventive, resilient, and varied Warlpiri Aborigines of western Central Australia effects the drastic transformation of perspective envisaged in this passage by James Clifford. Even so, the collection of essays, lectures, and book reviews assembled here hardly qualifies as ethnography pure and simple, still less as ethnography "proper." Although he spent more than three years researching the impact of TV on this remote Aboriginal community at Yuendumu, Eric Michaels never stayed long enough in one place, figuratively speaking, to establish a career as a professional anthropologist. Prevented from joining the "academic community"—even the radical, post-1968 one—on a secure, tenured basis by force of both temperament (some would call it bloodymindedness) and circumstance,[3] and by longstanding identifications with various threatened countercultures, he never ceded outsider status long enough to submit a "proper" finished book for publication during his lifetime. (It is infinitely more tragic than ironic that the one book he did "complete"—*Unbecoming: An AIDS Diary*—left him unfinished long before he ever finished it. To quote from that volume, included among the "little researchable questions" that I, for one, am disappointed not to see Eric Michaels testing are some of the major conflicts and controversies that have erupted in the years since his untimely departure. Any list of the losses sustained would have to include, for instance [to adapt Eric's sardonic "Postmodernism" title], *his* essays on the Rushdie affair, the Mapplethorpe-Helms controversy, and the politics of ACT UP and Queer Nation.)

For Eric Michaels, the "proper" was always primarily a category of analytical rather than professional interest and when he finally succumbed to AIDS in August 1988, aged 40, he died, according to his own account, with "only intellectual property to dispense."[4] It is difficult to know how best to allocate the legacy. Eric's analysis of the Warlpiri use of video and his application of features of the Aboriginal information economy to the emergent problems of corporate power and local control raise questions that reverberate beyond the residual category reserved for most ethnography on "traditional" peoples. In his work with the Warlpiri, Michaels established nothing short of a comprehensive critical agenda for cross-cultural communications research in the 1990s. In addition, the extraordinarily rich and diverse body of writing he left behind includes significant contributions to key debates in, *inter alia*, anthropology, aesthetics, art criticism and theory, epistemology and the sociology of knowledge, cultural studies, semiotics, audience and reception studies, mass communication research, sociolinguistics, film and TV studies, gay studies ...

Where exactly, then, in which section of the library, does the

name "Eric Michaels" belong? At a superficial level, there are at least three possible locations. Direct lines of affiliation connect Michaels's central project to the Canadian tradition of communications research (Innis and, especially, McLuhan), to work on orality and literacy (Ong, Derrida), and to the anthropological literature on the uses of communications technology among traditional indigenous enclaves (Carpenter, Worth, and Adair). However, none of these locations really qualifies as "home." Derrida is closest only because he, too, has no fixed disciplinary abode. In all the other cases, Michaels specifies the points at which his focal concerns and leading concepts force him to part company with his precursors. For instance, according to Michaels's judgment, Ong essentializes the differences between the spoken and written word, failing to see that orality is a "communicative system with economic consequences,"[5] while Worth and Adair are constrained in their experiments with Navajo filmmakers by their attachment to a structuralist model of "film language."[6]

More important, perhaps, Michaels takes the time to exorcise the ghost of the "electronic primitive" that might otherwise haunt his enterprise and that he inherited from McLuhan and, in a different guise, from Carpenter. Carpenter's fascinating study of the impact of radio on the tribal cultures of New Guinea and the associated genre of stories depicting "native" fears of photography's aura-stealing powers furnish anthropology with some of its most enduring popular anecdotes.[7] The response of "the Professor," the narrator of Oliver La Farge's 1934 short story "Higher Education," to a young Navajo woman's comment that the local Indian agent looks "sort of like Ramon Navarro" sums up the sense of matter out of place, of cannibals in dinner suits, which still characterizes that tradition:

"My God! Heavens above! There can't be anything in it but—subject for a Ph.D. thesis, 'The Influence of the Cinema in Aboriginal American Life.' Holy Moses!"[8]

The incredulity of that response has been echoing ever since in the tangled undergrowth of ethnographic and travel writing. Michaels picks it up and plays it back at us but in a different key. Thus, while considering Aboriginal video-viewing rituals, he observes that:

When Hollywood videos fail to say where Rocky's grandmother is, or who's taking care of his sister-in-law, Warlpiri viewers discuss the matter and need to fill in what for them is missing content.[9]

But when he cites these examples he does so for a reason. Here, for instance, it is to point up the different principles on which Warlpiri interpretive codes are

posited and the extraordinary intricacy and ubiquitous compulsion of Warlpiri kinship obligations, rather than the naïveté or inappropriateness of their response. The functional associations between narrative, Dreaming History, and Aboriginal Law are such that what Michaels is studying here is, in effect, as he himself puts it, "the impact of fiction more than the impact of TV per se."[10]

Michaels's refutation of McLuhan is even more direct. There are definite thematic parallels between McLuhan's work and Michaels's (e.g., the interest in slippages from "medium" to "message"), but the older man's promotion of the idea of the "global village" is dismissed as a conceptually slack piece of wishful thinking. The equation on which that famous metaphor is based—between "primitive" societies and universal "free and open" access to information—is, Michaels reminds us, simply not borne out by the abundance of ethnological evidence attesting to the prevalence among "traditional" peoples of communication taboos, secret societies, and restrictions on ceremonial knowledge.

This still leaves us with the question of where to put Eric Michaels. He demanded that his readers be as tolerant of uncertainty and as ambivalently invested in the quest for communicable knowledge as he himself was. Reflections on televisual form, or the contemporary art market, or anecdotal evidence of aberrant decodings of Hollywood movies at Yuendumu will suddenly break off into some erudite and densely worked aside on Western Desert demographics or the daunting and (for this reader at least) unfathomable technicalities of classic anthropological inquiry: glottochronology, the responsibilities of the avunculate, matrilineal patrifocal moieties, and so on. Classification is made especially difficult because the intellectual restlessness is visible in individual articles instead of being distributed in manageable fragments across the body of the work.

There is, however, nothing dilettantish about the range and depth of his scholarship. The ability to manipulate heterogeneous materials into new and untried patterns was integral to Michaels's method and approach. Both are rooted in an examination of the complexity of the linkages obtaining across disjunct social, spatial, cultural, economic, and technological orders. If that sounds too abstract and high-flown to be of interest to a general educated audience, then it is important to note how far the speculations are grounded in the acutely observed and analyzed details of the fieldwork.

If, on the other hand, it sounds vaguely reminiscent of Raymond Williams's prescription for a materialist analysis of culture (i.e., "the study of the relationship between elements in a whole way of life"), then the comparison, though apposite in some respects, also needs qualifying. The similarities in the two

men's marginal positions vis-à-vis their adopted "homes" (Williams, a Welshman in exile in Cambridge / English literature; Michaels, an American living under threat of deportation in Brisbane / Australian studies) fail to diminish the fact that their primary allegiances, strategies of reference, and assessments of the usefulness of literacy are fundamentally different. The same kinds of reservations complicate their common commitment to the study of cultural power and communications systems. Michaels's preoccupation with the political and ethical dilemmas of knowledge production and knowledge circulation give a peculiarly "un-English" spin to his take on what phrases such as "community mobilization" and "cultural struggle" might mean. When taken alongside his commitment to the one contemporary slogan with a paradoxically universal strategic value — "Think globally, act locally"—this emphasis on reflexivity works to drive a wedge through holistic systems of whatever kind, including Marxism, even the English culturalist version pioneered by Williams in the early 1960s. It is significant that when Michaels names the political, cultural, and intellectual formations to which he felt affiliated, Marxism appears as one element in a hyphenated compound: "marxist/zen/hippy."[11]

In a similar way, any attempt to align Eric Michaels too closely with the revitalized (and retheorized) versions of reception studies that circulate today would be liable to the same kinds of qualifications. While he clearly addressed many of the key issues raised, for instance, in the work of Morley, Ang, and Lull,[12] he didn't dwell on or in the major streams of audience research (partly because of the nature of his "sample") and was as interested in media production and distribution (including the production and distribution of Aboriginal painting) as in TV reception.

In many ways, then, though connected to various strands of contemporary social scientific research, Eric Michaels might be said to stand alone — the odd man out. Once we accept the validity of this description (Eric Michaels: odd and out!), then it is not difficult to find evidence of his singularity. What immediately establishes the uniqueness of Michaels's work is the way it places the issues raised by the Warlpiri uses of TV technology at the very center of contemporary concerns. Michaels refuses to reduce the analysis of those uses to the status of a "case study," a diminution that would effectively consign the Warlpiri Media Association to just one more poignant footnote in the triumphalist history of capitalist development and/or cultural imperialism. Instead, the challenge for Michaels is to demonstrate the general pertinence of Aboriginal appropriation and adaption strategies for anyone interested in developing alternative models of

TV production, distribution, and reception: "The problem is to develop a theory and a vocabulary adequate to account for, and provide choices in, our lives no less than in those of the Aborigines."[13] The outlines of such a theory and vocabulary, capable of extending choices and exerting pressure on the untested "truths" of communications research, are discernible in Eric's writing. There are no foregone conclusions in his "stochastic" system.[14] Instead, the (Ab)originality of his project consists in its derailment of the identical futures traced out in the broadcasting policy documents of the Australian state and the no less totalizing predictions of the Frankfurt School. It effects that transposition of priorities and vantage points that George E. Marcus associates with "the most interesting and provocative theoretical works [which are now] precisely those that point to practice ... that is, to a bottom-up reformulation of classic questions."[15]

Through his immersion in debates on postmodernist aesthetics and the philosophy of science, Eric Michaels developed a highly personal style of intellectual inquiry where attention to concrete worldly detail, serendipity, and scientific rigor are combined in equal measure.[16] The selection and order of words on a page figured prominently for Michaels among those concrete worldly details. The writing is "alive" to a degree rare in the English-language academic world. Eric plays with tone and voice, alternating between a range of personae (e.g., the veteran fieldworker, the obsessed boffin, the urbane aesthete, the mandarin, the trickster, the querulous outsider), and yet he never sacrifices integrity or gravity of purpose. The authorial presence that emerges through the work is both powerful and enigmatic, highly mannered yet disconcertingly direct. Thus, in spite or because of the apparent strangeness of the culture under study, these essays make for compelling reading and they do so partly because of the (strange) ways in which we ourselves as readers get positioned in relation to it.

Any evaluation of Michaels's legacy has, at some point, to consider the discursive strategies he used to establish the parameters within which text, author, reader(s), and Warlpiri "respondents" engage and interact. Here I shall isolate just three elements: mode of address, choice of titles, and the use of direct questions. First, mode of address: Michaels refuses to provide a stable position from which "we" can get an unobstructed view of the object of inquiry. He abstains from the (passive-)aggressive recruitment tactics of radical polemicists as well as the more "gentlemanly" interpellation routines of more established kinds of academic writing. There is no presumed collectivity of taste or interest to which Michaels makes any consistent appeal. The comparison here would be with

Meaghan Morris, who is equally suspicious of the first person plural: "we," that embarrassing macro-binary constraint, from the days of unity and solidarity, what-ever is to be done with "we?"[17] And, in fact, there is no stable "we" waiting for us anywhere in Eric Michaels's texts. The assumption of shared identities of interest and understanding between author and reader and among the diverse body of the readership itself is held at bay through the use of various distancing devices (e.g., irony, hyperbole, sarcasm). Michaels dismantles the us/them couplet by focusing as closely and unsentimentally on the first term as on the second.

As a result, there is nothing cosy about the discursive space over which he presides, and though meaning inevitably depends within that space, as in any act of utterance, on boundary imposition, there is absolutely nothing of the senior common room about it. The scholarship may be unremitting, the bibli-ographies intimidating, the literature reviews suitably dense. But the sensibility that selects the objects of research and proscribes and transcribes the relations between them (and between them and us) is, for all that, emphatically *un*bookish. Michaels liked nothing more than to expose the vanity of letters. He takes heart from the fact that the most popular programs with Aborigines are "the least char-acter motivated, most formulaic fictions,"[18] and though the reasons he gives for that assessment (i.e., that "they may encourage active interpretation and cross-cul-turally varied readings") are plausible enough, the sentence is constructed in such a way as to cause maximum offense to educated tastes.

Michaels refused to be po-faced about serious critique. Unable, like Roland Barthes, to countenance the dichotomy between "objective" science and "subjective" literature, Michaels "makes sarcasm the condition of truth."[19] His titles are a case in point: "My Essay on Postmodernism," "Bad Aboriginal Art," "Aboriginal Content: Who's Got It—Who Needs It?" Rather than encapsulating the essay's argument and thus enhancing its palatability for some protected ideal audience, each title discomfits us, the actual readers, by provoking a further set of questions. Together they force us to acknowledge how we—whoever and wher-ever we are—are caught up, or enmeshed and implicated, in the contest of forces described and analyzed.

Nor is the sarcasm just reserved for a safely faceless readership. Michaels's preference for occupying institutions and agencies meant that he often alienated the very organizations with which he was supposed to be most closely aligned. For instance, the "Aboriginal Content" essay, as the title suggests, ques-tions the validity and purpose of the category itself. We soon learn the answer to

the title's second question. It is ABC documentary filmmakers and organizations lobbying, like CAAMA, for the preservation and promotion of Aboriginal culture who really *need* "Aboriginal content":

Warlpiri Media Association programs only become "Aboriginal Content" when they are exported from Yuendumu, and perhaps only when they are expropriated from Aboriginal Australia. In the context of their transmission at Yuendumu, they are simply local media. [20]

One of the many valuable services Michaels performs throughout the present book is to offer a facetious running commentary on the protocols and pieties of contemporary cultural studies and the rhetorics of community activism. He keeps on questioning the comfortably institutionalized "radicalism" of much academic and grant-sponsored publishing today. To submit a report for the Australian Institute of Aboriginal Studies, the organization that sponsored the Yuendumu research, under the title *The Aboriginal Invention of Television* is, by way of contrast, to make a genuinely radical proposal. The simple substitution of the word "invention" for "appropriation" or "experience" or "encounter with" or "responses to" or "exposures to" upsets the tidy logic of the dominant spatial and temporal orders. It simultaneously interrupts the idyll of ethnographic "discovery" and challenges "our" monopoly on technical and scientific daring. But it also indicates a kind of ludic, pigheaded bravado more in keeping with the pranksterish style of the 1960s drug culture than with the sober realism of most conventional reports or the circumspect punning of so much self-defined "critical" writing in the pomo 1980s and 1990s. Occasionally the acid wit gives way to gallows humor: "Hundreds Shot in Aboriginal Community" (subtitle: "ABC Makes TV Documentary at Yuendumu").

Precedents for such distancing devices, though, can be traced back centuries rather than decades. There is something contemporary yet oddly antique in Michaels's style of intellection. Even when he is reviewing a Madonna tape his tone has the austere eccentricity and consciously willed detachment of some eighteenth-century satirist/scientist committed to an open probing of possibilities through the rigorous application of the logic of hypothesis and the fictional "what if?" By the double suspension of belief and disbelief, Michaels establishes a space in which the unexamined assumptions underlying critical work in communications can be subjected to intense, corrosive scrutiny.

To take one example: even now, after a decade of evangelical "viewers' liberation," literacy tends, in most social scientific research and "responsible" criticism, to be routinely categorized as prosocial and prodevelopment while

TV is seen as repressive and antisocial. Michaels challenges that binary assumption. He does so, however, not by pious hoping through the assertion of a faith in the "power of the people" to subvert, recode, or otherwise resist "preferred readings" of broadcast TV programs — but by reexamining the nature and functioning of orality and information management in Warlpiri culture. It is here in the process of making general extrapolations from the fieldwork that, in compliance with Marcus's suggestion, he reformulates the classic questions. What if Aboriginal forms of communication and the Dreaming History and Law transmitted through those forms are more amenable to televisual transcription and storage (i.e., preservation) than to alphabetic writing? What if publication of field notes documenting restricted tribal knowledge not only entails its desecration but literally reduces its exchange value on the ceremonial trade circuit? Is reading an appropriate metaphor for what we do when we watch TV? What if bland U.S. soap operas, rather than simply "polluting" the Aboriginal imagination with Western images of crass materialism, serve to educate a people who remain curious about Western norms yet are intuitively aware of the "weirdo" status and nonconsensual moralizing agendas of most of their "official" guests (the "preachers, teachers, researchers, administrators, and service workers who find their way into remote Australian communities")?[21] After all, as Michaels bluntly observes, as anthropologists "we are probably an odder and more atypical lot than the cast of *Dallas* or even of a Bruce Lee movie."[22]

Awkward questions such as these dot and spike every text Eric Michaels ever wrote. He always "wrote furiously," that is, in a ferociously interrogative mood. Direct questions proliferate, many of them permutations on Harold Laswell's opening gambit, delivered at the very outset of systematic research into mass communications: Who says what to whom in which channel with what effects? When inserted into Michaels's information-based models of social progress and used to probe not just the impact of electronic media on Aboriginal communities but the probity and value of the elaborate nexus of constraints regulating tribal lore transmission, Laswell's opener then generates an endlessly proliferating subset of inquiry. Consider how the questions escalate, for example, when Michaels challenges the sociological and ontological assumptions underpinning conventional market research categories as applied to Western Desert Aborigines:

How should we ask Aboriginal people who have no experience of electronic media . . . to choose between options of which they have limited or no experience? How do we evaluate their answers

when they are first speakers of languages quite different from our own? ... Who asks what questions of whom may be a better predictor of what telecommunications will be provided in Aboriginal Australia than any social, cultural, or economic indicators. ... Typical demographics require the respondent to be the head of the household, or in a stated relationship to such a "head." But what constitutes the "head" of an "eight-subsection kinship system grouping with patrilineal emphasis but matrilineal rights through mother's brother," as described for the Warlpiri? What indeed is a "household" in a mobile, foraging society in which residence may express itself in dozens of ways depending on demands of ceremonial life, age grade, rainfall, season, and other variables?[23]

The direct interrogation of every "ground" encountered reveals a will to deconstruction that contributes to the undomesticated feel of Eric Michaels's thought.

Nonetheless, despite the range of his analytic competence, and for all his intellectual nomadism, despite, too, Michaels's doubts regarding the ultimate viability of the ethnographic project, he always retained a particular loyalty to anthropology. He returned again and again to the interpretative and politico-ethical conundrums confronting those educated metropolitans who elect to do fieldwork in "traditional" societies. At the same time, he continually reaffirmed the classic "ethnographic rationale — that subjecting familiar problems to unfamiliar populations may provide useful insights."[24] Michaels's dialogue with his chosen discipline, however, and with the increasingly damaged models of ethnographic authority associated with it, meant that ethnography as either neutral reportage or textual salvage operation was never really an option. In fact, he performed some of his pithiest, most incisive critiques on the unreflexive "ethnographic mode" of writing.[25] For instance, the final coup de grace is delivered to one study of Pintupi hunter-gatherers when Michaels nominates it "the last of the holistic participant-observation ethnographies," a nomination that, he sarcastically observes, makes its author, "not the Aborigines, representative of the dying tribe."[26]

But neither was Michaels content merely to linger like some agonized Prufrock on the threshold of uncertainty between two cultures. He resisted any attempt to reduce to abstract speculation or gestural motif the awkward questions posed by reflexivity. The attention he brought to bear on the politics of discursive entitlement, positioning, and prohibition was sustained by his own entanglement in the concrete issues that confronted him day by day at the video-editing desk, in the library, or in "the field" (i.e., the world outside the library). It simultaneously informed and directed his critical practice at every level.

His interest in developing a processual model of communications and cross-cultural research cannot be detached from the enunciative strategies through which the model was itself articulated, tested, revised, evolved. And both the intellectual product and the style of its inscription are integral to the larger dual objective of, on one hand, preserving Aboriginal sovereignty in "the age of TV," and, on the other, sending our curiosity about the otherness of others back home where it belongs. Rather than parading his knowledge of Warlpiri "folkways" and thereby underlining the distance between "backward" and "advanced" or "pure" and "contaminating" cultures, he reverses the terms. "Otherness" is instrumentalized, that is, imagined as alternative: he uses the sophisticated Aboriginal information economy to "clarify our contemporary confusion," [27] not vice versa.

Thus reflexivity (and reversibility) are explicitly integrated into his substantive arguments, modes of address, and relation to his chosen objects of analysis in ways that distinguish his work from much of the "new anthropology." Michaels never resorted to those textual strategies ("heteroglossia," "confessionalism," "ethnographic ventriloquism") that Clifford Geertz associates with the failed attempt of anthropologists in the postmodern/postcolonial era to relieve themselves of "the burden of authorship." [28] Instead, he chose to confront head-on his own implication in power-knowledge networks and to pursue consistently politicized and morally responsible lines of action in relation to the sponsoring institutions, the Warlpiri people at Yuendumu, and the larger causes and communities of interest to which he made himself accountable. However, if Michaels translated the "fact-finding" or interpretive role of social scientific research into advocacy and activism, he was surely pulled in that direction by the seriousness with which he set about elaborating what Guy Brett, writing in a different context, has suggestively referred to as an "ethics of disclosure." [29]

For it may well be true that Michaels's most productive and original insights stem from his skepticism regarding the value and virtue of the ideals of a transparent public realm and the automatic "right to know" (and show) so central to prevailing definitions of science and democratic freedom. Michaels continually draws attention to the practical *legitimacy* of the constraints placed upon "properly" managed ethnographic disclosure. Even in death, his primary obligation is to the people at Yuendumu, not the "community" of strangers who may pick up or pay for this book (though it is certain that some Yuendumu residents will read it). Of course, the possibility of a switch of allegiances from social science to its subjects has always dogged the ethnographic project. Such a reversal supplies the guilt-laden subtext to the "Curse of the Mummy's Tomb" variety of

anthropological narrative in the colonial era. It has now become an explicit focus of attention in the new anthropology. When, in a recent collection of his essays, [30] Michael Taussig includes a box framing a statement explaining that this is where he would have liked to present Spencer and Gillen's drawing of an Aboriginal frog totem but has elected (unlike his two predecessors) not to do so on the grounds that it would breach a tribal interdiction, he is acting in accordance with the new ethical imperatives governing image circulation in the postmodern world. (The beauty of that gesture lies in the way it holds the space open and leaves it blank, despite the enframed writing.)

What marks out Eric Michaels's work is the extent to which he turns the implications of information restriction practices into a general topic of analytical inquiry. For Michaels discretion in these matters is not an exclusively moral choice any more than it constitutes evidence that he's "gone native" ("I am not, nor have I ever wanted or imagined myself to be, a Warlpiri Aboriginal," he once wrote). [31] Instead, it accords with his *analytical* assessment of the political, cultural, spiritual, and economic functions of information management in Warlpiri society: "The conditions, rather than the contents, of secrecy in traditional societies can be established, and for very practical reasons fieldworkers need to do so where such rules exist." [32]

It is these "conditions" and "practical reasons" that come to dominate Michaels's investigations. There is a way of reading all his work as a protracted meditation on the differences between the opposed models of property, propriety, custodianship, and ownership associated with literate and nonliterate societies. He uses the economic logic of exchange regulation in the overlapping Warlpiri systems of orality and kinship to challenge the fundamental rationalizing premise of capitalist information economies—that is, that all knowledge is theoretically reducible to signs and information that then circulate "freely" as commodities in an ostensibly open market. Media technologies such as the phonetic alphabet and the printing press make culture portable and this portability supposedly equates with freedom: freedom of speech, freedom of access, freedom of markets, knowledge as right (the biases remain hidden, of course, as Michaels points out—as with the cost of TV programs that "masquerade as freely accessible common property"). [33]

By contrast, the native Australian information economy endows each Aborigine with specific and inalienable knowledge rights, though what is inherited is strictly determined by gender, seniority, kinship, and locale. As restrictions apply not just to who can know what but to who can say (or otherwise refer

to) what in the presence of whom, where, and in what company, the system can be played to manipulatory advantage by groups and individuals intent on accumulating rank and prestige. The Dream Tracks, a vast continental network connecting tribally significant sites, serve like the *keda* (paths) in the Melanesian Kula ring as the sacred conduits through which valuables (in this case ceremonial and religious knowledge, dances, songs, etc.) circulate and are exchanged.[34]

Michaels nominates the Aboriginal knowledge system as the *first* information economy and thus gets to stage the Warlpiri "invention" of TV in an unimaginably archaic yet futuristic setting somewhat reminiscent of an outcut from *Mad Max.* Here in TV's second primal scene, the (mis)match between the two opposing systems is played out and made visible. The implications of the encounter are far-reaching: Aboriginal concepts of guardianship and exchange, mobility and place are counterposed against the principles of property ownership and copyright as enshrined in English law, to raise questions about topics as diverse as the efficacy of Aboriginal land claims strategies in Australian courts and the asserted "rights" of visiting photographers out to grab a few Warlpiri portraits. Ultimately, as always in the work of Eric Michaels, the focus shifts back to us. It is we who are invited to reflect on what happens when the utopian public space imagined in modernity—neutral, transparent, open to all—is replaced by a *social* space that is always already inhabited (for 40,000 years in the case of the Warlpiri), hence always divided, circumscribed, owned, though that ownership can be invested with conflicting values.

The responsibilities of translation and articulation remain, and while Michaels was always prepared to countenance the possibility that maybe "we can't do ethnography on anybody,"[35] he nonetheless took those responsibilities seriously. One example from his work can help to indicate the subtlety and distinctiveness of Michaels's approach to the problems besetting any ethnographer who seeks to articulate forms of life to global systems of power and exchange. In the wake of the controversy surrounding the "Magiciens de la terre" exhibition in Paris there has been renewed discussion of the criteria used to distinguish "authentic" and "inauthentic" tribal, souvenir, and tourist art, and the validity or otherwise of appropriations by Western artists, entrepreneurs, and collectors of "Third World" cultural forms.[36] The negotiations Michaels helped to inaugurate with tribal elders, dealers, and buyers over the terms of entry into the international art market of Aboriginal paintings demonstrates the delicacy and complexity of the issues raised here. Questions of the collective ownership and tribally restricted access to iconographically transmitted knowledge, of the imbrication of surface,

medium, and ground in Warlpiri art, of the transferability or otherwise of site-spe-
cific sacred paintings to portable formats and of their translatability into the elabo-
rated codes of modernist abstraction or neo-expressionism in the galleries and art
museums of Sydney or New York—each question becomes, in turn, the subject of
lengthy debate not just with readers and cited authors but with the Warlpiri indi-
viduals who "own" (i.e., are responsible for and have reproduction rights to) the
original designs. Among the outcomes of this debate are at least three linked
products: an illustrated book of Yuendumu door paintings,[37] Aboriginal paintings
of the same designs, and Michaels's article documenting and interpreting the
translation/transmission process. All three products circulate internationally as
commodities.

Michaels, in this instance, intervenes directly to oversee the
flow of exchange and labors to ensure that the return, when it is made, comes in
the community's preferred currency. An intricate relay of transmission is set up as
sandpainting designs owned by specific kinship networks and linked to Dreamings
tied to sacred sites are adapted and transferred via acrylics first to the doors of the
local primary school, then to canvases, then sold to dealers and the money used to
buy Toyota jeeps; these jeeps, to close the circle, can be driven to the remote
desert sites of the original Dreamings, which retain their sacred status only so long
as they are visited by the appropriate members of the appropriate moiety. The ele-
gance of this solution to the question of how a remote "traditional" enclave can get
to participate in the global economy, albeit on a strictly limited and unequal basis,
without ceding its sovereignty resides as much "out there" in the circuitry itself as
in the text Michaels produces on the process of its installation. Both the text and
the circuitry are, in the widest sense, acts of inscription attributable, in part at
least, to Eric Michaels's agency.

Perhaps the most productive and potentially explosive focus of
inquiry for Michaels on Aboriginal art—bad or otherwise—involves the fuzziness
of the claims to authenticity made on its behalf by accredited critics and dealers.
Once again, direct questions proliferate: In what sense can works that are, accord-
ing to the nomenclature under which they appear in the galleries, authored by an
entire ethos, designs that are, moreover, handed down and copied (and adapted)
from generation to generation, be said to fulfill the requirements of originality and
individual authorship that still underwrite valuation in most sections of the art
market? The uncanny formal parallels between Papunya Style dot-painting, "dis-
covered" in the 1960s and 1970s, and contemporaneous New York minimalism, or
between Yuendumu door paintings "emerging" a decade later and 1980s neo-

expressionism, become somewhat less mindblowing when we learn from Michaels that visiting professionals—artists, advisers, and so on—may, knowingly or not, prescribe emergent styles by discriminating between offerings on the grounds of "good taste" or plain market pressure. The charge of inauthenticity is thus transferred from the art to the criterion of authenticity itself as used in this context, and hence by proxy to those who (mis)apply it. ("Judgments of the product must always—ultimately—be exposed as fraud.")[38]

Through all Michaels's intensive soundings of the impact of poststructuralism on the security of scientific knowledge and individual selves, one of the most persistent and persistently disturbing echoes comes back from the undead category of the (in)authentic, buried, supposedly, at the bottom of the well. Thus, for instance, he ends a discussion of the absolute fusion of materials, iconography, site, and mode of execution in Western Desert sandpainting by speculating on the consequent "truth" of the designs that simultaneously present and conceal the sacred meaning of the "image" so presented:

Nothing in semiotic theory or contemporary scientific philosophy accounts for any such ability of phenomena to communicate directly, unmediated, their history and meaning.... How do we determine a semiotics of authenticity?[39]

As with Roland Barthes's final meditations on the spectral, hence redemptive power of photography in *Camera Lucida*, Eric Michaels's contemplation of Aboriginality spirals around in time to undercut the ground on which it was initially posited. Among the many guises that intensify the fascination exerted by the voices that run through his writing, this one remains a real possibility: Eric Michaels, closet existentialist.

Either way, there is a great deal more at stake in Michaels's critiques of self-authenticating strategies in contemporary ethnography than intellectual point-scoring. When Michaels berates Fred Myers or Bruce Chatwin or Sally Morgan for being insufficiently self-reflexive, it's not because he wants to draw attention to the gaps in their reading lists or to wield the bludgeon of political correctness. It's because Morgan (in *My Place*) and Chatwin (in *Songlines*) use the autobiographical voice to claim a privileged authenticity that preempts meaningful debate by sealing in the contradictions (Morgan by excising Europeans and European cultural influences—at least, undemonized ones—from her account of her hybrid ancestry; Chatwin by repudiating the anthropological discourse he so patently relies upon to establish his insider/outsider credentials vis-à-vis nomadic peoples). Similarly, Fred Myers, intent on demonstrating the validity of his thesis

on the egocentricity of Aboriginal social organization, is taken to task for failing to account for his own imbrication in the implicit exchanges surrounding a tribal elder's decision to show him secret, sacred objects. It isn't that the elder is "showing off"—demonstrating who he is or how he'd like to be remembered—so much as he is reminding Myers where he, as a visitor presumably connected to remote metropolitan powers, stands in the sociocultural nexus to which he's been fortunate enough to have been admitted. The elder's disclosure of tribal secrets is, according to Michaels's interpretation,

a familiar Western Desert discourse strategy where demands are not directly made. The old man is not only saying who he is, but who Myers is. He is not only demonstrating personal power, but also, more strikingly, Myers's obligation: to return, to hold, and to care for the Pintupi (who … are not terribly interested in his academic brief). [40]

Thus the authority- and truth-claims of Myers's account are placed in question because he misrecognizes a communicative act that *im*poses mutual obligations on both parties—witness and actor alike—as a revelatory statement that works just one way, that is, to *ex*pose the reality of a respondent's self-identity to a dispassionate, professionally trained observer.

It is in moves such as these and in his principled attention to the social facts of reciprocity and mutual obligation in communicative action that Michaels's work goes far "beyond the Salvage Paradigm." [41] For at a fundamental level his product is not about the poetics or the politics of representation. He doesn't seek to decipher the "meaning" of Aboriginal art or video texts, to stand in or stand up for "his" Warlpiri people, to render the arduous and singular experience of years spent in the field, or even to represent the equivocal nature of all situated truths. Instead, Michaels is concerned with the multiple performance dimensions of language- and inscription-acts: with setting possibilities in train. For him texts are first and foremost events that generate other events (interpretations, debates, exhibitions, publications, suppressions, policy documents). He antipodizes the "crisis of representation" (rather than agonize over it) by turning upside-down and back-to-front the hierarchies and histories that organize the positions still reserved, in the last instance, in most forms of ethnographic writing, for "us" as knowing subjects and "them" as transcribed objects. He actively inverts, then detonates center/periphery, primitive/developed, and pre- and postliterate oppositions, not by writing (righting?) them out as recorded Truth or as one more white man's True Confessions (Michaels always acknowledged the reality of fiction and duplicity). Instead, he writes in a more novel and visionary tense by choosing to discern

the cultural future of the planet traced out, but never fully legible, in someone else's Dreaming, by finding it inscribed in the communicative etiquettes, sand-paintings, rituals, and ritual prohibitions of what is, perhaps, the oldest, most uninterruptedly isolated civilization on the face of the earth.

There is a final irony, at least as far as veterans of the 1960s are concerned. As Michaels points out in a riposte to McLuhan, the authority accorded the elders in Warlpiri culture is such that "a future modeled on their [i.e., the Warlpiri's] information management systems would more closely resemble a vast gerontocratic bureaucracy than a hippie commune writ large."[42]

Irony and 1960s countercultural values bring us back at last to Eric Michaels's legacy and the question of its allocation. *Unbecoming*, Eric's AIDS diary, is partly devoted to that question. There are several passages in which he attempts to define his relation to Warlpiri culture ("My will, it seems, will be a position paper," he wrote with typical aplomb). At one point, he discusses the affinity between the Aboriginal "casualness about things, objects, permanencies" and "the vague hippy leftist economic ethic" he carried to Yuendumu from his years spent in the communes of New Mexico. The point of intersection, he suggests, "is this resistance to fixed notions of property ownership which is superseded by ideas of custodianship, utility, of 'looking after.'" He spends some time imagining the probable impact of his own death on the people at Yuendumu and mentions one bequest, a pair of cowboy boots he's about to send to a friend out there. It is entirely characteristic that the projection of this act into a future posited on Eric Michaels's absence sets in train a series of reflections on the malleability or otherwise of Warlpiri mortuary taboos, on the productive and eternal tensions between structure and agency, prohibition and transgression, desire and the Law:

I wonder whether [Francis] Jupurrurla — on hearing of my death — will burn my Texas cowboy boots which I will send him next week, or whether, as I hope, he will find and invoke some dispensation, some loophole in the "Law" to permit him to wear them for a while. For years, he eyed them with such obsessive fervor! It's these little researchable questions I'm a bit disappointed not to be able to test any further.[43]

Introduction
Marcia Langton

THE WORK of Eric Michaels straddles both anthropology and cultural criticism. His major contributions to these modes of inquiry were his descriptive and theoretical writings on cultural specificity in Aboriginal aesthetics and production. In a tangential way, his work follows on from that of N. D. Munn (1973), another scholar from the United States who worked with Warlpiri people in the late 1950s and early 1960s. But Michaels's analysis is unique in that it addresses how Warlpiri people make video and television, and discusses the specific Aboriginal cultural modes of sociality that are brought to bear in these endeavors. He made us think again about acts of representation and the power of representation.

His work can be located in the middle of a local revolution: the empowerment of Aboriginal people in representations of them and by them. As Visiting Research Fellow at the Australian Institute of Aboriginal Studies from 1982 to 1986, Michaels undertook a study at Yuendumu "to assess the impact of television on remote Aboriginal communities." All of the major developments in Aboriginal telecommunications—such as the only indigenous-owned television license, Imparja—have occurred since the early 1980s, starting just before Eric Michaels arrived from the University of Texas to carry out his research. His work had an important impact on developments in Aboriginal television and related areas, and enabled us to see more clearly this revolution unfolding.

The introduction of television services to remote Australia, particularly to Aboriginal communities, and the development of government policy in this regard, have been driven largely by the concerns of technocrats (see Spurgeon 1989). Michaels resisted that tendency with a relentless passion. But the impact of his work remains confined to the Warlpiri domain and the scholars who read his work. Today, there is not more than two hours of Aboriginal content on any national television service or commercial network—depending, of course, on how you define that content. Michaels's influential study "Aboriginal Content: Who's Got It—Who Needs It?" (chapter 2) indicates many of the reasons this question is still being asked.

Whatever the impact of Michaels's findings on government policy and its technocratic concerns, it is possible to situate his contribution to Aboriginal TV and telecommunications by tracing the developments at Yuendumu, where he worked. This Aboriginal community remains today at the forefront of these developments.

Yuendumu is on the edge of the Tanami Desert in Central Australia. Founded as a Baptist mission in 1943, it has been self-governing since 1978. Five hundred to a thousand people reside there, depending on the season. There is a community store, town office, police station, primary school, health clinic, art association, and, most recently, a local television relay and broadcast facility. Its Warlpiri and other local residents demonstrate a strong determination to survive, to fight back, to retain a heritage of great antiquity and continuity.

In Michaels's work, including his 1986 Institute Fellowship report *The Aboriginal Invention of Television in Central Australia 1982-86*, he highlights the need to understand the process of cultural incorporation—namely, how the Warlpiri, in this case, the people of Yuendumu, actually socialize Western things. Further, he argues that the problem with introduced technology, or instruments of mass communication such as TV, goes beyond the ethics of representation.

As far back as "The Costs of Video in an Aboriginal Community" (1983*),[1] Michaels stressed the significance of conditions of production and transmission among remote Aborigines. The luxury of 16- or 35-mm film, preferred for its high production values, is simply not an option in Aboriginal communities because of cost and technological or maintenance limitations. Thus video cassettes and VCRs, as the only realistic technological options at Yuendumu in the early 1980s, opened up possibilities for Warlpiri representation and power over production and transmission technology. This initial research, summarized later

on in "Hollywood Iconography: A Warlpiri Reading" (chapter 5), showed that remote Aboriginal people have their own production values, distinct aesthetics, and cultural concerns, and that such issues are important and complex.

As Michaels explains (1983*, 1986a), it was an economic logic that eventually led to the community's decision to transmit television without a license to meet its needs. The control Europeans exerted over Aboriginal access to videocassettes was based in the relations between blacks and whites in the region: "Most of the tapes coming into the community came through Europeans, because Alice Springs [video] rental agencies were reluctant to service remote Aborigines" (1986a: 40).

The Europeans made considerable profits, but also controlled content, whether for their own entertainment and advantage or to advance their own aims in Aboriginal policy. They believed that Aborigines preferred action/ adventure films, especially extremely violent ones. Michaels found to the contrary that "the most popular tapes of all, those by and about Aboriginal people, are never available from commercial Alice Springs outlets" (44). Moreover, he calculated that an individual might spend up to $5,000 per annum to maintain a VCR and obtain cassettes. The usual lifespan of a VCR was not longer than a year because of the harsh physical conditions and the Aboriginal exchange system. He estimated roughly the cost of video supplies to Aboriginal residents of Yuendumu during 1983 at about $18,450.

The sociality of videocassette use among Warlpiri, as documented by Michaels in 1983, can be seen as the precursor to their social organization of television production, transmission, and reception at Yuendumu. As he argues, "The sociometry and demography of the Yuendumu camp layout is ... an expression of many aspects of social structure, and an individual's home camp is one place one can be assured of standing in the correct relationship to people and place" (1983*: 12).

The Yuendumu store, in line with its general mark-up pricing policy, charged $2,000 for a receiver/VCR system that was not particularly suitable for remote needs. There was a community trade network of videotape cassettes, its logic reflecting not only the sharing of scarce media resources but the preference of people to remain in certain groupings. It was more appropriate for the videocassette to come to them than to view it in another camp.

The question of who "owns" a VCR was therefore an ambiguous one: "To selfishly guard personal property violates all the rules of etiquette, and a person who acts thus may find himself excluded from social life and

identity" (10). The most popular cassettes, which had not entered the exchange system, were those that people had made of their own community, as part of funded video production projects, and these raised questions of ownership, distribution, and viewing that had not been resolved at that time.

These cultural, social, political, and financial factors led to the reconsideration of videocassette usage in the Yuendumu community. The development of the video rental system was the basis of VCR sales in European societies, but the notion of renting is inappropriate in "a society that de-emphasizes private ownership and emphasizes reciprocal kin-based obligations, where the value of ownership implies the obligation to share. Thus the very thing that made VCRs commercially attractive to European society limits their usefulness to Aborigines" (11).

Transmitted television thus became the obvious alternative for the Warlpiri in overcoming the limitations, cultural and financial, of video rental. This mechanism was far more appropriate to the Yuendumu situation because receivers could be purchased relatively cheaply, would not require additional outlay, and were less susceptible to damage.

It was at this point, according to Michaels, that one community member suggested that the video production project should be extended into a local community station. On April 1, 1985, the "pirate" television transmission began at Yuendumu on VHF channel 4. Responsibility for operations was undertaken by the Adult Education group supported by the part-time instructors program. The Community Council directed the station to operate four hours each weekday, from 12 to 2 P.M. and 5 to 7 P.M.

There were deeper concerns, however. Some Warlpiri expressed fears that television threatened their culture in various ways, particularly because a daily stream of imported programming would undervalue and limit local cultural tradition and control, whereas video production projects and exchange in the community reinforced certain cultural traditions. The loss of control of scheduling and programming was equated with loss of control of culture.

Michaels thought to link TV to this cultural exchange process. While European colonization had destroyed whole segments of the traditional information network, in some areas these networks still function, especially through the Centre, the Top End, and the Northwest. Anthropologists have noted the transmission of cults along these networks, and now signal the role of communications technology, including Toyotas, radios, and video, in restoring and facilitating traditional information exchanges such as ceremonies (1986a: 5).

The technological solution was a low-frequency, low-power community transmitter that would allow the community to select from a variety of programming sources, including locally produced and imported videotapes as well as satellite-received programs. The cost of the system was less than the community spent on video supplies in one year. It also allowed more people to afford receivers and assured them programming without the need to purchase a VCR or tapes. It solved the software supply problem and retained community control (1983*: 12-13).

There was a rapid development of transmission facilities at Yuendumu and the range of content in Warlpiri television production grew considerably. In February 1985, the newly formed Warlpiri Media Association was funded by the Social Club to establish a permanent TV station and to purchase transmitting equipment.

The first videos made at Yuendumu were almost exclusively of sporting events, but within a few years the range of content had extended to include traditional ceremonies, dancing, manufacture of traditional implements, "message sticks" or taped messages, editing, "direct cinema" such as the Coniston massacre discussed in "For a Cultural Future" (chapter 6), educational videos, travel tapes, information about outstations, oral histories and stories, including catalogs of paintings and documentaries to be displayed at art galleries associated with the Warlukurlangu Artists Association.

According to Michaels, the purpose of the video production of the Coniston massacre was to explain a significant moment in the history of Warlpiri encounters with Europeans. It concerns events following the murder by two Japanangka brothers of the prospector and dingo trapper Frederick Brooks near Coniston Station in 1928 (1986a: 61).

Michaels found that the videotaping process involved an entire kinship group, all related in various ways to the Coniston story and to the land on which it would be filmed. These people, although never on camera, effectively authorized the filming of the story and assured its credibility to Warlpiri audiences. He noted that Jupurrurla, acting as director and cameraman, provided a "purposive" explanation for every motion of his camera: "This is where those policemen came over that hill," "That is where dreamtime figures are in that tree," and "This is the track old Japanangka came round." For the Warlpiri cameraman (and presumably his Warlpiri viewers) the camera was tracking inhabitants of the landscape, historical and mythical figures who resided there, but who were not apparent to normal vision (63).

In the words of Michaels, the dominant reading for Aboriginal audiences has to do with patrilineal rights to stories and restrictions on speaking about the dead. Hence the presence of the protagonist's grandsons, who may have more "rights" to the story than the son, authorizes its retelling as well as underscoring the continuity of tradition (63). As Michaels argues, "There is no necessary translation from orality to electronics; we are seeing instead an experimental phase involving the insertion of the camera into the social organization of events. The point is the necessity of locating such a position for the camera" (65).

The process of videotaping the Coniston massacre story illustrates that the principles having to do with the authority to represent underwrite the culture and politics of video and television production by the Warlpiri about themselves. There is not the Western subject/object relationship in Warlpiri video representations of their world. The camera itself has been given an explicit Warlpiri social role consistent with the obligations of Warlpiri men and women to *Jukurrpa*, the Law of the Dreaming that informs human social relationships and relationships with the environment. Rather, there is the dialectic provided by the Aboriginal moiety system, if not by the politics of gerontocracy. There is a subject/object relationship, but one radically modified by the Warlpiri dialectic.

Image production is another example of how Western technology and artifacts have been incorporated as part of Aboriginal customary law. Elsewhere, in "Western Desert Sandpainting" and "Bad Aboriginal Art" (chapters 3 and 8), Michaels identifies, in relation to the production of acrylic art depicting traditional ritual designs, features that distinguish Warlpiri from European production. These features are as significant in the way video images are produced as they are in acrylic art. Aboriginal art does not emphasize original creative individuals or assign them responsibility as authors: "Instead of an ideology of creative authority, there is an ideology of reproduction.... The art masks inventiveness and authorial intent."

Warlpiri artists earn rights to paint certain preexisting designs, not to introduce new ones. Rights to a body of work are inherited, so that one's son, daughter-in-law, or some other individual continues producing the same designs. Therefore, "a forgery adequately executed, when circulated, may be no forgery." Plagiarism is not a possibility in this tradition. What is feared instead is thievery—the unauthorized appropriation of a design, as well as the potential for such stolen designs to convey rights and authority to the thief.

As Michaels concludes, "These design traditions are consid-

ered to originate in a collective past, and project toward an infinite, impersonal future. By necessity, the authority of this system would be compromised by an ideology of invention which singled out individual producers."

Michaels's work laid some of the foundations for negotiations between Aboriginal communities and non-Aboriginal filmmakers and video producers in relation to content that is normally restricted from general viewing in the Aboriginal milieu. His "Primer of Restrictions on Picture-Taking in Traditional Areas of Aboriginal Australia" (chapter 1) was the first clear statement of Aboriginal rules on the right to represent and hold authority over images. One outcome is the recent *Jardiwarnpa* production (City Pictures/SBS). His involvement in videotaping a Warlpiri fire ceremony (now restricted from showing) in the 1980s made it possible for a professional film crew to negotiate a coproduction of the Jardiwarnpa ceremony in 1992.[2]

There is some historical background in the desire Warlpiri people have for a high-quality film on the Jardiwarnpa fire ceremony. It dates back to the making of the ethnographic film *A Warlbiri Fire Ceremony—Ngatjakula* by Roger Sandall in 1967, at Lajamanu, another Warlpiri community, some hundreds of kilometers north-northwest of Yuendumu. This film documented the Buluwandi fire ceremony performed by the opposite moiety. This intertextuality of ceremony and film is, in this instance, possible because of Michaels's work.

Warlpiri people have a long history of being media subjects. Since the 1950s, films have been made by ethnographers, officials from education departments, and documentary and television production teams. With the influx of VCRs, Aboriginal people have had the opportunity to review and consider the effects of this filmmaking, and to discover that they do not wish to be film subjects without any control over or determination of the representations made of them.

Michaels described their views in 1985 when an ABC documentary television team was filming (see chapter 4, "Hundreds Shot at Aboriginal Community"). Subsequently, the Warlpiri devised important interventions, particularly that of the coproduction, to deal with the problems that the white film gaze presented for their culture. This achievement, along with the developments in their own television station, empowered the Warlpiri to reconsider the place of religious traditions as video subjects.

Michaels had shown elders *A Warlbiri Fire Ceremony—Ngatjakula.* The fire ceremony is one of the great traditions of the Warlpiri and was once widespread among the other language groups of Central Australia. It is

described in the literature as early as 1904 by Spencer and Gillen, who witnessed this ritual performed by Warrumungu people at Tennant Creek in 1901. In the words of Spencer and Gillen, "its object was to finally settle up old quarrels and to make the men friendly disposed towards one another" (392). Peterson's text of 1970, an anthropological analysis, is widely agreed to be the most authoritative explanation of the ritual.

As explained by Peterson, the ceremony does not concern any fire totem; the name refers rather to the spectacular use of fire. Of all the public ceremonies, or public sequences of Warlpiri ceremony, the fire ceremony is the most visually striking. Fire is a powerful and polysemic symbol in the Warlpiri iconography and is an important economic tool in a spinifex desert.

The 1967 film was particularly significant because, after Michaels showed it, interest was regenerated in performing the ceremony. Incidentally, in 1986 near Yuendumu he recorded a second version of a Warlpiri fire ceremony (unnamed) on low-band video with the Warlpiri Media Association.

Both Michaels's and Sandall's versions had become restricted from public viewing by the Warlpiri because of the deaths of participants. The ban on seeing or naming the deceased had meant that the Warlpiri themselves had no record of the ceremony that they could use as a guide for novitiates to maintain this crucially important cultural tradition. The Warlpiri then approached Ned Lander and Rachel Perkins to make the film version of their ceremony.

Negotiations for *Jardiwarnpa*, a film of a version of the fire ceremony owned by men and women at Yuendumu and other places, led to interesting contractual, investment, and copyright arrangements. The issues of finance and copyright were complicated, but an agreement was reached that was satisfactory to all parties, including the men and women of Yuendumu with the ritual authority for the ceremony, the Warlpiri artists' cooperative Warlukurlangu, the producers, the Film Finance Corporation, and other funding bodies.

The agreement involved a number of features that further empowered the Warlpiri. One was that Warlukurlangu Artists, itself named after an aspect of the fire ceremony ritual, invested in production along with the other funding bodies, in order to obtain a legal interest in the representation of the Snake Dreaming and because the documentary would be a powerful accompaniment to a particularly significant acrylic art piece soon to be exhibited internationally.

This led to the beneficial copyright being assigned to the Warlukurlangu Artists. Also, senior Kurdungurlu, the ritual "managers," were appointed to supervise and guide the crew, to review the material, and to participate

in the editing. Appropriate payments were made to the ritual performers. The community also contributed food and other logistic material. This third production is the only one authorized for public showing to Warlpiri audiences, although there may be different versions for different audiences.

All of this represents a significant achievement over the terms of previous ethnographic and commercial filmmaking. The introduction of satellite television confirmed the concerns expressed by the old people that the younger ones would lose their language and therefore their culture. But the production of a broadcast-standard program takes up the challenge to turn the technology in the peoples' favor.

Further, since the 1967 Sandall production of the Buluwandi, it was inevitable that the "Law" be balanced and a production of the Jardiwarnpa be made to represent the other moiety. The two halves of society as represented by the moiety division were thus equally represented filmically.

The production of video material for internal consumption in Aboriginal communities is now at thousands of hours, and the producers range from community-based media associations, regional organizations such as the Central Australian Aboriginal Media Association (CAAMA), and land councils both statutory and nonstatutory, to service-delivery associations in the health, legal, and housing areas.

CAAMA, in Alice Springs, is the largest Aboriginal broadcasting association. It has a special-purpose Aboriginal radio license (FM) and is the major shareholder in Imparja Pty Ltd., which holds the Remote Commercial Television Service (RCTS) license for the Central Australian satellite zone. It has also established a video and television production house. Local community-based media associations, such as the Warlpiri Media Association at Yuendumu and EV-TV at Ernabella in South Australia, built their own local low-powered, and as yet unlicensed, television stations seven years ago. They have produced hundreds of hours of television, mostly in their own languages, and much of it experimental in both Aboriginal and Western terms.

The contradictions posed for Warlpiri people by the Imparja commercial license and their own local television transmission have been the subject of much debate, published and unpublished, between Michaels and Aboriginal people and a few scholars. The concerns about the impact of Imparja's programming—which only improves on the other services by a matter of degree—is still an issue of critical importance in Aboriginal communities within its zone.

As a result of these initiatives, the Commonwealth government

developed a policy for about eighty communities, known as the Broadcasting in Remote Aboriginal Communities Scheme (BRACS). The criteria for the eligibility of communities are restrictive. Under the scheme, communities are provided satellite-receiving equipment for the ABC and RCTS, transmitters to rebroadcast one television and one radio channel, video and sound cassette recorders, tapes, mikes, cameras, tripods, and so on. The idea is to allow remote Aboriginal communities to filter inappropriate ABC programs and to insert their own culturally relevant product into the service.

A new remote area development is the Tanami Network, based at Yuendumu. It is an interactive satellite network for video, voice, data, and audio communications between a number of communities in Central and North Australia, initiated by the Yuendumu community.

The motivations behind Aboriginal community video production and television transmission can be seen as basic issues of self-determination, cultural maintenance, and the prevention of cultural disruption that might have resulted from satellite broadcasts of alien programming, whether Australian, American, British, or "ethnic" (most of the world). The strategies they have employed include control of incoming television signals, control of self-representation through local video production in local languages, refusal to permit outsiders to film, and negotiation of coproductions that guarantee certain conditions aimed at cultural maintenance. These developments have arisen from the Warlpiri politics of representation. The essays in this collection are about those politics as much as they are about issues of global art and media.[3]

A Note to the Reader
Michael Leigh

ERIC MICHAELS was my friend and close colleague for the period of his work in Australia. His tragic and premature death left a gap in the lives of his friends and colleagues and in the ongoing fields of the study of indigenous Australian media production and the vociferous discourses that accompany it. This loss is, in part, lessened by the substantial body of work Eric bequeathed to us. He left us not only his voluminous videotape archive of the work he coproduced with the Warlpiri Media Association at Yuendumu covering all aspects of his work there and elsewhere, but also his report on the project, *The Aboriginal Invention of Television in Central Australia 1982-86*, and now this volume of his essays.

Eric wished that this volume had been published in his brief lifetime. Unfortunately, the narrowsightedness of mean-minded people denied him this satisfaction. He was most fortunate, however, in that he had friends such as Paul Foss who have seen to it that Eric's wishes were followed posthumously.

Whether we work in galleries, museums, archives (such as the one in which I work), media or other academic departments, or art magazines, in so many fields Eric's discourse now always informs our theory and our practice.

Eric, when represented by others, appears to have fallen from space to Yuendumu. This, of course, was not the case. The Australian Institute of Aboriginal Studies (AIAS) selected Eric, after lengthy deliberations and interna-

tional phone interviews covering three continents, to undertake research in a field it had been monitoring for some time: that of the impact of new global communications technology on communities well-known for their internal information systems and their control over them. At the time, many fears were expressed about the loss of languages and cultural viability in the remote Aboriginal communities deemed to be most "at risk" from the introduction of new communications systems based on satellite broadcasts. There was an opinion that research on the topic would be of interest to policy developers and others and that it was a rare opportunity to work on the problem in an "open-air laboratory."

We were all excited at the prospects of the project and we knew before Eric's arrival that the field was particularly fertile. What we did not realize then was how good a farmer we had hired to work it. One may sense this excitement in Eric's writings, especially those contained in this volume. There is a sense of the frontier about them, an emergent time and culture full of enormous creative potential. It was a time of *becoming*, as the world coveted acrylic dot paintings and sensed the excitement in the electronic media use of people who, only a generation before, had roamed the desert since time immemorial.

The time immediately prior to the AUSSAT satellite launch saw a school of sharks, charlatans, southern carpetbaggers, and all sorts of other opportunists congregate in Central Australia with a chance to influence policy (and often to promote their own self-interest). These people claimed to know best what Aboriginal people did or did not want. Eric, newly arrived in the midst of all this mayhem, was at least astute enough to hear different voices as yet unsuppressed by alien notions about silent lands. Despite the fact that he was really the only "expert" at work in the area covered in the Willmot Report,[1] his advice was, unfortunately, generally ignored at the time.

Even if cloth-eared bureaucrats didn't want to listen, others certainly did. His insights into Aboriginal information systems and his erudition in the areas of critical theory, deconstruction, postmodernism, and so on were a useful combination for those trying to cope with the boom in the international market for Aboriginal art. Eric helped such people understand how the ethnographic became art. An understanding of this transformation was critical to establishing economic and other values for the pieces in the market. No one likes to pay $50,000, or two Toyotas, for a curio, and an essay such as "Bad Aboriginal Art" explains why one needn't do so.

Furthermore, Eric was the perfect person to fulfill this func-

tion for the postmodern collector. He was himself a performance-artist academic. Eric's seminars were real shows. Often the delivery was everything. He alludes to this showy style in the letter to the Imparja board of directors appended to "Aboriginal Content: Who's Got It—Who Needs It?" saying "I have so far refused offers to publish the paper because it was part of a whole performance."

On the texts as a whole I have little to say, preferring to leave that to Marcia Langton and other colleagues of both mine and Eric's. I have, however, an important duty to perform in setting the record straight in regard to the film work of the Institute that employed Eric to conduct his research and of which I am currently an employee, as film archivist, and also a member. In his essay "Aboriginal Content" Eric writes of showing "'government' tapes, from the Australian Institute of Aboriginal Studies ... [which] involved Aborigines mostly in training capacities under the direction of Europeans.... They are intended to present Aborigines in a positive light; positive in the sense of development, or even assimilation." This slur on the long and (rightly) much acclaimed tradition of ethnographic filmmaking practiced here at the Institute since 1963 is absolutely unsupportable. Nowhere in the works of such fine filmmakers as Cecil Holmes, Ian Dunlop, Roger Sandall, Curtis Levy, David and Judith MacDougall, or Kim McKenzie does evidence for such an absurd proposition exist. Furthermore, none of the Aboriginal trainees in film at the Institute, including Wayne Barker (*Cass—No Saucepan Diver*), Coral Edwards (*It's a Long Road Back*), or the current trainee, Liz McNiven, have ever produced a film under the direction of Europeans but have, at all times, been free to direct their own films.

Why Eric would want to make such an unfortunate statement about our work eludes me, and no clue exists in the list of our films he supplies as notes to this essay. Well-known for biting the hand that fed him (once, when replying to a question from the then federal Minister for Aboriginal Affairs, Clyde Holding, he said that he was employed by CAAMA rather than the Institute), he was not alone in seeking to distance himself from his institutional employer. Perhaps his ill-considered remarks here served him in the same vein.

Indigenous media flourish today in Australia in a wide and fluid continuum or spectrum of genres, cultures, individuals, and groups. Paintings and other art objects now hang in many important galleries here and overseas and in many ordinary homes. In these same homes the radio may play Yothu Yindi's latest hit, *Treaty*, or a Kev Carmody song, *How High's the Nyandi, Auntie?* The TV pick-of-the-week may be Saturday night's late-till-dawn national radio and televi-

sion simulcast of a huge indigenous rock and roll concert, like the *Stompem Ground*, broadcast live from Broome in the Kimberleys in September 1992. Numerous poets and other writers have published and more regularly recite their works, and story-tellers are often called on to visit schools to spin their yarns. Musicals such as *Bran Nue Dae* are the best things seen in theaters for ages, and in the cinema Tracey Moffatt's *Night Cries* and other films continue to receive the critical notice and ac-claim they deserve. Indigenous radio is strong and indigenous production for urban community television continues to grow. Over eighty remote indigenous communi-ties are linked via radio and television narrowcast services in the BRACS, or Broad-casting in Remote Aboriginal Communities Scheme, and Imparja TV is still the only commercial television license owned by an indigenous group anywhere in the world.

The recently established Tanami Communications Network, or TNAC, which links people from the Yurntuma, Wirliya-jarrayi, Lajamanu, and Walungurru Aboriginal communities in the Tanami Desert, Central Australia, is as sophisticated a system of community-controlled modern media service as exists anywhere in the world. The network of satellite, digital-data, audio, and video sig-nals and hardware offers such services as school lessons, medical records and con-sultancy, access to central resource inventories and delivery systems and other such information, the archiving of cultural knowledge, entertainment, and so on—all vital to the life of small remote bush settlements and their outstations.

Partly as a result of Eric's work these remote desert and other bush communities now have the power to intercept the broadcast signal whenever they wish and replace it with a local production or whatever they think is a more appropriate program, perhaps one generated in another BRACS community—or not program anything at all, to encourage participation in a range of other com-munity activities such as school or council meetings. This power was felt by Eric and others to be the minimum needed to protect fragile languages and cultures.

As I write, Francis Jupurrurla Kelly is not making television at Yuendumu. But he has been making it at Lajamanu and Yuendumu since Eric's departure and will, no doubt, do so again. In the meantime the Warlpiri Media Association has produced a brilliant children's television series designed to pro-mote literacy and numeracy in the Warlpiri language, as well as to teach and to entertain. This series, *Manyu-Wana* (Let's have fun), uses all the technological gadgetry of modern computer-generated television and makes *Sesame Street* look tame and stilted in comparison. The Yapa Mutant Ninja Turtles and the zappy presenter would have appealed enormously to Eric.

Ernabella Video Television, or EV-TV, continues its pioneering work, having by now produced an archive of over a thousand hours of video-recorded Pitjantjatjara culture ceremonies, bush tucker and bush medicine, social events, meetings, education, entertainment, and other activities such as football and netball matches. They are still essentially producing for their own consumption in the same station that started with a ten-cent tax on soft drinks bought at the community store. Their most ambitious project has been the filming of ceremonies associated with the Seven Sisters Dreaming track, or "songline," as it crosses Pitjantjatjara lands.

Indigenous units were created within the national (in the sense of broadcast range as well as ownership) broadcasters, ABC-TV and SBS-TV. Here, indigenous staff curate seasons of independently made documentaries on and by indigenous Australians and produce current affairs programs such as *Blackout* and *First-in-Line*, introduced to air in 1988. At times they have produced longer documentaries such as *One People Sing Freedom*, about the indigenous protests against the Bicentennial celebrations in Sydney in 1988. Whereas SBS's *First-in-Line* folded at the end of 1988, the continued production of the ABC's *Blackout* gave many talented young indigenous filmmakers like Michael Riley (*Malangi*) and Frances Peters the chance to present new work. Peters's *Tent Embassy*, shown in 1992, is typical of this style of documentary. Rachel Perkins, who trained at CAAMA and on *First-in-Line* and is now Executive Producer, Aboriginal Television Unit at SBS-TV, coproduced a four-part television series, *Blood Brothers*, with independent filmmakers Ned Lander and Trevor Graham in 1992.

Other indigenous media workers are embedded in the mainstream media, with Rhoda Roberts, formerly the hostess of *First-in-Line*, now fronting the more general SBS current affairs weekly program, *Vox Populi*; and Stan Grant, a Wiradjuri, who has his own nightly current affairs show, *Real Life*, on one of the major commercial networks in Sydney.

Of course, it's not all perfect. BRACS is still underresourced, and a few national racist fools still splutter about the popular airwaves. Urban-based Aborigines and Islanders still lack local media systems of the sophistication of those employed in BRACS and the Tanami Network, but the situation is now better than it's ever been. Many of the fears of Eric Michaels and others about the future of indigenous media in Australia have not been realized. Today, a diverse indigenous media practice reflects the diversity and vitality of indigenous cultures and peoples and gives Aborigines and Torres Strait Islanders the potential to be

well heard (and seen) after being kept silent (and invisible) in their own lands for so long. As CAAMA cofounder Philip Batty says in the film *Satellite Dreaming*, the video camera is one of the most powerful tools ever used by indigenous Australians.

The flow of individuals across the continuum is well represented by the career of Wayne Barker, from Gunada Productions in Broome. Barker, a Yawuru Law man, trained with David MacDougall and Kim McKenzie in ethnographic film at the AIAS (now AIATSIS) and at present produces community health announcements for BRACS television, strings for the news on the Golden West Network, worked as boom operator on the Perth feature *Tudawali*, scored the soundtrack for Darwin-based Rhonda Foster's *Extinct but Going Home*, and is currently cutting his own major documentary project, *Milli-milli*. As president of BIMAC, or the Broome Indigenous Musicians Aboriginal Corporation, he coordinated the recent much-praised nationally simulcast music concert from Broome and in 1993 he will once again cocurate an international touring program of indigenous film and other culture.

This efflorescence of indigenous production in all media, including the electronic, gathers momentum not because of well-intentioned whitefellas like Eric or myself, no matter how much we think we influence policy and the rest, but because blacks themselves demanded to be heard and showed in the intelligence, wit, and seriousness of their own representations that they would not and could not be ignored. Having dealt with their hidden histories to a large degree now, they begin to look to ways of exploring the intersubjectivities and intertextualities with the dominant culture that inform their lives in this postmodern world. One of Eric's greatest insights was to see that the ways indigenous Australians do this may be of paramount importance in arriving at an understanding of ourselves.

In 1993 the Film Archive of AIATSIS will publish a companion to Eric's report and these essays, in the form of a videography of the material generated by the Yuendumu Television Project, as we call it. The videography will include a catalog of Eric's papers, both those he read and those he wrote, a catalog of the videotapes produced in conjunction with the project, and a videotape compilation of selected items chosen to illustrate his work or because they are those most frequently referred to in his writings. Together with the publication of these essays the videographic material will go a long way toward helping us understand more of Eric Michaels's work and the man himself. Perhaps then we will get a

more balanced view than seemed to be possible in the rushed couple of Festschrifts that followed his funeral. It was as if his very brilliance had inadvertently lit a box of fireworks that flared up briefly only to be extinguished in turn. This collection of essays is of more substantial stuff.

Acknowledgments

Paul Foss

OVER THE six years between beginning his researches among Warlpiri Aborigines and his untimely death in 1988, Eric Phillip Michaels came to feel that out of all his conference papers, published essays, and field reports, there was a book to be had. In 1986, upon completing his Institute fellowship, he put together a manuscript entitled "Aborigines, Information and Media: the Aboriginal Australian Encounter with Introduced Communications Technology." Eric had been especially eager to see the book in print. Aboriginal Australians figure prominently in his anthropology of tradition and autonomy in the postmodern era of electronic information. Their nonliterate and spatial culture furnishes a model for the movement of his speculations; the European sphere also figures in equal measure in this study. The Western world in fact tests the conclusions of his Aboriginal media analysis, our historical and literate orientation being subject to a critical reevaluation, while indigenous TV is seen as a mark of technological "refinement."

But disinterest and then fate intervened in the project. After his death from AIDS-related causes in Brisbane, where he taught media studies at Griffith University during the last two years of his life, Eric's written and visual material went, on his request, into the archives of his former employer, the Australian Institute of Aboriginal and Torres Strait Islander Studies (AIATSIS) in Canberra. Along with the appearance of *Unbecoming: An AIDS Diary*, which Eric

wanted published (for which purpose he directed the allocation of his savings), and the various essays and the *Continuum* tribute that came out posthumously,[1] there was growing interest in publishing an anthology of his work. Penny Taylor, AIATSIS colleague and executor of Eric's estate, ensured that his papers, correspondence, field notes, clippings, and computer disks were accessible in the Institute's library for future reference.[2]

Few, least of all Eric, could have foreseen the staying power of his textual persona. In the four years since his death, Eric has become about as celebrated as the Yuendumu people of whom he wrote so eloquently and decisively, and whose achievements in media and painting owe not a little to this gutsy American researcher who visited among them for a time.

Eric had trained as an anthropologist before coming to Australia in late 1982. A postgraduate at the University of Texas, he did his master's thesis on the dispersal of property among gay lovers, followed up by a doctoral thesis on the social organization of the interpretation of TV messages in a small Texas city based on fieldwork with Protestant fundamentalist media protest groups ("TV Tribes"). After finishing his doctorate, Eric accepted a fellowship from the Institute to research the impact of television on remote Aboriginal communities — eventually published as *The Aboriginal Invention of Television in Central Australia 1982-1986*. He mainly worked in the western/central desert region where he involved himself in claims by Aboriginal media associations for increased local autonomy in video production and transmission (see "Aboriginal Content: Who's Got It — Who Needs It?" and "For a Cultural Future: Francis Jupurrurla Makes TV at Yuendumu," chapters 2 and 6 of this book). At the same time, Eric became interested in the recent acrylic "dot paintings" carried out at Yuendumu and Papunya, occasioning the essays "Western Desert Sandpainting and Postmodernism" and "Bad Aboriginal Art." With these writings, exemplary in their refusal to romanticize indigenous cultures, Eric gained a wide reputation for his non-ethnographic approach to Aboriginal video and art.[3]

That this enthusiasm for his work should be based on a number of esoteric publications makes it all the more remarkable. Early on, Eric appeared mainly in journals and books of occasional or specialist circulation.[4] He was a sort of inside trader, operating between professional anthropology, institutional reports, marginal press, and pamphlets. Then, from March 1987, he began writing for the Sydney magazine *Art & Text*, opening up a new and more culturally

diverse audience for his work. This association eventually led to a commission to write *For a Cultural Future*, the monograph for which Eric is best remembered.[5] The direction taken in these late essays reveals a strength of mind and subject matter unequaled in his former output. *Unbecoming* in itself, perhaps the most unremitting portrait of AIDS ever penned, makes one wonder what he might have accomplished if he had lived.

As a friend, and as editor and publisher of a number of Eric's later writings, I have coincidentally occupied a focal point for the increasing interest in producing a compendium of his work. So it was with pleasure that I agreed to assist in selecting and coordinating the present volume for publication. How to do justice to the task, however, was something altogether different. One thing was clear. As I discovered when publishing the AIDS diary, it is best to allow Eric's thoughts to appear in the order in which they were conceived and to keep editorial commentary to a minimum — the basic strategy pursued here.[6] The other aim was to ensure that the book be adequately introduced, and I must say it has been very fortunate in that regard.[7] The general reader may approach these essays armed with helpful background and material information.[8]

Not that there is any way to totally elucidate the complex maze of events, proper names, and localities at the base of the stories narrated in this volume.[9] Many of us today who occupy the universe of global media have had to familiarize ourselves with the maps, physiognomies, and tongues of foreign lands and cultures, and so the particularities of Australia will be somewhat known. Even so, there is room for doubt of American comprehension when taking into consideration the overwhelming predominance of, say, American "actuality" on Australian commercial TV as compared to the odd Paul Hogan advert or episode of *Skippy* that alone used to air on U.S. network channels. Of course, the same applies with Aboriginal actuality in the metropolises of this country. Part of the message in the narration of *Bad Aboriginal Art and Other Essays* is surely that airwaves deliver far more than the medium, and that without the willingness to suspend and expand our habits of watching, reading, listening, and knowing, the cultural climate of the earth will lose its ambience, its always curved horizon.

It is to cultural horizontality and suspending the familiar that these essays are dedicated. But this is not to say that no interventions have been necessary. Much has changed in the time that elapsed since Eric first put together a manuscript along such lines, not the least being that what he wrote there-

after tended to consolidate and overshadow in pure inventiveness the more or less "vocational" papers that preceded it. Inarguably, the concerns motivating his text shifted in subtle, dramatic ways. Needless to say, the circumstances of those difficult last two years had a profound impact on the purport and force of his thinking.[10] It therefore seemed reasonable that any collection should be true to this later stage of his oeuvre. But there was no need to jettison the whole of the 1986 manuscript. In fact, three of its chapters were retained.[11] Once the decision was made to include only those pieces most representative of the panache, humor, and mordant charm of Eric in full flight, the book took shape as it presently stands.

Still, there was not, to begin with, a wide range from which to choose. But what remains of this life's work cut short cruelly in midstream is sufficiently demanding and fertile to warrant the most attentive hand, a task for which I cannot claim entire responsibility. To that end I enlisted the assistance of many of Eric's friends and colleagues, without whose advice, energy, and steadfast support for the project this volume would never have appeared. Among them I wish to thank Michael Leigh, film archivist at AIATSIS, who kindly agreed to sketch out the Aboriginal media scene since the days of Eric. Marcia Langton, well-known Aboriginal activist, lecturer in Aboriginal studies in anthropology at Macquarie University, and current Chair of AIATSIS, gave generously of her time in preparing an overview of Eric's role in a local Aboriginal revolution. Dick Hebdige, now teaching at the California Institute of the Arts in Valencia, proved once again his boundless affection and support for the cultures of other people by writing an extensive introduction to Eric's work in the broader area of cultural studies. Aboriginal artist and filmmaker Tracey Moffatt graciously offered to do a cover image incorporating a painting by Avril Quaill. But thanks are especially due to Penny Taylor, whose patience, diplomacy, and friendship rescued this project from oblivion on numerous occasions.

Also to be thanked are Tom O'Regan for a couple of lengthy telephone calls, Meaghan Morris for drawing my attention to Eric in the beginning, and Ned Lander and Rachel Perkins at City Pictures/SBS for giving permission to reproduce a still from *Jardiwarnpa*. Sandi Buckley and Brian Massumi in Montreal were instrumental in first suggesting the book to the University of Minnesota Press and proved to be diligent editors throughout, for which I am grateful to them.

Last but not least I wish to thank the Warlpiri people at Yuen-dumu, not just for permitting the reproduction of their images in this book, but also because without the extraordinary resolve and ingenuity of this remote desert community Eric Michaels could never have ultimately aspired to the audience he craved.

A Primer of Restrictions on Picture-Taking in Traditional Areas of Aboriginal Australia
[1 9 8 6]

Introduction: Photography as Spirit Theft

TRADITIONAL PEOPLES' first encounters with photography sometimes lead them to conclude that the camera is a dangerous, magical instrument capable of stealing some essential part of their being, causing illness or death. Generally such anecdotes are not explained but get filed away with other exotic superstitions held by curious primitives, leaving these people to sort out their own relationship to cameras, photographs, film, and now video. Traditional people sometimes follow through by taming the magical properties of recording media. For example, when missionaries and health workers banned the preservation and display of the bones of dead ancestors in Melanesian houses, photographs soon replaced bones in household memorials to these dead. Melanesian Australians in the Torres Strait Islands likewise make extensive use of photography in mortuary ceremonies and display photo collections of the deceased.[1]

The early evidence of Aboriginal attitudes toward photography in mainland Australia is partial and contradictory. Baldwin Spencer, one of the first scientists to make extensive audiovisual field recordings of Aborigines (1901/1912), reported both appreciation and fear resulting from his efforts. At least one Warrumungu elder claimed that Spencer's camera extracted vital essence from his liver, threatening his life. Other traditional Aborigines responded

with less hostility and seem to have enjoyed the novelty of the camera and its products.

One could pursue at length the ethnographic significance of people's fear of cameras and accusations of spirit theft. Or one might simply admit that there is a certain sense to the proposition that using someone else's image, property, or life as a subject to be recorded, reproduced, and distributed is a kind of appropriation. Such appropriation usually benefits the photographer (or his sponsor) more than the subject, and in some cases might indeed be injurious. Every society regulates the recording and publication of images of its citizenry to protect certain human rights valued by that society. Indeed, the issue is now hotly debated with respect to journalistic conduct, because quite different philosophies of media access obtain in Western democracies, the shrinking Communist bloc, Third World dependent nations, and, notably right now, South Africa.

Even in the Western democracies, the "freest" of expression is constrained by accepted cultural values that mass media are not entitled to breach. These change, of course, as cultural values themselves alter in time, so that we are no longer certain, for example, whether women's uncovered breasts or simulated sexual activity are to be considered obscene and restricted in certain media and contexts. However, every mother's daughter or son knows roughly where the line of acceptability lies. Pictures of Princess Diana drunk, runny-nosed, or lying in the gutter, for example, would not be permissible for public display anywhere. Various laws, including copyright laws, slander laws, obscenity laws, and so on, attempt to define these issues and ensure that both individuals and the state can impose sanctions to maintain such values.

What constitutes slander, plagiarism, or indecent or offensive displays is a characteristic specific to any particular culture, and so is likely to vary from one culture to another. To understand what constitutes a moral offense in cultures other than one's own, precise ethnographic examples are necessary. It is just not possible to treat one's own understanding of these things as commonsensical, and to generalize from that.

Traditional Aboriginal Australia does not maintain a free-speech ethic. Rather, as may be the case generally in oral societies, speaking rights are highly regulated. Knowledge is a form of property here, and violating the highly structured rights that restrict general access to information is regarded as theft. Aboriginal Law, like common law, identifies and penalizes blasphemers, slanderers, plagiarists, and the obscene. But it identifies different contents and

specifies different performance settings as subject to sanction. Lest anyone question the seriousness of the matter, however, it should be remembered that the most extreme punishments of Aboriginal society are reserved for people who violate these traditional restrictions on the communication of cultural knowledge.

Keeping in mind that the emphasis on information among Aborigines results in a particularly elaborate system of restriction, we can still draw several helpful, if simplified, analogies to Western law. This illustrates the major areas of violation involved in the Aboriginal system, but also demonstrates that the idea of rights, and wrongs, in such matters, and their protection by the state, is now wholly unfamiliar to Western thinking.

At least four areas[2] can be identified in which Aboriginal culture may be compromised and Aboriginal people offended when they, or information about them, become photographic subjects:

1. Unauthorized display or transmission of secret or otherwise restricted materials. These may be rituals, songs, dances, graphic designs, and perhaps oblique references to knowledge thus encoded.

2. Violation of mortuary restrictions that may prohibit reproduction of a now deceased person's body, image, or voice in the presence of his (or her) relatives. Restrictions may also include his name, words thought to sound like the deceased's name, and sometimes songs, stories, designs, dances, or things associated with that person.

3. Invasions of privacy: public display of what Aboriginal etiquette deems to be private or familial (e.g., most fights, interiors of humpy camps, certain ceremonies).

4. Rhetorical narrative devices that isolate Aborigines and constitute them as exotic rather than contemporary peoples, or otherwise depict Aborigines in what they judge to be a negative manner.

This listing begins with what traditional Aboriginal people have taught me is the most clear-cut and grievous example: public display of secret

matters to persons unauthorized to behold these; continuing through increasingly complex, subtle, and problematic areas in which a greater variety of interpretation and negotiation may be possible. In the last instance, for example, it is usual that different audiences and individuals will read the rhetorical perspective of a visual image differently, and offense may or may not be noted. Notions of privacy may likewise vary and occasions may be identified where people agree that privacy is less important than some other issue that compromised it. There are documented cases where families have decided to forego mortuary restrictions and even promote the showing of films about now-deceased kin.

This underscores the self-evident but sometimes neglected fact that Aboriginal people did not employ the communications technology with which they must now deal, and traditional law makes no explicit rulings on the use of cameras, tape recorders, or writing. Thus the application of Aboriginal traditional law to modern media must be an interpretive act, built on analogy or extension or even reinterpretation, and so may be open to negotiation.

What matters most in this act of interpretation is who does the interpreting. Because what is being protected here is the right and authority of particular people, usually elders, to uphold the culture and its values, their right to make the determinations regarding new situations cannot be undermined.

European media practitioners who photograph Aboriginal subjects are usually the defendants in the matter of violations. It is worth saying from the outset that for photographers to insist on their prerogatives, even to assert a bargaining position, is a little like a felon on trial claiming the right to overrule the presiding judge on matters of law. A more helpful stance for media practitioners would be to attempt to collaborate with Aborigines, beginning this even before bringing out the camera, familiarizing them with the type of media and its consequences but reserving juridical authority for Aborigines themselves.

Thus the emphasis of this essay cannot be an elaboration of Aboriginal media "rules." For a European, academic or otherwise, to construct such rules would be in violation of the authority and autonomy of Aborigines — something, finally, we intend to uphold by addressing and investigating the issues being discussed. Rather, this account will limit itself to identifying those areas likely to present problems for Aboriginal tradition, and ways that problems can be avoided, negotiated, or resolved in the conduct of media production and reproduction among Aborigines.

Areas of Sensitivity for Recording

Secret/Sacred Materials

Aboriginal philosophy contrasts the world of sacred knowledge to mundane, daily events. Sacred things have their sources in, and refer to, the "Dreaming" world, in which ancestral and cosmic spirits create the land, populate it with plants, animals, and people, and establish the proper relationships between these. The rules of conduct and observance for humans in ritual, ceremony, birth, marriage, and death are prescribed and explained in the Dreaming. This is the Aboriginal equivalent of religious experience and heaven, but it is more thorough and pervasive than the European variety. For traditional Aborigines, the Dreaming is not something that happened long ago, commemorated only on holy days, in some special place like a church. All life, all country, all relationships and all conduct have sources in the Dreaming, and every man and woman aspires to greater knowledge and more profound observance of the sacred throughout their lifetime.

Dreaming lore is expressed directly in several media: songs, stories, dances, and graphic or artistic designs. The accumulation of knowledge, prestige, and respect in the traditional Aboriginal world is based on an individual's accumulation of these. Some of these sacred media are public and accessible to everybody who shows an interest. But much of the lore is restricted. Only certain people can earn the right to know these things, based on their positions in the kinship network, their relationship to certain tracts of land, and their interest and skill in ceremonies where these media are performed and taught. These secret songs, stories, dances, and designs represent the most important personal property owned by Aborigines. By analogy, appropriation of these by unauthorized people, including photographers, is theft, and compromises not only the individual owner but the sacred realm as a whole.

It might appear simple for the photographer to ask whether something is secret, and avoid recording anything in question. There are many reasons why this is not simple or sufficient:

1. Truly secret things cannot be talked about, sometimes they may not even be asked about. An unauthorized outsider who has stumbled upon some secret thing may be ignored when inquiring about it. If the Aborigines asked are not themselves authorized to speak about these things, they may or may not

refer the questioner to the proper authority. Younger people (e.g., under 40) or the more Europeanized Aborigines such as council members, who in some communities are most likely to negotiate with outside Europeans, may also be the least likely to be able to speak of secret things.

2. Women and men maintain different domains in secret matters, so that men may not be authorized to speak for (or even be very aware of) women's matters, and vice versa.

3. The division between secret and public is not distinct and absolute. The same story, song, dance, or design may have both secret and public versions. Even public media may have secret underpinnings. There exists a whole range of materials that are sacred but that may be displayed publicly if the proper authorities decide to do so for certain purposes. Because secret things also serve as proof (of authority, ownership, religiosity) and because elders have a responsibility to teach as well as to store knowledge, there are some instances where secret materials may be displayed to outsiders. Such display is understood by Aborigines to honor but also to obligate the beholder. For photographers to assume "ownership" of images they have captured on film and to display them elsewhere to others may be considered an outrageous breach of this obligation.

4. Individual Aborigines under extraordinary circumstances (e.g., Christian mission influence, loss of tradition, inebriation) may wish to desecrate sacred traditions and either reveal secrets or even give away sacred objects to outsiders. Sometimes elders, despairing of the "cheekiness" of their own young people, even believe that sacred knowledge and objects are safer in the hands of Europeans.

All of these considerations are associated with any fieldwork that outsiders conduct among traditional Aborigines. But photography, which is a mass medium, poses special problems, because oral societies do not employ means of mass reproduction and publication of information/images, and are likely to be unfamiliar with these implications of recording.

Special Problems of Photography and Mass Media

In traditional face-to-face society, the revelation of a cultural item establishes a contract between the people directly involved, and may go no further. But when a photographer takes a picture of a dance, or a design, or an object, he then can take that picture away, reproduce it, even mass-produce it, and publish it so that it may reappear distanced in time, place, and context from the original event in which it was displayed and photographed. This difference between traditional and contemporary media takes the display beyond the control of traditional authorities and poses a more complex and worrying set of problems.

Class and Gender Restrictions

Aboriginal society assigns members to a complex, sometimes bewildering variety of classes based on parentage, place of birth, ceremonial accomplishment, and so on, and restricts information accordingly. The most familiar and typical example is in the case of information restricted by gender. In my own fieldwork, I generally attempted to avoid instruction in secret men's business. But because I was male, I was as a matter of course told and shown things that, although not highly restricted, were still men's business only. (Some of these things women probably know, or know about in some sense, so that one might think maintaining restrictions here was not important. But women could not admit to knowing these things publicly, and I would have been in trouble if I were believed to be discussing such things in women's presence.) At times, elders even insisted that I photograph or notate restricted things. But it was understood that these recordings must never be shown to women. Thus, while the act of photography was sanctioned, the publication of these photographs (which would make them available to women) was forbidden. This is a distinction that Aborigines, as they become familiar with the concept of reproduction and mass distribution, are likely to insist upon. Because it is an unfamiliar distinction, or some would say it offends Western values of sexual equality, Europeans may trivialize it.

Localism of Authority

The second problem that photographic reproduction poses in the secret/sacred domain has to do with the localism of authority versus the extensiveness of knowledge in the Aboriginal world. The designation of an item as secret as opposed to public is locally made and enforced. But a similar or identical item to that deemed public in one place may well be considered wholly secret and

highly restricted in another. Thus a photograph made in one place and authorized for public showing may be discovered to be quite offensive elsewhere.

This does not occur by accident. The ethnographic fact is that the items of sacred lore, the owned intellectual property described above, are also items of exchange between local groups. Thus a song, story, design, or dance is likely to travel great distances over trading routes so that it is performed in many places, often distant from its point of origin. These trading routes, which actively enmeshed the Australian continent before European contact, persist in the traditional areas today. Indeed, motor vehicles and modern communications may have revitalized some of these routes.

Secrecy is related to economic value in these exchanges. A community that successfully maintains the secrecy of a dance, for example, is well placed to trade that dance with a neighboring community in ceremonial exchanges. Over time the neighboring community may make a further trade with its neighbors, and so on down the line. In this manner, a dance (or song or story or design) may travel across much of the continent over a period of years, or over generations.

In this system, it is reasonable to suppose that after a community has traded a secret item it loses some of its value, and therefore secrecy, for that community. For some time secrecy will be guarded, to protect the value of the material for the neighboring community. But after subsequent exchanges, a secret item might well become public over time in the original community (while remaining highly restricted at the "leading edge" of the exchange route). This has been demonstrated to be the case with current dances that are performed publicly at Cape York but are restricted now in Central Australia. Similarly, certain trade items such as feathers and shells are publicly displayed near their sources but are highly restricted objects in distant areas. As a result, guarantees of an item's "publicness" by one local group do not assure that other groups will consider the item public as well.

Temporality

The final problem of photography and recording regards the capacity of photographs to freeze items in time. As the previous sections implied, the issues of secrecy and sacredness are not static, fixed facts but dynamic, changing negotiations. Hence a photograph from 1920, even if it was authorized at that time by the appropriate elders, may pose certain problems for their descendants.

Aboriginal tradition managed the possible contradiction of the

past by a set of mortuary rules that assured the destruction of the material possessions of deceased persons and placed restrictions on their intellectual property (e.g., their names). This is considered at greater length as a separate area of restriction below. But the possibility of contradicting living authorities by means of pictures of dead people, or by photos displaying their designs, dances, ceremonies, and so on, cannot be overlooked. While the simplest solution is to withhold old pictures from Aboriginal audiences, this will not prove satisfactory for long. It is a matter that requires consideration in any undertaking in which contemporary photographs and recordings are intended for archiving and later display.

The Secret/Sacred Again

The problem of respecting Aboriginal desires to maintain the secrecy of their most sacred knowledge is demonstrably complex and difficult in the case of photography or any other mass medium. No explicit general rules or guidelines in the matter can be determined. The domains of the secret and the public overlap and grade into each other, so nothing can be established as being absolutely one or the other. Having been granted the right to take a picture does not guarantee the right to display it, even in the same community. When a picture is reproduced, published, and distributed, one cannot even guarantee that authorization in one community will assure its acceptability in another. In time, even the same community may restrict a photo that was originally acceptable.

The sources of these difficulties, I believe, are in the profound differences between the nature of oral and print/electronic cultures: as such, they can't be simplified or wished away. But neither should we assume that one simply can't make photographs among traditional Aborigines. Aborigines themselves wish photographs to be taken and displayed. What is called for is a mode of collaboration in the matter, to be described in the conclusion of this essay. Here, it is sufficient to note that in insensitive hands, photography can indeed be a weapon of considerable destructiveness to Aboriginal tradition, and moreover an instrument of theft. Failure to anticipate, understand, and engage in proper consultation about these matters with local Aboriginal authorities can truly lay the photographer open to serious charges from traditional peoples.

Mortuary Restrictions

Judeo-Christian tradition honors the dead by recalling their names and even their images. We name children, streets, and buildings after dead people, and cherish paintings and photographs of dead relatives, which may be featured as "altars" in

special places in European lounge rooms. Mainland Aboriginal tradition prescribes nearly the opposite.

The death of an Aboriginal individual is considered so upsetting that elaborate precautions are taken to ensure that things associated with or owned by the deceased, including his or her name, are avoided by living relations. A dead person's camp is burned. Kin move away and avoid that area, often for years, and even words that sound like the dead person's name may be omitted from speech.

These restrictions have, in many areas, been extended to all recordings made of the dead person: film, video, sound, and photographs. One may not exhibit the photograph of a dead person to his or her living relatives (meaning at least their entire community, and often an extensive region) for as long as a generation. This means that all photographs featuring people will eventually become restricted for some period of time.

This rule may not be absolute, however. Christian Aborigines have been taught a different set of obligations and may express uncertainty as to which tradition to apply. Alice Springs Aborigines bestow the names of dead Arrente (Aranda) elders on buildings as an honor in the European manner. Even traditional Aboriginal elders concerned with cultural maintenance may approve pictures or films including dead people if the information contained there is needed and if the deceased can be considered as "in the background." The circumstances surrounding any given death may determine how flexible this rule is; some deaths may be more upsetting than others, and the implications then fester longer in living memory.

Because death is almost always believed to be caused directly or indirectly by human agents, death may provoke blame and even nostility between families. Ideally, these are resolved in mortuary ceremonies, which may extend intermittently over several years. But some deaths prove more difficult to resolve. In any case, the recall of the dead by name or image may prove to be not merely insulting: it may well provoke such unresolved hostilities and prompt fights and paybacks.

Mortuary traditions differ in different regions. Generally mortuary activities are thought to be private familial matters, so that things associated with death should not be photographed. Some of these things are obvious, such as funerals and ceremonial gatherings. But some, such as a mourning design or body paint worn by mourners after ceremonies, may be quite casually worn in public. Abandoned campsites may signal to Aborigines restricted territory, but appear to

the photographer as picturesque studies. In the former example, one should always ask if a subject is willing to be photographed. But the latter case reminds us that all landscape in Aboriginal Australia is rife with specific associations, is not likely to be considered public property, and appropriate residents must give permission for photography of even unpeopled scenes.

In some regions, bones of dead relatives may be ritually, even casually, displayed. In other areas, bones are highly restricted, and perhaps should not be photographed, even in the case of archaeological sites. For Aborigines who believe that bones of the deceased must rest in specified locales (e.g., grandfather's country), the removal of the bones may provoke dangerous, restless spirits. Some Aborigines believe that in this case a photograph of bones is equivalent; showing the photograph in distant places dislocates and provokes the associated spirit. Others disclaim this equivalence. It may be that this concern with human remains is one source of the restriction on portraits of the dead; people actually become fearful on seeing such pictures that the spirit may be provoked and seek revenge. Even where people are sophisticated and unwilling to admit such fears, they may persist.

In the case of mortuary restrictions and in the secret/sacred domain described above, Aborigines express uncertainty as to the status of photographs and the extent to which the actual properties of a restricted object or image carry over into its photographic representation. As a result, the photographer will encounter a variety of opinions about what is suitable to photograph and subsequently to display. Some opinions will guide the photo-taking, but even more important ones will be offered on reviewing the photographs and inquiring into who may see specific pictures. It is not uncommon to discover a restricted design, inadvertently included in what appears an innocuous photograph, or to discover that someone in a group picture has died.

Even where people refuse to see photos of the dead, individuals may themselves keep photos of parents or other close relatives hidden, and show these at certain times. This apparent contradiction can be explained in that the right of the individual to display a close relative's image is his to exercise. But they will not easily permit another this right by authorizing the distribution or display of such images by others.

Invasions of Privacy

All cultures maintain a distinction between public and private spaces, and photographers reasonably assume that rights to take pictures in public are different from rights to take pictures in private, intimate settings. Public set-

tings may be fair game for photographers, but permission is usually understood to be required for private picture-taking.

In a sense, this distinction holds as well for Aboriginal society, but difficulties arise because Aborigines may conceive of different places as private than do Europeans. In traditional communities and in warmer climates, Aboriginal life may be mostly conducted out of doors. But unlike Europeans, Aborigines do not assume that outside areas are public areas.

Both humpy camps and more modern structures may be designed to be used mostly for storage and occasional shelter in poor weather. The real living quarters are apt to be an area surrounding the structure, an invisibly bounded veranda on which cooking, socializing, sleeping, gambling, and all manner of "household" activities take place. These outdoor spaces are never conceived of as public. For example, when approaching an Aboriginal dwelling, proper etiquette may require a visitor to stand some distance outside this area, to await acknowledgment and permission before approaching closer. Rarely would one go directly to a front door and knock; if no one is around, it may be best to call out from some distance for the people you are seeking. Obviously, one does not take pictures here as one might on an urban street.

Traditional humpies were arranged so as to create very specific and intentional spaces between them, some signaling common areas, others indicating "no-man's-land." Where more modern housing is not oriented to create such spaces, alterations (physical and conceptual) may be made to simulate these functions. It can be very difficult for an outsider to recognize these spaces, or to tell the difference between their purposes. But these still may not be public spaces in Aboriginal terms.

This is dramatically clear when these spaces become arenas for large fights that occur in some traditional communities. Hundreds of armed men and women may take to the "streets" in what for the photographer must be an irresistible display. There are two reasons why the photographer should resist taking pictures here. The first is that the camera may be perceived as a weapon in these cases. Because these events are in fact familial disputes, recording is seen as an active, not a passive, intervention. Photographers invite themselves into the fray if they start shooting. Closer observation of such scenes reveals that most people aren't engaged in fighting but in witnessing. The whole may prove to be highly choreographed, indicating that in fact what is going on is a formal dispute adjudication, so that it may be more accurate to regard the space in which this is happening as a courtroom, another place where Europeans, too, restrict photography.

This is only one of many examples where things may not be what they at first seem, and where photographing may prove invasive.

Rhetorical Stance

The most difficult problem to describe and solve when taking pictures may prove to be what might be called "rhetorical stance." By "rhetoric" I mean a point of view, or attitudes, that the picture conveys toward the images inscribed there. Rhetorical stance may serve the viewer as an instruction for how to interpret a picture, to decide what it "means."

The 1855 Royal Geographical Society's North Australia Expedition was preceded by a debate about whether to employ a painter or a photographer for visual documentation. They decided on the painter Thomas Baines, rather than a practitioner of the newfangled camera technology. But the decision proved also to be one of point of view. In Baines's paintings, we as often as not are viewing the action from the "native" perspective, particularly in the case of representations of hostile first contacts. This remarkable perspective, of looking over the Aborigines' shoulders to the advancing Europeans, would hardly have been possible with a camera. Certainly this encourages the viewer to regard these images quite differently than if we were observing advancing Aborigines from behind the European lines. This example also illustrates how "rhetorical stance" can be taken quite literally to mean where the camera person stands in relation to the subject, and to emphasize some limitations of the camera in this respect.

The difficulties of discussing visual rhetoric apply for photography in the Western world as well as in the Aboriginal world, partly because we lack a language for describing images and partly because people probably interpret visual images variously. Thus different people may derive different meanings from the same picture, not agreeing on the "rhetorical stance." Still photographs are assumed to be somehow "true." If the subjects of the pictures are minority people involved in political struggles and thus concerned about their public image, questions of rhetoric such as "What truth are we to see in this picture?" can become heated and central issues. The potential for photographs to become influential historical documents is also important to Aborigines who are only now converting their oral tradition to a recorded one, attempting to redress the injustice of being excluded from their own, and Australian, history.

Let us take the example of photographs of Aborigines drinking alcohol. Alcohol occupies an important place in Australian life and culture, and so has come to be important for Aborigines as well. But it has also posed profound

problems at the individual, social, and cultural levels for Aborigines, and they are deeply concerned about that. Part of this concern is based on the apparent damage done to individuals and communities by overindulgence in drink—which may be more public and visible than in European society. Another part of this concern is based on the damage done to Aborigines by the promotion of a public image of them as alcoholics, used to justify various oppressive and paternalistic attitudes and actions. Even so, not to portray Aborigines drinking would exclude many important and positive events of Aboriginal sociability from the camera, including many (barbecues, weddings, town life, and so on) in which Aborigines demonstrate competence in contemporary society and their participation in modern Australia. To refuse to photograph Aborigines drinking could open the documentary photographer not merely to charges of inaccuracy, but to charges of discrimination: this could be seen as a refusal to depict Aborigines as participants also in the modern world. Not photographing becomes as much of a statement as photographing in such a situation.

The pictorial image of an Aborigine drinking alcohol will thus raise a problem of rhetoric: "What message does this photograph of an Aborigine with a bottle / with a wine glass / asleep in the street convey to us about alcohol and Aborigines?"

Visual researchers have suggested that there are two ways that people decide what a visual image means: by guessing what the photographer meant; or by treating the image as "real" and reacting to it as they would to the actual thing depicted (Worth and Gross 1974). This does not help us to predict which means particular people use in interpretation, or to know what attitude will emerge. It does help us to predict who will be held responsible for producing a photograph judged to be insulting or inappropriate: the photographer. Where a picture is unsatisfactory, either it is due, in the first instance, to the photographer composing the picture this way, or it is due, in the second instance, to the photographer's choice to take a picture of that particular subject.

There are certainly kinds of images, camera positions, cropping and composition, which suggest, perhaps subconsciously, certain attitudes toward the subject in the "grammar" of photography. For example, the direction of the subject's gaze toward the lens may convey much meaning. But as the remarks above imply, they guarantee little in terms of a viewer's evaluation, and could hardly serve as a defense in any disputation. Rather than pursue these subtle issues, it is probably more useful simply to note that photographs do take on rhetorical stance, that this is important, but that no rules or guidelines can be

established to determine how this problem can be solved within the composition of the picture itself. Instead, the practical and political problems implied by interpretive issues can probably be managed best by a cooperative, collaborative approach to production. Then at least the photographer has a choice of positions, to be behind or alongside the subject, rather than locked into frontal shots as a member of the advancing party. It may be hoped then that a cooperative relationship between camera person and subject will translate to the photographic image and partly solve some of the difficulties of rhetorical stance described here.

Conclusion: Toward a Cooperative Photography

None of the four problem areas described in this primer has been solved by providing simple solutions or exact instructions that could assure that photographic conduct in traditional communities will be successful from the point of view of either the Aboriginal subjects or the photographer. The explanations offered here for this limitation include various reasons why no such rules can be established in a written article such as this one. In each case, it was recommended that photographers negotiate their conduct with the people to be photographed. The contribution of the primer so far has been to identify areas likely to cause problems for Aborigines, in order to sensitize imported producers to local custom.

At this point, it would seem helpful to turn to the process of such negotiations to provide further assistance to the photographer. It has been implied that photographers should not enter communities with cameras blazing. Negotiations will initially take the form of discussion between photographers and Aborigines. There is some very helpful literature on speaking with, as against "to," Aborigines. Coombs, Brandl, and Snowden (1983) provide an extended guidebook for the lay person on Aboriginal etiquette and its sources in the tradition. Von Sturmer's (1982) article offers very useful descriptions of speaking and negotiating styles. Some background reading on the subject is advised, without suggesting that photographers become academic or develop overly rigid prior expectations from books. Having cited this literature and noted its utility, I want to proceed to consider matters that are more specifically visual, suggesting relationships between photographers and their subjects that may prove especially suitable.

The problem is signaled precisely by the language employed: "photographers and their subjects." The very terminology is borrowed from political systems that insist that one class of people dominate another. Translated to photography, this suggests that the person holding the camera is in some sense controlling the people in front of it. The way we have come to regard photography

in the modern world lends some truth to this idea. Particularly in the case of traditional Aboriginal "subjects," whose lives in remote communities are largely invisible to mainstream Australians, what and how the photographer chooses to photograph may determine the way these people are regarded by others. This has political consequences and justifies the criticism of not just the terminology but the process.

The last few decades have seen an attempt to alter the relationships between photographers and photographic subjects, to create a more cooperative and collaborative means of representation. In various ways, photographers have given increasing responsibilities to the subjects: as directors, even as producers. The person behind the lens gives up certain responsibilities to the subjects: "What do you want photographed?" and "How?" he asks. The photographer becomes a collaborator, even an employee, of the subjects, facilitating their objectives in representing themselves.

Such a procedure, especially with traditional people not entirely familiar with the medium of photography or the implications of its publication, involves a pedagogic component. The photographer assumes a responsibility to teach people about the medium and its consequences. But lest this new role restore the dominance of the photographer, now as teacher/expert, vis-à-vis his subjects/students, the relationship requires reciprocity. The subjects must in turn teach the photographer. This is especially so in the Aboriginal case, where there is much to learn, and Aboriginal tradition encourages the teaching of cultural knowledge as a fundamental social responsibility. Perhaps this essay has erred so far in understating how much importance Aborigines place on teaching even Europeans about their ways, and how responsive traditional people are likely to be to opportunities to do so.

All this may sound perfectly fine on paper. It can be quite a different matter in the field, when you discover yourself in the midst of an unfamiliar and bewildering world of people who may seem very unlike yourself, speak in unfamiliar languages and dialects, or engage in activities that make little sense to you. From being a competent, valued adult member of your own culture, able to make sense of what's going on around you, you become an incompetent child. The psychological effect on the individual has been called "culture shock," and various responses, positive and negative, have been described. Anybody's success at dealing with culture shock may depend on a tolerance for uncertainty, about oneself as much as one's environment.

For photographers, an understandable but deadly reaction to culture shock may be to grab the most familiar object at hand, the camera, and to hide behind it. This may be encouraged by uncertainty in the difficult early negotiations that your creative brief will ever be satisfied in this environment, that you'll ever get any pictures at all to bring home. These circumstances may encourage the photographer to start shooting prematurely, before an adequate relationship to the community is established and its own image-making objectives are understood. It is an article of aesthetic faith that the product of such panicked picture-taking will be images whose rhetoric presents the subjects as alien objects, which partly explains why there are so many bad pictures of Aborigines, and why they themselves have become suspicious of the medium.

So relax. Get to know people. Socialize and sometimes even leave the camera locked up—protected from your temptations. Be willing to lose some great shots in order to discover what Aborigines' own interests in visual representation might be. Aboriginal society is far more process-oriented than product-oriented. People may be far more concerned that you take pictures in the right way, than that you take a lot of pictures. They may be more concerned that you stand in the right place and in the correct relationships, than that you frame and capture the best shot. After all, there are literally millions of pictures of Aborigines already, most of them not very good or very useful. The failure of these pictures is not so much in the quality of composition, the technique, the aesthetic product, but in the relationship between the camera person and the subject, which is becoming increasingly evident in the modern appreciation of the visual product.

Finally, take your time. Aboriginal notions of schedule and appointment are radically different from European ones. Much of your field experience will at first seem to be spent waiting for things to start happening. Much of your credibility will depend on your tolerance for waiting; impatience can lead to coercion. Soon you may discover that important and visually interesting things are happening even when it appears you are waiting for them to happen. By appreciating this, you can reduce your own frustration level and perhaps begin to fit into the rhythm of community life. Only from there can you discover a legitimate, accountable position from which to photograph.

What is proposed, then, is a means of involving Aboriginal people in the entire process of visual production, not merely isolating them in front of the camera, to produce a visual product in which they have no say, which in fact they typically don't even see. Part of the problem of visual media for remote

traditional people arises because they are isolated from the mass media, and rarely get to see or comment on the results of recording. Or, when problems come to their attention, it is too late to negotiate solutions and they are restricted to a hostile or confrontative stance in relation to the producers or even the media as a whole.

To solve this problem, a review procedure at every stage of the media production process is recommended. In photography this means not only Aboriginal participation in directing and producing picture-taking events. It means review and selection of contact sheets, assistance in captioning or sequencing where appropriate, and vetting of galleys before publication. At each of these stages, invaluable information may be revealed that increases the knowledge of the photographer and the value of the images. The involvement of the pictorial subjects in all these functions increases their own sophistication about the medium as well, and resolves some of the problems associated with subjectivity. This may not prove quite so simple or golden a solution as it has been promoted to be. Certainly, questions may arise and be disputed, and the difference between documentary and public-relations objectives may prove difficult to resolve. Indeed, as the section on rhetorical stance implies, differences in the evaluation of a photograph's positive intent are likely. The point is not that cooperative practice makes photographic activity easy or assures political correctness. The value is instead ongoing, as the subject participates in and learns and perhaps benefits from the collaboration. Then accusations of magical theft can be managed, not trivialized as we have done with them in the past.

Aboriginal Content: Who's Got It— Who Needs It?

[1 9 8 6]

DURING A telephone conversation with an executive of a television company licensed to begin direct broadcasting to one of the remote satellite footprints next year, I was asked, somewhat plaintively, if I could help him to identify precisely what would constitute "Aboriginal Content" and if perhaps I might help get him some. This category is evolving as a criterion for judging the suitability of program services by the Australian Broadcasting Tribunal when evaluating applications where a significant component of the intended audience will be Aboriginal. The Tribunal may in fact be extending its criteria for suitability, within the policy context of localism, by analogy to the "Australian Content" requirement it imposes on radio and television license holders. The notion of Australian content has proved problematic in some respects, which may have contributed to the difficulty of enforcement. But, as I intend to indicate, compared to "Aboriginal Content," Australian content is a piece of cake. Presumably, an Aboriginal content requirement will encourage a considerable market for documentary and ethnographic film production, and as such could prove to be of general interest to students of Australian cinema.

I could do little more than commiserate with the TV executive; he indeed had a problem. Would the Tribunal accept programs made by Europeans about Aborigines: a *Country Practice* episode with an Aboriginal character? Or only programs made by Aborigines themselves? And if the Central Australian

Aboriginal Media Association (CAAMA) makes a videoclip of Midnight Oil, what is that? In fact, this typology of possible Aboriginal content would have to be expanded still further, and perhaps some earnest taxonomist might offer his or her services to the Tribunal to develop a discussion paper on the matter. Instead, I want to take this opportunity to attempt to develop a response to what seems an eminently fair question, without, I suspect, ultimately coming up with an answer that will do the TV executive much good. The matter intrigues me because the problematic of Aboriginal content expands in a number of interesting directions that allow us to consider not just the media text, in its narrow sense, but the production contexts and institutional practices that ultimately reach into the much broader social and cultural facts of the ascription and inscription of Aboriginality in Australia. Indeed, I will begin by noting my own genetic lack of Aboriginal—or even Australian—content, and admitting that the topic excites me partly because it requires a reflexive posture if I intend to develop this any further at all.

My own interest in coming to Australia was not Aborigines per se, in whom I had no specialist background, but their experience of coming to the media as a test of and an analogy to questions posed within the modern Western tradition. Ultimately, I wanted to understand our, not their, media revolution. To accomplish this, I undertook three years of field studies in remote Central Australia, which were involved with the introduction of TV and video mostly at the remote community called Yuendumu. Somewhere along the line, the distinction between "our" media revolution and "theirs" may have blurred as the particularity of the Australian situation engaged me during my fieldwork. But now, even as the field recedes in some sense and I become more reflective, I remain impressed with just how important the Aboriginal experience of television is proving to be for Australian media as a whole.

For that reason, these matters of Aboriginal media policy, practice, and law arise in the more general context of documentary cinema. It might be argued, of course, that these are interesting issues, if peripheral to the central enterprise of Australian media production, and then one would proceed with an admittedly specialist concern. But I prefer to suggest that the issues that arise around the practice of Aboriginal media will eventually inform the construction of diverse mass-mediated images from documentary resources, the raw materials of people's lives, and lived experiences. By putting it this way, I am rejecting a generic definition of documentary as a particular expository convention that presumes some privileged relationship to the real (a definition still useful in much textual analysis) because it is assumed there is a transparency of opposition between

truth and fiction (actuality and imagination) which, I think, obscures the significant issues for theory and practice.

I am proposing a more utilitarian, "processual" definition, geared more to media practitioners, subjects, and viewers. Such a definition would be based not on the properties of the text but on the conditions of its production and use. These may or may not be easily identifiable in that text itself, especially if we are not trained to look for them. This requires that we expand the critical analysis to consider evidence of the conditions of making, transmitting, and viewing, and to acknowledge that texts come into existence, and must be described, in terms of social relations between institutionally situated audiences and producers, and that meanings arise in these relationships between text and context in ways that require a precise description in each case.

The impetus for an altered definition is not merely theoretical: it has an industrial basis as well. The new availability of home video cameras and other inexpensive imaging machines, and the proliferation of channels for display and transmission, means that we are seeing more and more media (and a proliferation of genres) constructed from lived events in nonfictive modes. Aboriginal video is one of the examples that has received special attention and analysis, but I suspect it heralds a general expansion of a class of texts that we will be involved in producing and criticizing increasingly over the next few years.

Let me turn now to three items, which I will associate later with particular texts, to describe a locus of contradictions for my consideration of "Aboriginal Content." My analytical bias throughout will remain on remote "traditional" communities, not because I want to argue that they are somehow more "really" Aboriginal, but because their former isolation from mass media triggered the debate on Aboriginal air-rights. Thus they form a particularly important piece in the puzzle of Aboriginal content.

Cases

Item I

The Warlpiri-speaking people of Yuendumu, in the remote Northern Territory, between 1982 and 1986, archived over 300 hours of videotape essentially produced—photographed, directed, and edited—by community members themselves. These productions are first circulated around camp VCRs, and later are transmitted over a pirate low-power transmitter. A researcher (myself) and certain educationalists in the community assist in training and in some phases

of production. Similar video production and distribution systems emerge, over this period, in as many as a dozen separate remote communities. They can be distinguished by the degree to which their products are accessible (either by content or distribution) to nonlocal, non-Aboriginal audiences. They can also be distinguished, as the non-Aboriginal assistants working in support functions for these video units tend to do, by the degree of European intervention. Or, as Penny McDonald, executive producer of the "first feature-length video made entirely by traditional Aborigines," and I have debated it: "My Aborigines are more self-managed than yours."

Item 2

The Central Australian Aboriginal Media Association expands from radio broadcasting to video production in 1983. Arguing that imported satellite-delivered television may present certain dangers for traditional Aboriginal language and culture (24 distinctive language communities exist in the service area), it mounts a successful bid for the Central Zone RCTS (Remote Commercial Television Service) license. CAAMA's television production unit, which will supply the original programming for the licensed service, is headed by an exclusively European direction and production staff managing a trainee group of town-based Aborigines, none of whom speak any Aboriginal languages or practice traditional custom. CAAMA's subsidiary television company, Imparja, enters negotiations with the Western Australian Zone license-holder, Golden West Network, which will effectively extend the Western Australian service to Central Australia with perhaps three hours a week reserved for CAAMA-produced transmissions—which means perhaps six minutes per language group per week, not counting commercials or the English-language component.

Item 3

The Task Force on Aboriginal and Islander Broadcasting and Communications published its recommendations in 1984, which were accepted, mostly, by the Australian cabinet late in 1985, and poised for implementation in 1987, following consultation with a Department of Aboriginal Affairs (DAA)—determined Aboriginal broadcasting "consultative" committee. The Task Force recommendations are far-ranging, but a number of themes emerge in close reading. Of particular interest is a notion ascribed to the chairman, Aboriginal bureaucrat and educator Eric Willmot, called "embedding." In its simplest sense, embedding means the interpellation of Aborigines, Aboriginal issues, or themes in

programs that are not otherwise identifiable as Aboriginal in content or production particulars. Significantly, Professor Willmot recommends that such programming constitute the majority of Aboriginal television content. It is more likely to be produced by, and appear on, public service television (ABC, SBS) than in any specialized commercial or Aboriginally organized context. The Task Force appears to endorse the embedding concept, with the recommendations for a major role for ABC Television in the production and transmission of such materials. In response, there has been an upsurge of activity within the ABC around the opportunities seen to flow from the Task Force's recommendations.

Discussion

Each of these items abstracts circumstances at a pivotal site in the recent struggle for Aboriginal media access. Taken as a whole, they do not pose merely contradictions; they suggest a complete fragmentation of the discourse on Aboriginal media. DAA seems not to be talking about what CAAMA is talking about, and CAAMA in turn fails in its dialogue with the remote communities; they don't seem even to be talking to each other very much.

Examples are not difficult to find. The Task Force policy for regional and remote broadcasting was based on the assumption that no Aboriginal media group would have direct access to a satellite transponder, and worked its distribution policy around what now CAAMA—and the Tribunal—have disproved. But no revision of policy to consider this fundamental shift and the possibilities it poses has been discussed, so that CAAMA's situation becomes isolated and encapsulated in government thinking. Even so, the government can claim that the problems in the remote Central Australian communities are now solved by the CAAMA license. CAAMA, meanwhile, its resources and attention largely diverted by Darwin, Canberra, and the demands of its commercial license, has no dedicated resources for supporting, assessing, or even communicating with the remote Aboriginal-producing stations, who in turn are kept in fair ignorance of all the policy and planning whose first cause, it was said, is the interests of "traditional language and culture." And DAA seems to have an almost pathological fear of actually communicating with the bush. No remote producers were invited to the recent consultative committee meeting, even though an agenda item was a major, multimillion-dollar scheme for licensing and hardware supplies for remote stations.

These, however, are familiar contradictions of Australian Aboriginal affairs in their neocolonial manifestation, and perhaps only seem more

Junga Yimi, WMA magazine, vol. 5, no. 1 (May 1984).

grotesque because the subject of these miscommunications is, in this case, communication itself. Equally alarming are the contradictions within sites, identified by each of the items above:

1. The government (via an Aboriginal bureaucrat) recommending that Aborigines 'embed' themselves in the ABC.

2. CAAMA, in the service of Aboriginal cultural maintenance, undermining the very sense of the remote satellite licensing scheme by proposing a networking system that will probably dump extensive American media via Perth into Central Australia.

3. The apparent contradiction of self-determined and self-managed television broadcasting in remote, traditional communities whose record in most other areas of development (e.g.,

health, literacy, management, and essential services) has hardly been impressive.

Associated Texts

We are screening several videos in association with this address[1] to provide examples of some of the kinds of programs that might qualify as Aboriginal content. Admittedly, the choice had as much to do with availability as with any curatorial principle. But I think it becomes clear quite quickly what kinds of products are associated with what kinds of production systems.

It so happened that all of the tapes involved Aboriginal producers to varying degrees. The "government" tapes, from the Australian Institute of Aboriginal Studies (AIAS) and the Northern Territory government, involved Aborigines mostly in training capacities under the direction of Europeans. To my knowledge, none of the Aborigines involved speaks an indigenous language or maintains traditional customs. However, all feature "traditional" subjects, often as not, doing European things. They are intended to present Aborigines in a positive light: positive in the sense of development or even assimilation. In fact, the emphasis on technology and high production values (intended rather than realized) seems part of a more general attempt to constitute Aborigines as "world-class, export quality" natives. They feature what the government sees to be "good" Aborigines doing productive (i.e., non-Aboriginal) things.

There may be relatively few audiences that can be identified outside of bureaucracy (or perhaps Johannesburg) who will share this reading. There is some uncertainty in my mind, and I think in the tapes themselves, about just who the intended audience is in any case. The funding that produces these tapes usually instructs producers to aim them at diverse Aboriginal audiences, to whom the government wishes to transmit a message of its accomplishments. They are first vetted by bureaucrats who must be satisfied that they conform to the image the bureaucrats have of themselves (as well as of Aborigines). They are assuredly not meant to be controversial. But because Aborigines are likely to read these tapes quite differently from European bureaucrats, and bureaucrats are unlikely to be able to anticipate Aboriginal readings, unanticipated meanings can emerge quite freely at different screenings. I have seen Aborigines double over with laughter at certain parts of these tapes not at all intended, I take it, to be funny. And I have seen them become livid with anger when traditional restrictions on the display of sacred information have been breached, as the Northern Territory government (and the ABC) does quite often. I suspect a Sydney audience

reads these tapes with a certain dreadful irony, but I assure you they are not intended to produce that response.

The second group of tapes comes from regional Aboriginal media organizations. The model of this type is, of course, the "CAAMA Video Magazine." These are distinguished by a quite different rhetorical style: they are culturally assertive, they feature translations in Aboriginal languages, and they take on controversial topics. But underneath this rhetorical surface, they seem to me surprisingly like the government tapes. They again have a similar mix of Aborigines succeeding at apparently European tasks, as well as inserts of a certain amount of traditional material—indeed, a content analysis shows this may be even less than in the government tapes. Perhaps my processual definition of documentary will reveal that the means, if not the relations, of production are in some respects similar to the government video units, thus accounting for the similarity in product. Again, an Aboriginal trainee staff is under the direction of European specialists. There is an acceptance of basic Western conventions of format, framing, narrative, and episode, and an attempt at sophisticated production values. Part of the interest and charm of these tapes, for me, is the failure to achieve these production values, which in recent "Magazines" is itself becoming conventionalized as a kind of folksy style that can be quite appealing. But it is difficult to detect anything uniquely non-Western about the use of the medium here.

CAAMA is quite explicit about the relationship between producers and audience. A sign on the old radio station used to read, "Aboriginal Radio in Aboriginal Country," and "Aboriginal Radio for Aboriginal People." I think the CAAMA radio service did achieve this in a number of remarkable ways. The unpalatable early experience of working at the Alice Springs ABC studios led them to an aggressive redesign of their first studio space, which featured considerable outdoor areas, breezeways, and other camplike features to make the space accessible to local town campers and other Aborigines. The requirement to broadcast in three or four traditional languages meant creating a flexible production schedule and comfortable workplace for their interpreters—traditional people who were the heart of the on-air operation. The transmission range, which then was Alice Springs only, assured continual feedback from the audience, which took an active and immediate interest in the station's operations. CAAMA radio, during 1983–85, exemplified local community-access media. It was refreshing and, to the community's thinking, unarguably Aboriginal. This did not always show up in the content, which more often than not was American country music and imported reggae. It was in the organization of the workplace and the relations of production,

which emerged on air mostly as format, announcing style, and call-in cheerios, that gave the station its authority and resonance for its Aboriginal audience.

With the expansion into television and the demands of a commercial license, increased staff, higher technology, and a more distant and less interactive audience, all these properties of the workplace may become compromised. The radio slogan now has been generalized at the new studios to "Aboriginal Media for Aboriginal People." But the more recent "Magazines" and the ABC weekly broadcasts recognize that the important audience at the moment may be the European public, the politicians and others, who now need assurances about Imparja Television so they will cease their harassment and permit the service to proceed.

I do not mean by these criticisms to give support to the view current in some southern Aboriginal quarters that CAAMA is a whitefella organization in league with the government, and that its massive funding base should be redirected to urban and more diverse Aboriginal organizations. I believe these charges are ill-considered, and have more to do with a too-familiar struggle for limited resources in which "Aboriginality" becomes an ascription to be negotiated more as a commodity than as a recognition of content or authority. Rather, if there is a charge to be made, it is to the government, or perhaps the structure of the broadcasting system, which may be beating CAAMA to death with its stick in return for a very questionable carrot: a license to broadcast regional commercial television. To the extent the institutional demands of government alter the means by which Aboriginal media are produced, the Aboriginality of the content may suffer. CAAMA counters that these are early days, and that forward planning intends the redundancy of the European staff and increased Aboriginal management.

In all fairness, I should point to the videotape from the Torres Strait Islanders Media Association (TSIMA) that is included in the video program under discussion. This tape was essentially shot and edited by me, under instruction from the TSIMA. In the end, this tape was rejected due to the poor signal quality, although the post-production at Metro Television Ltd. (Sydney) provided a cleaner signal than we achieved in any of the Central Australian tapes. TSIMA was happy with the production arrangement; if they can get a white Ph.D. to do their camerawork and editing for them, this was acceptable. The tape was rejected because what was wanted was an even more "professional" look, one that could compete with imported commercial programming.

Torres Strait culture and politics are quite different from their mainland counterparts. Of all indigenous Australians, they alone have charged the

government with discrimination in its failure to import commercial television to their population. The question of Islander control of production may matter less here. I am uncomfortable exhibiting and describing this video, partly because an "indigenous" tape made by me is not going to provide me with much interesting data about production (or is it?). For others, I believe that the contradictions of production compromise and confuse the product and its possible readings unless the situation is admitted. The final scene in this drama, of course, is telling you this. I prefer to move on to the area in which I feel more comfortable: remote, traditional production based on my more collaborative work at Yuendumu.

"Traditional" Aboriginal Television

The idea that "traditional" oral societies might express themselves in unique and interesting ways using electronic technology has its roots in Sapir's (1921) and Whorf's (1956) formulations of the relationship between language and culture. This seems to be contradicted by McLuhan's claim that the medium will cause the message, and was tested by Worth and Adair (1973) in an experiment with Navajo Native Americans in the late 1960s. The experimental and interventionist components of my own research among the Warlpiri arose from this tradition. I posed the question: What might television look like if it had been invented by Warlpiri Aborigines? The answer is described in detail in my project report, purposely titled *The Aboriginal Invention of Television* (Michaels 1986). Some matters treated more fully there command our attention in a discussion of documentary theory and practice.

The Warlpiri proved to be documentarians par excellence — specifically, practitioners of a verite mode pioneered by Morin and Rouche in France and developed in the United States as "direct cinema" by Pennebaker, the Maysells, and Wiseman, among others, emerging in Australia in films by the Mac-Dougalls, McKenzie, and Dunlop (see filmography).[2] The Warlpiri people of Yuendumu now prove to be the most doctrinaire practitioners of this style. The Warlpiri deny fiction, both in their oral tradition and now in videomaking. Stories are always true, and invention, even when it requires an individual agent to "dream" or "receive" a text, remains social in a complex and important sense that assures truth. Rights to receive, know, perform, or teach a story (through dance, song, narrative, and graphic design) are determined by an identified individual's structural position and social-ritual history within an elaboratively reckoned system of kin. Novelty can only enter this system as a social, not an individual, invention. Not only is one's right to invent ultimately constrained, it is particularly con-

strained with respect to the kinship role, for it is the genealogy of an item—not its individual creation—that authorizes it. In the most simpleminded sense we might say that this is a solution to the problem of continuity in oral tradition. The narrative imagination and memory are consumed by the requirement of preserving knowledge over time by encoding it as true stories collectively authored. There is little inducement to confound the matter with individuals' invented fictions.

When conformity to traditional values is encouraged in video training and production, Warlpiri videomakers respond by inventing a version of direct cinema in order to subsume the text under the general requirements of sociability and veracity required by Aboriginal orality. People did not "make things up" for the camera; rather, they were careful to perform everything in a true and proper manner. Indeed, they proved quite sensitive to certain implications of this inscription process, and in particular instances took great care that the entire kin network necessary to authorize a ritual performance be involved in the video performances as well. Otherwise, the camera preferred to find for itself a comparatively inconspicuous role in a variety of public performances.

The social and historical consequences of mass media are quite different from the consequences and conditions of oral traditions, which we can appreciate by contrasting the commodity form and the consequent exchange value of information in the two systems. Script, and especially print, tend to disassociate the author from his utterance. Indeed, complex conventions of signature, copyright, even the social construction of authorship—as a concept with legally enforced economic rights—emerge from the historically associated inventions of the printing press and modern capitalism. These conventions are required by the weakened links between speaker and speech in print and mass culture.

By contrast, oral transmission, where authors and their utterances remain linked in performance, does not emphasize elaborate social engineering to reinforce this linkage or assure the value of the utterance. Indeed, stories are attached in such a way to particular speakers that these stories are said to be owned. But I think the translation to English here is misleading, for the conditions of ownership in oral societies are, as I will discuss, quite distinct from what we mean by owning in materialist society. Probably ownership concepts for Aboriginal orality concern obligations to transmit and exchange rather more than to acquire and hoard in a capitalist sense. Instead of restricting use by signature and copyright, the social engineering required to assure value in oral traditions involves restricting access to performers and performances so that no one whom the social structure does not position in the correct kinship relationship can bear

witness to any valuable speech or performance event. Indeed, kinship practice involves speech and associational restrictions that prescribe and proscribe interaction and styles so that what one says to whom, and in what way, is itself restricted.

Let me return to the problem the oral system poses for historiographic analysis: How does this system assure social reproduction of the cultural text over time without written archives? In fact, this problem is converted to possibility in Warlpiri orality by engineering a capacity for oral truths to respond to change without ever appearing to be changing. One means by which this is accomplished is by refusing to externalize inscription except in social discourses and performance. From within the oral system that stores information in specified authorities and reproduces it in socially regulated ritual, there is no contradiction possible to the claim that Dreaming Law is and always was, as it is, eternal. From outside the system, we may observe that the Law can change, without ever appearing to do so.

This is also managed by recourse to a spatial metaphor corresponding to identity with the land. By distributing information, as story, differentially throughout the society via the interlocking kinship matrix, the Warlpiri establish a network of information specialists, each maintaining some aspect — but never the whole — of the truth. Thus, important matters (such as ceremonies, authorization, decision-making) require the assemblage of many people who will each contribute their piece of the puzzle. For example, for a whole song cycle to be performed may require many people (often from diverse locales) to collaborate in the performance. Information is dispersed in time and space through a network that eventually encompasses the continent, and perhaps the world, in which each adult individual has particular, but constrained, speaking and knowing rights. Significantly, this system is not hierarchical, something extraordinarily difficult for people from class societies to appreciate, whether that society is British colonial administration or a film crew.

Problems of Conduct for European Producers

It may be helpful to deviate from the line of discussion at this point and identify some of the problems that my analysis of the traditional system implies for the conduct of European producers of Aboriginal subjects. Because one isn't allowed free access to events where information is displayed, traditional Aboriginal communities pose a particular problem for filmmakers who wish to use these communities as sites for location shooting. One cannot film anybody, anywhere, at any

time. Certain events and performances will always be off-limits, and responsible filmmakers should take care to inform themselves of these facts by identifying the appropriate senior authorities and, minimally, securing permission for each take. This would be the least requirement; more extensive collaborative relationships would be preferred, as my points so far suggest. Of course, if you are of the Alby Mangels[3] adventure/documentary school, venturing where no white man has ever gone before, you will instead take these limitations as challenges so that you can bag for your audience especially rare specimens of exotica. I suspect that there is a unique level of hell reserved for these filmmakers, and would like to encourage the possibility that we will reserve a special section of our jails for them just to make sure. But the problem is not always so clearly drawn.

Aboriginal information ownership obligates the owner to display that information, and to teach it to assure its value and continuity. Such display is understood to obligate the person so honored and educated. In a face-to-face society (without print, electronic recording, or mass distribution) the system operates as it is intended: to assure the continuing value of information. Not being especially racist, just ethnocentric, Aboriginal elders often include Europeans and even filmmakers in these displays, honoring them and obligating them at the same time. Unfortunately, filmmakers (and journalists and anthropologists) do not always choose to understand the implications of this obligation. The transfer of knowledge here does not include the transfer of copyright; ownership still remains with the Aborigines.

In the past, when traditional Aborigines resisted literacy and remained outside the mass media distribution network, they rarely were aware of what happened to the words they allowed to be written and the images they permitted to be recorded. It could be argued, therefore, that there were no important consequences to this appropriation, although I would not take that position myself. But with the extension of the national media network to the outback and with Aborigines' newfound ability to see what Europeans make of them, the consequences become real and undeniable.

Aborigines who now are regarded by their countrymen as having leaked information into the public network are accused by their fellows as having "sold their Law." Fights, social upheaval, and elaborate paybacks can follow the desecration of a ceremony or even a design that occurs when it is broadcast. The problem is grave, serious, and "culturecidal." I would recommend that filmmakers who intend to distribute their work on television should consider their

conduct very carefully from now on. If not they are likely to find their access to Aboriginal communities wholly cut off in the near future, and possibly find the Aboriginal Heritage Protection (Commonwealth of Australia) Act 1984, or even the laws governing obscenity and blasphemy, extended retroactively to ethnographic films. The ABC, the most persistent offender, should be paying very close attention here if they plan to continue accessing federal funds as the major site of appropriation and dissemination of Aboriginal images. Traditional people care not a whit what trendy and pro-Aboriginal rhetoric is used to frame these desecrations.

It is tempting to pursue this point further, to detail the rules and propose procedural guidelines for filmmaking in traditional communities. I demur, however, and not just because any complete elaboration of Aboriginal information management traditions would result in far too prolonged a discussion. In fact, I could not undertake an exhaustive inventory for three reasons:

1. I don't know all the components of this system.

2. I suspect that the system is emergent in some respects, so to treat the system as an inventory of static rules would always be misleading and inaccurate.

3. The point of these rules, I take it, is at the very heart of Aboriginal authority, orality, and autonomy. If I succeeded in inscribing a Hammurabi's code in the stone of my text, I believe I would utterly subvert Aboriginal tradition, and in particular the essential rights, responsibility, and definition of eldership in the lived Aboriginal tradition.

Or, to put it simply, if I had a complete understanding of this system, as a researcher/observer/European, I would disappear; I would have become "Aboriginalized," and so might even refuse to tell you these things. But having argued that these rules exist as essentials of Aboriginal orality, that they contrast to and subvert print culture, and that they are involved in the ways that traditional Aborigines constitute themselves in the making of video, I want to continue discussing what it means when people outside this tradition try to make films or television from the resources of Aboriginal people and events. And I want to address the very dangerous position in which this may place Aboriginal subjects; and finally, why Aborigines themselves judge the outcome of these efforts not as

fictive but as false — in fact, as lies — and judge the means of their production to be theft.

The Ethnographic Filmmakers' Response

The idea that taking pictures of native peoples may be considered by them to be theft is now familiar enough to have become the point of a joke in *Crocodile Dundee*. Certainly, ethnographic filmmakers have had the issue under consideration for over a decade. The ethics sessions at the Conferences on Visual Anthropology held in Philadelphia throughout the 1970s annually featured a certain amount of chest-beating and public displays of white guilt about the matter (see Ruby 1983b). The discourse was imported to Australia in 1978 at the Ethnographic Film Conference held at the AIAS (see Pike 1979). I assumed these were ritual performances, intended, finally, to justify our practice, not to revolutionize it. A certain amount of stylish and interesting reflexivity did make its way into ethnographic conventions. It became usual, for instance, to show the results of field-recording to the subjects, and insert their responses in the completed film itself. But in the end, the people who gave cameras to natives remained people who considered themselves researchers. Filmmakers did not give up their cameras so easily. But in retrospect, I think some very important changes may have emerged from those sessions.

First, it was important to substantiate the charges of indigenous subjects, to demonstrate that the ethical problematic of image appropriation was not merely one of curious superstitions of "backward savages" who misunderstood the technology. Our own analysis was leading to quite similar conclusions. There was a discourse on power here, signaled and enforced by the politics of positioning of people as either before or behind the camera.

Second, a limited defense was mounted by asking: What is the essential difference between taking pictures of people and writing about them? Is it anything more than that the visual product proves more accessible to our subjects than our writing, so that it attracts their criticism first? The criticism might be one of ethnography as a whole, not just ethnographic film.

Third, raising these issues led into a new discourse, which found resonance in some of the more interesting critical theories — particularly the newer Marxisms and poststructuralist approaches. All of these return us to questions such as the relationship between subject and object, the problematic of authorship, and the linguistic character of representation. If it is not clear that this

helped people make better films, I would claim at least that we became better at talking about our films. But this may be too cynical. If I fail to detect any important revolution in explicitly ethnographic filmmaking in the last decade that could posit an answer to these questions, I do detect a considerable change in what kinds of texts we are willing to treat as ethnographic and to encompass in our considerations, as well as the kinds of roles we are willing to perform. Avant-garde and experimental film made by artists, home movies and videos, indigenous and Third World production, have all been identified and treated for ethnographic interest. This interest is something more than Mead and Métraux's (1953) "culture-at-a-distance" studies of texts; it is more immediate and reflexive.

There now may be far more willingness among a new generation of filmmakers to act on the criticisms of appropriation and propose a radical, collaborative practice in film and video work with Aborigines. Cavadini and Strachan, Digby Duncan, David Woodgate, David Batty, Penny McDonald, and others are involved in a body of contemporary work in which their role as producers is no longer dominant, and where they seek to act as catalysts, providing conduits through which a more indigenous representation is possible. These relationships impose a new set of contradictions, as I suggested in my introductory examples of "Aboriginal Content," and which I admitted with respect to my own work, particularly the TSIMA video. So I do not mean to suggest that handing the camera over to the subject automatically restores the subject and converts the process into a transparent act of auto-inscription. In fact, the working relationships between filmmakers and Aboriginal subjects that result from the intention of media self-management are diverse, and have different success rates as judged from the perspective of either the participants or any given audience. Certainly, the results vary—in the case of video products, in their interest and accessibility to Europeans.

Viewing this work can be a difficult experience for an urban audience. The pace is slow, the narrative difficult to grasp, and the work of reading these forms can prove alienating to viewers, especially when the tapes are presented in a theatrical space. Yet some of these difficulties are precisely the qualities on which Aborigines judge these media to be positioned successfully in their own discourse. The matter is of theoretical interest, but may be even more important pragmatically.

Producing community media in locales with no productive economic base means that video expression here requires economic incentives and

outside support. Media development could prove more successful in remote communities than have agricultural, industrial, or other material development projects, precisely because of the traditional Aboriginal interest and expertise in information management. My argument elsewhere (Michaels 1985) has been that the Aboriginal world is an information society, and as such offers something of particular value to the modern information age that can ultimately provide the basis of a reciprocal exchange. This goal, however, is unlikely to be achieved within the dominant discourse on Aborigines and "development." The argument seems too subtle, and people remain unconvinced that Aborigines have anything unique to offer modern media. The emergent indigenous forms are vulnerable and likely to be destroyed precisely by the forces of media education, training, and development. In that sector, I detect an "official" rejection of indigenous production as clumsy or amateurish. The government, which sees the economic potential of these media mostly in terms of their suitability for export, despairs at the "quality" of the local product in terms of these imposed standards. Much of its support will be directed at providing professional training to upgrade this quality. Certified professional film and television producers are likely to find themselves enlisted in this activity, which I argue may prove subversive of the emergent indigenous forms themselves, and so rob them of their ultimate exchange value in the Western information economy. Rather than expand this theoretical argument, let me return to the ground with a last example: a description of how media is transmitted at Yuendumu, so that some further qualities of the communication system and its possible contribution to modern media can be demonstrated.

Yuendumu Television: Brechtian Theatre

Sometimes, on certain weekdays, perhaps around noon and again around 4:00 P.M., Yuendumu Television may or may not go to air. The basic format is usually a kind of video DJ: a compere selects premade tapes to show, and announces them along with any other news or commentary she or he thinks worthwhile. Sometimes kids come into the studio and read school stories, or old men tell stories live, but the DJ format is the basic one.

 Quite early on, the Warlpiri looked at the production system and decided that it really wasn't necessary to have several people in the studio to go to air. One person could turn on and focus the camera, do the announcements, and switch over the tapes. This conforms to the Aboriginal work ethic, which demands maximum efficiency with no unnecessary waste of personnel or effort

(especially when performing tasks for pay). The more difficult problem was finding a way to let people know when the station was broadcasting. The solution was to turn on some music (the signal is also received over AM radio), focus on a graphic, and let that play for perhaps a half hour before beginning programming. Then, word of mouth would circulate through the camps and let people know to turn on their TVs.

Jupurrurla, one of the Warlpiri TV producers with whom I was most closely associated, is a big reggae fan, so for his schedule he begins with reggae music and focuses the camera on his Bob Marley T-shirt draped over a chair. After a while he refocuses on the compere's desk, walks around and into the shot, announces the schedule and any news, then walks out of the shot, turns off the camera and switches on the VCR. This procedure is repeated for each tape.

For me, the effect is almost an essay in Brechtian—or more precisely, Beckettian—dramaturgy. The question that underlies a good deal of criticism of mass media seems to have its modern sources in these playwrights' work and that of Artaud. All proposed a different kind of involvement with the image than the "willing suspension of disbelief," the conventionalized verisimilitude of both fiction and documentary narrative that lulled the nineteenth-century audience out of a critical posture and into a passive, receptive mood for entertainment. To the extent that today's mass media are entertaining, they now are also said to be anti-intellectual, druglike, and politically oppressive. Critics of mass media who are not simply elitist critics of proletariat culture may in fact be asking: Can there be a Brechtian mass medium? Can alienation and critical distance be preserved without losing the audience? The received wisdom is that this is somehow a contradiction in terms, although the ABC, unwittingly I think, nearly achieves this in its scheduling and program choices.

This is what fascinates me about Warlpiri TV. It could simply be argued that these forms emerge not from a mass society but from a local one, and thus that the media this local society produces are not massified. Whatever the case, I am enthralled—as I am, say, at avant-garde filmmakers' challenges to conventional forms. But I am forced to wonder if this was the point of the whole exercise, to satisfy my own quirky aesthetics, to satisfy my tastes for an alienating television. Indeed, the Warlpiri sometimes complain; they want to know why they can't also make Bruce Lee movies (which they dearly love) with Warlpiri language and characters. My response has been that we don't have the money or the equipment, that these are highly expensive entertainments, and that we need to stay with the things that Warlpiri people can do, and therefore do best. We can use

Bruce Lee films as training exercises, in a Freirian sense, and learn from a close reading just how they were made, how the special effects work, and why they're comparatively expensive. But I don't think this gets me off the hook entirely. There is a contradiction here.

As I have suggested, Warlpiri cosmology and expression imply a conservatism, a means of regulating social reproduction to obscure any influence of invention. This involves the identification of proper models for conduct as well as story, and only by encouraging an analogy to traditional expression could we in fact "invent" a unique Warlpiri TV. But Aborigines are entirely familiar with other kinds of TV, and want to know why they are restricted from access to other models. Indeed, they are well aware of the economic and prestige value of commercial cinema and TV, and there may be some fear that their own efforts are less prestigious and less valuable. Had the resources been available, a Warlpiri kung fu series would have been a fine idea; although I doubt that the Warlpiri production system could have succeeded here, I would have no problem being proved wrong. I suspect that the particular relationship between producer and audience that I am here reading as "Brechtian" is actually a prerequisite for the authority of Aboriginal television, and that a Warlpiri Ninja adventure would either come out looking like this or result in a very different audience involvement.

I raise these points not because the Warlpiri (who are fiercely proud of their television as it is) think they are terribly important, but because they exist in a world that does. Australia as a whole, and the Department of Aboriginal Affairs in particular, places the highest value on "professional standards," "world-class status," "broadcast quality," and other imported credentials. The general aim of Aboriginal advancement seems to involve bringing Aborigines up to standard. And indeed, much of the Aboriginal Affairs media budget is directed at this goal in both the reception and production of media. Anything else would be less, and anything less could be discriminatory (a term that the mining industry has demonstrated can be perverted rather easily).

Aborigines who have positions of power in this bureaucracy are encouraged to see the media increasingly in terms of the power of inscription; to occupy a gap created by the contact of cultures and the contrast with technology, and to access the new media in ways that inscribe their own success as a model for others, as signatures drawn across that gap. As a result, they show little interest in distant developments such as the Yuendumu TV station, and are more involved in developing Aboriginal and even personal access to national and commercial media.

Culturecidal Content or Community Access

Edmund Carpenter (1973), an anthropologist who was employed in the 1960s to advise the Australian government on the impact of modern media in traditional New Guinea culture, concluded: "We use media to destroy cultures, but first we use media to create a false record of what we are about to destroy."

The real difficulty with Carpenter's prediction is that it suggests only a protectionist agenda: quarantining Aborigines outside mass broadcasting. I think it fair to say that in Australia we have heard Carpenter's warning, and mean to find a more creative solution. But which solution will serve? DDA's current support (at least in principle) of community production and other proposals to create "balanced" services tailored to Aborigines, surely has this objective. I also take the sense of the Tribunal's encouraging "Aboriginal Content" to be an attempt to prevent culturecide through media, problematic though its signification may be. But if my analysis is correct, both these proposals emerge not from any precise understanding of the Aboriginal information management tradition, but on a liberal, humanist, "fair-go" or equal rights argument. Attractive as they seem, these ideas may backfire. In my project report, I argued the curious probability that a national television service with no Aboriginal content would be less culturecidal for Aborigines than badly conceived and produced Aboriginal programs. These latter could be truly destructive.

I mean to have identified in my studies and my analysis here some of the particular characteristics of the clash between oral and mass media that is capable of subverting the oral tradition, and thus of destroying it. But unlike Carpenter, I am convinced that the reason orality comes out the loser lies not in any inherent vulnerability, but in the political and institutional forms that conspire to privilege modern mass media and their messages when these traditions collide. Thus an "oral" film or video may be possible if the circumstances in which they are engaged can become more equitable. I sought to accomplish something like this in my own work, and have pointed to other work by Australian filmmakers with similar goals. This required our own disappearance as signifiers, a painful and unfamiliar abnegation for media people. There is very little that we will be able to take credit for in this enterprise. Oddly, contemporary Aboriginal politics encourages certain Aborigines, identified by the government, to position themselves much more conspicuously than the system traditionally encouraged, identifying their newly, bureaucratically constituted selves as signifiers, to engage in a massive opportunity for self-inscription that these new media provide. It is this oddity that I want to examine — and suggest a solution to — in my conclusion.

To me, the more worrying part of Carpenter's prediction involves the creation of false histories. Now it may be, if Baudrillard and others are correct, that this is the irresistible pressure of the twentieth century, and that all histories are being rewritten to satisfy the demands of the simulacra. Whether or not this is so, we may yet ask: Who gets to write these new histories, and to whose advantage?

Aborigines and Aboriginality have always been subject to appropriation by European Australians, so that we consider the production of Aboriginal images for mass consumption as a right, if not a responsibility, of a nation consumed with the manufacture of its own mythology. None of this should prove to be novel considerations for Australian film scholars, engaged as we are in a self-conscious exploration of the received postmodernist debate and its application to the national situation. In that discourse we learn of the power of inscription, the disappearance of the signified as it collapses into the signifier. What may be new is who Australia now regards as having the rights to make this appropriation. By identifying a class of people as Aborigines and providing some of these the right to authorize programs about others of these, we may risk not only inhibiting unique indigenous expressions, we risk employing media's vast transmission range to usurp local autonomy and to attack the base of traditional life.

To the extent that exotic media producers dominate the discourse on Aboriginality for the public, they will write the new Aboriginal history. To the extent that Aboriginal "experts" (politically or academically authorized) do so, they write that history. The competition seems mostly between these two non-local classes, and what has proved remarkable is the state's interest in all this; the government's recommendations in the Task Force report on Aboriginal communications mostly concern models of collaboration between these more powerfully situated elites. The conditions and possibilities for remote or traditional local communities to enter the process, to image themselves, are denied by being ignored. Here we are engaged in an inscription process truly capable of murdering the subject.

I think Steven Muecke (Benterrak et al. 1984) is right when he claims that we have excluded Aborigines from this discourse in another sense, preferring to position them as modern subjects, or even premodern objects. The dominant filmic and documentary conventions (not to mention the ethics) applied to imaging Aborigines are rarely more recent than the 1950s; we engage a vulgar and ill-considered realism in the treatment of Aborigines. But do the few specialist readers we now position politically (both professional students of Aborigines and

professional Aborigines themselves) to evaluate any text offer any improved insights? In the polemics that emerge here, these students and Aborigines seem to ask, as do remote people, whether an image is "truthful." But unlike truth in the Dreaming Law, this truth is based on public relations law: Is the text sympathetic to an image certain Aborigines think useful to project when based on essentially public relations notions of the persuasive function of film and TV? Attempts to challenge this notion from within film practice are being increasingly marginalized, so that works by the Cantrills and MacDougalls, for example, are not to be considered suitable candidates for Australian Bicentennial funding. I wonder if Alby Mangels is? Certainly, CAAMA is being forced to consider the extent to which its funding commits it to public relations objectives of the government as opposed to its earlier objective of Aboriginal media for Aboriginal people.

The means by which "Aboriginal Content," as an identified and authorized category of television and film, risks the destruction of traditional Aboriginal society ultimately can be identified as racist. This is because it requires an act of false identification, or ascription, of Aborigines (consistent with the more general Australian conception of race) as an equivalent class whose culture is written in their blood. The point, precisely, is that culture is not written in blood, only genetics is. Culture is extrasomatic, and it is inscribed in the communication process itself. By attempting to resolve the dilemma new communications pose for traditional culture, we err terribly by offering a false cultural identification of Aboriginality. The essence of Aboriginality is localism: land-based systems working against hierarchy and authoritarianism.

Any requirement for Aboriginal content is by necessity so vague that the issue becomes not the identifying marks of the text, but the political issue of just who is to designate these texts. As I conceive political privilege to be constituted in the Aboriginal bureaucracy, the contents likely to be identified are those that:

1. employ Aborigines as media subjects, perhaps as producers in certain "approved" forms;

2. provide an opportunity for powerful Aboriginal bureaucrats to become more powerful;

3. result in a certain distribution of media production resources, probably in the direction of those already best situated to

deliver products of a quality and style suited to the tastes and demands of Europeans;

4. rewrite Aboriginal history while inscribing particular signatures as authors of this new/old Aboriginality.

None of these results begins to address the charge of media as an agent of culturecide. Indeed, they all are subject to that charge. Our newly constructed, media-simulated Aboriginality, delivered as content by AUSSAT satellite to the remote communities, can succeed at subverting their traditions in a way that no other invasion has. It is not, then, through the dumping of European content to these locations but through the transmission of a powerful competing Aboriginal image, appropriated from the bush, purchased at the expense of local media, and filtered through the grid of a manufactured history that culturecide could readily be accomplished.

The other way to think about all this, I propose, is simply as a particularly compelling case for localism, to be achieved through community-access media projects. What other opportunity exists to avoid the discrimination of Aboriginal peoples in the reprehensible terms of degrees of Aboriginality in the authorization and evaluation of media and communications systems?

If we take "community" rather than "Aboriginality" to be the subject, and make "local" the qualifier, only then do we avoid the traps of racism and paternalism in our rhetoric and practice. We also avoid empowering certain people to make decisions for others along racist lines, which forces competitors for these resources to charge each other with inclusion or exclusion from the community on the basis of some perverse and vulgar Social Darwinism. "Community" would seem to be the correct term here, restoring us to a cultural discourse proper. Such a suggestion will admittedly not sit well with a Department of Aboriginal Affairs that has recently asserted its right to control all projects involving Aborigines. What I am suggesting refers the matter back to the Department of Communications, which has shown no more taste for taking responsibility for the Aboriginal component of its clientele than it has for developing its brief for community television. But it will make more sense, and be more productive, I think, to tack Aboriginal requirements onto a general public television proposal than to tack public television on to an Aboriginal agenda. And it may be the only opportunity for remote community television to develop within an adequate structure of

support, outside of the disastrous competition for authority I have discussed in the current system. This restores us to the positions posed earlier in my talk: that the Aboriginal media revolution signals a revolution in our own media, and that the only position capable of salvaging the Aboriginal subject will be its own disappearance.

Conclusion

The title of this address posed two questions regarding Aboriginal content: "Who's got it—who needs it?" I want in conclusion to summarize the argument I have made in answer to these questions. But I begin by noting what I did not ask: "Aboriginal content—what is it?" Because I think I have demonstrated that this is not only *not* the important question, it isn't even answerable (or perhaps it has too many answers) in Australia today.

Clearly, the question of who's got Aboriginal content is the really tricky one, because in Australia it asks a question not only about texts, but perhaps more about subjects and their positioning. This too, I submit, is not a question that can be answered in any useful way right now. Rather, I meant to observe how this question, or one very much like it, operates pivotally in a neo-colonial Aboriginal discourse, and what substantial ideological and material resources get attached to any answer. I have taken the position, taken by some Aborigines themselves (Langton 1981), that the rhetoric here is oppressive of its subject. "Aboriginality," as a category, is entirely likely to destroy Aborigines. This more general argument, then, applies to the question of broadcasting and communications, where I believe precise examples of how this can and does happen are to be found too easily. Because culture is not your skin color or your blood type, but a tradition communicated to you, the central place of communications in cultural maintenance or destruction makes this matter of introduced media of critical importance for Aborigines right now.

Which leads to the second question: Who needs it? The answer to this seems largely to depend on political and social constructs. The satellite TV owner needs it because the Broadcasting Tribunal might make its license dependent on it. The ABC might need it because DAA has indicated that it will divert resources to the Corporation for it. But the curious fact could prove to be that remote Aborigines themselves don't need it—not just in the quantitative terms of CAAMA, whose Imparja license may contain less of "it" than any of its competing European-controlled remote satellite licensees. Look also to the case of Yuendumu Television.

Warlpiri Media Association programs only become "Aboriginal Content" when they are exported from Yuendumu, and perhaps only when they are expropriated from Aboriginal Australia. In the context of their transmission at Yuendumu, they are simply local media. I am proposing that such content only becomes "Aboriginal" when it becomes "their" media. "Our" own media never really qualifies. This distinction, at the heart of the larger public and community television effort, seems to have been missed entirely in the debate about Aborigines and their media needs. Nowhere is this collapsing of distinctions between "us" and "them" so dramatic as in Jupurrurla's walk from on-camera compere position to the camera operator's position and back again. There is, at Yuendumu Television, this collapsed distinction between object and subject, producer and talent, "us" and "them." Any notions of Aboriginality are subsumed, even destroyed, by this more fundamental set of concerns.

I suppose I do also mean "Who needs it?" in the cheekier and more vernacular dismissive sense. An Aboriginal content category simply doesn't serve those Aborigines we're supposed to be so concerned about: the people in remote communities who will be watching imported television for the first time. What we need is an adequate program for local community television. This, I submit, will serve Aboriginal interests better, and everybody else's as well.

Appendix

Following the presentation of this paper at the ASSA conference, word reached me that people at CAAMA were disturbed by what was said about them, suggesting that it might undermine their position in the federal court hearing of the challenge to their Imparja license, which was taking place at the same time. The following memo is my response. Although it received no formal acknowledgment or reply, I subsequently discussed these matters casually with individuals within (but not representing) the organization, especially regarding my decision to publish the text here. I invited a response or right of reply. This was not acted upon—but I was asked, again unofficially, if I might merely include my introductory remarks making clear my position on the Imparja license challenge. By publishing the memo in full (the only place the spoken asides exist in written form) I accede to that request, and in so doing again invite a reply. My argument is that such critical exchanges are not merely constructive in this case—they may be essential political dialogues in which Aboriginal organizations will need to participate more willingly to ensure no loss of position in the shifting alliances that seem to be diminishing general support for the Aboriginal cause.

To: The Board of Directors, Imparja Television
From: Eric Michaels
Re: Australian Screen Studies Association Paper
Date: December 10, 1986

Philip Batty told me on the phone today that people were very unhappy with the paper I gave here in Sydney about Aboriginal media. He thought the things I said about CAAMA were unfair and that this was a very bad time to say them because of the license hearing. Jim Buckell then said the problem might go to the Board meeting this week. So I am writing these things now because if my paper comes up there are some additional things I hope you will think about.

First of all, I do not believe what I said was against CAAMA. There are places in the speech where I criticized things that worry me. Mostly, this is whether CAAMA/Imparja is doing all it should to help support community stations like Yuendumu and Ernabella. I have said this many times before, so there is nothing new about that. Also, these are things I hear people say in the communities. If the Board wants to consider these issues, I hope they will also look at the recommendations that came out of the Yuendumu TV October workshop.

Maybe some of the things I said are the same things those recommendations say. Maybe it is okay to say these things ourselves, but you think it's bad to say them in public. I try to be very careful about that. Philip says that people may think I'm now on the side of the N.T. government and the Darwin TV station. This is not likely. The talk was part of a whole day of discussions and video showings. I showed tapes from Ernabella, Yuendumu, CAAMA, TSIMA, and the government. The Aboriginal video magazine from the N.T. Community Welfare Department was so bad that people hissed and booed in the audience. Nobody thought I was supporting that mob. In fact, here is what I said to begin my speech. It doesn't show up in the written paper, because I said it just then. I've transcribed this from the audiotapes they made, and if you need a copy to check it, we can send one.

I started my talk saying:
The directors of CAAMA are at this moment elsewhere in Sydney trying to teach some manners and civilization to the Northern Territory government in court, something I consider of primary importance. Somehow, it reminded me of the profoundly racist notion of that challenge to the CAAMA license that is being presented in court through the television station in Darwin, NTD-8 ... by, in fact, the intractably racist and "Old Right" N.T. government.

If you had a chance to see any of the videos we showed last night, you might then have an experience, if not a direct one, of what those people are up to. I

call them the "Old Right" to remind us that, from my experience in the U.S. with the Moral Majority and what is called the New Right, it demonstrates that those people are not just the descendants, they are the very same people who were the Ku Klux Klan and the John Birch Society and we shouldn't forget that.

These are the strongest words I could think of to support CAAMA, and to make it clear from the beginning that even if I had some worries about Imparja, I stand strongly for you in the license fight. I believe that the things I said in the talk were right.

I believe I had a right to say them. And I think that the effect of my criticisms [is] really positive. If all I ever said were good things, people would think I worked for CAAMA and they wouldn't listen to me. I think it is important to have this kind of independent support. But to have it, you have to accept criticism too.

I told Philip about the paper a week before, even before I'd finished writing it, and we tried to get a copy up to Alice Springs. I invited him and Freda onto the discussion panel (and also Shorty O'Neill, who I got a copy to earlier that week in Canberra). I was concerned that people might take it the wrong way and wanted to give CAAMA a chance to see it and even correct any mistakes. But I am now unemployed and [have] no money to fly around or fax things or anything like that. And the license hearing was that morning. We had Helen Boyle from Tranby College and Lester Bostock on the panel because no people from the Centre were available.

I have so far refused offers to publish the paper because it was part of a whole performance and without the talk and the response by the panel, it might get misinterpreted. If people are afraid that what was said there could be used against CAAMA (and I don't believe that) they probably shouldn't make a big thing about it. The audience was mostly film students, and I doubt any government people were there. There is no way NTD-8 is going to cite the thing because they don't really want me on the witness stand. I'd make mincemeat of them! So I doubt there is really a problem there.

You know I feel strongly about these things. First, that I have a right and an obligation to speak, even critically. And second, that CAAMA/Imparja must win their license struggle. I told Philip that if there was anything I could do to help, including saying publicly to the press the things against the N.T. government and NTD-8 that I said at the beginning of my talk, I'm happy to put myself on the line for you. But I am not happy to hear that "I better not show my face in Alice Springs." I hope you can straighten that out.

Western Desert Sandpainting and

Postmodernism

[1 9 8 7]

IN 1983, Mr. Terry Davis, the new local school headmaster, brought consider-
able excitement to the Yuendumu community by his interest in and support of tra-
ditional Warlpiri culture and language. One of his more modest suggestions was to
make the school look less "European" by commissioning senior men to paint the
school doors with traditional designs. The results were more spectacular than any-
one had envisaged.

Both European and Aboriginal residents of Yuendumu took
considerable pleasure and pride in the achievement. Visitors to the community
were equally enthusiastic, and word about these remarkable paintings began to
spread. My own response was to see this accomplishment as a major one for con-
temporary international art as well as an achievement in indigenous culture. For
me, these doors seemed to strike a chord with issues and images that were being
negotiated in the art galleries of Sydney, Cologne, or New York.

The doors constitute a definitive series of Western Desert de-
signs that may prove accessible and coherent in a manner that has so far eluded the
presentation of Aboriginal "dot" paintings in other contexts. They form a com-
plete text, a primer, which may have the capacity to communicate the paintings'
meanings more directly than any other presentation can. It is timely to consider
these paintings at a point when the extraordinary success of the neighboring

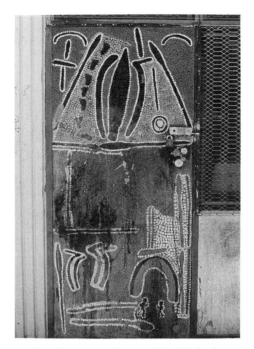

Yuendumu door. Photo by Eric Michaels.

Papunya Tula painting cooperative, which wins major prizes and commands high prices, has created something of a backlash. On the one hand, it is claimed that these paintings are easy to do and take no special talent. On the other hand, it is said that in the movement from ground and body painting to canvas, the style has become inauthentic, bastardized for the tourist market. These objections are so easily applied to any traditional arts that one might dismiss them out of hand. But the criticism suggests a deeper misreading of these paintings and what they are, as much as what they mean.

The Yuendumu doors stand midway between canvases exported to European audiences and their sources in ceremonial ground paintings oriented and applied to specific geographical sites. They constitute a related series and an exhaustive inventory of the techniques of Warlpiri design, seen from the perspective of the Yuendumu community. Contained in them are clues to their complex meanings. But as a whole, they make a direct and authentic statement about art, contemporary and ancient, and its place in society. It is this latter quality that now invites the spectators' attention and, I hope, may form the contribution of this book.[1]

It would be presumptuous and misleading for me to suggest

ways of decoding these designs as evidence of their significance. I do not "understand" these paintings, not in terms of the meanings the painters put there. Nor, I expect, can many readers of this book hope to either. These meanings are complex, implicit, even restricted. To understand them, one would need to be a full member of a particular Warlpiri kin group, initiated and competent in the stories and ceremonies and landscapes that are intimately associated with the sources of these paintings. Even then, some meanings would remain inaccessible until the painter, reciprocating some ancient or contemporary obligation, passed on the design to another. The ability to interpret these paintings is inseparable from the right or the obligation to paint them: their sources are in a participatory ritual where there is no proscenium, and no passive, distanced observer. Despite endless hours spent with the men while they painted, listening to their stories and explanations, and performing "working-boy" functions, I would not claim to be able to describe the meanings of the paintings from the painters' points of view.

Usually the problem of meaning in traditional art is managed cross-culturally by offering a reduced, schematized gloss of some figurative meanings associated with non-Western and unfamiliar images. Indeed, the stories facing the illustrations in this volume provide this. This may be justified because for the Warlpiri community, these are in a sense representational paintings, as Nancy Munn (1973) has claimed. The "true" and "proper" Warlpiri vision of the landscape is conveyed graphically to the initiated viewer. But something false and damaging may result from the invitation to peek into the painting and select out a few figures to serve as handles in the construction of a meaning satisfying to the uninitiated viewer. Warlpiri designs are learned and employed in many social and ceremonial settings. This learning process is exterior to the painting; increased aesthetic sophistication or treatises in art criticism provide no substitute. These only reduce the mystery and the terror of the ambiguous so that the European observer is able to construct a readable text—indeed, may take pride and pleasure in doing just this. The confrontation with the image is reduced to an exercise in cryptography. Of course, modern abstract and expressionist art can be subjected to the same procedure. In both cases, I believe this to be at the expense of art and of meaning.

Alternatively, one can take traditional art to be "craft," implying that it is something other and less than art, subject to different standards of evaluation and interpretation. Craft is judged on how well or carefully constructed something is. When approaching a thoroughly unfamiliar aesthetic or symbolic system, this is a conveniently covert hegemony. Where evaluation is literally a problem of buying and selling, even the wholly ignorant can distinguish tiny, even

strokes from bold broad ones, and apprize accordingly. One would imagine that art brokers involved in this kind of exercise would be quickly exposed as unknowledgeable, not only about the traditional arts they purvey but of their own society's aesthetics, at least since Cézanne and Duchamp. But in the marketing of Aboriginal arts, this exposure is late in coming and the effect of brokerage has been an increasing formalism and attention to "well-crafted" surfaces. The imposition of a craft aesthetic on Aboriginal art restricts that art to a nineteenth-century context and cheats it of its place in the modernist discourse.

The aesthetically striking thing about the Yuendumu doors is a boldness and energy of application that modernist art would call "painterly." This appears to contrast with the style encouraged at Papunya where the craft aesthetic was cleverly exploited by the supply of raw linen and thinned paints to produce a stained-canvas "minimalist" look suitable for the 1970s when this school commenced.

Previously, local Europeans had accepted, without any particular self-consciousness, that Yuendumu did not produce fine painters. There has been acrylic painting at Yuendumu, but the ornamented traditional objects (boomerangs, coolamons, spears) and the small canvas boards seemed unaccomplished and even gauche in comparison to the work being done at nearby Papunya. Yet these men are closely related to many of the Papunya painters, and share many of the same designs. No one had asked why Yuendumu painting seemed unremarkable. The doors provided the first clues to an answer.

The Yuendumu doors are large. They were painted with the available standard school acrylics. Their execution was a joint venture by many senior men of different kin subsections, who collaborated without supervision or critical European comment. The doors were painted quickly, usually in a single day. They were painted for the community. Such is the combination of conditions that creates a supportive setting for Warlpiri painting. Whatever authenticity Warlpiri designs possess can be achieved only in these conditions.

Warlpiri graphic motifs are used in various circumstances — body ornament, sacred rock paintings, tool decoration — but the closest equivalent to European painting for the men are the sandpaintings. These are assembled for certain ceremonies from various materials, not just sand. Significantly, sandpaintings tend to be quite large and are completed in one day as a cooperative venture by specified kin groups with particular ceremonial roles. When a painter is given a comparatively small canvas or object to decorate, the design tends not to be reduced; instead, only a portion is used. The larger the surface, the more complex

and the more integrated the design is likely to become. Sandpaintings are situational and ephemeral. I am told that they should be completed in a day's sitting to conform to the ceremonial schedule of a ritual gathering. Thus a large painting takes many people to complete. The degree to which the design will be extended and other designs incorporated, determining the visual complexity, is a function of how many painters are at work and how many kinship sections are represented.

The European model—one man, one (preferably small, portable) surface, one painting—produced a solution that was like a single "window" on a huge computer spreadsheet. Scale did not reduce, and the technical precision that might have made these partial designs seem more "attractive" was rarely achieved. These early small canvases seemed clumsy and uninteresting because they were actually small corners of far larger ones. Aboriginal painters can be trained, for better or worse, to make the transition to surfaces of a more marketable size; but the Yuendumu painters hadn't had this training. The doors provided the first sufficiently large surfaces for the paintings to develop as complex, integrated designs.

The lack of European supervision and evaluation was an important lesson, one I had to recall frequently when I later served as "patron" of the Warlukurlangu painting studio. The authority of a painter to paint the designs to which he has particular rights cannot be questioned. The distinction between telling someone what to paint and how to paint is one that escapes the modernist sensibility. Yet it is a tempting distinction to introduce when supervising painting for market. Because no one was planning to buy the doors, no one took any authority away from the painters.

We are by now familiar with the idea that traditional Aboriginal graphic displays are embedded in ritual and ceremonial activities that are in many senses economic exchanges. Designs signify, among other things, rights: rights to songs, to myths, and to the land and its resources that they depict and celebrate. To display a design is to articulate one's rights not only to the design but to all things associated with it. To see such a design, to learn about its meanings, and finally to be permitted to paint and then display it, means to be involved in an exchange in which one must reciprocate. Indeed, in many oral cultures, such knowledge may function like currency, and this knowledge is not "free."

What this book puts before the viewer is not, however, a set of painted doors at the primary school at Yuendumu in the Northern Territory. Instead, this is a volume of color plates made from photographs of the doors, intended to be purchased and viewed by a presumably European audience. The

doors, which were created to serve a particular sign/exchange value, are now required to perform a somewhat different task. It is precisely because some Europeans saw these doors (or pictures of them) and decided they were aesthetically significant in a non-Aboriginal context that this book was proposed. And because the door painters want this book to be produced, a new semiotic exchange emerges from the original event and invites discussion.

When the doors were painted, the men were given a token payment for each one. It was thought that because they were painting for their own children, a modest honorarium would be sufficient reward. But the painters must have had some different idea about the exchange value of their work. After all, this was a staggering and unprecedented feat: they were establishing publicly the major Dreamings, and thus the charters and the knowledge, for the land extending from the Yuendumu settlement. The explicitly secret designs, those accessible only to initiates, were of course edited out of the door paintings. (In the case of questionable material, criticism from senior men resulted in the painters covering or converting certain sections of the doors.) But the decision to assemble all this, at one place and at one time, must be seen as a historic moment in the life of Warlpiri tradition. It was not one to be celebrated by small honorariums.

There was talk of a more appropriate return. Because I was coincidentally going to Canberra for some work at the Australian Institute of Aboriginal Studies, I offered to show a set of snapshots to the administration there. The excitement was considerable, sufficient to propose, and finally create, this book. The Institute, in its correspondence, was careful to explain the economics of book publishing. There could be no immediate payment to the artists, and even in the future, as the production expenses would cut severely into any profits. I took this news back to the old men. We would have to think up some additional source of revenue.

The problem was that Europeans pay to own but not so much to see art. The doors could conceivably be transported and sold, but this seemed to violate their educational intent for the community (they'd also be expensive to move and replace). But the men were familiar with the books of the Papunya Tula artists, as well as the prices their work commanded. In our discussions, we considered the relationship between the literary documentation and the market value of the paintings. When their Yuendumu doors book was published, their paintings would be worth more. This led to the decision to reproduce the door designs on canvas that could then be sold "down south." The ultimate price for the collection would be two Toyotas.

This exchange value—paintings for Toyotas—is not arbitrary. The paintings depict, in terms of a religious iconography, geographical sites for which the painters have some special responsibility. Several Warlpiri terms describe this responsibility and are variously glossed by English translators. The closest term, for our purposes, is a verbal form meaning "to care." The men who paint these pictures are, by that very act, describing their responsibility to "care for" these places. Long ago (but within the lifetime of these painters), this caring would have included traveling to these sites to perform recurrent ritual and other actions to assure the continuity of the land and its Dreamings. When the Warlpiri were relocated to Yuendumu, they were cut off from many of these lands, which are as far as 400 km. distant and not necessarily accessible by road. Only Toyotas can get you there. And this is precisely what land rights have meant to traditionally oriented Aborigines—access to their sites so they can resume caring for their land.

In sessions with the men that followed, I became a student of painting, but also of the exchange system. No longer an expert, in media, anthropology, or anything, I was a pre-initiate. An "uninitiated boy's" Dreaming design was made and was the first to be hung. My problem was to fulfill this role but at the same time to exercise a critical European eye and occasionally let the painters know what would probably be saleable and what wouldn't. This could be a painful process, as it became clear that what constituted a "proper" or "number-one" painting might, from my perspective, have degenerated into a static formalism on one hand, or rampant kitsch on the other. Yet the expressed objective of the men was to sell the paintings to Europeans, and it was made my responsibility to evaluate the work in these terms. If my judgments differ from those of others who have performed this function for Aboriginal artists, it is due to my sense that these doors have a unique place in contemporary painting.

My first reaction to that unsupervised work was to evaluate it not in terms of ethnographic validity but in terms of the 1984 Biennale of Sydney (which was deeply influenced by Neo-Expressionism, iconicity, and spirituality).[2] Something that was articulated as a "problem" in the Biennale work seemed to me to be addressed, even solved, in the door paintings. I sought then, and now in this essay, to develop some general ideas about this correspondence.

The correspondence I am suggesting may be simply historical and circumstantial in many respects. One hundred years ago, the beaux-arts tradition would have had no place for such paintings. When "primitive" art began to enter into the modernist discourse at the turn of the century, it was largely African, Iberian, and Native American forms that, for various reasons, were valued.

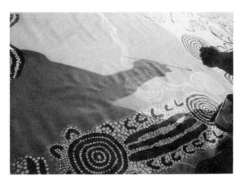

Yuendumu painting. Photo by Eric Michaels.

Early modern artists were themselves among the first collectors of indigenous art, as Robert Goldwater's seminal *Primitivism in Modern Art* reported when first published in 1938. Melanesian and Polynesian sculpture was appropriated soon afterwards, and now has a major impact as demonstrated by the 1984 Maori exhibition at the Metropolitan Museum in New York. In many cases, ethnographic identification must predate modern artistic interest. Arnhem Land sculpture and then bark painting began to command some attention, especially after the Berndts' essays (1949, 1950, and 1964). But the striking comparisons between Aboriginal painting and prewar work by Klee and Miró, in particular, isn't easily traceable to their exposure to this work so early.

My guess here is that the appreciation of various non-Western traditions is a function of, and must await developments in, Western art history. Today, Aboriginal art is shown alongside modern works in leading national galleries in Australia, France, Germany, and America, and has provided a prime source of inspiration for such international exhibitions as "Primitivism in 20th Century Art" (1984) at the Museum of Modern Art, New York, and "From Another Continent: Australia. The Dream and the Real" (1983) at the Musée d'Art Moderne de la ville de Paris. Why all this attention? Some of the answers have to do with surface similarities between some contemporary and some Aboriginal painting. The Neo-Expressionist school, for example, tends to be heavy on a kind of pseudo-iconic content. Figurative representations abound, but these very figures are ambiguous: a face here, an animal there, some object elsewhere. The relationship between these may be masked, so we assume that the logic of these literal relationships is only accessible through the artist's idiolect. The viewer is tantalized by the conspicuous display of meaningfulness in a composition that itself fails to establish these meanings.

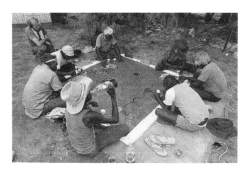

Making a painting for the SA Museum. From *After 200 Years:
Photographic Essays of Aboriginal and Islander Australia Today*, ed.
Penny Taylor (Canberra: Aboriginal Studies Press, 1988).
Photo by John Rhodes.

Warlpiri sandpainting corresponds, superficially. Design elements of variously readable iconicity are essential elements of the paintings. But they are not "readable" to the European observer. Each Warlpiri sandpainting tells a story, but it does not tell it unassisted. These are not self-contained texts. In a way reminiscent of Neo-Expressionism, the observer is encouraged to perceive meaningfulness, but not the meaning itself. The difference is that the source of meaning exists for Warlpiri design not in the psychological imagination of an individual artist, but in a collective, social, and religious discourse. Whether this provides some perceptibly greater authority, some less idiosyncratic or arbitrary semiosis (a mystery, in the theological sense, rather than an obscurantism) is a more difficult judgment to assign to the viewer.

Technique, in the sense of the attention to materials and their applications, is also superficially similar in the Yuendumu doors to some contemporary painting. In both, the "painterly" appears as a transparency of technique, a frankness about the properties of the medium. The effect on the viewer, of course, may be the opposite, for we are drawn to consider the visible marks of application as elements of content themselves, as statements of a sort. In contemporary art, this is clearly an inheritance of the New York tradition culminating in abstract expressionism. But it has evolved through several distinct stages of internal criticism and self-commentary since then. In Aboriginal painting, the a-technical technique is less self-conscious, perhaps. Acrylics are, of course, an introduced and unfamiliar medium. But I suspect there may well be some traditional sources influencing acrylic usage. The materials of traditional art (ochres, sand, feathers, charcoal, flowers), while meaningful elements of the bricolage, may not have been

problematic in a technical sense—red ochres, once extracted and pounded into a medium, became isomorphic with the design element to be painted red. Questions of shading, application, and so forth—a transubstantiation of the medium in the process of becoming part of a graphic image—may not have played any part. Indeed, the common words for the elements from which the pigment is extracted, and the color itself, are mostly the same (e.g., *karrku* means the place where red ochre is mined, red ochre itself, and the color red). The painted object therefore retains its relationship to the source of the materials, and brings these associations into the image, rather than excluding them, as would be the point in classical illusionistic technique.

These, and perhaps other surface similarities, provide a "look" to Desert painting that makes it appealing right now. But it must be admitted that this look is the most manipulable feature in the relationship between the painter and the art adviser. As both provider of materials and judge of marketability, the European art broker, whether in the community or at the town art gallery, can influence color, technique, and other surface qualities, issues that may be seen more as peripheral than central by the traditional painters. Consider the different look of a number of Desert painting schools: the rather formalist Papunya painters with their more restricted palettes; the somewhat freer expressions of the outstation Pintubi; and now this alleged postmodernist "influence" at Yuendumu. Recall the extreme example of the related desert Arandic watercolorists, notably Albert Namatjirra (whose work raised all of these questions a generation ago), and compare their work to the first paintings with acrylic on boards in anthropological collections at universities. It is undeniable that there is a discourse here between European criticism and marketing and the product itself. This could be interpreted alternatively as proof of the corruptibility of the indigenous tradition or, as I would prefer to think, of its range and durability. In either case, a deeper analysis is required unless we are to disrespect both modern and Aboriginal painting as products of no more than commercial fashion.

Jean Baudrillard, in "Gesture and Signature: Semiurgy in Contemporary Art" (1981), sees the modernist movement as having elevated the artist, or more properly the artist's oeuvre, to a privileged place in the aesthetic discourse. A series of self-referential paintings are produced within a creative lifetime, whose semiotic as well as economic value resides not in the individual work but its position in the series. This notion of the authorial series is especially pertinent here. The Yuendumu doors, indeed all traditionally based Aboriginal paintings,

are likewise part of a series—in the simplest sense, as pages of an atlas, maps that describe as a whole the Australian landscape. Here is where the difference, and ultimately the dynamic, between Aboriginal and modern painting lies in the terms of Baudrillard's analysis:

In a world that is the reflection of an order (that of God, of Nature, or more simply, of discourse) in which all things are representation, endowed with meaning and transparent to the language that describes them, artistic "creation" proposes only to describe.... The oeuvre wishes to be the perpetual commentary of a given text, and all copies that take their inspiration from it are justified as the multiplied reflection of an order whose original is in any case transcendent. (103)

Baudrillard thus develops a contrast between this language of traditional arts and modern art, which produces in the latter "the insistent mythological demand for authenticity" (104) that gave rise to the modern authorial series or oeuvre. But for art such as Aboriginal painting, signature is unnecessary. Authenticity is determined with reference to the adequacy with which the original text is explicated. Forgery, for example, is impossible but theft is feared. What is of particular interest concerning the doors collected in this volume is that they likewise represent a series, but a series of "God," "nature," and "discourse," which may permit a clearer critical appraisal of this very point than collections whose relationships are established by the European critic or collector. Fortuitously, the doors are of the same size, shape, and materials, so that their seriality is signaled in terms conventional for Western art.

The question before Baudrillard is now applied to Aboriginal painting: How do we determine a semiotics of authenticity? Or is there a manner in which, despite the vast cultural and especially semiotic distances that separate the Warlpiri from us, some sense of the truth of Warlpiri philosophy is being communicated through these paintings to the uninitiated viewer? Perhaps this question is not at all new to art. For isn't this the claim that classical art once liked to make for itself: some privileged universality, some capacity for a communication less mediated than the linguistic? And doesn't this remain the issue even in its apparent repudiation in modern aesthetics? For by a curious reflective objective, doesn't art still attempt a commentary on the absolute even within the multiple, tautological, self-referential properties of the modernist series described above? Or have we dispensed utterly with our Greek sources in the equation of beauty with truth (or its new equivalent, authenticity)?

When I first came to Central Australia and used to drive those

desert tracks by myself (before I had established relations and obligations which fill up the Toyota on any journey), the desert distances were to me unfamiliar and unmarked. Now, of course, they are a landscape full of significance—where we broke down last time, where we found Jupurrurla walking at night, where Japanangka jumped off the truck, the back way to Mt. Allen, and occasionally, the place where the ancestors came, or where water is, or bush tomatoes. But in those early days, my reflections were almost wholly abstracted, centered around a singular question.

These desert landscapes looked to me like the oldest in the world. The mountains were worn down to craggy hills, the valleys flat with millennia of settled sands. Everything about the place spoke to me of an incredible age. But did it?

I am not a geologist, so I am not trained to interpret landscape through some scientific model that would convince me of these things. But I suppose I had read about the geology of this continent and the age of the Central Desert features. Perhaps that's why I thought they were old. I played a game, and told myself that this was a new continent, that these hills were mountains just beginning to grow, that the mulga and spinifex were the first steps toward a forest, that time would build this landscape up, not wear it down. But I was never able to convince myself of this alternative.

Nothing in semiotic theory or contemporary scientific philosophy accounts for any such ability of phenomena to communicate directly, unmediated, their history and meaning. Rationally, I have to reject the possibility, and admit that I have been influenced by my reading and other prior associations and information. But I recognized that the epistemic problem raised here is precisely the one of such interest to Aboriginal philosophy, and the one the paintings themselves attempt to bridge. These paintings make the claim that the landscape does speak, and that it speaks directly to the initiated, and explains not only its own occurrence, but the order of the world. Perhaps this meditation brings me closer to some appreciation of Aboriginality than all my other efforts.

The dilemma is transferred here to the reader of this book and the viewers of these paintings. Do they convey some authentic vision beyond the cultural and linguistic specificity of the iconic and semiotic codes employed in their construction? Or are they "art" merely because of the correspondence of their surfaces to the current fashions of form and technique, elevated in value only because of their ethnographic rarity and curiosity? I believe they attempt the for-

mer. The senior men of Yuendumu believe in the truth of these paintings and intend to convey that to Europeans, to whom they believe they have a responsibility to communicate these things of which they know more than anybody. That intention I take to be an artistic one. The reader is invited to determine if the authenticity of their knowledge is demonstrated here.

IV

Hundreds Shot at Aboriginal Community: ABC Makes TV Documentary at Yuendumu
[1 9 8 7]

THE ANECDOTES reported in this somewhat jocular story occurred several years ago (1985) and may not seem especially relevant to today's reader. Changes in ABC staff and organization, emerging federal policy on Aboriginal broadcasting, and the awarding of the RCTS license to CAAMA all could be interpreted as altering the circumstances described here and solving the dilemma that introduced television poses for remote Aborigines. But I think not. Despite all of the resources, policy, and planning that have gone into Aboriginal broadcasting in the last few years, I believe the conditions of traditional Aborigines in places such as Yuendumu remain essentially unassessed and unresolved, particularly in these locales' use as locations for filmmaking by Europeans.

In my report of the Yuendumu project (Michaels 1986) I drew as the most urgent, certain conclusion the culturecidal threat that national broadcasting of unvetted Aboriginal material may pose to traditional people. The charge awaits an answer. The penetration of the outback by Australia's only national broadcaster, the Australian Broadcasting Corporation, carries with it this insidious threat. The ABC continues to make and air programs that publicize secret domains of Aboriginal life, most recently an *Australian Impact* TV program that featured many minutes of explicitly restricted male ceremonies. If anything, commercial media groups have proved more sensitive, as evidenced by isolated examples where programs have been withdrawn at the request of Aborigines. But generally,

the media's fascination with broaching Aboriginal rules in these matters approaches obsession. Considering the increased role recommended for the ABC in federal Aboriginal communications policy, the events reported here become more, not less, alarming.

The board and the executive of the Corporation are not ignorant of these issues. My own correspondence to the Corporation, responding to each program of this sort that comes to my attention, is regrettably long. I am aware of relevant correspondence by Aborigines and their organizations as well. The matter was recently raised with much concern at a Remote Aboriginal Community TV Producers meeting at Yuendumu in October 1986, and a recommendation was produced calling for urgent action on Aboriginal copyright and media contracts.

On occasion, I have been called to Gore Hill,[1] and even taken to lunch to discuss the problem of restricted material for the ABC. But even the precedents established in the *Open File* program reported here have had no further force. Quite detailed proposals from myself and others for means of addressing the issue within the Corporation have come to naught. The ABC's interest in Aborigines is seen more in initiating projects that can attract special funding and political prestige than in cleaning up the mess of past projects or responding to ongoing problems. I suspect the solution to the ABC's cavalier appropriation of Aboriginal Law (remarkably, most often masked by the pro-Aboriginal rhetoric of its programs) will not be solved within the Corporation. Rather, external controls, either by extensions of the obscenity and blasphemy laws, the Aboriginal Heritage Protection Act, or direct action by traditional Aborigines refusing to air or participate in any ABC projects, may result. This seems strong, even unpalatable medicine. But the issue is precisely that serious, and the risk real and immediate.

For these reasons I have agreed to the request to publish this article at this time. I hope this preface negates any tendency of the reader to treat this as a historical or isolated case, safely behind us. If there remains any question in the reader's mind, it might be resolved by calling the ABC and asking for the opportunity to preview "Fight Fire with Fire." They will suggest you buy a video copy, which they will sell to you for $40. The Warlpiri Media Association has not released copyright of its material on that tape for this purpose. WMA, needless to say, doesn't get any return from the sales of its images by the ABC. WMA doesn't even know it is being sold in Sydney.

"You see, Bill, your real film here is that one," I said, "the one about you guys making the film." It's a cliché of "New Cinema" circa 1960, but it fits the ABC

documentary Bill Stellar and his crew shot at Yuendumu in July, about this Aboriginal community's "pirate" television station and the introduction of new technology, 300 km. northwest of Alice Springs.

Warlpiri Aborigines freely traveled this, their Tanami Desert homeland, until Yuendumu was built by the government in the late 1940s and the nomads were "settled down." Until now, they have mostly remained outside the national and transnational electronic information grid. No live television reaches here, radio picks up only intermittent shortwave, and the radio telephone barely works—more of a frustration than a service. But that is all about to change, like it or not. The communicational isolation that has protected Warlpiri culture and language from competition with *Countdown, A Country Practice*, and *The Evening News* is ending. A variety of services, not just those associated with the new satellite, AUSSAT, is being introduced over the next five years to redress the "media disadvantage" and to assure communicational equity ("equalization of services") for all Australians, like it or not.

One senior man at Yuendumu, testifying to the Australian Broadcasting Tribunal last year, liked it not at all. "That's why Aboriginal people got the land back," old Jampijinpa said, "to keep away from European things. Now the government's chasing after us with satellites to interrupt our tribal law."

Yuendumu's 1,000 residents are precisely the kind of outbackers for whom Canberra claims AUSSAT was designed. In fact, most of the people who remain unconnected to any mass media (except shortwave), and who have no automatic telephone, live on Aboriginal land. But are these new services what they want? Or are they to become "fringe-dwellers" on the margin of an electronic grid in which their interests are incidental? Assimilationist policies are no longer *de rigueur* in Canberra. They have been replaced by self-management/self-determination goals. But these may be implemented in a maze of shifting policy and contradictory practices that can encourage the same passive dependency on federal subsidy and European intermediaries that they were intended to replace. For example, after four years of confusing and contradictory government promises about satellite-delivered television, telephone, and other communications services, Yuendumu still had no clear indication what kind of media would be available from AUSSAT, or whether expressed Aboriginal goals of local input and bilingual services had been recognized. This community decided to go it on its own; in April, it announced to the press that they were operating "Australia's first public TV station." It was unfunded, unlicensed.

The ABC crew had just been through a rough day: the power

station was crook, and there was no juice excepting occasional, tantalizing mega-volt surges; a church service had to be shot in intolerably low, hand-held battery light, upsetting the service but producing unusable footage; appointments for interviews were missed by Aborigines whose priority was to play in a spontaneous grudge footy match. Most unsettling had been the appearance of Japanangka over lunch, with a list of unnegotiable demands for control of the ABC shooting script and the unit's resources. Bill was ready to chuck it in. He had a tense, grumpy crew by now and was waiting for the "SUP" (shot under protest) sign to appear on the next slate. After a week of shooting, he still had no clear story, no "guts." And Japanangka's threat to run the ABC out of town was not made when anybody was in a mood for negotiating.

About six months earlier, during a visit to my Canberra office, I had received a phone call from Gianpaolo Pertosi, a researcher for ABC's *Open File* social documentary series. They were interested in doing a program on the issue of the satellite and how Aboriginal communities were responding. As the AIAS Research Fellow on the subject, did I have any leads? In fact, I was in Canberra for meetings with the Department of Communications (DOC) and the Department of Aboriginal Affairs (DAA) regarding remote media. The issue of pirate television stations was beginning to concern Canberra. While the government engaged in endless rounds of inquiries, task forces, and policy negotiations about what kind of media Aborigines should get from the satellites, remote communities themselves were beginning to develop their own homemade facilities and transmit their own programs. It wasn't just at Yuendumu, where I had been working for over two years, but in a dozen or more remote communities in the Top End, Queensland, and South and Western Australia. The idea had begun in mining camps and pastoral homesteads where DOC had installed or approved facilities to intercept ABC programs from the national feed on INTELSAT, the American satellite ABC is using until AUSSAT becomes operational later this year. It hadn't taken too many reruns of *Brideshead Revisited* for outback folks to discover that for about five dollars, they could buy a jack that would let them substitute rented videotapes and transmit these from home video decks through the same aerial. Aboriginal communities caught on, but they also began to play some local productions and tapes from other communities and Aboriginal organizations, like the "CAAMA Video Magazine." These alternatives to all-English, ABC programs, sometimes about incomprehensible European issues and manners, became important fare for people considered (in fact, unconsidered) a marginal cultural and linguistic market for the mass media. A problem with government communications

policy for remote people (not only Aborigines) was that these developments, what people were actually already doing to get TV, were unacknowledged and unplanned for. By the time DOC and DAA have their policy in place, they might well find that unconsulted folks out there had already developed their own media and delivery systems, incompatible with what the government finally decided it would be selling. A clash was in the works; the question was how soon, and how loud.

I described to Pertosi a few communities that had refused to buy into the ABC INTELSAT system: the price was too high, the system wasn't convertible to AUSSAT, and both Ministers Holding and Duffy had sent out warnings that people risked being ripped off by hardware companies trying to dump obsolete dishes on uninformed "bushies." But some Aboriginal communities had rigged up local transmitters and were producing and transmitting their own television without any imported programming. At least two, Yuendumu and Ernabella (in South Australia), had been in negotiation with the Department of Communications for licenses and the Department of Aboriginal Affairs for funding for over a year with no clear progress. It seems these indigenous stations didn't fit into any Canberra policy. At some point, the story about these stations would break nationally and might provoke some government response. Perhaps this was the kind of situation *Open File* might be interested in?

Pertosi suggested I stop by the Sydney ABC Features office on my way up to Yuendumu the following week and have a chat. I sent a number of recent articles and correspondences on the issues, and then spent several hours interviewing and being interviewed by Pertosi. Over the next three months, I discussed the possibilities with the Yuendumu Community Council, the local Warlpiri Media Association, and the ABC Features department.

Yuendumu has a long history of being a media subject. Films have been made in this area since the early 1950s, from documentaries of explicitly secret men's sacred ceremonies, to Department of the Interior films with catchy titles like *Walking in the Sunlight, Walking in the Shadow* (1970). The community had become wary of the intrusion of media people into their lives. Now VCRs and some television are becoming available to Aborigines and they have a chance to review and consider the effects of this filmmaking. They are often not happy with the results. The public display of private and restricted ceremonies is intolerable. The showing of pictures of people who have died violates traditional law and is an insult. And the more subtle rhetorical stance of many productions, and the inaccurate or disrespectful BBC-style narrations, are no longer taken as merely funny.

Last winter, anticipating media interest in the annual Yuen-dumu sports weekend (which the press dubbed "the Black Olympics"), the local media association demanded, and got, written contracts with commercial and ABC crews. More and more, the community wished to manage its own media and the production of its own images (as well as those transmitted into it). It recognized also that imported, professional media would remain necessary for any mass distribution. Working without funding, two home video cameras might be adequate for local television transmission (if both weren't in the shop trying to have their short "planned obsolescence" lifespans extended). But even raw footage of important events was technically unacceptable for national transmission according to broadcasting standards. High-band, high-resolution recording and editing costs in the hundreds of thousands of dollars and will probably forever be out of reach of small, impoverished communities. The problem was to develop some kind of coproduction model in which the Aboriginal video workers could participate behind, as well as in front of, the cameras. This was all the more intriguing because it offered a kind of training otherwise unavailable to remote, traditional Australians. It simply is not possible for such people to spend six months, even six weeks, in a Sydney or Melbourne training program. It's not just the alienation or the linguistic disadvantage, but the breakdown in familial and ceremonial responsibilities that are a consequence of prolonged absences from the community. It was with these considerations that a coproduction was proposed to Andy Lloyd-James, head of ABC Features, midway in the negotiating process.

The proposal, "Through Aboriginal Eyes," was modeled after those documentaries that studios sometimes shoot about the making of important (or exotic) movies, which provide behind-the-scenes action, "blooper" outtakes, celebrity interviews, and so forth. In this case, the ABC would take equipment to Yuendumu and demonstrate its operation to the videomakers (not a complicated process, but rather like learning how to drive a truck when you already can handle a sedan — only mistakes aren't fatal). The Aborigines would then produce a short film of their own choosing, and the ABC crew would document the process, provide an analysis/translation (Aborigines don't make films that look or sound like ABC features), and around this evidence of distinctiveness for the Aboriginal techniques, interviews and other more usual documentary episodes about the coming of the satellite could be shot. Edited, the finished program might be perhaps one-third direct Aboriginal production and two-thirds ABC. It might be very interesting. It certainly wouldn't be any duller than some recent ABC fare. At worst, it should win a few awards.

The meeting in Lloyd-James's office was, if anything, a chummy affair. After a courteously off-handed swapping of credentials (Lloyd-James scored very well on this), we undertook a discourse both scholarly and gentlemanly. It was only later, reviewing the session, that I realized its substance. The proposal had been broadly complimented, even apparently approved. But it boiled down to a familiar Hollywood scene: "Loved the story, just loved it—only we'll change the heroine to a collie and switch the location to the Amazon. Oh ... and he'll get shot in the end." In short, ABC had agreed to something, but I wasn't clear just what.

Pertosi, in the cab to the airport, commiserated. He, at least, had been sympathetic and active in his support, not just of the proposal but of the idea that a fair treatment of the issue, and the Aborigines, demanded an unlikely stretching of ABC's arcane documentary conventions. Stretching the hierarchical pecking order was less likely, though, and Pertosi, an ethnic Italian, was a mere researcher, not a policymaker at the Corporation. Still, the first thing is to get the green light, he said, and we'd gotten it. Pertosi would fly up to Alice Springs in a few weeks and I'd drive in and take him back out to Yuendumu for a few day's research.

In the four days "G.P." (Pertosi suggested this substitute for Gianpaolo, which posed some difficulty for Warlpiri phonetics) spent at Yuendumu, the Warlpiri Media Association produced its own half-hour documentary under his direction—a remarkable feat. Using the need for "location shots" as the justification (as well as the need to demonstrate to his superiors that Aborigines could, indeed, speak comprehensible English), G.P. had the local videomakers tape interviews, location shots, construction of the new TV station building, sunsets, sunrises, and anything else that struck his, or their, fancy. For those few days it was quite a sight to see G.P. looking each day more Felliniesque, parading down the central road of the settlement with his Warlpiri crew. Everybody seemed to love it.

Yuendumu videomakers rarely make videos in English, or for European audiences. They prefer to stick to their specialty, Aboriginal media for Aboriginal people. So, of the 300 hours of tape produced over the three years of video production here, this "location shoot" for ABC was one of the first that was made specifically to communicate to outsiders. In addition to Gianpaolo's using it as an internal memo at ABC, we edited it at CAAMA to bracket the public announcement of the pirate TV station made several weeks later at a seminar in Sydney. (ABC had a crew in Sydney for the showing of the tape and the telephone

question-answer session with Yuendumu following. Later, Bill shot a reconstruction of the Yuendumu answers for the documentary.) The tape has also been played for Canberra departments, at overseas conferences, on the Warlpiri TV station, and on stations in other Aboriginal communities. I believe it bought us the DOC license, as well as $25,000 emergency funding from DAA.

Two months after Pertosi's visit, Bill, Gianpaolo, and four crew members arrived in two large vans. These had been driven first up from Sydney to Darwin, where two weeks were spent shooting crocodiles for another documentary, then back down the track to Alice and up the Tanami to Yuendumu. I arrived four days later, having been away, and found them comfortably resident in two houses, temporarily vacant for the school holidays. The shoot was well under way and seemed to be going smoothly.

I lived with Gianpaolo and Faye, the continuity assistant, for the rest of the shoot. Bill, the soundman, the assistant director, and the production assistant bunked next door. This meant that we remained involved in a kind of ongoing conference, interrupted mostly by meals (a production assistant turns out to be, among other things, the crew's cook) and selections from a large box of videos rented, along with a VCR, from Alice Springs for the evening's busman's holiday.

For the first few days, things appeared to be going well enough. The only problem seemed to me to be that no one in the community knew exactly what the crew was making a movie about. The crew could be seen wandering around, sampling the interesting visuals that Yuendumu offers. They were fascinated by the old men's painting workshop (Bill and Gianpaolo had collaborated on a Papunya Tula artists' program that was well received); they found various projects of the last days of school interesting; they filmed a church service, a trachoma eye test examination, interviews with various community leaders, the community store, and a football match. They appeared to be getting along famously with everybody in town, and it had become quite the thing to be singled out to be filmed. Only, as I asked around, it occurred to me that people had wildly various notions about what they were making a documentary about. I was becoming curious also. I thought this was to be about the TV station and the introduction of new media and technology here. Certainly, this could be broadly defined, but ... I asked Bill if they had a treatment, an outline, anything tangible that they were working from.

In fact they didn't, Bill said. ABC headquarters in Sydney, according to his description, was in turmoil, reeling from budget cuts, staff reorgani-

zations, series cancellations, and whatnot. In fact, it wasn't even entirely clear what documentary series the Yuendumu program would be aired on, or when. (Originally, we were discussing an *Open File* program, but the series would be canceled soon.) Andy Lloyd-James was on a suspiciously extended vacation in Greece. Cutbacks meant the shooting ratio (footage shot to footage used) was severely reduced, and that reversal, instead of negative stock, was being used (a matter of some consequence, as it developed). Somehow, in all this madness, and perhaps because of our earlier meetings discussing the community's own objectives, something most unusual occurred. There was no script, no treatment; the crew was essentially "winging it."

For filmmakers familiar with Aboriginal life, an ad hoc shooting strategy is probably the best option, even though it is one the ABC rarely takes. The rhythm of life in these communities is loose and flexible, and from a European perspective, unpredictable. Clock time may not be important; appointments are kept or dropped according to external events and shifting priorities. The best, or at least most empathetic, films of Aboriginal life are made by filmmakers like the MacDougalls, Barker, or McKenzie,[2] who live months or years with these communities, adjusting their schedules to local conditions. ABC production crews are more comfortable setting up scenes, arranging people, prompting action, and creating a hybrid between dramatic and documentary shooting styles. With Bill Peach,[3] it works well. With Aborigines, or any other amateurs, it assures frustration, and it was beginning to show. Faye confided to me that although there'd been a lot of good footage, Bill the sound man didn't feel he had the "guts" of the story; when he described it to me directly, he wasn't sure he had any story at all.

So for the next few days, I took a more active part in the production, helping to set up scenes, "talent," and schedules around what I thought might be people's own interests and priorities. It was difficult to convince Bill, for example, not to rely on appointments. Just because somebody agreed, when asked, to be interviewed, it didn't assure that five hours later, when they had been scheduled, they would feel it was more important than something else. It's a busy community, and Bill had to be convinced to shoot when and where people were available, not several hours later when the crew was all set up. I remember chuckling to myself when he said how interesting and spontaneous all of the activity focused around the Adult Education center seemed one morning, and asked if I couldn't see that everybody hung around just like that for two hours until they could get set up. It was less amusing when they drove 150 km. to an outstation to shoot people watching a videotape. They brought a tape they thought the people would be par-

ticularly interested to see, set up, turned on the tape, shot the viewers ... and then turned off the tape and left, leaving some fairly puzzled people hanging around a blank TV screen.

In these few more organized days, something most peculiar happened. The crew focused on the "guts," which was to be, as originally planned, the community TV station. Only, during this time, there really wasn't any TV transmission. A death had interrupted the community schedule, and many people were in the mourning camp, including one of the station staff. Another had been seconded to a health project in a distant community. A dog tripped over the tripod and broke the one working camera; we were awaiting replacements. Notification had just come of a $25,000 grant urgently needed for equipment, but we would have to submit three estimates for each piece of equipment to Canberra, which alone would take months (mail comes twice a week and takes as long as two weeks to get to Sydney; radio telephones are nearly impossible to use for complicated business; Alice Springs retailers don't stock this kind of equipment, etc., etc.). And the electrician who was to wire the new station was six weeks late coming in from a nearby homestead. So during the entire time the ABC was at Yuendumu, there really wasn't any TV station. But viewers of the completed documentary will never know that. The quasi-fictional production style meant we could fake it, and we did.

It was at this point that I was getting worried. As a social scientist, I feel a certain unease with intentional fabrication. Truth is hard enough to get at without purposely muddying the facts. But there are facts, and there are facts. I thought the problems we were having keeping the station going were an important, dramatic story, more accurate and more revealing than anything that made this look easy. But the community wanted the station to be operating; they wanted to present a positive image. And researchers who work in communities often find themselves in dilemmas about becoming public relations people. At first, I was easily bought off. A series of shoots of myself leaning against my Toyota, drawing in the dirt with the Yuendumu skyline behind me, sitting at my computer surrounded by artifacts and carefully dressed in Ralph Lauren "Western Casual" gave me a chance to pronounce on the truth of all these matters in my best Carl Sagan style. A week-old beard (Faye said because I was unshaven in the first shots, continuity demanded I couldn't shave till they finished) might even lend some authority to my performance. But the beard was beginning to itch, and so was my conscience.

One solution we tried was shooting my sequences in a meeting of the media association. There is always something uncomfortable about being alone, speaking to a camera, the "talking-head shot." In Western society, people who speak to themselves are considered psychotic, except on TV. But Aboriginal society is especially particular about speaking rights: who has the authority to speak about given issues, to whom, or to speak for or represent others. By having me address certain topics in a group, any overstepping of my authority would be quickly corrected by the group. Any misinterpretation of Warlpiri viewpoints would be pointed out. And the underlying question that nobody wanted to ask out loud—why and how this whitefella was working with Aborigines on the television station—would be illustrated, if not resolved. It's something of a risk. I've never seen a tape of a European addressing a meeting of traditional Aborigines that doesn't make the European seem pompous and a bit ridiculous. But there might be truth there too.

Usually, you can't expect to assemble such meetings on demand, but it so happened that almost 30 people wanted in on this one, and that people had some important issues on their minds. I began by filling in the meeting on recent developments in Canberra about licensing and funding. Then I said that since the ABC was here, maybe there were things people wanted to say about the documentary they were making, things they wanted to know, things they wanted on film. Here the meeting took a very interesting and characteristic turn. First, some people spoke highly of the crew, approving of their conduct and of the video they had shown of the Papunya artists, and related opinions of some of their relations who had been on that film. But soon the discussion turned to an experience with a previous ABC crew who had filmed the sports weekend last year, and had failed to fulfill an agreement to preview their documentary in the community. By the end of the session, very strict press guidelines had been demanded for the coming sports weekend that would assure local control over what was shot and provisions for vetting material to be aired. At one point, some members suggested that the media association do all its own filming and bar outside media, but this was determined to be impracticable. This reference to the sports weekend, and to the previous ABC crew, is a typical kind of Aboriginal etiquette; the message was to apply to the present ABC crew without seeming rude, personal, or unappreciative.

I was sorry that we hadn't taped the meeting (as we usually do) for our own archives and for community transmission; it was the clearest, most spirited presentation yet of people's feelings here about the media and their own

objectives. It was, to my mind at least, the "guts" Bill had been looking for. But it won't be on the ABC program, because midway in the session, the crew pulled out. Bill said they felt "embarrassed."

That evening, the crew was exhausted. They'd been on the road a month now, and talk turned to Sydney restaurants they planned to visit when they got home at the end of the week. They reckoned it a good day's shooting. But I was feeling glum. Yuendumu had a number of reasons for agreeing to make this documentary with the ABC, and now, as the shooting drew to a close, it seemed hard even to remember them. Of course, the general public relations motives remained, and nobody saw any reason to doubt that the ABC would make a responsible film. But the collaborative model was down the drain; the media association had learned very little about the mysteries of commercial production. They had been kept resolutely in front of the camera, and never got behind it. The political intent of getting the program aired in time to add a remote voice to the AUSSAT debate concerning what services the government would support and license was also dismissed; reorganization and schedule shuffling in Sydney made it unlikely that the program would be aired until 1986. Perhaps we could use that time to involve the community in post-production? I asked Bill what chances there were for the video workers to add commentary, get a look in at the editing, or, at the very least, review the documentary before it went to air—for it is an odd and uncomfortable feeling to watch a film crew leave town with three or four hours of images of a community, and not know what will come out of it. Community review is the minimum condition the Warlpiri insist on. What would happen if anybody filmed died, and an image of the deceased were broadcast? It would be more than shame for the family, it would be trouble and fights for those who lived by traditional law. And what if they had made a mistake and accidentally taken pictures of something sacred, or something private? Or maybe not accidentally; the Warlpiri are beginning to understand what even lay Europeans don't—that you can appear to be filming one thing, but focus over somebody's shoulder and film something else. Who in Sydney would be able to prevent such violations from going to air and causing trouble in the community? Perhaps we could volunteer our services to help in post-production and review the film in the process.

No, Bill said. The problem had to do with the cutbacks at the ABC. Because of this, they had to shoot on the cheaper reversal film stock, which meant much less flexibility in the editing process. The transfer to video would have to be done all at once for the whole series, not this one program, to save costs. Review would be impossible. The problem wasn't that he didn't want to, the

problems were, you see, all due to economic and technological limits imposed by this unaccountable, faceless bureaucracy. Nothing to be done about it.

Nobody seemed particularly surprised when, on the last day when we were all to head to Alice Springs for a shoot at CAAMA of the guys editing at the studio there, none of the Aborigines showed up. We all understood by this time that people were getting a bit tired of making a documentary all about Aborigines' desire to make their own TV, to manage and control their own media, which took the form of an ABC production process in which they had no management voice, no control, no role, other than to remain resolutely on the other side of the camera, talking about, but not doing, any of these things. I wonder if just maybe somebody at an editing deck at Sydney ABC might notice this contradiction one day when they're putting together the final product. Or if the community performed strongly enough to carry that contradiction over into the living rooms of Australia so that the program becomes, in some way, subversive of itself. But I am cynical about these things.

The people at Yuendumu spent over two years trying to communicate to the government their interest in local television. Testimony had been given to the Tribunal, videotapes made and aired at the Departments of Communication and Aboriginal Affairs. These were unequivocal. The nature of Aboriginal tradition, autonomy, and authority is local and land-based. Mass media threatens this by overwhelming the local community with an unprecedented stream of imported, alien information. If the goal is to be cultural maintenance, not deterioration and assimilation, the only solutions for traditional people will be developed at the local community level, where these comparatively small cultural and linguistic groups can buck the bias of mass media by filtering incoming signals through local stations and inserting local material. Yuendumu had no dedicated support for this undertaking, nor did Ernabella, or any other community. The government's sights have been set firmly on the sky, on the high technology of the satellite and its engineering marvels. It has not looked at the users — the remote people, mostly Aborigines — who will have to deal, somehow, with the results of this technology-driven planning. These communities have assembled their stations and their production facilities from borrowed equipment, homemade components, off-the-shelf hardware, funded by community resources and hijacked from school and researcher's equipment budgets. It has been a small miracle of determination. Following the ABC shoot, the Department of Aboriginal Affairs finally promised $25,000 to Yuendumu and $12,000 to Ernabella from end-of-the-fiscal-year grab-bag funds.

Most of these people do not know that the Canadian government, when they put up a satellite system, spent tens of millions of dollars to equip a single indigenous group—the Inuit—to broadcast to their 40,000 remote population (about the same as the Aboriginal population of the Northern Territory) and now dedicates around $12 million a year as starting funds for community broadcasting and TV to their other indigenous groups, as well as $2 million annually to keep the Inuit Broadcasting Corporation going. This is the kind of investment civilized nations consider adequate for assuring that new communications technology respond to the needs of their native populations. Yuendumu has done what it has on the cheap. Nobody asks for or expects Australia to make this kind of investment in Aboriginal broadcasting in the fiscal climate of the mid-1980s. But money does get spent.

The ABC probably spent $40,000 producing this documentary about Yuendumu Television; several thousands more were spent sending up news crews to shoot stories about the station for *The National* and other programs. In all, the government spent considerably more in a few months keeping the Aborigines in front of the camera than they have been willing to invest on allowing them to be where they say they want to be, behind it.

In return, what did the Yuendumu videomakers get? It isn't yet clear. By the time the program is produced, it may well have lost its political bite; most of the critical decisions about policy and funding regarding Aborigines and AUSSAT should have been made by then. It's likely the community, for a change, will get to view the program in its proper context in the ABC lineup, for it is expected that by next year, Yuendumu will receive ABC television from AUSSAT, if the receiving dishes get designed, built, shipped, and repaired by then—some big "ifs." They can then applaud or denounce the program, but not much else. Excluded from collaboration or cooperation, their own expertise about their own culture and achievements denied them, Aborigines get locked into this dialectic: Yes or no. Film crews are not very welcome at Ayers Rock, outstations, and many Aboriginal sites. A few weeks after the ABC left, the Yuendumu people decided they didn't want Mike Willesee[4] here either. The press picks these things up and plays them as confrontations. The confrontation is the result of the ever narrower options the subject has in the production process.

Gianpaolo seemed to understand. But Bill was resolute. The ABC had its rules, and they'd already been stretched. Moreover, he felt they had a good program in the can. Maybe they could even find a way to break format and air it as a full (instead of a half) hour. This is presumably a great compliment from

the ABC. But no community review? Perhaps I'll write an article for the *National Times* about all this. That way, you can vet my article if we can vet your film.

Postscript

The Yuendumu program, titled "Fight Fire with Fire," went to air nationally as an *Open File* special on Wednesday, August 28 (1986), at 8:00 P.M., coinciding with the launch of the AUSSAT satellite. Warlpiri Media's hopes that a late 1985 or early 1986 air date would provide some space for further negotiation on post-production with the ABC were thus dashed. However, the earlier broadcast did mean that their testimony might enter into important current deliberations about funding, licensing, and law.

In fact, the ABC had planned to air it a week earlier, on Thursday, August 22, in what Bill Steller assured us was a "dream" time slot, between *The National* and Peacock's[5] speech replying to the Hawke budget. The community, with only days' advance notice, promptly consulted the Aboriginal Legal Aid Service in Alice Springs and determined that they had grounds for an injunction. They communicated this fact to ABC management, after having no success within the features department explaining their problems with the early air date.

The issue was community review. The program itself was all about "local control" and the reasons why unvetted material might violate and threaten traditional Aboriginal law regarding the showing of sacred material or images of the dead. As nobody at Yuendumu had seen the program, or knew exactly what ABC had taken away with them, nobody was assured that all the material was public, or that there were not scenes of people who had died in the month following the shooting. The media association conveyed their concern that the material be vetted and offered to fly a representative down to Sydney for this purpose. But the issue was bottom-line; the community would not approve the showing without first seeing the program.

For the ABC, of course, this was out of the question. As Lloyd-James pointed out, no such agreements had been legally contracted (despite the community's impression they had made their demands in this matter clear). The ABC simply couldn't consider having subjects vet their own material. This would compromise their editorial freedom, and no policy existed to identify traditional Aborigines as a special case. Indeed, no policy regarding Aboriginal traditions, or appropriate procedures for working in traditional communities, exist at the Corporation.

The legal case for Yuendumu was based on something quite

different; the inclusion in the program of the community's own tapes for which copyright had not been assigned. It was on this basis that legal action was threatened and the air date delayed. The community agreed to forgo copyright (or legal action) in return for vetting the program. Gianpaolo was flown up to Yuendumu, the community approved the program, and it went to air only a week later.

There is a story behind the story here too, of the urgent phone calls, the depositions with the lawyers, the details of Gianpaolo's visit, and so forth. Again, this never appears on the screen, and is inaccessible to the viewer.

In fact, the program isn't bad. Ideologically, it might even pass as "correct." The issues the community wanted to put forward do make it to the screen, though in that uniquely "illustrated radio" style that plagued *Open File*. The whole is narrated by an Aboriginal woman from Sydney whom nobody at Yuendumu of course knows. But this too is "correct" from a southern viewpoint. All in all, it is presumed that the experience should be judged a success because the product was mostly accurate, informative, and, within the production constraints and limitations of the ABC, respectful.

I don't share this opinion. If, in the end, this is a demonstration that the ABC elite can depict Aborigines better than Aborigines themselves, I count the exercise as a loss in precisely the battle that the program itself describes. All of the events that led up to the product had to be masked, disguised, kept off-camera, to produce the illusion of ABC competence and authority. I think there was great TV to be made here, but the ABC, valiantly defending its own prerogatives, settled for adequate.

The story may not be over even at this point. The ABC shot several hours of footage, only 30 minutes of which appear in the final film. Who owns the rest? Perhaps it will show up, months or years later, in some other program. (Some of the material used for this documentary was, in fact, shot for an earlier Aboriginal series and was pulled out for this one.) Perhaps the footage will be destroyed, and much valuable information will be lost. Lacking policy on these matters, the problems are apt to resurface again and again.

One thing the new satellite should do is force this accountability on the ABC. In the past, remote Aborigines had few opportunities to see how the national media depicted them. When AUSSAT brings TV to the outback, and when Telecom provides phones, it may not be quite so simple to get traditional Aborigines to serve as fodder for Australia's media mill.

v

Hollywood Iconography: A Warlpiri Reading

[1 9 8 7]

ISOLATED ABORIGINAL Australians in the Central Desert region, where traditional language and culture have survived a traumatic hundred-year contact period, began to view Hollywood videotapes in the early 1980s and are now beginning to receive television from the new national satellite, AUSSAT. This situation raises many issues for humanistic research, including questions about the ability of the traditional culture to survive this new electronic invasion. I spent three years living with Warlpiri Aborigines of the Yuendumu community undergoing this imposed transition, partly engaged in applied research and development leading to the birth of an indigenous community television station that challenged government policy and licensing. In the process, I noted what many other field-workers in nonliterate, Third World, and indigenous enclaves are recognizing: that electronic media have proved remarkably attractive and accessible to such people where often print and literacy have not.

We are used to selling literacy as a prosocial, prodevelopment medium. We are used to denigrating video and television as antisocial and repressive. In this essay[1] I want to examine these biases and their sources in an effort to see if our thinking on these matters can't be brought more in line with indigenous peoples' own capabilities and preferences, to lead to a perspective that might prove more helpful and less protectionist.

This is of theoretical interest as well, because we have come to

regard the Western world's media development sequence as somehow natural: from orality to literacy, print, film, and now electronics. But Aborigines and other "developing" peoples do not conform to this sequence, and produce some very different media histories. For philosophers and historians such as Ong, Innis, or even Lévi-Strauss, who posit special equivalencies between oral and electronic society, these ethnographic cases ought to prove especially revealing.

The Fallacy of Unilineal Evolution of Culture

Despite our best efforts, anthropologists have been unable to undo the racist damage of the unilineal theory of cultural evolution developed by our discipline's founding fathers. The Victorian passion to classify encouraged Edward Burnett Tylor and Lewis Henry Morgan, for example, to borrow from Darwinian biology a vulgar theory of evolution and apply it to the very different problem of cultural variation. This produced the idea that people too unlike the Victorian English represented less evolved stages in a single great chain of culture.

This thinking was then used to justify both a dismissal of the value of non-Western cultures and the evangelical urge to civilize heathens and savages. The *reductio ad absurdum* of the fallacy was realized by the 1940s in Nazi cosmology. By then, anthropology had well and truly repudiated the theory of unilinealism and had produced evidence of the authenticity and distinctness of cultural types. The theory of cultural relativism that replaced unilinealism now seems naive, but its basic tenet — that cultures do not arise in a single historical sequence — remains established in the canon of anthropological thought. This revision has not been conveyed to the popular mind, however, or even much to other disciplines. (The problem is a bit like Lamarckism in biology. Despite the evidence, and the theoretical incompatibility with accepted theory, the possibility of inheritance of acquired traits persists, even in biology textbooks that sometimes talk as if the giraffe got its long neck from stretching for leaves; certainly, almost everybody else talks this way.)

Evidence of the persistence of unilinealism is everywhere, from popular thinking about "primitives" (aided and abetted by the etymology of the very word), to Third World development agendas, to a remarkable variety of humanist scholarship. It matters not whether the value-loading is Rousseauesque romanticism, or native advancement, or simple garden variety racism. The point is that very few people believe what anthropology teaches: that indigenous, small-scale traditional societies are not earlier (or degenerate) versions of our own. They are rather differing solutions to historical circumstances and environmental partic-

ulars that testify to the breadth of human intellectual creativity and its capacity for symbolization.

In the case of Aboriginal Australians, it may be said that comparative isolation from the network of world cultures for perhaps 40,000 years encouraged a continuous cultural sequence such as is to be found nowhere else. By contrast, modern European culture is assumed to have recent points of disjuncture (the industrial revolution, the world wars, the electronic revolution), so that certain of our own cultural forms may prove only a few generations old. If Aborigines have had 40,000 years (or more) to elaborate a continuous cultural tradition, certainly there must be respects in which this degree of elaboration produces results of extraordinary value. We can hardly justify a claim that Europeans proved more sophisticated than the Aborigines, unless we take the technology and the will to subjugate as privileged measures of human values.

Unilinealism surely persists in our theories of media history. The idea that media are either signals or engines of cultural sequence is familiar at least since Innis and McLuhan. Both, in accounting for European media, simplify histories of development to a unilineal historical causality for the West. And both are guilty of generalizing from here to some universal evolutionary sequence, using "primitive" societies in curious and usually uninformed ways to illustrate their points. But the fault cannot be attributed to these scholars alone. The very commonest terms we use to distinguish our civilization from others — "historical" from "prehistorical" — are semantically loaded with precisely the same ammunition, and refer to writing as the pivotal event in this presumed sequence. It seems telling that when we searched for a new, nonpejorative term to describe the distinction that would contain contemporary nonwriting cultures as well as ancient ones in a class contrastive to our own, "literate" and "preliterate" gained the widest currency. Attempts to unbias the matter by substituting "nonliterate" never really caught on. And the descriptor "oral," itself mostly unexamined, became confused with "tribal," a word whose technical meaning is inappropriate for many of the groups so classified.

All these terms underscore Western society's perhaps Judeo-derived cultural emphasis on our own writing skills and reveal our opinion that people who can't write are backward. This very deeply rooted conceptualization is now being challenged as we move from writing to electronic coding as the central symbolizing system of our age. Marshall McLuhan (1962) looked for precedents and claimed that this new age would make us more akin to "preliterate," "tribal" societies. And whether the public read McLuhan or not, it began to panic, aware

that something was happening to our reliance on reading. Illiteracy rates appeared to be rising among our own young. The very fabric of culture and society was being sundered, and we risked degenerating into some new form of savagery.

One problem with this literate myopia has been that we haven't paid much attention to what other people do instead of writing, and how information is processed, stored, transmitted, shared, or received in its absence. This paper offers a reconsideration of the sequence of media history in a society that doesn't write, or at least has been believed not to.

Aboriginal Australian Media

Contemporary Aboriginal Australians have generally resisted several generations of concerted literacy teaching, first from Bible-toting missionaries and then from an "enlightened" school system. Wherever their traditional law, language, and culture are viable in Australia, literacy rates remain well below 25 percent, even when bilingual and special education services have been available. I believe this implies that there is something essential to cultural maintenance associated with *not* writing, which is yet to be understood. But in this same population, video recorders have appeared in the last few years, and during my three years of fieldwork I was able to observe the rapid adoption of electronic media by people who rejected print. This provides us with the intriguing but perhaps no longer so unusual situation of a people's moving rapidly from "oral" to electronic society, but bypassing print literacy. Attention to the particulars of both the traditional system and the accommodation to the imposed one offers insights into the limitations of our unexamined theories of unilineal media evolution.

Traditional Aboriginal society did not employ, and presumably did not discover, alphabetic writing. It is probably accurate to classify this culture as "oral," and elsewhere I have discussed at some length some of the nature and consequences of this central feature of the society (Michaels 1985). Yet Aborigines were not without resources for codifying experience and inscribing it in various media.

The Warlpiri people of the Yuendumu community with whom I worked are noted particularly for a rich graphic design tradition described to us at length by Nancy Munn (1970, 1973). This design system extends throughout the central region of Australia and across most of the Western Desert, although symbols and techniques vary in particulars from community to community. It appears that the northern coastal communities employed an appreciably different design system, which may correspond partly with the classification of many groups

in this area as comprising a language family distinct from most of the rest of the continent. Graphic systems in the southeast quadrant are apparently defunct, along with most of the languages, so that rock art and artifacts contain suggestive clues but probably are insufficient for reconstructing the system as a whole, compared with the opportunity to observe the system in full use, as among the Warlpiri. It will be difficult to generalize accurately from the Warlpiri example, but I suspect that the basic graphic system described for them will prove to apply fairly widely in general outline to many Aboriginal societies.

Warlpiri Graphics: A Traditional Medium

Warlpiri design is a form of inscription that operates quite differently from more familiar writings. It neither provides phonological symbols that combine to record speech (alphabets), or pictorial glyphs that denote specified objects or ideas (picto/ideographs). If anything, it poses a sort of mediation between the two. It does provide pictographic symbols that are recombined to express ideas and things, but unlike Oriental ideographic writing, and more like alphabets, it abstracts elements so combined and reduces them to comparatively few. Attempts to provide lexicons that associate the symbols with discrete words or even with broad semantic domains prove unsuccessful and ultimately misleading, as Munn seems to have discovered.

The system relies on a fairly discrete but polysemous inventory of graphic symbols: circles, dots, lines, semicircles (additional representational depictions of a specific tree leaf or animal body can be included — attempts by reviewers such as Dubinskas and Traweek [1984] to treat Munn's corpus as an exhaustive generative system are incorrect). These are combined in ground paintings (made of soils, ochres, feathers, flowers), body decoration (ochres, pipeclay, animal fats), utilitarian objects and weapons, and special ceremonial objects (boards, stones, sticks), as well as being painted and carved on caves and rock faces. In recent years, traditional designs have been translated to acrylics and applied to canvas, objects, and murals, and women have developed a batik technique. Most of my experience of Warlpiri graphics comes from assisting in the formative stages of this transition to modern media for sale to contemporary art markets.

The distinctive features of Warlpiri graphics are many: I want to focus on some of the features that contrast this system to contemporary writing systems. This is not the approach taken by Munn, or more recently by her critics. The grammatical structures and social-psychological functions of the design system for the Warlpiri that are discussed by these authors are accepted here as

evidence of the richness of that system, which can support various interpretations. Instead, I want to ask, as Havelock (1982) might: What kind of writing system is this? And I will conclude that it is as close to what we call writing (logo/ideographic or alphabetic) as you can get without compromising the authority of human speakers and interpreters — that is, it is a writing in the service of orality. Havelock would call Warlpiri graphics *solipsistic:* they record ideas rather than speech, are evocative rather than denotative, and do not assure a given reading. Unfortunately, such systems do not attract his attention except to remark that others have been most careless in their classification and attentions to such systems, a point well taken.

Some differences between Warlpiri graphics and other writing systems are immediately and visibly apparent. For example, both Western alphabets and pictographic writing systems arrange symbols in linear sequence and are biased toward surfaces, such as scrolls and book pages, which frame and support the cumulative string so produced. For Warlpiri, the relationship between the symbol and the surface is more creative. The painter-writer arranges the designs in a manner that relates them to the shape of the object, body, or ground contour on which they are applied. Perhaps this is why Warlpiri graphics get reviewed as art, not writing. But this attention to the inscription surface is appropriate because the contents typically inscribed are Dreaming stories, which are the myths accounting for the land, its objects, and its people. This is like bricolage in Lévi-Strauss's (1966) sense, where components enlisted in the service of an abstract recombinative system still retain their associations with their origins. Warlpiri graphics might be called a "meta-bricolage" because the inscribing media, the messages, and the surfaces to be inscribed are all meaningful bricolage elements of a dynamic intertextuality.

Another way to describe these graphic constructions is as maps. As stories of the landscape they are also images of that landscape. To this extent, spatial relationships of the symbols are constrained by a compositional and topographical system that the artist must respect. For a painting to be deemed a "proper law one," its elements must be in a correct proxemic arrangement. Scale and relationship are conventional, but obviously in terms quite distinct from Western linear writing.

The adage "the map is not the territory" may not prove accurate for the Warlpiri. Where the land, a rock face, or even a body is embellished, the result sometimes may be an articulation of actual or perceived features of the

thing itself. This is one area in which the transition to portable painted surfaces like canvas took some working out. Early acrylic paintings by traditional artists, for example, do not reduce large designs in scale to smaller surfaces. To achieve complexity in a painting, very large canvases had to be provided. Small canvases tended to depict what proved to be only small sections of large design complexes, like a single window in a computer spreadsheet. Only after some time and experience is an artist likely to scale down large designs to smaller, marketable surfaces.

Because the "icon," the inscription medium, and the surface are all meaningful semiotic elements to be considered in the reading of Warlpiri graphics, it begins to appear that the system contains too many functioning semiotic levels to achieve either the denotation of pictographs or the abstract creativity of alphabets. But there are more levels than this. Eight are listed by Dubinskas and Traweek. (The additional ones are sociolinguistic matters of the performance event in which the design is produced and used.) We have now a problem like the one Bateson (1972) considers exemplified by the croquet game in *Alice in Wonderland*: If the balls, the wickets, and the mallets are all independently motivated moving elements, the game is too unpredictable to play. It is therefore an organic system, not a mechanical one, he concludes. Writing, if it is to accomplish the functions it achieves in the Western world, must be a mechanical system, rulebound and predictable. Reading must become automatic, transparent, or, as Havelock says, "the purely passive instrument of the spoken word." The system must detach itself from its human author and operate more or less equivalently for all literate users. This is precisely what Warlpiri graphics do not attempt. Warlpiri designs remain attached to their authors, as their property, and to paint another's design may be regarded as theft of a particularly troublesome kind.

To call the owners of these designs their authors is not precisely correct, however. Warlpiri cosmology is staunchly conservative. It insists that truth preexists human apprehension. The creation and recreation of the world is an established eternal process; the stories, songs, dances, and designs that contain and explain these truths are likewise unchanging. What one paints or sings or dances is what your fathers and mothers and their fathers and mothers painted, danced, and sang before you (although one may acquire additional information about these truths through revelation or exchange). Your rights to do the same are determined by your position in an elaborately structured system of kin, itself handed down along with these expressive arts from the ancestors themselves.

In terms of what we know of cybernetic systems, this is impos-

sible, a prescription for total cultural entropy. To explain how novelty enters the system, so that it can respond to environmental circumstances and remain viable, we have to step outside the explanations the system offers us.

Ethnology takes this vantage point when it notes ways in which the system does respond to change. Hale (1984) has described how pedagogic events may permit creativity. Wild (1975) has discovered ethnomusicological equivalents. Morphy (1983) has described the public display of secret designs. Rose (1984) has documented a historical account of Captain Cook becoming a legend, and I have analyzed elsewhere elements of a history transforming to Dreaming construction in which videotape has become involved (Michaels and Kelly 1984). What we have not so readily pursued is how our own activity in inscribing these in literate print may prove subversive of these traditions.

It is precisely the point that Warlpiri graphics are a writing system that does not subvert the authority of living people, and does not permit the identification of historical change as Western literacy does. Warlpiri graphics oppose publication and public access. They do this partly by limiting denotation, operating instead as an evocative mnemonic, recalling stories without asserting any authorized text or privileged reading. They also do this by restricting access to both the production and viewing of designs. In the "sand stories" described by Munn, which are women's casual accounting of dreams, daily life, and folk tales, the public designs in this ephemeral, shifting medium are mostly illustrative and serve as entertainment and to introduce children to the system. In ritual, sacred and often secret designs are applied to bodies, objects, and the ground, and the rules governing the construction and viewing of these designs are highly constrained, and permit less creativity. Most of these designs are obliterated following the ritual performance. Kolig (1982) observes that the secret designs painted on bodies may remain dimly visible in camp for days afterwards, undecipherable to the uninitiated, but testimony to the existence of secret lore nonetheless. It would seem that the most secret designs, those inscribed on sacred boards (*tjuringa*) and rock faces are also the most permanent. They are tended, and rock paintings and boards are ritually renewed cyclically. These are the only permanent texts, and their locations are rigorously guarded. For uninitiated or otherwise inappropriate people to view these, even accidentally, is punishable by death. Other than these, Warlpiri graphics are mentally stored and sociologically guarded, and emerge only in ceremonial and storytelling performances.

These constraints on ownership and meaning become clear when, in the Yuendumu artists' association studio, we try to identify paintings in

preparation for sales. Usually, people refuse to provide the stories for any paint-
ings but their own, or sometimes for designs owned by their kin group. However,
understanding our relative naïveté and the economic incentive, sometimes when
the painter is out of the community another senior man or woman may try to pro-
vide a story for the painting. Remarkably, they sometimes fail, and more often
come up with a reading that proves to be at variance with the "correct" version
provided later by the painter.

For a full, "correct" version, a male painter will assemble other
senior men of his patrimoiety associated with the same or adjacent land as himself,
and negotiate the interpretation along with a set of men from the opposite patri-
moiety who maintain rights as "witnesses" or caretakers (*kurdungurlu*—see Nash
1982), but not performers or owners of the story.

Glenn (1963), in an insightful but overlooked note, provides an
explanation. Comparing Munn's early reports of Warlpiri iconography to "State
Department graphics," he suggests that Warlpiri symbols seem much like the
unique shorthand that translators and state department staff take of speeches dur-
ing top-level meetings. These provide a means of recall of speech texts to be tran-
scribed shortly after the event and prove quite accurate. But despite great similari-
ties in the symbols used, rarely could a reporter reconstruct a speech from
another's notes. Even the author might have difficulty as time elapsed. The differ-
ence between these idiolectic glyphs and Warlpiri symbols is partly in the collec-
tivity of the Warlpiri system, where shared meanings are emergent in the interpre-
tive negotiations that occur in graphic display events very much more than in the
text itself.

Munn described these iconographs as devices for mediating
symbolically between essential dualities expressed in Warlpiri cosmology, includ-
ing subject/object, individual/collectivity, and especially Dreaming Time / present
time. In the last instance, my analysis suggests there is more than a structuralist
abstraction operating here: this writing system functionally reconciles a conserva-
tive ideology, where things are always the same, with the contradictory lived evi-
dence of a changing world. If this proves true, then the changes imposed on Ab-
origines since European invasion must present the most fundamental challenge to
this system, and we begin to suspect that the dismal literacy rates represent more
than just a failure of effort or will on the part of teachers or students. The failure
of literacy might be seen as a resistance as well—not to change, but to a threat to
the culture's capacity to manage change.

Certainly, many senior people feel this way. They complain

about the school and about writing. They say it makes the kids "cheeky," so they don't listen to their elders. Especially interesting is the attitude of the middle-aged people who succeeded at the school in the 1950s and 1960s, before the bilingual program was established. They say that the bilingual program is holding up the kids, wasting their time with Warlpiri when they should be learning English, presumably as they did, usually by rote. (This contradicts all of the evaluation and testing evidence collected at Yuendumu, which demonstrates that English is being learned better and more quickly in the bilingual program.) Because this generation now operates in a uniquely powerful role in the community as spokespeople and leaders of the Council and other European-inspired institutions (and thereby commands and channels substantial resources), they have been capable of engineering a considerable political challenge to bilingual education. The fact is, they themselves usually cannot read Warlpiri. These community leaders often are themselves in an anomalous cultural situation, and probably take the brunt of "civilization"—ennui, alcoholism, corruption—harder than anyone else. But from a distance, what we observe is a classical Aboriginal situation: generations in competition with each other. What is new is that the resource that the society afforded the most senior people to control—intellectual property in the form of Dreaming Law—is now subverted by the intellectual property accessible to younger people, through the medium of literacy.

TV and Video

In the last few years, another medium of inscribing and accessing information has entered Warlpiri life: video and television. Within a year of the first VCR coming to Yuendumu (and sufficient tape-rental services opening in Alice Springs to support these), videotape penetration was effectively total in the community. Only nine VCRs were reported in Aboriginal camps in 1983, for a population of 1,000, but these meant that essentially every extended family had access to at least one machine and could view in appropriate groupings, respecting avoidance restrictions and other traditional constraints on congregating. (When similar contents were screened as films at the school or church 25 years earlier, mass viewing required violations of traditional avoidance and association rules, which produced considerable stress and often ended in chaos or fighting. This hardly encouraged the acquisition of cinema literacy.)

My Aboriginal associate and I (Michaels and Japanangka 1984) surveyed the situation and discovered, among other things, that it was costing at least $5,000 annually to maintain a VCR here, which exceeded annual per capita

income. The difficulties of equipment purchase, maintenance, and program supply in desert camps 300 km. along a mostly dirt road from the nearest repair or tape-rental shop proved enormous. Indeed, we found communities without electricity where ingenious generator installations were rigged up for the first time, not for lights or heat but to play video. By the summer of 1985, the glow of the cathode ray tube had replaced the glow of the campfire in many remote Aboriginal settlements. There could be no question of motivation. Of all the introduced Western technologies, only rifles and four-wheel-drive Toyotas had achieved such acceptance.

The situation was reported with predictable alarm by the press, but also by Aborigines themselves (noting no contradiction in the fact that many of the most articulate objectors were themselves video-watchers/owners). People were predicting "culturecide" and claimed that Aborigines appeared helpless to resist this new invasion. The analogy to alcohol was quickly made, and the received wisdom was that the electronic damage was already done, the pristine culture ruined, and so forth. These "facts" were used with great ingenuity to support a wide and contradictory array of agendas, schemes, and proposals, none, as far as I could tell, having much to do with the actual situation.

During this time I was watching Aborigines view video and watching them make video. It became quite clear that here was a situation where the bankruptcy of the "effects" fallacy was amply demonstrated. From my observations, a very different "uses and gratifications" picture emerged than the passive victimization of Aboriginal audiences suggested by the alarmists.

One kind of insight was available by asking my associates what any given videotape was "about," in the most usual, conversational way. This produced what were to me quite extraordinary readings of Hollywood programs I thought I was already familiar with. Additional evidence came from school children and creative writing exercises. Another kind of evidence came from assisting in the production of indigenous Warlpiri video programs along the lines of Worth and Adair's (1973) studies of Navajo filmmaking, and analyzing both production style and product (see Michaels and Kelly 1984). The evidence from these two sources proved complementary and permitted the beginnings of a theory of Aboriginal interpretation of imported television. Here, I will summarize some of the elements of this theory, which I have treated more fully elsewhere (Michaels 1987g).

The most suggestive finding was that Aboriginal people were unfamiliar with the conventions, genres, and epistemology of Western narrative

fiction. They were unable to evaluate the truth value of Hollywood cinema, to distinguish, for example, documentary from romance. This may be because all Warlpiri stories are true, and the inscription and interpretation processes that assure their preservation also ensure their truthfulness (or at least engineer a consensus on what is true at each re-creation, which amounts to the same thing). Thus I was observing the impact of fiction on Aborigines much more than the impact of television per se.

Comparisons between Warlpiri story form and imported video fictions demonstrated that in many instances, content (what is supplied in the narrative) and context (what must be assumed) are so different from one system to the other that they might be said to be reversed. For example, Warlpiri narrative will provide detailed kinship relationships between all characters as well as establishing a kinship domain for each. When Hollywood videos fail to say where Rocky's grandmother is, or who's taking care of his sister-in-law, Warlpiri viewers discuss the matter and need to fill in what for them is missing content. By contrast, personal motivation is unusual in Aboriginal story; characters do things because the class (kin, animal, plant) of which they are members is known to behave this way. This produces interesting indigenous theories, for example, of national character to explain behavior in *Midnight Express* or *The A-Team*. But it is equally interesting that it tends to ignore narrative exposition and character development, focusing instead on dramatic action (as do Aboriginal stories themselves).

Violence, for instance, described by some as TV's cheap industrial ingredient overlaid on narratives mainly to bring viewers' attention to the screen for ultimately commercial purposes, is for Aboriginal viewers the core of the story. The motivation and character exposition that the European viewer is expected to know, to explain why someone was mugged or robbed or blown up, is missing. It is more likely in Aboriginal accounts to be supplied by what we would consider supernatural reasons, consistent with the reasons misfortunes befall people in Aboriginal cosmology.

These brief examples should make it clear that it will be very difficult to predict the effects of particular television contents on traditional Aboriginal audiences without a well-developed theory of interpretation. To advance a theory of interpretation, it may be helpful to consider now what kind of writing system television is that makes it so accessible and attractive to these people whose traditional preference was for writing systems of the sort explained above. An analysis of the videotapes the Warlpiri made themselves provides some insight.

Warlpiri videotape is at first disappointing to the European

observer. It seems unbearably slow, involving long landscape pans and still takes that seem semantically empty. Much of what appears on screen, for better or worse, might easily be attributed to naive filmmaking. Finally, the entire corpus of 300 hours of tape shot at Yuendumu is all documentary-type "direct cinema." The only exceptions, when events were constructed and people performed expressly for the camera, were the result of my intervention for experimental purposes.

Yet Warlpiri audiences view these tapes with great attention and emotion, often repeatedly, beyond what could be expected from a fascination with "home movies." If this is attributable to novelty, it has yet to wear off in the three years I've been involved. In fact, the limits to some tapes' lifespan are the limits of the lifespan of the characters. A mortuary rule prohibiting the mention of the names of dead people now applies as well to their recorded images, which means that when a tape contains pictures of someone deceased, that tape is no longer shown.

Producers and viewers will describe the tape, its purposes and meanings, in ways not immediately apparent from the recorded images themselves. For example, proper videotape production for a particular story may require the presence of several families including many people. But not only do most of these people not appear on the tape, but a proportion of them (related to the on-screen "owner" of the story through the mother's patrilineage) must not appear on screen. They may, however, operate the camera. This is consistent with equivalent rules in ceremonial performance. But what attracts our attention is that everybody seems to know how that tape was made and whether these rules were observed, and therefore if the tape is a "proper" and "true" story, without any apparent evidence on the tape itself. Similarly, what are to the European observer semantically empty landscape pans are explained by Aboriginal producers and viewers as full of meaning. The camera in fact traces "tracks" or locations where ancestors, spirits, or historical characters traveled. The apparently empty shot is quite full of life and history to the Aboriginal eye. The electronic inscription process may be said to be operating for the Warlpiri in a way not unlike their graphic system, providing mnemonic, evocative symbols amenable to interpretation and historical accuracy when viewed in the proper social and cultural context.

Video-viewing is a very active interpretive social event, particularly in groups, made possible by private ownership of VCRs. In fact, ownership of VCRs is not quite private in the European sense, and our early survey determined that these machines were corporate purchases and circulated along traditional exchange/obligation routes, usually within families. This means that viewing

groups, as described above, are appropriate assemblages of kin, and provide a suitable setting for events of social interpretation, not unlike what was described for Warlpiri artists explaining their paintings. One interesting difference between groups viewing Warlpiri productions and those viewing European ones is the placement of the elders. With the former, elders sit toward the front, turned half around to interpret to the younger people. With Hollywood videos, the children sit in front, often interpreting and explaining to their elders.

Conclusions

Warlpiri Aborigines have perhaps discovered some comfortable analogies between their experience of video production and viewing and their own traditional graphic system. For Warlpiri viewers, Hollywood videos do not prove to be complete, authoritative texts. Rather, they are very partial accounts requiring a good deal of interpretive activity on the part of viewers to supply contents as well as contexts with which to make these stories meaningful. When home video made it possible for Warlpiri to control the place and membership of viewing groups, it became possible to assemble the small, interpretive communities that are associated with other performances in which stories are told and their associated graphics displayed. At this point, video-viewing became a most popular and persuasive camp activity.

By contrast, reading and literature did not. While this article has not expanded a theory of literacy except by contrast to Warlpiri graphics, a historical point is worth making. Current literary criticism now questions the notion that there are correct or even privileged readings of literary texts; reader-centered criticism claims that readers will make diverse interpretations. But the Warlpiri were introduced to literature through that most privileged of texts, the Christian Bible, by missionaries who took the Calvinist position that every word therein had one and only one "commonsense" meaning. Thus literature may well be associated by Aborigines with a dogmatism, a certitude, a sense of revealed and inscribed truth that would prove subversive of their own Dreaming history and law. That history and law required a different mode of writing to maintain the continuity of its authority.

The evidence from Warlpiri graphics and Warlpiri video proves useful to the reexamination of the "oral/electronic" analogy proposed by my media historians. It would be important in this reexamination to note first that some "oral" societies, for example the Warlpiri, do have writing of a particular sort: a writing subservient to, and in the service of, oral performance and living authori-

ties. The writings that became the source of Western literacy are distinguished functionally from "oral writing" in that they subverted and replaced orality as the interpreting mode of symbolization for society.

We may now question whether written texts are in fact so authoritative as we have been used to considering them. But we raise this question at a time when another inscription system competes for centrality in our information processing and imaginative symbolizing: electronics. It seems particularly interesting that this new inscription process is proving more accessible, and perhaps less culturally subversive, to people in those remaining enclaves of oral tradition. The most useful first question to ask may be: "What about their writing systems is like electronic writing?", rather than "How is their society like ours?"

At least one result of this kind of inquiry is to suggest some useful considerations for dealing with commercial video narratives and emergent television genres. Although historically the sources for plot and character are found in earlier novel and literary forms, Warlpiri viewers, and perhaps now many others, put video fictions to quite different uses and make quite different sense of them. What Warlpiri viewers require is a good deal of visual and visceral action, a rich familial and kinship context, and a means of combining these into a classificatory universe whose truth is partly in the structures they can produce with these elements and partly in the opportunities the texts provide for negotiation and social discourse. As Western television develops its own conventions, themes, and genres, reaching out for the vastest pancultural (or acultural) mass audiences, it is clearly offering more of these kinds of materials to its viewers. To the horror of literacy-biased critics, it is stripping away cultural denotation, culture-specific motivations and psychologies, and their place in character development. Its commitment to "inscribed truth" is gone. Indeed, we might seem to be realizing Lévi-Strauss's prophecy:

This universe made up of meanings no longer appears to us as a retrospective witness of a time when: "... le ciel sur la terre marchait et respirait dans un peuple de dieux," and which the poet evokes only for the purpose [of asking] whether it is to be regretted. This time is now restored to us, thanks to the discovery of a universe of information where the laws of savage thought reign once more: "heaven" too, "walking on earth" among a population of transmitters and receivers whose messages, while in transmission, constitute objects of the physical world and can be grasped from without and within. [2]

That video now proves acceptable and accessible in a way that alphabetic literature did not could prove to be partly a transitional feature of Ab-

origines' recent encounter with the medium. Warlpiri-produced video may preserve these features, if its unique properties are recognized and encouraged (a difficult proposition when overzealous "professional" trainers intercede, and media institutions force competition between indigenous and imported programs). It is likely that Warlpiri people will develop greater sophistication in European genres and the interpretation of imported narrative fiction that will bring them closer to European readings. In so doing, it may be that the "gaps" I have identified will fill up, and the medium will become more denotative and less evocative and, finally, less Warlpiri.

It could prove promising that the most popular genres appear to be action/adventure, soaps, musicals, and slapstick. Whatever our educated palates may think of these forms, they have advantages in the context of this analysis. As the least character-motivated, most formulaic fictions, they may encourage active interpretation and cross-culturally varied readings. The trend in popular TV and international video marketing continues to be in favor of those entertainments in which universal familial relationships are highlighted, action is dominant, and culture-specific references are either minimal or unnecessary for the viewer's enjoyment. From this perspective, it would seem difficult to see in the introduction of imported video and television programs the destruction of Aboriginal culture. Such a claim can only be made in ignorance of the strong traditions and preferences in graphics, the selectivity of media and contents, and the strength of interpretation of the Warlpiri. Such ignorance arises best in unilineal evolutionism.

VI

For a Cultural Future: Francis Jupurrurla Makes TV at Yuendumu

[1 9 8 7]

ON APRIL 1, 1985, daily television transmissions began from the studios of the Warlpiri Media Association at the Yuendumu community on the edge of Central Australia's Tanami Desert. Television signals, when broadcast as radio waves, assure a kind of mute immortality: they radiate endlessly beyond their site of creation, so this first program might be playing right now to the rings of Saturn. But it no longer exists at its point of origin in Australia. The message, the events behind it, their circumstances and meanings, have mostly been ignored and are likely to be forgotten. That is why I recall such events here: to reassert their significance and to establish in print their remarkable history.

All content the Warlpiri Media Association transmits is locally produced. Almost all of it is in the Warlpiri Aboriginal language. Some is live: school children reading their assignments, community announcements, old men telling stories, young blokes acting cheeky. The station also draws on a videotape library of several hundred hours of material that has been produced in the community since 1982 (a description of this material and the conditions of its production is one of the main purposes of this essay). Yuendumu's four-hour schedule was, by percentage, and perhaps in absolute hours, in excess of the Australian content of any other Australian television station. The transmissions were unauthorized, unfunded, noncommercial, and illegal. There were no provisions within the Australian broadcasting laws for this kind of service.

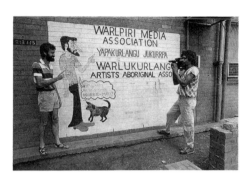

Peter Toyne and Francis Jupurrurla Kelly at the WMA.

Yuendumu Television was probably Australia's first public television service, although it might be misleading to make too much of this. *Open Channel* sponsored experimental community-access TV transmissions in Melbourne for a few days during 1982. The Ernabella Aboriginal community had been experimenting along similar lines since 1984, and began their own daily service days after Yuendumu started theirs. Even before, throughout remote Australia, small transmitters had been pirated so that mining camps and cattle stations could watch kung fu and action/adventure videos instead of approved and licensed ABC "high culture" satellite feed, which became available to outback communities in 1984–85. Issues of community access and local transmission had been on the agenda certainly since the Whitlam government, but they had lain dormant in Fraser's and then Hawke's official broadcasting agendas. In the 1980s, inexpensive home video systems proved subversive of the bureaucracy's tedious intents, while satellite penetration and sustained interest in production by independents had all kept issues of public television very much alive in the public arena.

Yuendumu's accomplishment must be seen in the context of these developments. Yuendumu's need and motivation to broadcast should also be considered in evaluating any claim to the accolade of pioneer. There was, in the early 1980s, a considerable creative interest among Aborigines in the new entertainment technology becoming available to remote communities. There was equally a motivated, articulate, and general concern, especially among senior Aborigines and local indigenous educators, about the possible unwanted consequences of television. In particular, the absence of local Aboriginal languages from any proposed service was a major issue. Without traditional language, how could any media service be anything but culturally subversive? Native speakers of indige-

nous languages understood (a good deal better than anyone else) that this was something only they could correct.

There are more than 22 Aboriginal languages currently spoken in the Central Australian satellite footprint.[1] The simple logistics of providing for all these languages on a single service clearly indicates a fundamental mismatch. The bias of mass broadcasting is concentration and unification; the bias of Aboriginal culture is diversity and autonomy. Electronic media are everywhere; Aboriginal culture is local and land-based. Only local communities can express and maintain linguistic autonomy. No one elsewhere can do this for the local community—not anyone in Canberra, Sydney, or even Alice Springs. Indeed, Warlpiri speakers at Yuendumu make much of the distinctions between their dialect and the one spoken by the Lajamanu Warlpiri, 600 km. away on the other side of the Tanami Desert. These differences are proper, for they articulate a characteristic cultural diversity. The problem of language signals a more general problem of social diversity that introduced media pose for indigenous peoples everywhere: how to respond to the insistent pressure toward standardization, the homogenizing tendencies of contemporary world culture?

Postmodernist critique provides very little guidance here. Indeed, the temptation to promote Warlpiri media by demonstrating a privileged authenticity—the appeal to traditionalism that legitimates these forms—would be firmly resisted. How can we even employ such terms? "Authentic" and "inauthentic" are now merely labels assigned and reassigned as manipulable moves in a recombinatory game. Postmodernism may promote an appetite for primitive provenances, but it has proven to be an ultraconsumerist appetite, using up the object to the point of exhaustion, of "sophistication," so as to risk making it disappear entirely. It would be better to shift ontologies, by problematizing the very term "originality" and denying that any appeals to this category can be legitimated. Then, we refuse degrees of difference or value that might distinguish between the expressive acts (or even the persons) of Warlpiri videomakers, urban Koori artists in Fitzroy, Aboriginal arts bureaucrats in Canberra, a Black commercial media industry in Alice Springs—none of these could be called more truly "Aboriginal" than any other. This redirects the mode of analysis to a different if somewhat more fashionable inquiry: Who asks such a question, under what circumstances, and so on? An analysis of the history of the official constitution of Aboriginality, as well as its *mise en discours*, its rhetorical and institutional deployment, might explain, for instance, current moves toward pan-Aboriginalism. It can provide at least a much-

needed caveat to the banal and profoundly racist war that is being waged in this country.

Despite the importance of subjecting Aboriginal expression to these critical debates, there is a danger that they lead away from the specific pleasures to be found in an encounter with the Warlpiri and their video. And it is these pleasures I want to describe, indeed to promote as something more than the product of my own research interests—even if this risks reasserting authenticity, with an almost naive empiricist's faith, and employing a positivist's notebook to amass the particulars necessary to bring these "alien" texts into focus. What I am seeking also is a way to test critical theory's application to ethnographic subjects. It is possible that such an investigation will supersede the dilemmas that tradition, ethnicity, and value have variously posed for empiricism.

Of course, to understand what happened with media at Yuendumu—and what didn't happen—one needs to describe more than just local circumstances. It will be necessary to reference the state and its interventions again and again. Warlpiri media, no less than its history, is the product of a struggle between official and unofficial discourses that seem always stacked in the state's favor. This might suggest a discouraging future for Yuendumu Television. Given the government's present policy of promoting media centralization and homogenization, we would expect that Yuendumu will soon be overwhelmed by national media services, including "approved" regional Aboriginal broadcasters who serve the state's objectives of ethnicization, standardization, even Aboriginalization, at the expense of local language, representation, and autonomy. If this scenario is realized, then Yuendumu's community station seems likely to join the detritus of other development projects that litter the contemporary Aboriginal landscape, and shocked Europeans will take this as one more example of Aboriginal intractability and failure of effort—if not genes. We won't know that the experience of television for remote Aborigines could have been any different: for example, a networked cooperative of autonomous community stations resisting hegemony and homogenization. Instead, we expect Warlpiri TV to disappear as no more than a footnote to Australian media history, leaving unremarked its singular contribution to a public media and its capacity to articulate alternative—unofficial—Aboriginalities.

But something in Warlpiri reckoning confounds their institutionalization and the grim prophecy this conveys. A similar logic predicted the disappearance of their people and culture generations ago, but proved false. A mirac-

ulous autonomy, an almost fierce stubbornness, delivers the Warlpiri from these overwhelming odds and assumes their survival, if not their eventual victory.

How Warlpiri People Make Television

Videomaker Francis Kelly does not like to be called by name. He prefers I call him "Jupurrurla." This is a "skin" or subsection term that identifies him as a member of one of eight divisions of the Warlpiri people, sometimes called totemic groups by anthropologists.[2] Better yet, I should call him *panji*, a Kriol word for brother-in-law. The term is a relative one, in both senses. It does not merely classify our identities, but describes our relatedness. It is through such identities and relationships that cultural expression arises for Warlpiri people, and the description of these must precede any discussion of Aboriginal creativity.

Warlpiri people are born to their skins, a matter determined by parentage, a result of marriage and birth. But I became a Japanangka—brother-in-law to Jupurrurla—by assignment of the Yuendumu Community Council. One result of my classification is that it enables Francis and me to use this term to position our relationship in respect to the broader Warlpiri community. It establishes that we are not merely two independent individuals, free to recreate ourselves and our obligations at each social occasion. Rather, we are persons whose individuality is created and defined by a preexisting order. In this case, being brothers-in-law means that we should maintain an amiable, cooperative reciprocity. We can joke, but only in certain ways and not others. We should give things to each other. My "sisters" will become wives for Jupurrurla; I might take his "sisters" for wives in return.

These distinctions refer to a symbolic divisioning of the community into "two sides" engaged in reciprocal obligations. But it implies also a division of expressive (e.g., ceremonial) labor, and particular relations of ritual production reaching into all Warlpiri social life and action. For certain ceremonies this division is articulated as roles the Warlpiri name *Kirda* and *Kurdungurlu*, two classes that share responsibility for ritual display: one to perform, the other to stage-manage and witness. The roles are situational and invertible, so identification as Kirda "boss" and Kurdungurlu "helper" may alter from event to event. As "brothers-in-law," Jupurrurla and I will always find ourselves on different sides of this opposition, although the roles themselves may reverse from setting to setting. This seesaw balancing act that shifts roles back and forth over time affected all our collaborations.

Warlpiri brothers-in-law can also trace their relationships and their obligations more circuitously through mothers and grandparents. This describes a quite complex round of kin, which eventually encompasses the entire Warlpiri "nation" of over 5,000 people. It can even go beyond this, identifying marriages and ceremonial ties that relate to corresponding skin groups among Pitjantjatjara people to the south, Pintupi to the west, and Arrente, Anmatjarra, Kaitij, Warrumungu, and others to the north and east. Thus a potentially vast social matrix is interpolated with every greeting.

I introduce the reader to Jupurrurla to promote a consideration of his art: videotaped works of Warlpiri life transmitted at the Yuendumu television station in this desert community 300 km. northwest of Alice Springs. But it is not quite correct to identify Jupurrurla as the author of these tapes, to assign him personal responsibility for beginning video production at Yuendumu, or for founding the Warlpiri Media Association, although these are the functions he symbolizes for us here.

In fact, the first videomaker at the Yuendumu community was Jupurrurla's actual brother-in-law, a Japanangka. It was Japanangka who was already videotaping local sporting events when I first came to Central Australia early in 1983. It was Japanangka who responded to the prospect of satellite television by saying "We can fight fire with fire," making reference to the traditional Warlpiri ritual, the fire ceremony or Warlukurlangu, and assigning this name to their artists association. But Japanangka, for all his talent and rage, found the mantle of "boss" for the video too onerous—for to be a boss is to be obligated. During 1983–84, a sensitive series of negotiations transferred the authority for Yuendumu video to Jupurrurla. Part of Jupurrurla's success in this role resulted from his cleverness in distributing the resources associated with the video project. He trained and then shared the work with a Japaljarri, another Japanangka, a Japangardi, and a Jangala. Eventually, all the male subsections had video access through at least one of their members.

Obviously, the identification of an individual artist as the subject for critical attention is problematized where personhood is reckoned in this fashion. Rather than gloss over this issue, or treat it romantically within a fantasy of primitive collectivity, I want to assert more precisely its centrality for any discussion of Warlpiri expression. And I want to use this example to signal other differences between Aboriginal and European creative practices, differences that must be admitted and understood if the distinctiveness and contribution of

Warlpiri creativity is to be evaluated critically in a contemporary climate — the goal of this essay.[3] These differences include what may be unfamiliar to readers:

ideological sources and access to inspiration;

cultural constraints on invention and imagination;

epistemological bases for representation and actuality;

indistinctness of boundaries between authorship and oeuvre;

restrictions on who makes or views expressive acts.

By describing these, I hope to avert some likely consequences of European enthusiasm for Aboriginal media that results in the appropriation of such forms to construct a generic "primitive" only to illustrate modern (and, more recently, postmodern) fantasies of evolutionary sequences. In a practical sense, I also want to subvert the bureaucratization of these forms, such as may be expressed in the training programs, funding guidelines, or development projects that claim to advance Aborigines, but always impose standards alien to the art (because these will be alien to the culture producing it). Wherever Australian officialdom appropriates a population, as it has attempted to do with the Aborigines, it quickly bureaucratizes such relationships in the name of social welfare. This assuredly defeats the emergence of these sovereign forms of expression, as it would defeat Jupurrurla's own avowed objective to create Yapa — that is, truly Warlpiri — media.

Those European art practices following on the Renaissance and industrial revolution that constitute the artist as an independent inventor/producer of original products for the consumption/use of public audiences do not apply to the Aboriginal tradition. This has been said before, in more or less accurate ways, and has led to some questions (misplaced, I think) about the "authenticity" of "traditional" Aboriginal designs, such as those painted in acrylics and now made available to the international art market (Loveday and Cook 1983). In the case of Jupurrurla's art, the implicit question of authenticity becomes explicit: Jupurrurla, in Bob Marley T-shirt and Adidas runners, armed with his video portapak, resists identification as a savage updating some archaic technology to produce curiosities of primitive tradition for the jaded modern gaze. Jupurrurla is indisputably a sophisticated cultural broker who employs videotape and

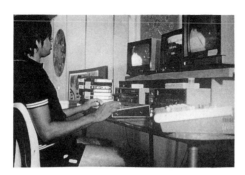

Jupurrurla editing. Photo by Eric Michaels.

electronic technology to express and resolve political, theological, and aesthetic contradictions that arise in uniquely contemporary circumstances. This will be demonstrated in the case of two videotapes that the Warlpiri Media Association has produced: "Coniston Story" and "Warlukurlangu (Fire Ceremony)."

The choice of these two out of a corpus of hundreds of hours of tape was a difficult one. Not even included is Jupurrurla's most cherished production, "Trip to Lapi-Lapi," the record of a long trip into the Western Desert to reopen country people had not seen for decades, a tape that often causes its audiences to weep openly. Also excluded are the politically explicit tapes, those documenting confrontations with government officials that became important elements in Warlpiri negotiating strategies: these tapes cause people to shout, to address the screen, and then each other, sometimes provoking direct action. But my purpose in this monograph is not to survey the whole of the work, the various emergent genres, or the remarkable bush networks that arose to carry these tapes when official channels such as the new satellite were closed (Michaels 1986). My choice of tapes was made because they illustrate best some things about the Warlpiri mode of video production: how Jupurrurla and others discovered ways to fit the new technology to their particular information-based culture. The only way of beginning such an analysis is by locating the sources of Warlpiri expression in an oral tradition.

Jukurrpa: The Law

Two domains take precedence in Warlpiri thought: kin and landscape. People are continually positioning themselves in both social and geographic space. As might be expected, the ontological interactions between social spaces of kin and physical geographies of land are themselves matters that must be mediated. The

metaphoric and metonymic relations of kin and land are most dramatically expressed in ceremonial events, where performances materially enact and renew these associations. The ideological site in which these mediations arise (and which authorizes performance) comprises a body of tradition called *Jukurrpa* in Warlpiri. Early anthropologists translated this as the "Dreamtime" and placed it in a mythological past. Stanner (1959) revised the translation to "The Dreaming," which underscores the processual and expunges the error of evolutionary sequence. But the translation still can mislead; "The Dreaming" has been appropriated to describe a cultural product (and to sign a commodity) that seems to me very much an invention of Western imagination.

Warlpiri Aborigines are more likely to translate Jukurrpa in most contexts as simply "the Law." This emphasizes the binding power and the contemporary force of this body of knowledge. They distinguish themselves from more Europeanized Aborigines not by racist notions such as "half-caste" or "yeller-feller" but by concerns of law: "Those people lost their law," they say of more assimilated Aborigines. And they may acknowledge another community's success in cultural survival as due to their "having strong law there."

The ideology of the Law invokes continuity and masks change. The Law always was, is, and will be, a chronotope that interpenetrates the mundane space/time it generates, but differs from it. The stories and designs and dances that express it preexist human apprehension, a cosmology approximated by Platonist essentialism in the West. The way this system assures social reproduction involves rigorous divisions in the labors of knowledge and expression—quite unlike the fictitious primitive information collective on which McLuhan modeled his global village. This Law, in its characteristic story forms, is differentially distributed across the population. Age, gender, kinship category, and "country" determine who might have access to which aspects of the knowledge, which parts of songs, what designs or dance steps. "Country," a critical qualification for access to knowledge, is reckoned in terms of place of conception/birth, death (of ascendants), and residence. One speaks for, and from, one's own particular place. This means that each individual Aborigine will be entitled to distinctive portions of, and perspectives on, the Law. No one will have total access, or privileged authority.

Superficially, this might seem to be an entirely egocentric identification. But social accounting (ceremony, storytelling, decision-making) requires assemblages of kin to constitute the Law. Stories "reach over the hill" to the next episode and to the next person. A long story, a full myth, a major decision, requires many people, enmeshes many communities, in its enactment.

The stories that recount the Law tell of the actions of certain beings, and how they create and recreate the landscape, its resources and natural forces. The places articulated by, and which articulate, these mythic actions may be identified as "special sites," and the knowledge of these obligates the people of that country to perform certain actions there to renew (reproduce) the Law and assure the maintenance of both social and natural orders—indeed, of the complex linkages between them. This cosmic law is emergent in any given site for a Warlpiri adult. As people pass, through creek beds, over hills—once on foot, now by truck—they sing the songs and tell the stories and figure the designs that invoke the local portion of the Law. Just as people are positioned in a complex web of kinship that can be traced extensively to encompass distant communities, stories are positioned in the extensive landscape, ultimately girding the continent.

The conditions in which a story can be altered or a new story invented are highly regulated, as might be expected wherever an ideology of continuity is promoted in oral tradition. This conservatism can be illustrated by analogy to social practices, such as marriage. To elaborate this example, if a man does not marry into the proper subsection, his children will be ambiguously categorized, requiring some recalculation and reassignment to bring the system back into line. A wrong marriage resonates throughout many communities, and too many wrong marriages could exhaust the system's capacity for homeostasis. In the past, "wrong-marrieds" might flee to the distant bush, or be killed; today, they move to the city.

Similarly, a new or invented story threatens the web of narrative that supports the Law. New stories are most often explained as variants, as missing parts—forgotten, now rediscovered—of known accounts. Inventing too many stories threatens the system as a whole, and is resisted. Desert Aborigines have no category of fiction (although there is a rich tradition of parody). There may be no genre that admits unambiguously of authorship. Instead, every story is owned, identified with specific individuals who are responsible for its authenticity and transmission. At most, one can claim revelation, but not authorial intent.

The problem that video and television posed for Japanangka, and then Jupurrurla, was how to discover means of bringing this new medium "inside the Law." Unless this could be accomplished and demonstrated, the medium, its contents and consequences, necessarily would result in threats to that Law, and it would work against cultural survival. Certainly the fearful, unknown consequences of becoming audience to a machine that churns out an unprecedented stream of alien fiction motivated such a response. To understand Warlpiri

video and its challenge to imported TV, one must appreciate this sense of Jukurrpa as a model of social reproduction—the management of information transmission across generations—and identify the ways in which novelty must be counterinterpolated to the system. But when taking this perspective, simply identifying an expressive act as an artwork can become a problem. The boundaries of performance event and artwork become blurred. Art or video objects become difficult to isolate for analysis because the producers' intent is itself the opposite. Warlpiri artists demonstrate their own invisibility in order to assert the work's authority and continuity with tradition. They do not draw attention to themselves or to their creativity.

Restricted Expressions

Aside from the specific conditions of ownership and access based on country and kin, there are at least two more general means of channeling information flows through time and across space that give Warlpiri orality its character. The divisioning of Jukurrpa into secret or public domains partitions information and restricts access. There are certain things that can only ever be known by members of one gender or another, learned in proper sequence through ritual initiation. Young people may know very little, and even adults may be unknowledgeable if they have been lazy at ritual work, and so have not advanced far in these sequences. If someone unauthorized to do so demonstrates knowledge of such restricted lore publicly, they will be punished, even killed. The determination of secrecy is not absolute, however; it is negotiable and local. Public displays may have secret underpinnings, and the proper authorities must determine what can be revealed at each time and place. In this way, Warlpiri law restricts the movement of information through social and geographic space, encouraging it to accrue value to itself. Consequently, secret knowledge can become the most valued item of exchange in Warlpiri economy. People who compromise this system today are still scorned for "selling their law."

While secrecy regulates information flows across space, complex mortuary restrictions regulate information reproduction through time. When a person dies, all material association with the deceased is destroyed; people relocate away from the camp and burn the individual's possessions. But intellectual property is also obscured. The person's name is no longer uttered, all words sounding like the name are replaced, and even songs and stories associated with that person may be forbidden.

Recording/inscribing media and mass distribution directly

contradict oral systems. Video, but also writing, print, photography, film, and sound recording preserve information through time and favor its dissemination through space. Both secrecy and mortuary rules are subverted by the bias of mass media. The local negotiations that assure authority, autonomy, and social reproduction of Warlpiri law are likewise compromised by modern inscriptive practices. One cannot guarantee that a design public in one place will not be secret in the next. It is safe to assume that in a very few years any videotape archive will contain many forbidden images of, and references to, the dead. How are these problems to be solved? That is the issue that faced Jupurrurla in inventing Aboriginal television, and that also faces me in writing about it, if this essay is not to subvert its own objectives.

Each of the videotapes I wish to discuss in order to demonstrate Jupurrurla's solutions to the problems posed by recording now contains restricted sections — mostly from deaths, but also through reconsideration of the publicness of some recorded images. One could choose other tapes that, as of this writing, do not contain such problems. But that would miss the point, which is precisely that inscription will in time always produce this result for oral traditions.

Certain conventions are arising to handle these problems. In an old and valued photograph of a champion football team, several of the young men pictured have tragically since died. Today their faces are obscured by ink, or "whited out," so that the picture can still be displayed. In reviewing an old film of the fire ceremony, which people wished to use as a mnemonic to revive the ritual twenty years later, an audience of senior owners of the ceremony agreed that the deceased were all "in the background," although my eyes thought otherwise (while the women disagreed and refused to watch). But by that pronouncement, the dead were officially backgrounded, and the Warlpiri viewers' perception indeed shifted. This is similar to the way men will avert their eyes when their mothers-in-law appear full face on a TV screen, to avoid compromising traditional rules that govern this relationship.

Conventionalized disattention to the image is used to respect an etiquette of avoidance of the person. Actually, the traditional prohibitions on the dead draw more attention to them than might first appear. It takes a great deal of vigilance to avoid campsites, to censor one's own speech, and generally to observe all the demarcations a relative's death imposes on Warlpiri activity. Linguistic conventions, including a replacement word for the ones that evoke a dead person's name — *kumunjayi* — are employed. One can refer to the dead, as to the living, by recourse to the skin name: "that old Jakamarra," perhaps specifying more

precisely, by reference to his descendants, his own country or place of death. By contrast, violations of secrets are avoided unequivocally, point-blank. There is no justification for playing any cat-and-mouse game with the owned, valued, and hidden aspects of the secret Jukurrpa lore described above. My rationale for mentioning it here at all is the belief that conditions of secrecy can be discussed as a metasystem, without invoking sanction. For a secret to have force, it must at least have some vague public shape that demarcates it, if only to warn others away from the area.

Employing these conventions, we are required to admit that we can only test their limits; there is nothing to assure that the acts of recording and publishing do not prove subversive of the oral—assuredly, they will. By taking videotaped images out of the Warlpiri Media Association library at Yuendumu, and putting them into circulation as photographs in this book,[4] control over distribution is unavoidably compromised at the expense of the very conventions we want to maintain. But Jupurrurla and the people at Yuendumu also agree that there is a value in identifying their art and describing it to the rest of the world. What we seek is not a false and impossible mediation between truly opposed forms. Rather, symbols of acknowledgment and respect for the oral as inserted in the written, may, optimistically, function in favor of Warlpiri autonomy, offering choices and sites for decision-making that provide some ground for negotiation in response to the unavoidable invasion of the historical. With these qualifications and sensitivities in mind, we may approach Jupurrurla's work more directly.

Coniston Story: Warlpiri Modes of Video Production

Coniston Story is the first tape Jupurrurla produced and shot. It records an oral narrative delivered by an old Japangardi, describing events he witnessed as a child along Crown Creek on what is now Coniston Station, 70 km. east of present-day Yuendumu. In 1929, Aborigines clubbed white trapper and dingo hunter Frederick Brooks to death with an axe. In the punitive raids that followed, perhaps 100 Warlpiri men, women, and children were murdered by police, a massacre of extraordinary proportions for this small community. This historical period has come to be called "the Killing Time."

If you visit Yuendumu and talk to any of the old people there, they are soon likely to tell you a version of this story. It has come to function like an origin myth, explaining the presence and nature of Europeans and articulating the relations that arose between the two cultures. Which version of the story becomes "official" would seem to matter greatly. Will it be the version that Alex

Wilson tells, recalled from his point of view as a young Aboriginal police tracker who may or may not have led the police to their prey? Or will it be the version passed down along the Japanangka/Japangardi patriline that traces its perspective from the two old Japanangka brothers, who everybody now agrees delivered the fatal blow to Brooks? These are crucial historiographic issues for the Warlpiri.

Observing these negotiations may offer us remarkable insights into the hidden creative discourse in which the Dreaming is emergent. The massacre wiped out a ritual gathering, a congregation functioning as a repository of local stories. Generations from now, the Coniston story might well enter the oral tradition to replace those decimated stories associated with the country in the Lander River area around Crown Creek—indeed, to become "the story for that place." Yet I want to push these insistent (and political) speculations about the story to the background, although they are crucial for understanding the videotape and its significance for Jupurrurla and his audience. Instead, I want to focus on the production history of the tape, to use "Coniston Story" to describe how video is made at Yuendumu.

We had been making videotapes in the community for nearly a year, documenting a variety of activities: sporting events, meetings, public dances. Yet these all seemed somehow similar. Events were never created or staged for the camera. Nor did the camera interact with or direct these ongoing events in any obvious way. Videotaping seemed restricted to predetermined public events and available observational vantage points. A spectacular point of view was employed. The result was what filmmakers call "observational" or "direct cinema," similar to the style that arose with Rouche and Morin's postwar films in France and then utilized in America to shoot rock concerts in the 1960s, thus becoming the basis for a whole tradition of social documentary as practiced by the likes of Wiseman, the MacDougalls, and the Maysell brothers (see Rosenthal 1971, Vaughan 1977).

My own research and investigative practice had the same bias; rarely did I propose experiments or conduct formal interviews. But it proved difficult to account for Warlpiri video on the basis of their observational documentaries. Editing was never a major concern and provided no grounds for a theory of unique filmic grammar, such as Worth and Adair (1973) described for Navajo filmmakers. Warlpiri video directed analysis away from the technique to the content; and to an extent, they required the analyst to understand fully the depicted events themselves. I realized that other studies of production in media-"naive" populations had assumed a mode of creative invention, a kind of fabrication that

invited semiological deconstruction. Because the Warlpiri resisted "making things up for the camera," it became more difficult to analyze their products as electronic cultural Rorschachs. I did not yet realize the centrality of the prohibition against fiction for Warlpiri oral tradition. So I proposed an experiment: I solicited a story "made just for the video."

At this time, Jupurrurla had just begun to visit the video studio and sit in on meetings. But he responded to my request and said that he would shoot old Japangardi's story, directing me to be ready for a bush trip in a few days. It is not so strange, from an Aboriginal perspective, to undertake a major expressive act without apparent experience. Jupurrurla's waiting and watching around the video studio for several weeks had counterparts in Aboriginal dance. While it seems nothing is happening, much may be going on, producing the mistaken impression among some observers that people just suddenly leap up and produce a burst of performance. At the appointed moment Jupurrurla arrived at my camp with four carloads of people, and together—him, old Japangardi, 26 more Warlpiri men, women, and children, and myself—we headed off to Coniston to undertake a major epic production.

Europeans are used to what they regard as this annoying tendency of bush trips with Aborigines to grow into multipurpose expeditions, involving far more people than seem necessary or desirable. Indeed, Peter Willis (1980) has labeled the phenomenon "kinship riding." The implication is that access to a vehicle enables various unrelated projects to be attached covertly to the original purpose. It was easy to interpret the picnic / hunting-party / video crew combination as implying fairly diverse agendas. But closer attention to the group's composition revealed an underlying imperative.

Anthropologists have computed that the number of people making up the nomadic collective among the Warlpiri is about thirty, in times of adequate resources (Peterson 1976). This number is not arbitrary, nor is it based on mere ecological calculation in regard to work force and resource exploitation. It may also be an ideological consequence of Warlpiri kinship reckoning, which requires certain identified relations to be ritually articulated in acts of cultural reproduction. Although very few of these people would be participating directly in the videotaping, either in front of or behind the camera, everyone had to be present to authorize the product. From another but related perspective, everyone had rights to both the story and the land on which—of which—it speaks. The credibility of the resulting tape for the Warlpiri audience is dependent upon knowing

that these people were all participating in the event, even though the taped record provides no direct evidence of their presence.

The ritual relations between participants were effectively translated by Jupurrurla into those of video production. Because the storyteller was a Japangardi, from "one side," it was entirely appropriate that Jupurrurla, from the "other side," would be behind the camera. This modeled the in-front/behind camera dichotomy after their Warlpiri equivalents. Kirda ("boss") is on stage, Kurdungurlu ("helper/manager") is behind the scenes. This arrangement was followed throughout the first three scenes, while the fourth includes an innovative deviation from this practice.

Each virtually uninterrupted take was shot on the site where the events of the story being told by Japangardi occurred:

1. the site of Brooks's murder;

2. that of his grave;

3. a waterhole where people were encamped for ceremony;

4. a cave in which an old Japanangka hid from police trackers.

In them, Japangardi is first seen from an extreme long shot, his figure appearing to emerge from the landscape. He walks toward the camera, and begins speaking when in medium-shot range. The elaborate Warlpiri hand-sign vocabulary allowed Jupurrurla to signal his directional instructions while remaining behind the camera. The effect of these scenes conforms to a ceremonial convention in which certain ritual story-dances do not begin on the dancing ground proper, but are "brought in" from the bush at some distance. The effect is to express the contiguity of such stories and to invoke that corpus of all stories, the Dreaming. More specifically, the relations of stories to land and place are acknowledged by these conventions. Any story comes from a particular place, and travels from there to here, forging links that define the tracks over which both people and ceremonies travel. Jupurrurla models his electronic discourse on exactly such principles of orientation.

The last scene contains an interesting variation on the relationship between Jupurrurla/director and Japangardi/actor. Jupurrurla requested that I take the camera, so he could appear with Japangardi. They sit side by side while Jupurrurla fields a series of questions:

Nyajangukulpa nyinaja?
(How long was he here for?)

Nganangkurla yimi-ngarrurnu?
(Who told about him?)

Nganapaturlu yapapaturlulujana luwarnu kardiyakurlurlu? Yapa?
(Who were the Aborigines who went about shooting the people with the Whites?)[5]

The effect is startlingly like the familiar TV talk show, except for the replacement of the lounge setting with big red rocks, and the language with Warlpiri. Jupurrurla may have used this setting to permit Japangardi to fill in certain parts of the story that were missed in the original formal telling, now permissible in this more casual, intimate framing. He may also have wished to establish his presence unequivocally. But note that the interviewer/interviewee relationship expressed here can be considered as another interpretation of the Kirda/Kurdungurlu relationship, shifted from production roles to on-screen performances. No contradiction is necessarily implied. We are reminded that Jupurrurla's transference of Warlpiri discourse to video is exploratory: after all, Dreaming Law makes no explicit reference to camera techniques. It may well be that the oral tradition itself is best expressed not as immutable rules but as socially emergent interpretations of a more fundamental Law.

Reviewing the tape, one is struck by the recurrent camera movement, the subtle shifts in focus and attention during the otherwise even, long pans across the landscape. The superficial conclusion is that we are seeing the effects of "naive" camera work: the preference for landscape is a preference for things that don't move, and are easily photographed: the shifts in focus and direction seem evidence of a simple lack of mechanical skills. Jupurrurla denies this. When asked, he provided a rationale suggesting a meaning in everything his camera does. The pans do not follow the movement of the eye, but movements of unseen characters—both of the Dreamtime and historical—which converge on this landscape: "This is where the police trackers came over the hill," "that is the direction the ancestors come in from…." Shifts in focus and interruptions in panning pick out important places and things in the landscape, like a tree where spirits live or a flower with symbolic value. The camera adopts technical codes to serve a predetermined system of signification in this radically *Yapa* sense of mise-en-scène.

Viewers from outside Warlpiri culture are unlikely to retrieve such intended messages from the video. Partly this is because these are especially context-sensitive meanings; the tape itself contains only subtle hints of its production process and the intent of the camera's technical codes. It is a particular disadvantage of moving pictures' deceptive iconicity that the visual text encourages many plausible readings. The European eye, failing to see the epic authority of *Coniston Story*, observes instead a home movie, in the most banal sense of that term. Of course, the notion of home movie might otherwise be quite productive, if Warlpiri concepts of family and place are taken into consideration. But the problem works both ways. We know that Aboriginal viewers enjoy our culture's home movies, such as the *Dallas* series—but it would be hazardous to predict their readings of them.

Behind all these matters are questions of value and evaluation. Is Warlpiri video any good? What, and who, is it good for? Such questions are behind those the bureaucrats ask when deciding to fund or "develop" indigenous forms, so that these terms are inflicted on the people at Yuendumu. Clearly, both a failure to value, and a banal overvaluation, can produce disastrous interventions when based on alien readings of the text. It seems irresistible from that perspective to dismiss tapes like *Coniston Story* as not good enough—or worse, to encourage the videomaker to make it better. It is much more difficult to accept that video can legitimately take many forms or employ various discourses. But such a recognition is essential for any informed reading of Jupurrurla's work.

The Fire Ceremony: For A Cultural Future

In 1967, anthropologist Nicolas Peterson and filmmaker Roger Sandall arranged with the old men to film a ritual of signal importance for the Warlpiri: Warlukurlangu, the fire ceremony. In a subsequent journal article, Peterson (1970) described these ceremonies in terms of the functions of Aboriginal social organization. He identified such Warlpiri ceremonies as a means of resolving conflict, or of negotiating disputes—a kind of pressure valve for the community as a whole. One pair of patrilines (or a "side") of the community acts as Kurdungurlu and arranges a spectacular dancing ground, delineated by great columns of brush and featuring highly decorated poles. The Kirda side paints up and dances. Following several days and nights of dancing, they don elaborate costumes festooned with dry brush. At night they dance toward the fire and are then beaten about with burning torches by the Kurdungurlu. Finally, the huge towers of brush are themselves ignited and the entire dance ground seems engulfed in flame. Following some

period (it may be months or even years) the ceremony is repeated, but the personnel reverse their roles. The Kurdungurlu become Kirda, and receive their punishment in turn.

Visually and thematically, this ceremony satisfies the most extreme European appetite for savage theater, a morality play of the sort Artaud describes for Balinese ritual dance—what could be more literally "signaling through the flames" than this? Yet I do not think the Peterson/Sandall film does this, partly due to the technical limitations of lighting for their black-and-white film stock, and partly because of the observational distance maintained throughout the filming. The effect is less dramatic, more properly "ethnographic" (and, perhaps wisely, politically less confrontational). It was approved by the community at the time it was edited in 1972 by Kim McKenzie, and joined other such films in the somewhat obscure archives of the Australian Institute of Aboriginal Studies, used mostly for research and occasional classroom illustration.

Remarkably, the ceremony lapsed shortly after this film was made. When I arrived at Yuendumu in 1983, the fire ceremony seemed little more than a memory. Various reasons were offered: one of the owners had died, and a prohibition applied to its performance; it had been traded with another community; and the church had suppressed its performance. These are not competing explanations, but may have in combination discouraged Warlukurlangu. The interdictions by the church (and the state, in some versions) was difficult to substantiate, though it was widely believed. Some of the more dramatic forms of punishment employed in the ceremony contradict Western manners, if not morals. There seemed to be some recognition among the Warlpiri that the fire ceremony was essentially incompatible with the expectations of settlement life and the impotent fantasies of dependency and development they were required to promote. The fire ceremony was an explicit expression of Warlpiri autonomy, and for nearly a generation it was obscured. The question arises, as it does also in accounting for the ceremony's recent revival: What role did introduced media play in this history?

Yet Warlukurlangu persisted in certain covert ways. The very first videotape that the community itself directed in 1983 recorded an apparently casual afternoon of traditional dancing held at the women's museum. Such spontaneous public dance events are comparatively rare at Yuendumu. Dances occur in formal ceremonies, or during visits, in modern competitions and recitals, or in rehearsal for any of these. Yet this event appeared to meet none of these criteria. Equally curious was the insistence on the presence of the video camera. These

were early days—Jupurrurla had not yet taken up the camera, and Japanangka and I were having trouble arranging the shoot. A delegation of old men showed up at each of our camps and announced that we must hurry; the dancing wouldn't start till the video got there. What was taped was not only some quite spectacular dancing, but an emotional experience involving the whole community. When I afterwards asked some of the younger men the reason for all the weeping, they explained that people were so happy to see this dance again. I later discovered I had seen excerpts of the dances associated with the fire ceremony.

Some months later, I was invited to a meeting of the old men in the video studio. They had written to Peterson, asking for a copy of the film, and now were there to review it. I set up a camera, and we videotaped this session. As it was clear that many of the on-film participants would now be dead, how the community negotiated this fact in terms of their review was very important. The question of the film's possible circulation was raised. Following a spirited discussion, the old men (as mentioned above) came to the decision that all the people who died were "in the background"—the film could be shown in the camps. Outside, a group of women elders had assembled and were occasionally peeking through the window. Some were crying. They did not agree that the deceased were sufficiently backgrounded, and it made them "too sorry to look." These women did not watch the film, but didn't dispute the right of the men to view or show it.

It became clear that the community was gearing up to perform the fire ceremony again for the first time in this generation. As preparations proceeded, video influenced the ritual in many ways. For example, the senior men announced that the Peterson film was "number-one law" and recommended that we shoot the videotape of exactly the same scenes in precisely the same order. (When this did not happen, no one in fact remarked on the difference.) Andrew Japaljarri Spencer, who acted as first cameraman, stood in Kurdungurlu relationship to the ceremony. This meant that he produced an intimate record of the ceremony from his "on the side" perspective.

We are at close-up range for some of the most dramatic moments, alongside the men actually administering the fiery punishments. Jupurrurla absented himself from this production. Although he was willing to do certain pre-production work, and subsequent editing and technical services, he would not act as cameraman because he would be a Kirda for this event. Quite sensibly, he pointed out that if Kirda were cameramen, the camera might catch on fire.

Jupurrurla was not unaware, like many of the younger men, that he too might catch on fire, so at the climax of the ceremony they were nowhere to be found.

The tape of this major ceremony was copied the very next day and presented to a delegation from the nearby Willowra community, who were in fact in the midst of learning and acquiring the ceremony for performances themselves. This is a traditional aspect of certain classes of ceremonies. In oral societies where information is more valued than material resources, ceremonies can be commodities in which ritual information is a medium of exchange. This exchange may take years, and repeated performances, to accomplish. For instance, there was a dramatic (if not unexpected) moment when a more careful review of the tape revealed that one of the painted ceremonial poles had been rather too slowly panned, rendering its sacred design too explicit. This design had not yet been exchanged, and so the Willowra people might learn it—and reproduce it—from the tape. Runners went out to intercept the Willowra mob and to replace their copy with one that had the offending section blanked out.

These new tapes of the fire ceremony circulated around the Yuendumu community, and in their raw state were highly popular. In fact, it became difficult to keep track of the copies. This was one of the motivations to proceed with broadcasting—more to assure the security of the video originals and provide adequate local circulation of tapes than to achieve any explicitly political intent. But perhaps there was a broader public statement to be made with the record of these events. I recommended, and was authorized to propose to the AIAS, that we edit together the tapes to produce an account that would describe both the ceremony and its reproductions. We had the Peterson film, the community dance, the review of the film, and the extraordinary footage of the 1984 performance. This seemed to me an excellent and visually striking way to articulate the ceremony in terms of some of the more fundamental questions concerning the place of such media in Warlpiri life. The Institute did not support the idea, and when one of the central performers died shortly thereafter, the community dropped the matter. The tapes took their place on a shelf in the archive that Jupurrurla labeled "not to look." Later, however, the Institute did transfer the Sandall/ Peterson film to videotape and put it into general distribution without, to my knowledge, informing the community that this was being done.

There is no point in isolating any one instance of this failure to address or resolve the problems that the appropriation of Warlpiri images poses. The situation is so general that it proves how fundamental the misunderstandings

must be. Alien producers do not know what they take away from the Aborigines whose images, designs, dances, songs, and stories they record. Aborigines are learning to be more careful in these matters. But the conventions of copyright are profoundly different from one context to the other. Perhaps these urgent questions will never be solved: "Who owns that dance now on film?", "Who has the authority to prevent broadcast of that picture of my father who just died?", "How can we make sure women will not see these places we showed to the male film crew?", "Will we see any of the money these people made with our pictures?" Whenever "appropriate" Australian authorities are confronted with such questions, they go straight to the too-hard basket, not only because they are truly difficult questions, but also because they refer to equivocal political positions.

 Underlying the problem is not a failure to specify the processes of reproduction and their place in oral traditions; there is also a contradiction of values regarding the possibilities for Aboriginal futures, and the preferred paths toward these. Many Aborigines do wish to be identified, recognized, and acknowledged in modern media, as well as to become practitioners of their own. They recognize the prestige, the political value, the economic bargaining position that a well-placed story in the national press can provide. They attempt to evaluate the advantages—and what they are told is the necessity—of compromising certain cultural forms to achieve this. But the elements of this exchange, the discrimination between what is fundamental and what is negotiable, resists schematization. On neither side is there a clear sense of what can be given up and what must be kept if Aborigines are to avoid being reprocessed in the great sausage-machine of modern mass media. For them, it is the *practices* of cultural reproduction that are essential. If by the next generation the means of representing and reproducing cultural forms are appropriated and lost, then all is destroyed. What remains will just be a few children's stories, place names for use by tourist or housing developments, some boomerangs that don't come back, a Hollywood-manufactured myth of exotica. These will only serve to mask the economic and social oppression of a people who then come into existence primarily in relation to that oppression.

 The criteria for Aboriginal media must concern these consequences of recording for cultural reproduction in traditional oral societies. Warlpiri people put it more simply: "Can video make our culture strong? Or will it make us lose our law?"

 The problem about answering this sort of question as straightforwardly as it deserves is that it usually is asked in deceptive cause/effect terms: What will TV do to Aborigines? The Warlpiri experience resists this formulation.

Jupurrurla demonstrates that such questions cannot be answered outside the specific kin-based experiences of their local communities. His productions further demonstrate that television and video are not any one self-evident thing, a singular cause that can then predict effects. Indeed, Yuendumu's videomakers demonstrate that their television is something wholly unanticipated, and unexplained, by dominant and familiar industrial forms.

Here I want to emphasize *the continuity of modes of cultural production across media*, something that might be too easily overlooked by an ethnocentric focus on content. My researches identify how Jupurrurla and other Warlpiri videomakers have learned ways of using the medium that conform to the basic premises of their tradition in its essential oral form. They demonstrate that this is possible, but also that their efforts are yet vulnerable, easily jeopardized by the invasion of alien and professional media producers.

My work has been subject to criticism for this attention to traditional forms and for encouraging their persistence into modern life. The argument is not meant to be romantic: my intent has been to specify the place of the Law in any struggle by indigenous people for cultural and political autonomy. In the case of Warlpiri television, the mechanisms for achieving this were discovered to lie wholly in the domain of cultural reproduction, in the culture's ability to construct itself, to image itself, through its own eyes as well as those of the world.

In the confrontation between Dreamtime and Our-time, what future is possible? The very terms of such an inquiry have histories that tend to limit any assured, autonomous future. For example, if it were true that my analysis of Warlpiri TV provided no more than a protectionist agenda, then the charge of romantic indulgence in an idealized past might be justified. I would have failed to escape a "time" that anthropologists call the "ethnographic present"—a fabricated, synchronic moment that, like the Dreamtime, exists in ideological space, not in material history. It is implicated in nearly all anthropology, as well as most ethnographic discourse. Certainly, the questions of time that seem essential here cannot be elucidated by constructs of timelessness.

It seems likely that grounding Aborigines in such false, atemporal histories results in projecting them instead into a particular named future whose characteristics are implied by that remarkable word, "lifestyle." This term now substitutes everywhere for the term "culture" to indicate the latter's demise in a period of ultramerchandise. Culture—a learned, inherited tradition—is superseded by a borrowed or gratuitous model; what your parents and grandparents taught you didn't offer much choice about membership. Lifestyles are, by contrast,

assemblages of commodified symbols, operating in concert as packages that can be bought, sold, traded, or lost. The word proves unnervingly durable, serving to describe housing, automobiles, restaurants, clothes, things you wear, things that wear you — most strikingly, both "lifestyle condoms" for men and, for women, sanitary napkins that "fit your lifestyle." Warlpiri people, when projected into this lifestyle future, cease to be Warlpiri; they are subsumed as "Aborigines," in an effort to invent them as a sort of special ethnic group able to be inserted into the fragile fantasies of contemporary Australian multiculturalism. Is there no other future for the Warlpiri than as merely another collectivity who have bartered away their history for a "lifestyle"?

I propose an alternative here, and name it the *cultural future*. By this I mean an agenda for cultural maintenance that not only assumes some privileged authority for traditional modes of cultural production but also argues that the political survival of indigenous people is dependent upon their capacity to continue reproducing these forms.

What I read as the lesson of the Dreaming is that it has always privileged these processes of reproduction over their products, and that this has been the secret of the persistence of Aboriginal cultural identities as well as the basis for their claims to continuity. This analysis confirms Jupurrurla's claims that TV is a two-edged sword, both a blessing and a curse, a "fire" that has to be fought with fire. The same medium can prove to be the instrument of salvation or of destruction. This is why a simple prediction of the medium's effects is so difficult to make. Video and television intrude in the processes of social and cultural reproduction in ways that literate (missionary, bureaucratic, educational) interventions never managed to do. Its potential force is greater than guns, or grog, or even the insidious paternalisms that seek to claim it.

But in a cultural future, *Coniston Story* operates over time to privilege the Japangardi/Japanangka version of that history, to insert it bit by bit into the Dreaming tracks around Crown Creek until the tape itself crumbles and its memory is distributed selectively along the paths of local kinship. In this future, when the mourning period for that old Japangardi is passed, his relations will take the fire ceremony tape from the "not-to-look" shelf and review it again, in relation to the presence or absence of recent performances of the ceremony. Audiences at Yuendumu will reinterpret what is on tape, bring some fellows into the foreground and disattend to others. They might declare this "a proper law tape," and then go on to perform the ceremony exactly the same, but different. I expect, in the highly

active interpretative sessions that these attendances have become, there will be much negotiation necessary to resolve apparent contradictions evoked by the recorded history. I expect that a cultural future allows the space and autonomy for this to happen.

In a lifestyle (ethnic, anticultural) future, it's not so certain that anyone will be there at Yuendumu to worry about all this. Why should they? After all, the place has only cultural value, lacking any commercial rationale for the lifestyle economy. But if people are to be situated in this future, we can assume that they will be faced with a very different kind of, and different participation in, media. Their relation to the forces and modes of cultural reproduction will be quite passive: they will be constituted as an audience, rendered consumers, even though there's not much money to buy anything (the local store is reduced to selling tinned stew and kung fu videotapes). But it would be mistaken to claim that the ethnic cultural policy has ignored Aborigines. In fact, they play a major part in the construction of the national, multicultural image; in this scenario, they become "niggers." Then they will be regularly on the airways, appearing as well-adjusted families in sitcoms, as models in cosmetic ads, as people who didn't get a "fair go" on *60 Minutes*. Nationally prominent, academically certified Aborigines will discuss Aboriginality on the ABC and commercial stations, filling in the legislated requirements for Australian content. In the lifestyle future, Aborigines can be big media business.

The people at Yuendumu will watch all this on their government-provided, receive-only satellite earth stations; but we can only speculate about what identifications and evaluations they will make. Perhaps the matter will not be inconsequential. Imported programs supplant but may not so directly intrude on cultural reproduction. Rather, it is when some archivist wandering through the ABC film library chances on an old undocumented copy of the Peterson fire ceremony film, one of the competing versions of the Coniston massacre, or even some old and valuable Baldwin Spencer footage, circa 1901, of Central Australian native dances, that something truly momentous happens. In pursuit of a moment of "primitivism," the tapes go to air, via satellite, to thousands of communities at once, including those of its subjects, their descendants, their relations, their partners in ritual exchange, their children, their women (or men). One more repository guarded by oral secrecy is breached, one more ceremony is rendered worthless, one more possible claim to authenticity is consumed by the voracious appetite of the simulacra for the appearance of reality. At Yuendumu, this already causes

fights, verbal and physical, even threatened payback murders, in the hopeless attempt to ascribe blame in the matter, to find within the kin network the one responsible, so that by punishing him or her the tear in the fabric of social reproduction can be repaired. However, the kin links to descendants of Rupert Murdoch or David Hill[6] or Bob Hawke may prove more difficult to trace, and the mechanisms for adjudication impossible to uncover.

A cultural future can only result from political resistance. It will not be founded on any appeal to nostalgia: not nostalgia for a past whose existence will always be obscure and unknown, nor a nostalgia we project into a future conceived only in terms of the convoluted temporalities of our own present. The tenses are difficult to follow here—but in a sense, that is precisely the critical responsibility now before us. Francis Jupurrurla Kelly makes, is making, television at Yuendumu. He intends to continue, and so assure a cultural future for Warlpiri people. His tapes and broadcasts reach forward and backward through various temporal orders, and attempt somehow to bridge the Dreaming and the historical. This, too, is a struggle that generates Jupurrurla's art.

The only basis for non-Warlpiri interest in their video is recognition of these explicitly contemporary contradictions. Channel 4 at Yuendumu resists nostalgic sentiment and troubles our desire for a privileged glimpse of otherness. It is we who are rendered other, not its subject. Ultimately, it must be from this compromising position that such work is viewed.

Appendix

The people at Yuendumu were not entirely happy with this text when I brought it for them to review prior to publication. We took out the few offending pictorial images—this wasn't the problem. It was said by some that the pessimism I expressed seemed unwarranted. Certainly, the evidence of continuing motivation and activity at the TV studio was startling. This was late August 1987, and my visit coincided with the installation of a satellite earth station receiver that introduced the live ABC program schedule to Yuendumu after so many years of waiting, worrying, and preparing.

There still was no license to legitimize the service that Jupurrurla began that week, mixing local programming with the incoming signal (Warlpiri News and documentaries at 6:30 P.M.). Nor had the equipment repaired itself magically since the last visit: signal strength remained unpredictable, and edits were completely unstable. But the community was still passionately involved in making

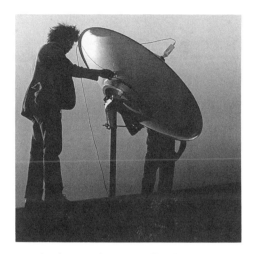

Jupurrurla adjusting the new satellite dish, August 1987.

and watching Warlpiri television. This became clear when a battle ensued with the very first day's transmission. Warlpiri News replaced *EastEnders*, and at least one European resident was incensed. Jupurrurla decided (somewhat unilaterally, it seemed to me) that the service would shut off at 10:30 P.M., so that kids could go to bed and be sure of getting off to school in the morning. No *Rock Arena*. No late movies. It seemed likely there would be a lot of hot negotiating in the coming months.

VII

If "All Anthropologists are Liars ..."

[1 9 8 7]

GEERTZ (1973) claimed ethnography is something "we do." Others have suggested that it is something we write (see Clifford and Marcus 1986). Both writing and doing (inscription and practice) have received considerable critical attention in semiotics, aesthetics, and theoretical science in the last few decades. What happens when we apply some of these recent reflexive considerations that have emerged in philosophical theory to particular anthropological practices and ethnographic inscription? I want to examine a recent ethnography that, because it is new and means to be, because it attempts certain classical holisms while citing more contemporary equivocal theory, and because it deals with a "the last of the ..." people, seems to occasion these questions anew. Indeed, *Pintupi Country, Pintupi Self* by Fred Myers (1984) is a remarkable book if only because it so unproblematically seems to manage all these thorny issues, requiring critics to delve rather deeply below its smooth surface to explain how this is done and whether the procedure is ultimately defensible.

There are three sorts of concerns I want to apply to this text. First, I want to consider how the author has positioned himself within the more problematized discourse, what traditions he invokes, and what he takes these to require for his intellectual responsibilities and inscriptive practices. Second, I want to consider whether reflexive considerations, especially where they are missing,

might require revaluation of some data, improve arguments demonstrated to have flaws, or otherwise alter the interpretive act and product. Third, I want to consider the position of the subjects within a discourse that remains mostly external to the ethnography, a political struggle ongoing among the people described, their advocates, and the state in its various guises. I want to insert political evaluations here that ask not just whether the ethnography is "helpful" in some absolute sense but whether its subjects will regard it as so, and that then raise epistemological issues concerning this regard.

I do not claim to invent the terms of this criticism, or to craft a "Tao of the reflexive" out of the whole cloth of abstract ruminations. Myers invokes these issues himself with both terminology and citations that assert his place in the more contemporary, problematized, and less positivist discourses. But Myers fails to spell out his practice or to describe just what the consequences are for doing, or writing, ethnography, so the task falls to his reviewers.

We could begin by invoking the general postpositivist criticisms of scientific facticity in subject-object relations, which compromise any claims to the validity of measurement and perception (Gödel 1962, Kuhn 1970, Foucault 1972)[1] and wonder in what intellectual circumstances we can justify participant observation (Ricoeur 1974, Hymes 1972, Dumont 1978), or we can invoke the neo-Marxist literary studies that problematize both inscription and interpretation (Macherey 1978, Lukács 1950) and wonder in what circumstances writing about fieldwork could have any epistemological rationale (Clifford and Marcus 1986, Tedlock 1983). And we would not have to go far afield to consider also the objection of our "cultural subjects," who raise equivalent questions, if more polemically and in a more political discourse: "What right have you to appropriate our lives and inscribe our histories to advance your own, and your culture's, objectives without even considering if this may be at the expense of ours?"

If we assume it is self-evident, important, or simply worthwhile, a "right" in any case, to observe, interpret, and inscribe traditional societies, we are apt to try to rule these questions out of order, or at least find means to keep them at bay. It can be argued that asking such questions is too much like feeding the Epimenides paradox (if "All Cretans are liars ...", how do you evaluate Cretan response to a true/false question?) into a computer, which can only spit it out or blow up (see Bateson 1979: 116–17). Indeed, the history of at least twentieth-century Western philosophy could be described in terms of what is done with such questions. Reflexive social study (Ruby 1983, Nash and Wintrob 1972, Honigmann 1976), which privileges epistemological questions and problematizes meth-

ods, has arisen as one response to these questions. Reflexive practice probably differs from the anthropology it criticizes not by proposing solutions to these questions but by moving them to the central position in the inquiry: If "All anthropologists are liars …?" This may or may not be an adequate response or philosophical justification for the harder questions, political and personal, that these criticisms imply. Nor does it solve the more or less profound question of whether we can do ethnography at all.

What I am calling "reflexive" is not really new to anthropology. Malinowski's theories are sometimes described as first principles, although his posthumous diaries serve better as models of inscriptive practice than does the published ethnography. All ethnographic inquiry insists on the encounter with "the other," as Lévi-Strauss (1955) reemphasized, and part of the result (some might say the intent) of this encounter has always been a challenge to our assumptions and our tools. In the past, this justified claims that ethnography is atheoretical. Today, it may be pressures from outside as much as discoveries within the discipline that challenge the possibilities of unpositioned knowledge and now demand we elevate our problematic and label it. "Reflexivity" is merely one such label. It must be admitted that in its short history it has proved capable of encouraging a false resolution: reflexive practices can be transformed into gestural motifs, employed as rationales merely to keep us going (at least past the edge of Occam's Razor). This in turn may have resulted in far more dishonesty than positivist perspectives could ever have been accused of. Conversely, reflexivity can so decenter the cultural subject that ethnography becomes opaquely self-inscriptive. So the course is full of danger.

Rose (1987) grapples with what seems to me identical difficulties with Myers's text. She pursues what might be described as a critical (for example, Marxist) perspective that results in what I believe is an exemplary exegesis. She gives Myers's analysis good marks, while remaining inexplicably dubious about the author and his relationship to his subjects. It is in that gap I wish to assert the following criticisms, because I believe reflexive principles may help specify the problem Rose senses. I should note (not unreflexively) that like Rose I undertook fieldwork in a community near Pintupi country shortly following that of the author (see Michaels 1986). My purpose here is not, however, to dispute many facts or even general conclusions. Part of the advantage of this text for the purposes of this exercise is that I have few disputes with the author at this level, and, like Rose, generally agree with his ethnographic "facts." I am concerned more about certain evidential and interpretive strategies and their outcomes, which is the focus of my criticism. I want to ask also: What is the purpose of publishing this material in the

form of a classic ethnographic volume at this time? Can we still justify placing a bell jar over a culture, or claim to describe it adequately in nine (or twelve or twenty) chapters, or does this now prove preposterous? Geertz recently said, "Walking barefoot through the whole of culture is no longer an option and the anthropologist who tries it is in grave danger of being descended upon in print by an outraged textualist or maddened demographer" (1985: 623). My criticisms probably can be classed with outraged textualism; Fred Myers so deftly sidesteps these very issues that it takes perhaps too terribly close a reading to evaluate the work and to specify some consequences of his practice.

Not long after Fred Myers's major periods of fieldwork (1973–75, 1979, 1981–82) among the Western Desert nomadic hunter-gatherers named (by others, notes Myers) "Pintupi," a remaining uncontacted family "came in" from the desert to meet with their relations who had settled in a more permanent, government-assisted community. Fred Myers employs this anecdote to introduce *Pintupi Country, Pintupi Self.* I suppose he means to invoke in his readers a sense of the awesome responsibility he has undertaken to be the scribe for what, at least in Australia, may really be the "Last of the Nomads," and to imply a historical/archival imperative for this publication. But as Myers's text (and literature he cites dating back to the 1930s) later reveals, Pintupi contact history may not be so singular. It is difficult to account for Myers's succumbing to this sensational reference. It seems misleading in several respects to frame the text as an adventure story.

 Pintupi Country, Pintupi Self employs an analytic discourse, not a narrative one, although anecdotes pepper the text. It rewrites and restructures some valuable earlier journal articles, combines these with selections from Myers's doctoral thesis, and includes new material within a more ambitious theoretical framework. The result does not seem intended to evoke identification with an authorial persona. Even so, *Pintupi Country, Pintupi Self* might prove to be the last of the holistic participant-observation ethnographies, making Myers, not the Aborigines, representative of the dying tribe. It seems poignant to consider then not only the drama of the Pintupi between two worlds but the dilemma of Myers's own position between two discourses.

 Like Rose, I must express deep appreciation for Myers's earlier articles on the Pintupi, especially "A Broken Code" (1980) and "Always Ask" (1982). I believe these eloquently detailed studies are among the more intelligent, perceptive, and theoretically informed analyses of Western Desert peoples available. My own fieldwork benefited enormously from their publication. I thought

Pintupi life described there was remarkably recognizable; my own encounters were enriched. And, as it did for Rose, this poses certain problems for my reading of the current text. These early articles appear, in altered form, as chapters in *Pintupi Country, Pintupi Self*. If I think that they do not seem as insightful, as precise, and as intellectually successful in this new context, why are they not? Perhaps the fine melding of theory and data apparent in the more discrete problems posed in these articles gets ruptured when they are repositioned as elements of a broader ethnographic account and a more general, and difficult, theory of personhood. This "minimal pairing" makes *Pintupi Country, Pintupi Self* an interesting study with which to test the points I raise above, and permits us to discuss whether it is in ethnography itself, in its form/practice/objectives, where the problem lies.

The central argument of *Pintupi Country, Pintupi Self* is that the Pintupi must be understood, as they understand themselves, from an egocentric rather than sociocentric or culturological viewpoint, which invokes Bourdieu's and Ricoeur's perspectives in understanding the "person" or "cultural subject," but contrasts with most other accounts of Western Desert society. Sociospatial analysis—which Myers privileges in his explanations of cosmology, land tenure, and polity and group formation—has its basis here in the autonomous individual. The world is reckoned from the perspective of any given sociospatially positioned Pintupi. This claim authorizes the psychological perspective and problematizes group formation and cultural identity. These problems of community and coherence are resolved by referring to emotion-bearing Pintupi values such as "holding / caring for," which can be analyzed as social products individually articulated rather than systems or structures of rules. The Pintupi construct "the Dreaming" to express and mediate possible contradictions between the autonomous subject and shared cultural identity, and Nancy Munn is credited with first describing this function. But the Pintupi obscure to themselves the mechanisms by which the Dreaming reproduces social life (and is reproduced by it). It is this last point that identifies ethnography and Pintupi cosmology as contrastive discourses and historiographies, which a reflexive approach would point to as the central difficulty for presenting this case. Myers's failure to develop this contrast, or to specify just how social reproduction operates in Pintupi history (or in his own history), is a failure of reflexive practice with identifiable consequences.

Myers distinguishes his approach from earlier (pre-1960) culture and personality studies, rejecting their emphasis on a Western concept of the "self" (104) as he distinguishes his approach also from more formal structural analysis. Although he refers to Marxist critiques and their recent literary applications,

he never really does locate his psychology in a tradition. The approach is probably best illustrated in the useful chapter on kinship, which describes kin reckoning and marriage preference from the perspective of adult users, not by the requirements of formal structures. This allows the system to be depicted in all its complexities and contradictions, as necessary matters of potentiality and choice available to the Pintupi who may emphasize one or another principle (i.e., descent, generation level, gender) in given circumstances. This "openness" of the system is considered to be an essential characteristic of social organization among hunter-gatherers in areas of unpredictable resources, and is revealed through the emphasis on Pintupi personhood. It is true that much violence has been done to Australian and Western Desert kinships (and related land-tenure systems) by attempts to fit these to reductionist (e.g., African) models. But Myers's psychological bias never does become sufficiently articulated to achieve the status of a contrasting theory or model.

The analysis displays mostly heuristic power by providing a rich and accurate reading of nomadic social organization that does not demand structural closure, and demonstrates how that society resists disorder. A hierarchy of emphases inherent in kinship is said to distinguish certain principles such as generation level (*walytja*, kin) and coresidence through time (*ngurra*, camp), which are likely to take precedence over, for example, descent lines for most purposes. Even so, the solution to the "problem" of Pintupi social structure is asserted more than demonstrated. We are not much clearer about how specific practices of social reproduction operate, either for the Pintupi or for the implied theory.

The sources of evidence for this portrayal of Pintupi "mind, self and society" come from various forms of participant observation and interview. Myers describes Pintupi men teaching him cultural competence in their terms somewhat more than in his. He admits they showed little interest in his scholarly functions and objectives. In such circumstances, relatively unstructured interviews and nondirective questioning were employed. In the reconstruction of life histories, particularly to retrace precontact demography and travel, the technique seems productive, although we are provided with only very selective excerpts from what must be very rich field narratives.

Stories are conspicuous in this ethnography as the privileged mode of discourse and the basis for its veracity. But the reliance on oral histories for evidence and insight leads recurrently to a familiar if somewhat unsatisfying semantic/linguistic mode of explanation. Pintupi terms are widely used and explored as keys to Pintupi thought. Certain key terms (i.e., *ngurra*, camp; *walytja*,

kin / family / reference group) and key oppositions (i.e., *yarrka*, hidden / *yuti*, visible) are relied on consistently as explanatory devices. This is a conventional enough means of arguing ethnographic interpretations. But it is not entirely clear to me that here this recourse to semantic correspondences is the most convincing evidence for the kind of explanation that will avoid the reifying practices Myers criticizes in his introduction; it tends to make both thought and social life seem somewhat more pat than he encourages us to believe. We remain more dependent on the writer's linguistic interpretations and his architectural skill in constructing semantic domains than the technique admits.

For example, people are reported to have explained their reasons for abandoning a punitive expedition as being because they were "homesick," which is claimed to illustrate the importance of the home base (*ngurra*) (93). The Pintupi term for homesickness is not provided here. But later (119) *watjila* is translated as "homesickness," as well as "pining, lonely, worry, melancholy." Perhaps the more inclusive equivalent would be simply "separation anxiety" (which Róheim claimed was central to Pintupi psychology). Yet this semantics-derived explanation for why the raid was abandoned seems narrowly and suspiciously tautological, and other reasons might have been uppermost in the informant's mind of which she did not want to speak (as is elsewhere noted to be often the case where secret matters of men's "business" is involved).

Admittedly, this criticism does not damage Myers's intended point on page 93; he is only seeking an illustration there. Legitimate ethnographic issues of cultural translation and inscription (see Tedlock) may be masked more than revealed by explanatory strategies that invite such various and fortuitous applications. The situation could be improved by a more thoroughgoing presentation of the linguistic context, as Sapir ([1921] whom Myers invokes with a prefatory citation) would himself have argued. This absence of a discrete, extended discussion of Pintupi semantics and linguistics strikes me as a serious omission inasmuch as language is the recurring organizing principle for the entire text. Myers demonstrates considerable facility in Pintupi speech. But the reflexive posture I claim is necessary in fact requires even more than formal linguistic description; the common thread of the postpositivist criticisms cited in my introductory remarks is indisputably a broader attention to signification. The common motif throughout my more general criticisms of ethnography, and the example of its expression through the Pintupi text, is this: What is the cost of failing to describe the signifying practices of our cultural subjects in explicit comparison to our own signifying practices?[2]

If Derrida is correct that footnotes serve to signal gaps in theory, then evidence of Myers's difficulty in addressing ethnographic production practices should be found there. Indeed, it is really only in the footnotes that the discussion of subjectivity finally admits its problematic with the acknowledgment of the contribution of French theory (Jacques Derrida, Jacques Lacan, Paul Ricoeur) and Victor Turner, causing Myers to consider:

> *The problem of alienation this analysis presents is a fundamental issue for anthropology, related to the recent concern in the humanities with "decentering the subject." ... The existential attempts to address the problem are, I believe, vital dimensions of religious activity. In anthropology, the critical difference between an individual and his contingent subjectivity has not been given the attention it deserves. (302)*

One could say that the issue does not get the "attention it deserves" by isolating it in a footnote, either. For me, this problem that Myers terms "alienation" is central to the discussion. I shall return to this point several times, because I suspect that Myers's cloak of invisibility, as it wears increasingly thin, reveals his own alienation to (and in) his text.

A more familiar code of criticism would consider simply whether the theoretical bases and the evidential data that coreside in the same text provide an adequate fit. In these terms, *Pintupi Country, Pintupi Self* describes an author attempting to mediate between the issues of traditional ethnographic practice, particularly as received in Australian studies via Radcliffe-Brown, and a more contemporary if equivocal discourse (i.e., Myers's citation of Bourdieu), where the problematics of the subject are less transparent than in the earlier positivisms of structural functionalism. This is what I take the introduction and the social/ psychological focus of the text to mean. But instead of the pyrotechnics we might expect from pitting these theoretical models against each other (which have been claimed by their adherents to be ontologically opposed), we find these side by side without emphasis on either competition or contradiction. Does this imply what would be a fairly original claim: that these approaches can be subsumed in the same tradition or discourse?

The example of chapter 3, concerning band organization and resource exploitation, offers the best arguments for an egocentric rather than sociocentric (rule-governed) Pintubi cosmology. The claim, a rather damning challenge to the official Australian discourse on which land-rights legislation has become based through anthropological advice, is presented as merely adumbrating the dominant debate on Australian social organization — a fine-tuning of theories

and countertheories in direct descent from Radcliffe-Brown through Hiatt, Meggitt, Stanner, Birdsell, and Tindale to Peterson and now Myers (71). Certainly, if one wants to be taken seriously in Aboriginal studies, it helps to position oneself in this patriline. But Myers's data themselves seem to me more radical and confrontative than this, and seem to present the opportunity for a more radical synthesis.

Some further consequences of the failure to attend to the contrasts between signifying practices become clear when describing the case of a disputed claim (142). This is contrasted to the present: "The question of ordering claims—of determining who was really boss ... did not have to be decided with the finality of an explicit listing on paper. There was room for pragmatic political ambiguity" (143). Now, these are very important assertions that implicate all literary representation of traditional (oral) life: land claims, social organizational modeling, and ethnography itself.

By contrast to a previous generation of ethnography, there is little recounting or analytic reliance on mythology. Only one myth is glossed, and that for the purpose of demonstrating how Dreaming stories relate to landscape. Myers claims to be avoiding complex problems, which he describes, for publication of restricted Pintupi sacred knowledge. He deserves credit for facing this inherent conflict of interest squarely and making no apologies for respecting Pintupi restrictions. This would at first appear to be good evidence of a reflexive concern for the implications of publication based on a recognition of the subjects' own discourses. Even so, from his own descriptions of the complex negotiations by which the Pintupi ascribe secrecy, it seems unlikely that this solution will serve more than a gestural purpose. Nor is Aboriginal practice analyzed to develop a position from which oral and written practices might be mediated; the problematic remains in the margins, or in this case, outside them. What would constitute a defensible intervention (politically, scientifically, historiographically) of the oral "Dreaming" by printed ethnography remains unaddressed, despite the central place of social reproduction in the text's vocabulary.[3]

Myers's handling of reflexive issues can be illustrated also by his use of Róheim (1945), whose very early but ethnographically marginal Pintupi studies Myers considers. His response to the challenge posed by psychoanalytic theory is to find value in Róheim's data while claiming that "his polemical style tended to obscure his acute ethnographic observations" (108). (Róheim is grudgingly vindicated on pages 247–48 and elevated to "insightful" on page 287.) This damning criticism enables Myers to factor out these "polemics" and appropriate Róheim's "observations." For example, he discards the "maternal separation

anxiety" explanation from Róheim's psychoanalytic reading of paired mythological heroes (which a good deal of Myers's data could have supported) and retains only the "fundamentality of the Aboriginal need for the other" (110). There are two problems with this appropriation. The more particular problem concerns the contemporary reevaluation of Freudian theory, via Lacan, for whom the separation from the mother is perhaps the critical site for a universal explanation of social perception and gender construction. This would seem to make Róheim's assertion here remarkably contemporary, and to offer Myers an opportunity as rich in some ways as Malinowski's (regarding Oedipalism in the Trobriands) to make a definitive ethnographic critique of a theory that has reemerged with considerable force in social philosophy. The dismissal of Róheim's "polemic"—by which I think Myers pejoratively means theory, or theoretical position—is strategically unfortunate and probably unfair. But it may indicate a second problem, which I think is more general, serious, and revealing: the idea that there is "polemics" (or theory) on one hand, and "acute ethnographic observations" on the other, and that one can be separated from the other without violence. There is an extensive critical literature regarding this very issue; without rehashing the whole, it seems adequate to characterize it as claiming that the assertion that such separation is possible is a necessary foundation (and fallacy) of positivism. Indeed, Myers would not claim that the Pintupi would separate language and theory; to reiterate his central point, he claims that Pintupi analysis demonstrates "the emotions and the mind as reflexive products of social action."

Perhaps I make too much of what is little more than an aside in the text regarding Róheim; the point, again, is intended to illustrate a problem I believe is implicit in familiar forms of ethnographic argument and not evidence of a contradiction Myers invents. We have seen ethnographies produced from a wide variety of theoretical positions meant to test all sorts of propositions. With some notable classic exceptions (Mauss comes first to mind), it might be said that time, criticism, and anthropological convention tend to divorce the theory from the data, and often the intended purpose or contribution of the work is lost in the process. After all, it is not Malinowski's response to Freud that we value today in the Trobriand texts. The Mead/Freeman dispute seems to illustrate how difficult it is to resurrect and defend anthropological theory after several generations. The consequence of the theory for the quality of the data has never been well described. The effect is a tendency to forgive inadequacies of theory if they result in rich data and "thick description," which can be valued on its own. I also face this trap; what I want to avoid saying of Myers here is, "Great data, inadequate theory," or worse,

"His polemical style tends to obscure his acute ethnographic observations." I see a way to rule that criticism out of order.

The problem with employing the Pintupi book in this critique is partly Myers's apparent sophistication in recognizing these problems, or at least citing the literature (and its terminology) that does. This makes it more difficult to explain why certain errors are committed. For example, reification is identified early on as a trap, which is meant to be avoided by "social reproduction" models that produce negotiations rather than rules. But in the final chapters, this trap is squarely stepped on without apparent notice in the reification of Meggitt's Warlpiri to provide a contrast to Pintupi society. I say "Meggitt's" intentionally; in Myers's usage, these Warlpiri may not be quite the same as "Munn's Warlpiri" (or "Peterson's" or "mine").

The question of the dividing line between Pintupi and Warl-piri has remained somewhat uncertain, particularly historically, as Myers notes in the first chapter, and as his own analysis of "egocentric" social reproduction would predict. Perhaps the only "ethnographic fact" offered in the whole of the text that seems indisputably contrastive is the differences in the way the connectedness between sites and tracks is reckoned. The Warlpiri are said to relate these as they do semi-patrimoieties, while the Pintupi fail to make this connection. But could this be a recent consequence of the gradual movement of the eight-section system from the northeast over the last 200 years that Meggitt hypothesized? Myers cites Fry's reports that in 1933 the Pintupi had not yet adopted the eight-section sys-tem, and Meggitt's description of the Warlpiri's charge (circa 1950) that the Pin-tupi lacked sophistication in this (183). It appears then that the last 50 years have seen remarkable shifts in Pintupi social organization and kinship reckoning that need to be accounted for. (Bell [1983] responded to this requirement to explain the history of the eight-section adoption in the less recent Warlpiri case.) The Pintupi in (hypothetical) time might come to connect tracks as do their eastern neighbors, a problem the ethnographic present cannot handle. But unlike the Pintupi, the Warlpiri have been instructed in such conceptualizations for several generations, and in my experience have come to delight in comparing Meggitt's diagrams with Nash's or Munn's, or those of dozens of others who in the past and present employ them as informants, translators, and literacy workers, as Myers employed the Pin-tupi. It seems entirely possible that this is a developed consequence of ethno-graphic investigation, a historical rather than a psychological contrast. At least as problematic is a statement reported to me from an old "Pintupi" man at Nyirrpi Outstation in 1985: "We all Warlpiri now."[4]

The synchronic depiction of any particular ethnographic moment will prove difficult to defend for kinship analysis in this case. Myers admits the problem, if not the consequences, and claims that he is placing social life in a temporal perspective by centering the question of "social reproduction" in his analysis. But social reproduction is revealed in the ethnographic present to be curiously static. It does suggest possible paths of historical change, for example, in his identification of the primacy of generational level in Pintupi kinship usage (as opposed to the Warlpiri gender distinctions emphasized in cross-cousin identification), which might conceivably be employed in a historical reconstruction of the Pintupi adoption of section systems. But this matter, which is very interesting and which could provide considerable insight into hoary questions of precontact social change, is not developed. One begins to wonder what is the advantage of the term "social reproduction" over E. B. Tylor's definition of culture as simply "learned, shared behavior and belief." Myers's "ethnographic present" here begins to look much like the "Dreamtime" it describes. It obscures the same historical processes, which implies a reification of another sort, and suggests that what is social consensus in the oral tradition could prove to be reification in the ethnographic one.

If Pintupi identity is so markedly emergent in discourse, how can Myers avoid considering how the anthropological project intervenes in this identity? This is not really a dispute about social facts. The Pintupi probably do privilege negotiation over rights; I am just not convinced that in this they differ from the Warlpiri. This is only one of several examples in which Myers could be accused of inventing the Pintupi, but not like Castaneda invents Don Juan. He invents the Pintupi by defining them in the particular terms he chooses. He draws his boundary between Pintupi and Warlpiri. He even reifies (with considerable aplomb) the group's naming, the very naming that he criticizes. When the next anthropologist goes looking for the Pintupi, they will indeed be there, probably much as Myers has described them. Perhaps the Pintupi come into existence precisely in such texts. I take this as evidence of the need for a broader criticism on the discursive practice, rather than any absolute challenge to the validity of Myers's report. This is admittedly a difficult criticism to mount without separating theory from data or simply saying that from the same data I would have written a book about something else. I mean instead that the failure to attend to reflexive issues is capable of compromising the authority of the interpretation and does problematize the analysis in ways I think Myers means to avoid.

This conventionalized failure of ethnography to articulate its practice has a name: the "ethnographic present." It refers to a conceit that can only

arise where discourse is masked, the author disguised, and the subject objectified. It is symptomatic of a failure to admit that the fieldworker is inescapably employed in a reflexive practice, which can be obscured but not changed by writing about it.

Such criticism necessarily leads us to consider what I take to be very similar criticisms Aborigines make of anthropologists and their models. The last chapter's analysis of recent Pintupi history will have political consequences that are difficult to assess because they interact with competing discourses being employed by Aborigines themselves. Many resent the implications of structural-functional descriptions of their tradition that may consign them (and their struggle) to a place outside history, or worse, alienate them from that history. Myers's purposes in the last chapter are not entirely clear. He does demonstrate there the explanatory power of his negotiation model by accounting for contradictions of "self-management" among traditional Aborigines, as well as setting straight the historical record about the Pintupi's movements into and out of the Papunya settlement. But he positions himself in opposition to the more polemical histories produced by Nathan and Japanangka (1983a), although he understates their place in (and therefore his challenge to) the emerging "liberal/progressive" rhetoric of Aboriginal history. Myers applies his theory of Pintupi management of the contradictions of autonomy and community to particular case studies of meetings held at Yayayi and Papunya settlement (although he fails to explain their historical context, to position them in ongoing political debates, so their importance is obscure to the non-Australian reader). The various and contradictory ways these same events have been reported to authorize different development agendas for the Pintupi make Myers's chapter signally important for Central Australian politics. Other critics certainly will debate whether he legitimizes a protectionist agenda in his reading of the "boss"/"boy" relationship. But I think the description of how Pintupi manage the new demands of settlement politics in terms of their traditional values justifies his implication that the outcomes of their preferred discourse strategies may not always produce results they intend or be in their best interest. How such a finding will be regarded in the political environment on which it comments is not noted. This applies also to the case of community-controlled health services, which are problematized in an account of the Pintupi's own evaluation of the historical case, which disputes other reports (see Nathan and Japanangka 1983b).

Pintupi Country, Pintupi Self proves here to be in a competition—both with the oral tradition of the Pintupi and with recent written non-ethnographic accounts—to inscribe Pintupi history. To complicate matters, and

politics, some of these alternate written accounts are asserted to be products of Aboriginal participation and control. Myers himself emphasizes the rights of senior men to produce and reproduce the "conscious collective" (he cites Durkheim; 255) and acknowledges the centrality of this task to Pintupi autonomy. He admits, but does not pursue in the text, events that demonstrate how oral reproduction is challenged by a written reproduction. This raises a problem in historiography that is in fact anticipated in the last chapter, which discusses to what extent a whitefella could be accused of "not helping" the Pintupi. But the question is not applied to Myers as author; it is not asked whether by writing this history he oversteps his authority and violates the bond of trust, which is revealed in this last chapter to concern considerably more than merely not displaying sacred objects or quoting secret texts.

Perhaps the historiographic problem can be summarized by the observation that the Pintupi maintain no categories of fiction. "A story either happened or it did not. If it did not occur, the story is a 'lie'" (49). This commonplace observation among Western Desert peoples remains curiously unanalyzed in the ethnographic texts, which themselves are problematized, I think, by this pivotal condition of Aboriginal discourse.

We have before us several competing histories of the Pintupi movements in and out of Papunya. What is their factual status, in Aboriginal terms? Which will be inscribed historically? Does inscription itself compromise Pintupi autonomy, which Myers claims is so central? Does the very vulnerability of these people account for their selection as ethnographic subjects? These questions, of course, apply to every ethnography, and perhaps every book, newspaper article, videotape, or film. Myers does not find a solution, unless we presume that creating ethnographies is itself a solution. But we have a right to evaluate how any author problematizes these matters. In this case, there is reason to fear that the failure to address these consequences of one's own practice may prove intentional. The objective would be to avoid issues that would make this a far more difficult book (to write? to read? to evaluate? to live with?). Still, I believe we now have a vocabulary with which to approach these questions, if not to solve them. Myers himself contributes to this vocabulary with the beginnings of some perceptive insights into Aboriginal discourse. But his perception seems to dim where his own "personhood" and role in "social reproduction" is involved.

There is a poignant section that describes how the "boss" for Yayayi, who stood in mother's brother's relation to Myers, unexpectedly shows him the store of sacred objects just before his departure from his first fieldwork.

Myers reads this event as personal evidence of the man's authority: "More than a great trust, it was a demonstration to me of who he was" (245). This is the interpretation Myers's psychologistic analysis would of course lead him to. But I believe he misses a more central purpose of this demonstration. He mentions in telling the story the man's own explanation that he has stored these things here as evidence of his commitment to remain around Yayayi. This I take to apply to Myers, an example of a familiar Western Desert discourse strategy where demands are not directly made. The old man is not only saying who he is, but who Myers is. He is not only demonstrating personal power, but also, more strikingly, Myers's obligation: to return, to hold, and to care for the Pintupi (who, we have already noted, are not terribly interested in his academic brief). (Compare also page 283 on the principles of reciprocity and the attribution of these to Whites.) I find it odd that Myers either misconstrued this encounter or limited his analysis of it. But that is what my criticisms of the ethnographic mode predict will happen in such cases, and it underscores again what appears to me to be missing in Myers's analysis—Myers himself. This is an absence more characteristic of positivism than of the practices that criticize it. To the extent that Myers, or anyone, invokes critical literature and then proceeds in this fashion to disregard it, how are we to regard theoretical claims made in introductory disclaimers?

 The question then is not personal but structural, and it applies to the original challenge I identified concerning *Pintupi Country, Pintupi Self*: Does it achieve a new synthesis of ethnography and the theories that criticize it? Or is it superficial, achieving little more than hitting on some intellectually fashionable bases at risk of compromising an assumed ethnographic responsibility to inscribe these last hunting-gatherers? Or is *Pintupi Country, Pintupi Self* really a valiant effort that evidences definitively the limitations of anthropological discourse: proving that ethnography cannot resolve the contradictions of its own inscription practices or permit the ethnographer a reflexive position?

viii

Bad Aboriginal Art

[1 9 8 8]

DURING 1987 the Australian press reported frequently that Aboriginal art, especially Western Desert[1] acrylic "dot paintings," had become flavor of the month in New York, Paris, and Munich. "Flavor of the month" is an odd descriptor Australians overuse to resolve the incompatibility of such reports of Australian success overseas with a cherished and characteristic myth of the second-rate, sometimes labeled "cultural cringe." Indeed, Australia now has a suspiciously elaborate terminology for identifying the contradictions of colonialism and creativity. The notion of radical unoriginality is claimed to privilege this discourse, so that Sydney, for example, now asserts itself as the most dislocated, imitative, unoriginal, and therefore *postmodern* city (which only goes to show that Sydneysiders never make it north to Brisbane).[2] What Australia (and postmodernism) may not have a vocabulary to deal with so readily is the unwelcome appearance of any possible claims to authentic creativity, as with our own indigenous art.

In this essay[3] I want to consider examples of the *mise en discours* by which Aboriginal Australian paintings are positioned for sale in contemporary markets, in order to ask what chance exists for the work to command serious prices, and to note some peculiar difficulties of evaluating it. I want to consider the curious fact that almost nothing of this work is ever designated "bad"—a lacuna that would not seem to make it easy to sell anything as especially good, either.

There are exceptions (including a vulgar judgment that all primitive art is bad), and I will feature some as examples here. But my main purpose in this essay is to advance a critical perspective on some contemporary Aboriginal painting practices in what I believe must be uncharacteristically contemporary terms: to identify how particular "primitive" painting traditions can articulate what have been identified as issues in the postmodern debate, and to describe why such painting might be of particular interest (and value) right now. Considering Aboriginal art practices as problems in contemporary discourse—problems of production, circulation, and exchange—may indicate that something about world economics and ideology is also centrally involved here.

Neo-Kantianism asserts more than just the end of determinate concepts and, therefore, of any consensus in aesthetic taste (see Lyotard and Rogozinski 1987). That we no longer think it odd that a commodity comes onto the market whose uncertainty of value seems itself part of that value is arguably itself a consequence of this aesthetic dilemma. As the auction traffic of the 1980s at Parke Bernet and Christie's has shown, the creations of value now can come quite late in the production game, to the point of challenging the approved methodologies of materialist analysis. Part of what makes "fine art" particularly attractive to the investment market obviously must be this negotiability of worth based on cultural rather than material calculations. But material constraints also underpin the contemporary art market's evaluations: these include a concern for the identity and scarcity of the resource. Art history links these calculations to certain conventions of authorship and assumptions of creativity.

Jean Baudrillard has traced these conventions to a history that predates the industrial revolution in an account of how it has become established that the individual artist/author/identity now constitutes the domain of value: "The painting is a signed object as much as it is a painted surface" (Baudrillard 1981: 102). It is not a given artwork but named individual artists who (with respect to their oeuvres) are judged better or worse; from that assessment, when it is approved in any critically designated moment, flows the assignment of market value to particular signed works. The signature, in this system, does literally sign the commodity and constitute its value. A "bad" Picasso will probably cost more than a "good" Sidney Nolan, assuming that we still have critics willing to risk discriminating between particular works of individual artists (on grounds other than typicality to an oeuvre).

One attraction of this system, at least to the present machinations of the speculative art market, is that the artist's oeuvre provides a manageable

limitation on the availability of the resource, which is the number of paintings produced in a given individual creative lifetime. Here the importance of an artist's death is related to the closing of the series, that essential limitation that allows a far more definitive postmortem valuation of the work than is possible while the artist is alive and continues to produce.

In all of these terms, "primitive" art (particularly Aboriginal Australian paintings, and specifically Warlpiri acrylics, with which I am most familiar) poses certain intrinsic problems of valuation and even evaluation, because it involves very different creative and authorial practices:

1. The modes and relations of production from which many Aboriginal forms arise do not emphasize original creative individuals or assign them responsibility as authors. Instead of an ideology of creative authority, there is an ideology of reproduction. The artist is *counterinterpolated to* the tradition so that the art masks inventiveness and authorial intent.

2. In the example of Warlpiri artists, the body of work is predetermined; one earns rights to paint certain preexisting designs, not so much to introduce new ones. Death has no purchase here. Rights to an oeuvre are inherited so that one's son, daughter-in-law, or some other (usually explicitly prescribed) individual continues producing the same designs. The details of this system are complex.

3. Consequently, plagiarism is impossible in Western Desert painting. What is feared, instead, is thievery—the unauthorized appropriation of a design, as well as the potential for such stolen designs to convey rights and authority to the thief. A forgery adequately executed, when circulated, may be no forgery.

4. Everyone in traditional society is effectively entitled to paint certain designs, not from particular notions of skill or talent (i.e., personal predispositions) but as a result of certain negotiated positions within systems of inherited rights and obligations. These design traditions are considered to originate in a collective past and to project toward an infinite, impersonal future. By necessity, the authority of this system would be

compromised by an ideology of invention that singled out individual producers.

Because my focus here is on issues of practice and exchange, the above list does not pursue the observation that Western Desert symbology resonates with contents privileged in contemporary international painting. For example, I do not consider a recent argument by George Alexander: "Today images are read as texts and texts are read as images. Something strangely calligrammatic is afoot" (Alexander 1987; but see my examination of the "reading and writing" of Warlpiri symbolic content in chapter 5). Rather, I am concerned with contrasts of the sort Baudrillard has identified between modern art and some apparently historically prior, pre-industrial practice in which artistic creativity also is not emphasized:

> *In a world that is the reflection of an order (that of God, of Nature or, more simply, of discourse) in which all things are representation, endowed with meaning and transparent to the language that describes them, artistic "creation" proposes only to describe.... The oeuvre wishes to be the perpetual commentary of a given text, and all copies which take their inspiration from it are justified as the multiplied reflection of an order whose original is in any case transcendent. In other words, the question of authenticity does not arise. (103)*

This actually refers to something more than a contrast between modern and an unspecified "traditional," practice. Unlike Lévi-Strauss (who covers some similar territory in *The Savage Mind* with his notion of "bricolage"), Baudrillard is not really interested in defining primitive art but in anticipating a postmodern critique of originality in the "age of reproduction." For him, these questions of authorship, ownership, and signature within a radical reproductive practice seem to be at the core of postmodernist activity. Not only do we now have a genealogy of unabashed reproducers and imitators (from Duchamp to Warhol to Sherrie Levine) but also the great forgers of both recent and distant past (Rrose Sélavy, Dali, and maybe da Vinci) are reevaluated in a more positive light. Practices once of interest merely to ethnography, ascribed to pre-industrial culture (but obscured when marketing so-called primitive art), now resonate with modern or postmodern aesthetics and obviously affect the manner of inserting "traditional" works into the contemporary market.

A full, academic treatment here of the subject would require a review of the critical literature on Australian Aboriginal art, necessarily focusing

on the anthropological contribution given the paucity of any other. Recent articles by Howard Morphy (1983) and Vincent Megaw (1986), for example, take up the question of the intrusion of European history and aesthetics into "traditional" Aboriginal painting practices—a question whose significance the Berndts identified in their pioneering work on Arnhem Land barks (R. M. and C. H. Berndt 1949, 1950). This work may be set against the more familiar taxonomic pedantries that characterize rock art studies (see Ucko 1977), which offer a less problematic invocation of an unsullied tradition. The collection by Loveday and Cook (1983) of "applied essays" on the market is helpful. But in none of this literature is there really anything other than an ethnographic standard promoted for evaluating particular works: aesthetic judgments of value are avoided. This would be the expected consequence of Australian academic positivism, which required until recently (when the funding ran out) an "objective" separation of commerce from scholarship. The result masks what in fact may be an implicit standard of "traditionalism" and "authenticity" that, by avoiding definition, seeks to avoid aesthetic controversy and suppress possible alternative "nonexpert" judgments. But if Baudrillard is right, then traditionalism and authenticity are now completely false judgments to assign to Aboriginal painting practices. This is borne out by contemporary ethnography and material history. The situation I worked in at Yuendumu demonstrated unequivocally that the Warlpiri painting I saw, even if it accepts the label "traditional" as a marketing strategy, in fact arises out of conditions of historical struggle and expresses the contradictions of its production. This is really where its value and interest as "serious" fine art lies; furthermore, it may also be the source of its social legitimacy. To make any other claims is to cheat this work of its position in the modernist tradition as well as to misappropriate it and misunderstand its context.

This Acrylic Lasseter's Reef

Consider a recent article in *The Weekend Australian* (August 8–9, 1987) that describes an intriguing expedition to the Warlpiri at Yuendumu: some anthropologists from the South Australian Museum, a French ethnographer studying at the Australian National University, an "important" art curator (from an unfamiliar but nonetheless New York gallery), and, by implication, the journalist. These clever sorts managed to discover a whole tribe of Picassos in the desert, presumably a mysterious result of spontaneous cultural combustion. We're told of the curator's astonishment at finding more painters per capita of population than in Manhat-

tan's SoHo! The tedious description of painting as the desert's new cash crop is trucked out again, as if for the first time. Here we have any number of the current discourses on "Aboriginality," art, and cultural cringe personified:

> A pair of authorized Australian academic experts properly institutionally affiliated, assisting in the location of this hidden treasure — this acrylic Lasseter's Reef[4] — in the distant outback (Burke and Wills? Spencer and Gillen? Lone Ranger and Tonto? — Why do men always go among the natives in pairs, and why, incidentally, do women go alone?).

> An anthropological student who speaks this complex Australian language absolutely fluently (as only the French can!), and proves to be intimate with the natives (she is shown fondling a baby in a six-inch photo).

> And the requisite overseas valuer ready to pronounce the work "first-class, export quality," or at least worth a full page in *The Weekend Australian*.

As proof of the value of the art, with New York and Paris both represented, who could ask for anything more? But I find it telling that no historical perspective is offered in this article. It's as if Nancy Munn had not described Yuendumu graphic traditions, and some of the very same artists, a quarter century ago (Munn 1973). As if the half-dozen canvases hanging in the Australian National Gallery ceased to exist, as well as a number of current private shows in Sydney, Melbourne, and Perth (implying that this art is too valuable, or difficult, for the Australian public to see and appreciate). As if a book describing examples of this work (Warlukurlangu Artists 1987) hadn't been launched a few weeks previously and wasn't concurrently being reviewed in the national press.... We never discover that the community has been engaging in five years of difficult arts organizing and marketing, resulting in dozens of shows and hundreds of thousands of dollars of sales in the last two years. There is no mention of what is, for the artists, the very important if somewhat seedy history of art advisers, marketing schemes, and attempts at state intervention that resulted in an all-too-typical history of missing profits, receipts, and paintings. All or any of that would obviously compromise the myth being manufactured, and thus their stake in the promotion of the art. The

material circumstances that produced these paintings are obscured by such fantastic reports.

The overseas expert did, however, raise an issue of interest to us here—his astonishment at Central Australia's demography of creativity. Given so many painters, what is the limitation on the body of Aboriginal art that closes the series, identifies the degree of uniqueness of art work, and assures its rarity value? We may be in some difficulty when admitting that each of the 50,000 Aborigines classed as "tribal," and (arguably) each of the 250,000 urban and rural "nontribals" as well, is entitled to claim the signature "Aboriginal" for nearly any product. The facile reduction of contemporary Aboriginal painting to a cash crop is certainly encouraged by such a situation.

Is an assertion of authorship the only marketing solution for Aboriginal art to be classed as "fine"? Do painters need to succumb and assign a personal signature to their work to solve the problem? Andrew Crocker (1987) has argued in the catalog for a recent solo show that it is a necessary precondition for any serious critical attention. I disagree. Postmodern debates offer some very interesting alternatives to individual authorship, into which Warlpiri production practices may be fitted comfortably at the same time as they advance these debates. Even so, one finally must admit sympathy for the arts advisers and tourist-shop proprietors who fall back on the old crafts-pricing criterion of so much neatness per square inch. In what other political or aesthetic circumstances would anybody be willing to identify anything as bad Aboriginal art? In fact, some recent reports of the "desecration" of desert paintings may imply just this sort of judgment.

The Case of Bad Rock Art

I began with a search for bad art, but so far have mostly discussed bad talk. Tangible examples of bad Aboriginal art may not be so rare as implied; some are close at hand. The most startling case concerns the recent "restoration" of certain Western Australian cave paintings (the so-called Wandjinas) by unemployed Aboriginal youths from Derby, producing a result claimed by some to be rather more like tea towel kitsch than original 5,000-year-old designs. The circumstances, as reported by the popular press and television, involve Mr. Lorin Bishop, owner of Mt. Barnett cattle station in the Kimberleys, and his concern that the designs painted on a cave rock face situated on the property were deteriorating. He contacted the Federal Minister for Aboriginal Affairs, seeking advice. The result was a $110,000 commonwealth employment (CEP) grant, administered through the

Wanang Ngari Cultural Corporation in Derby, 310 km. east of the site. The young workers were brought out from Derby with video and still cameras. After recording the site, Bishop charged, they painted it out with "housepaint, aquadhere, wood glue and plastic" (*The West Australian*, August 8, 1987). It was then repainted from the photographic record, according to a subsequent lead story on *60 Minutes*.

One can study the example as a typical tragic case of bureaucratization of Aboriginal processes that ensures the defeat of the culture. Why did Bishop write to a federal minister instead of just heading down the creek to talk with the local Aboriginal stockmen, who were either Ngarinyin owners responsible for the cave and its paintings (according to *The West Australian*) or would know who was?[5] Why did Canberra in turn contact Derby rather than the locals? These were the pivotal questions raised at a later meeting between the concerned parties and Bishop, recorded on video by the Wanang Ngari organization—presumably with the same offending camera as was purchased for the project.

Reasons for such disrespect may be self-evident to anyone familiar with Aboriginal affairs in Australia, but would require hundreds of pages of sociology and historical analysis to begin to explain to anyone else. A brief gloss would say: colonial Australian administration has always refused to recognize that there is no one Aboriginal culture but hundreds of them, as there are hundreds of distinct languages, all insistently autonomous. Local political systems promoted no "leader" to be taken to, a problem that apparently stymied Captain Cook and has plagued 200 years of subsequent race relations. The overarching class "Aboriginal" is a wholly European fantasy, a class that comes into existence as a consequence of colonial domination and not before (although many Aborigines will make concessions to this fantasy, seeing possibilities thereby for political and economic power). But my point here is not to explore the political background or criticize the bureaucracy. I'm not convinced it was the government that made the art bad.

The evaluations that resulted from the "restoration" were represented in the media in headlines like "Priceless Art Desecrated, Grant Cancelled" (*The Australian*, September 11). That such matters should command front-page banners in the national press itself must be noted. Other issues provide us with some more thoughtful features ("Coming to Grips with a Living Culture," by Alex Harris, *The West Australian*, August 18), or offer the editors opportunities for some quite startling agenda-hijacking editorials ("How Sacred?" *The West Australian*, June 15). It remained for *60 Minutes*, that uniquely Americanized news and

features format, to raise the alarm to a more general public. *60 Minutes* reported the story using the following cast of characters: Lorin Bishop, the station owner/ protagonist; Michael Robinson, sites officer from the Western Australian Museum (the bureaucrat officially responsible for Aboriginal sites and paintings); David Mowarljarlai, Aboriginal elder and chairman of Wanang Ngari who organized and administered the grant and oversaw restoration; the requisite "anthropological expert" (one who seems suspiciously to emerge only on TV and whose credentials were properly questioned later by Mowarljarlai); and the old men whose cave it was said to be and whose responsibility these paintings presumably are, along with some of their young descendants.

 This entire cast, excepting Mowarljarlai, claimed the effort was a disaster, one of the remarkably rare examples of a consensus that defines a work of Aboriginal art as bad. But Mowarljarlai's defense of the outcome was more interesting than it was allowed to appear. Certainly, he would want to deny accusations of having participated in sacrilege and desecration. In this account he does seem to have been operating well beyond any local basis for authority (although he might well be able to claim some traditional association with the area of the cave; none of the reports discussed this, which, from the juridical perspective, is the critical point). Although the rhetoric of the program resists empathizing with Mowarljarlai, he is allowed to raise some telling points: for example, he privileges the pedagogic function of these paintings, arguing that, although perhaps 5,000 years old, these paintings would have been cyclically renewed on ritual occasions in which young initiates would probably play a part not entirely different from the one that the young fellows from Derby played (the point taken up in Alex Harris's feature). It would have been fair to ask why the local owners had let the paintings deteriorate, or whether this was entirely in the perception of the station owner — who, we only discover later, runs a tourist business on the property. But one has to look elsewhere for such pertinent facts, or to find Bishop's more blatant statements that may help to explain his motives — such as "the safeguarding of these relics is too important to be left to Aborigines" (Harris). The question of authority is pivotal, but can't be resolved with the data made available through these reports, which are contradictory. Certainly, Mowarljarlai believed that the designs were in bad shape and that he rescued them. The other grounds for objection seem related to the technology: materials (permanent acrylics rather than soluble ochres — the actual media are variously reported in the different accounts), the accuracy of reproduction (one report has shorts painted on an "Aboriginal God"), and perhaps

the use of camera images as authorities instead of Aboriginal elders. Mowarljarlai was allowed one great line. When the reporter asked why they couldn't have practiced first on another rock, he said: "Aborigines don't practice."

Mowarljarlai may be denying any possibility of a traditionalist aesthetic judgment of art products, or at least of Wandjinas such as these, privileging their process and practice instead. He refuses the notion that the cruder, less detailed, more graphicized acrylic version is less valid, less "good" than any original. Even when such an evaluation is imposed on him, he resists it, challenging in turn the prerogative of others to make these judgments.

The episode of the Wandjinas is ripe, perhaps overripe, with such cross-cultural discourses; but I leave it to others to analyze the full implications. I am more interested here in how the critical consensus manufactured by the mass media—an apparently clear, determinate judgment of bad Aboriginal art—dissolves instead into a dispute requiring a historicopolitical analysis more than an explicitly aesthetic one. We cannot rule out circumstances in which legitimate Aboriginal owners might have made the same "mistake." If that were so, then we would have a less convincing instance of such bureaucratic offenses, providing a particularly difficult case study in the politics of Aboriginal aesthetics. Therefore, this episode is not the best illustration of my thesis. I believe I can provide a better example, one with which I am more familiar: the "Yuendumu doors."

A Telling Secret

The "Yuendumu doors" is a series of 30 to 40 "traditional" dot paintings on the doors of the primary-school building at Yuendumu community. (To call these paintings traditional requires qualification: for example, translators had a difficult time finding a Warlpiri-language equivalent for "door" to use in the bilingual documentation.) Yuendumu is a settlement of about 1,000 Warlpiri people, the product of a government-induced movement from the desert regions, west and northwest of the present location, mostly during the 1940s. The community can be a strange and anomalous sight. It retains the skeletons of several discourses applied to it over the years: Baptist-missionary, government assimilationist, self-determination, and, lately, Country / Liberal Party "Tidy Town." Whatever one makes of the jumble of abandoned buildings, new demountables, white-painted rocks, satellite receiving dish, and graffitied walls, it is soon clear that the residents view all this with eyes quite different from what Europeans first imagine. The Education Department is the major landholder and most visible presence in the community. Commissioning the doors in 1984 was intended to make the school look "more

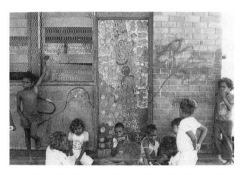

Painting on the school doors. From *After 200 Years: Photographic Essays of Aboriginal and Islander Australia Today*, ed. Penny Taylor (Canberra: Aboriginal Studies Press, 1988).

indigenous." A number of senior men, mostly connected to the school already as cleaners and yardmen, were enlisted, supplied with acrylic poster paints, and promised five dollars per door.

The result is fully documented (Warlukurlangu Artists 1987). But that process—the recognition not just of the doors but of a painting oeuvre that came to be dubbed the "Yuendumu Style"—provides an interesting history. For the original pronouncement by designated valuators was that the paintings weren't very good. When the official experts of the Inada Holdings Pty Ltd. (a Department of Aboriginal Affairs operation then engaged in attempting a monopoly of all nonurban Aboriginal art marketing) first saw these early paintings, they suggested that the artists might wish to spend some time at Papunya settlement to learn their craft and improve their technique—and that federal funds might be found for such training.

Papunya is the mother lode of the Western Desert painting movement. In 1971 a sympathetic and innovative art school teacher, Geoff Bardon, bucked the assimilationist policy of the Education Department and recognized in the old mens' wall paintings something eminently worth encouraging. After muralizing the Papunya school, the men moved on to boards and canvases, forming an artists' cooperative and, by the late 1970s, attracting considerable interest among cognoscenti in Sydney and Melbourne. At least some of this interest concerned the appearance of old forms in new, marketable media.

Bardon (1979) describes how he exercised, though hesitantly, some selective pressures in his role as art adviser, an unavoidable consequence of such bidirectional mediating between artists and markets (15). When he commented on some representational animal forms appearing alongside the abstract

Western Desert iconographs in an early painting, the artists painted them out (14). Bardon presumes, but doesn't bother substantiating, that such representationalism implies modern influences. Even so, he denies any justification for imposing his own aesthetics ("I was always conscious that I must not intrude my own opinions about colors, methods or subject matter"); but such contradictory evidence of an enforcement of "traditionalism" is striking. The same contradictions can be detected in nearly all arts advisers' confessions—they are built into the project. What may differ is how they are managed and, then, how they are admitted.

The earliest Papunya paintings look similar in many respects to the first generation of Yuendumu canvases produced a decade later. The communities are nearby (150 km. apart), they are closely related by kin, ceremony, and language, and share rights to many of the same designs. By the late 1970s, with land rights and the end of restricted movement, the frequent traffic desired by residents between the two communities became possible. Despite ten years' lag between market painting at Papunya and Yuendumu, the logistics of using the new media (acrylics, rectangular portable surfaces) combined with the overlap of local graphic traditions in such a way that the early work from the two sites is strikingly alike. This seems to support Bardon's claims to nonintervention. But within a year or so of the introduction of acrylics, something already remarkably different had begun to happen with Papunya painting, imparting its characteristic look, which deserves a hypothetical reconstruction here. For as the painters interacted more and more with Australian and then overseas markets, attracting sophisticated brokers, critics, and patrons along the way, the "Papunya Style" began to interact with certain issues in 1960s and 1970s international painting, especially the extreme schematizations of New York minimalism.

Art advisers can deny influencing indigenous art until they are mauve in the face. But even if they never commented on a painting in progress or completed, by word or look or gesture or price, in Central Australia at least one irreducible source of influence persists: materials. Unlike Arnhem Land, where local bark and pigments are still collected, marketable painting in the Centre requires a supply of canvas and acrylics, and the painters consider this to be the adviser's first responsibility. As Papunya art became recognized, it obviously received advice on materials justified by arguments of durability and suitability for the museum/collector market it was attracting. Canvas boards and school poster paints would no longer do. What evolved was the use of raw linen and thinned acrylics. This produced a comparatively flat, stained surface. There must have been some restriction on paint colors during the late 1970s, emphasizing an

"authentic" earth palette: red, yellow, and white ochres, browns and pinks (what Brisbane upholsterers call "autumn tonings").

A set of conventions seems to have arisen at Papunya — at least partly as an articulation of these modern materials that favor the precision, placement, and coloration of the "fill" dots. This resulted, I suspect, in the curiously schematic, minimal, Jules Olitski / Agnes Martinesque technique, as much as the ensuing critical and market approval. The look was muted, cerebral, and undeniably tasteful in exactly the way that tourist Aboriginal art — black, red, and yellow cartoons (also the product of an invented palette) — was not. By 1980 there had arisen an easily recognizable Papunya Style. Not all painters adhered to the style, and some truly original works were produced that don't at all fit this description. But to the extent that an industry came into being (by now promoted and fought over at the national level by the Australia Council, the Aboriginal Development Corporation, and marketing units within the Department of Aboriginal Affairs, as well as museum/university staffs), it produced that redundant, recognizable, brand-name product: *Papunya Tula*.

Desert Aboriginal ground, body, implement, or rock art employs earth pigments, animal products, plants, and feathers. Each material, in a manner Lévi-Strauss associates with "bricolage," retains its association with its source, origin, and locale, and brings these into the work as elements of its meaning (see chapter 3). Even the words for the elements used may signify all of the associations: red ochre from Karrku Mountain is called *karrku*, which may signify "red" generally. Thus color is only one basis for identifying, choosing, and then "reading" a medium. But with acrylics, color is the only basis for differentiation. This radical difference in the semiology of materials can take some getting used to, but in the end may free the artist in another sense, presenting new choices unavailable to the bricoleur. My argument is that there is nothing that can be called "traditional colors," as the concept is quite alien in this context. Never mind the evidence that precontact palettes in fact contained green oxides, pink and blue flowers, and other shades now judged nontraditional. The very idea of choices based solely on color is itself a result of contemporary conditions and materials.

Were the Papunya painters totally passive, while their art advisers conspired with the market to invent Papunya Tula aesthetics, to define both the "good" and the "tasteful," and to construct the painters' authenticities in the process? The invention of such traditions was possible only because what mattered to the painters about the art was usually quite different from what mattered to Europeans. Specifically, acrylic colors offered all sorts of decorative possibili-

ties, but were conceptually so unlike traditional media that these painters probably regarded color as incidental. Likewise, dotting, which came to be the strongest visual element of the Papunya Tula style, was generally background, mere fill, inconsequential, and often omitted in the ground and body paintings on which these canvases were based.[6] This technique, which privileges pattern and grid, tends to play down the iconographic figures. The mythological text remained hidden and obscure, which was fine with the painters, who at first had great difficulty (according to Bardon) in keeping secret designs out of the canvases and off the market.

It is too bad that Nancy Munn did not take an active role as art adviser during her field studies of Warlpiri iconography in the 1960s. Imagine if she had. Given her interest in Warlpiri proto-writing, wouldn't she have encouraged, even unconsciously, a technique that resisted this tendency to foreground the semantically empty dots at the expense of iconic forms, and preserved the centrality of the figure against the ground? The example is not entirely hypothetical. My own researches 25 years later, not unlike Munn's, concerned issues of semiotics and communication in which Warlpiri iconography was of considerable interest. I began working with the old men on their painting as a respite from my researches and the more politically confrontational video work with the younger men (I intended only to satisfy my own creative interests in a setting that I might find less emotionally demanding, less painfully contradictory). In short, I saw my involvement with the painting studio as an indulgence. I was aware that the old men, frustrated by my refusal to become involved in ceremony (atypical for most anthropologists), considered my participation in the painting activities to be a means of not merely teaching me but of establishing my accountability to them — a lacuna that had persisted rather too long at this point in my fieldwork. Whatever the motives, those lovely days spent sitting around, priming canvas, getting water, fetching tea, assisting where and when requested, were among the most pleasant I spent at Yuendumu. If painting subsequently proved the basis for many surprising insights and actions, I still thought of myself as on holiday from my formal research and free of any scholarly agenda. But good ethnographic questions are not always imposed; some may only emerge from the fieldwork itself. The differences between Yuendumu and Papunya painting posed a contrast with considerable implications.

If Papunya Tula seeks to distance itself from tourist art, then what does Yuendumu art oppose and engage? Two possible solutions may be developed. First, the Yuendumu style seeks to distinguish itself from Papunya

Tula, partly as a marketing strategy and partly on the basis of an implicit criticism of the legitimacy of certain technical choices generally regarded as externally, and perhaps unnecessarily, influenced. However and by whomever they were made, certain formal choices employed in Yuendumu painting contrast dramatically with those made at Papunya. As adviser and in-house critic at Yuendumu, I at least gave no encouragement to neatness or limited palettes; nor did Peter Toyne, then an adult educator, or Mark Abbot, the first Warlukurlangu art adviser. We all favored the "sloppy" style that first appeared on the doors, where I imagined I found confirmation that neatness was not a preferred criterion for the painters themselves. Yuendumu painting during this time was bold, bright, colorful, and messy—perhaps "gestural." It turned out that the symbolism assumed a fully central place in the image, which meant that the contemporary preference for "something strangely calligrammatic" was also engaged. Consequently, the shift in Western Desert painting styles closely imitates what occurred in the international art world during approximately the same time (say, in very general terms, the apparent shift from Minimalism and color-field painting to Neo-Expressionism). Thus the Yuendumu product might well look at home in any contemporary New York gallery, without even so much as a program note to describe its Aboriginal sources—a hypothetical and wildly subjective criterion I sometimes applied in my personal evaluations. Here, an anecdote might confirm that such a phenomenon is only possible when the painting practices are freed from Papunya tastefulness.

One of Yuendumu's more prolific and accomplished painters had been spending considerable time with close relations at Papunya. While there, he joined in on a painting work (not at all an unusual reciprocal cultural exchange). On his return, he joined a group of four to six men attempting an especially large canvas—a Milky Way Dreaming. The preference at Yuendumu for collective painting is preserved, especially on larger canvases. To describe these relations of production requires a full treatment of Warlpiri kinship and social organization too detailed to attempt here, except to say that our painter did not have primary responsibility for this Dreaming or this project. The senior man who did was noted for his expansive performances at such times when he was in authority, and in this case he defined and took up a position at the head of the canvas that was rolled out on the ground (Yuendumu also preserves this association with sand-painting). Work proceeded over several days.

Midway in the process I noted that the painter who had just returned from Papunya had brought the dotting style back with him: orderly rows

of contrasting dots in the characteristic palette. This imparted a very unwieldy look to that corner of the painting, the rest of which, by hue and design, appeared stylistically wholly different. Sometimes such differences work and create appealing textures that articulate the social complexity of the painting collective. In any case, one is hesitant (as Bardon said) to offer any explicit critique. Usually, things work out.[7] But now I was getting nervous, as this large canvas represented a major investment in labor and materials. It was one of those occasions that screamed "major project." The men were already talking about a sizeable return for this one. So I intervened.

I casually inquired of the senior painter (not the offender) "what he thought" about the dots. Were they part of the Dreaming/Story (*jukurrpa/jimi*)? No, of course not. He went over the story again, tracing the large dark figures centrally placed in this canvas. Sometime later, I remarked that it was hard to see the story in the Papunya-looking section: there were so many colors, the dots looked like *jukurrpa* (text). Europeans might get confused looking at the picture. I held my breath.

Everything stopped. With the grand gestures I associated with the senior painter, a pronouncement was made. My Warlpiri is not good enough to follow the specifics, but a full ten minutes was spent discussing the matter, which resulted in a paintbrush being applied to some of the offending section, producing a more consistent and less defined area of fill. The painting subsequently set a new record for Yuendumu prices and now hangs in the Australian National Gallery—whatever that tells us about our example, and whatever questions it raises about interventions.

The choice of dots as background or foreground is one of the contradictions of intervention that tends to occupy the thoughts of most Central Australian arts advisers I've discussed it with. Dots label and authenticate desert acrylics for the European viewer, but may be inconsequential to the painters, for whom dotting might be likened to striping in wallpaper. Dotting may be treated as a chore, assigned to junior painters. What if it should actually be discovered that a European was responsible for applying these dots? (At the instruction of an Aboriginal painter, of course). Wouldn't this disqualify the painting from the discourses of authenticity, of spontaneous, untainted production, which are still employed in its marketing, thus raising scandalous assessments of the advisers' professionalism and judgment? Or could we mount a myth based on the practices of classical and contemporary masters who employ others to do the backgrounds,

draperies, clouds, and so on? This situation is not mere conjecture. There are "Aboriginal" paintings hanging in major collections that include large areas filled in by Europeans. My argument so far leads me to accept that this is perfectly valid, and that any notions of authenticity that are compromised by such practices are false criteria in the first place. The matter may be illustrated even better with a more peculiar, inverse example.

Earlier on, I wondered to what extent the brushes we provided, and the consistency of the paint itself, were affecting the dots as well as the difficulty of application (some of the older men tired easily). We were painting in an Education Department house in which I was also camping. One day, after the painters had all left, I took off a half-meter of canvas and attempted my own painting. I invented a "Dreaming" based on a favorite locale from home, spent a few hours painting, and made some useful discoveries about technique. Later, I rolled up the half-done canvas (which, I thought, failed to look at all Warlpiri) and promptly forgot about it. Several months later, I discovered my painting exhibited at the community store. Not only was nobody particularly fussed by the fact that this Dreaming, and its author, were unidentified, even unidentifiable, but the painting had been completed—the dotting filled in—by some old men in my absence!

Let me propose a partial response to what I take to be something of a challenge to our usual ways of thinking about art authorship and sales (but also authenticity and tradition) represented by this case. I earlier asked the question: To what does Warlpiri art oppose itself? The evidence suggests that the opposition to Papunya Style that I detected and encouraged may have mattered to Europeans, but had little relevance to what the painters themselves were concerned with. The history of the Yuendumu doors again may provide clues.

Bad to Paint on the School?

One of the intentions of painting the Yuendumu doors was to prevent the children from messing up the school with graffiti, as had often occurred. At least, some of the old men rail against this graffiti at great length. They go so far as to question the value of literacy, when its only visible result is said to be these scrawls on public places. It was an open question whether the kids would subsequently respect the doors and keep away from them. As it happened they did not (although some doors have been overpainted and graffitied more than others, and some study could be made to see if there is any semiotic calculation at work here, though I

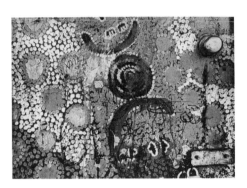

Graffiti on one of the Yuendumu doors. Photo by Eric Michaels.

doubt it). Indeed, in all my years of visual recording at Yuendumu, in what I intended to be a respectful manner, the only time I disputed a prohibitory judgment was when taking pictures of the children's graffiti. This alone was judged by the elders to be a subject unworthy of reproduction under any circumstances. This suggests to me that what Warlpiri painting also opposes itself to may be graffiti. What is (and will probably remain) less clear is whether this opposition has its sources in a discourse learned from Europeans—tidy towns and church sewing circles. Or are there sources in Warlpiri tradition that need to be accounted for as well?[8]

What is graffiti? It is, of course, writing on walls or other appropriated surfaces, and it involves "something of the calligrammatic" that initiated this study of Warlpiri iconography. Then are cave painting and rock art graffiti? The discrimination may have more to do with contexts of authorization than with any inherent property of the text. Graffiti is unauthorized images—images where they should not be, or images by those unauthorized to make them. This recalls the *60 Minutes* Wandjinas case and suggests that its confused reporting of it may have been more expressive of actual contradictions than it first appeared to be.

The way that Warlpiri people talk about paintings and designs revolves around these very questions of authority. Who owns the design? Who is authorized to paint (reproduce) it? Who may see it? The anthropological literature locates these considerations in an ethnographic past, but the story of the Wandjinas demonstrates that exactly the same issues prevail today (Mowarljarlai 1987). Whether the result of these restorations is precious art or worthless graffiti is very much a current concern. When there is a dispute, it will likely be discussed by con-

trasting "European" ("official") with "Aboriginal" ("traditional") terms of authority. It cannot be so very farfetched to imagine that this is at least part of what is on the Warlpiri painters' minds when they make paintings for the market: a concern to be seen as the proper authorities to value the art, untainted not by the *inauthentic* but by the *unauthorized.*

The intrusion of the art adviser may not be considered as such when responsibilities and accountabilities are understood. The intervention described here in the assessment of authenticity would mostly be seen as inconsequential in terms of Aboriginal authority: dots, refinements of color, and so on. At the same time, advisers are themselves authorities, specialists, people who are supposed to understand Western taste and economics and who will offer that expertise to the painters. It is mostly the European discourse that concerns itself with the possibility that the contribution of these advisers taints the art, renders it inauthentic, and so compromises its value, as if some intact arcane authority can be transferred directly from Aboriginal elders onto canvases, which can then be purchased, owned, and hung in European lounges and corporate boardrooms.

Examined in this light, all the possible discourses that distinguish Aboriginal art from graffiti turn out to be nonsense when judged by the proposition with which our discussion began: no such "determinate concepts" can ever be the basis of a "stable consensus" in matters of taste.

The failure to make discriminations of value about a painting style cannot be ascribed solely to racism, or claimed for Australian art alone. Problematics of aesthetic discrimination are now universal. Lyotard and Rogozinski, in repudiating a certain neo-Kantianism in contemporary criticism, contrast it with their own reading of Kant:

In matters of taste, though it is not possible to dispute, *i.e., demonstrate "by means of* determinate concepts," *and hence arrive at a stable consensus, it is still possible to* discuss, *to appeal to the assent of the other, without ever being certain of convincing. In fact, in this type of judgment our power to judge is not* determinate, *but* reflective. *It is not based on a category or some pre-given, universally applicable principle, but on the necessity, when dealt an odd hand, an unexpected case, of judging without rules in order to establish the rules. The activity resulting from the reflective type of judgment is that of the artist, of the critical philosopher, of "republican" politics—any inventive step which, on the path of the unknown, of the unacceptable, breaks with constituted norms, shatters consensus, and revives the meaning of the* différend. (30)

In practice it is probably easier, and more common, to identify a work of art as bad than to explain why another is good. Current criticism certainly does a better job of ruling out possibilities than specifying the "rule beyond rules" fantasized by Lyotard and Rogozinski. In arriving at such a rejection again and again, the critic always risks confronting chaos, staring directly down the maw of the primordial dark. We seek strategies to plug that gap, to obscure that sight with various critical inventions: the Sublime (or divine), rules beyond rules, Benjamin's "aura." In doing so, criticism seeks to supersede art itself.

Premodern art (from primitive to classical) always was aligned with order against chaos. This is what Beauty claimed for itself: a statement of order, a meta-ordering device, a means to illuminate the inchoate void. This, too, is the function anthropological reconstruction attributes to traditional Aboriginal rock, body, and ground designs — an ordering of the social and natural universe.

Yuendumu and Papunya acrylics — indeed, all painting coming to the market today as Aboriginal — tempt us to accept this proposition we would reject in any other context. Because these designs claim sources in a religious iconography, a "cult ritual" (satisfying Benjamin's definition of "aura"), it may somehow be imagined that they carry intact from the primitive (Dreamtime) some exemption from the modern/postmodern condition and its unbearable (if oblique) view of chaos. But such claims require also an exemption from recognizing the relations and conditions of their production, and their own historical (not prehistorical) construction. But this asserts that dangerous fantasy of authenticity that all our other critical terms resist. I have argued the opposite: that these works are to be judged first and foremost in terms of the social practices that produce and circulate them — practices that promote issues of authority, not authenticity. From this analysis, their history can be appreciated as expressing precisely the extreme contradictions of colonialism and racism in which they are generated and sold.

But I have not presented any criteria that can be used to judge the art object itself. I have failed to define bad Aboriginal art, or pose any scheme for evaluating the good, as my title seems to promise. This is intentional. It should be clear that the work itself does not support such assertions or evaluation. It is the product of too many discourses: the painters' attempts to have their designs (and themselves) acknowledged seriously in the contemporary market, the market's requirements for exchange-value fodder, and the consumer/collectors' own interests, which may well include the desire to be associated with auras of authenticity as well as investment speculation. The contradictions of this system resist resolution.

The result is a *stochastic* system, neither determinate nor indeterminate, but one that nonetheless seeks description and deserves judgment (i.e., of the processes of production and circulation, but not of the product). Good Aboriginal art, as well as its criticism, must indeed "appeal to the assent of the other" and does not seek to convince. Judgments of the product must always—ultimately—be exposed as fraud.[9]

IX

Para-Ethnography
[1 9 8 8]

THERE IS an unlabeled variation on the *roman à clef* whose plots revolve around communities reacting to the publication of research or stories about them. An insider (or an outsider—this is the major plot variation) "tells all" and exposes a certain institutional corruption or set of individual hypocrisies. *The Kinsey Report* (movie version), *Harrison High*, the Bob Hope vehicle *Bachelor in Paradise*, "Harper Valley PTA" in some sense (the song itself serving as the "publication" and then the basis for a TV series), but most classically, *Return to Peyton Place*, were examples of this type. These narratives typically describe a universe peculiarly socially organized, driven by complex genealogies of kin and exchange, constantly reproduced by gossip and revelation. The sources of *Dallas's* and *Dynasty's* fantastic character networks lie here. Indeed, the conventions that drive these texts irresistibly generate continuing serials. Gossip and revelation offer the reader/viewer a sort of detective-novel relationship to the story, but more in terms of ongoing mysteries of, and clues to, character (and the modes of disclosure) than any classical form of plot. The narrative strategy has the characters matching up identities in the embedded literary text with identities in the lived social text of the "real" community that is being exposed, since names are always changed, even if there is no innocence here to protect. Thus the activity of

the characters mirrors the activity of the reader/viewer who likewise is engaged in second-guessing this play of identities, masquerading through several layers of fictionalization.

I cite this subgenre to account for how certain Australians are now reading Bruce Chatwin's (1987) study of Central Australia, *The Songlines*, and (in the hope of resisting the temptation myself) to account for the peculiar position in which this text places those of us who are close to the people and events that Chatwin is fictionalizing. I also intend, somewhat deviously, to develop a contrast to Sally Morgan's (1987) Western Australian popular autobiography, *My Place*. Both feature Aboriginal subjects, both are high on the bestseller lists: the auto-bio-historical *My Place* has topped the Australian booklists and is now going into overseas publication, while Bruce Chatwin's travelogue nouvelle, *Songlines*, has done especially well in Britain and America. I think these books pose certain difficulties, not the least of which concern classification, and so it is worthwhile to begin by raising a question of genre: How should we read, regard, and criticize these texts in comparison to others?

It is tempting for the anthropological reviewer, especially of *Songlines*, to develop unconsciously a positivist critique instead, citing ethnographic corrections, matching up real and fictional identities, driven by tedious comparisons between some "objective" truth and Chatwin's fiction or Morgan's "stories." But by doing so the critic falls into the very trap this subgenre has laid. The demand for facts unwittingly turns the critic into just another character in this same Peyton Place, arguing our claim to privileged information—turns one into "the expert," bristling with insider knowledge that is then employed, as is the general trend, to justify an attempt to dominate the discourse, to sell our version of the story. Like the rest, we can be observed busily seeking to repair the breach in the social fabric, intending ultimately to restore the local processes of social reproduction, and thereby assuring a sequel. Acknowledging these tendencies, I do admit that in the end I mean to approach exactly these questions of facticity that *Songlines* and *My Place* raise for us—but perhaps in a less sleazy manner.

Sally Morgan does not so obviously invite this treatment. In contrast to Chatwin's book, her characters are named: her subjects insisted that their stories be told truly and properly, and that they be given due credit. Yet the narrative frame is so strong and the literary conventions so central to the strategies of the text that *My Place* cannot be said to exist in the world of documentary, but, as with *Songlines*, somewhere in between. Morgan describes an explicit desire for self-inscription and authorization that actually inverts Chatwin's masquerade of

identities. This makes *My Place* politically much more difficult to approach, for one may be seen to be criticizing people (indeed, Aboriginal people) rather than the constructed and interpreted characters that we know populate such narratives. Critical summaries may help to illustrate these issues.

My Place

Sally Morgan sticks to a fairly explicit narrative line throughout *My Place*. She reports a journey of discovery that begins with a reconstruction of her childhood, when she was told that her darker skin was due to Indian ancestry. Her recollections of childhood are touching, at times eloquent, and offer a rare insight into the culture of urban poverty in postwar Perth. Her recall of her white father, who died from a combination of alcoholism and war wounds (physical as much as emotional), is moving, and sets the scene for the characterological emphasis and psychological empathy that is central to the book's success—but maybe also to its fictional problematic. As she grows up, Sally uncovers bit by bit—not without difficulty, even with some pain—a truer history, and we share these discoveries with her.

When she matures into a university-educated, literate, professional woman she undertakes a reconstruction of her antecedents by eliciting oral histories from her mother, her uncle, and eventually her grandmother. On a trip home to the ancestral country, armed with tape recorder, she traces relatives there and completes the picture. These oral histories are inserted into the narrative at the points where they are elicited, and this technique anchors Morgan's chronology at the center of the text even when we are involved in lengthy subnarratives. The book is consequently easy to follow.

A number of tensions are developed throughout, most notably the attempt to get the grandmother to acknowledge her Aboriginality, tell her story, and admit the truth of her life. This happens only on her deathbed, and constitutes the emotional dénouement of the narrative. It is never made explicit why the grandmother is so recalcitrant (although her history suggests reasons), nor why this admission is so important as to take on religious overtones of confession and absolution. Perhaps this latter point is self-evident; a reader who doesn't share this sense of the importance of identity would have rejected the book altogether in a much earlier chapter. *My Place* assumes the critical value of "knowing who you are" for any model of fulfilled personhood, and then provides an example, even a primer, of what sort of knowledge will prove adequate, and how to get it. Yet there are secrets here too, and certain incestuous relations in Morgan's genealogy remain subtextual; but are perhaps more pervasive, effective, even shocking for that.

What is challenging about criticizing this book is first, simply: How dare anyone dispute Morgan? Even more than Chatwin, she constructs criteria for evidence, history, and truth that are self-referential. Aborigines do not forget, do not lie, do not selectively interpret their memories, and so their stories are true—beyond even the context of their presentation (i.e., neither the narrative genre nor the translation from oral to written modes influences the story).[1] It is here that the contrast with objective formalisms is highlighted. An anthropologist would be inclined to treat an informant's words as data, requiring that they be filtered through or tested against a theory before their status as evidence or information, let alone as facts, can be judged. By contrast, Morgan's approach elevates the autobiographical genre to the status of methodology. Narrativity achieves the status of a theory, even of proof. A lifetime thus becomes an act of inscription: telling, and now writing, your story is regarded as a social responsibility. And no authority may supersede the autobiographical expert.

Certainly, these notions of the autobiographical self have a history, and an indisputably modern one at that. On the other hand, Western Desert oral traditions of story making and telling have been described as something more collective and culturally constrained.[2] There must be complex forms of translation at work here, but they are utterly masked. I do not mean merely the odious problems of transcription (Morgan's appear highly edited), but problems of a more fundamental ontological fit that seems forced in order to construct the easy narrative surface—indeed, to achieve the verisimilitude that makes *My Place* so credible to a popular readership.

It is no more profitable to challenge these truths by reference to some privileged history, some ethnographic facticity, than it is with the Chatwin book. As I have claimed, that is an epistemological trap. Even so, something conspicuously odd can be detected regarding the forms of Aboriginality that Morgan describes. In particular, there is a Christian mythology (and a Protestant "self") demonstrably at work here, acting almost as a kind of filter through which these histories are processed. The result is that, for example, "the elders" begin to look suspiciously like Pre-Raphaelite angels. They seem to exist in the air, almost to fly, and they assemble to exercise a protective benevolence at times of crisis, especially death. They are described as an undifferentiated class (whose elders?), and one proof of Aboriginality seems to be the capacity to be in psychic communication with them. The recurrent trope of the "death bird" may prove more familiar from the TV miniseries *Women of the Sun* than from any ethnographic source.

There are elements of theosophy, New Age astrology, even something like pyramid power in Sally Morgan's religion that are indeed interesting syncretisms.

But Morgan implies more than a syncretic invention; she makes the discovery (not the invention) of an authentic, lineally descended Aboriginal identity. What she uncovers nonetheless is so inconsistent with what we have hitherto understood about Aboriginal theologies that if Morgan is right, much will have to be rewritten and certain practicing elders will have to be corrected. Perhaps more relevant to the critical criteria I am promoting here is the supposition that Sally's very personhood—as an individual who seeks a cultural identity (and to become a character in her own book) and makes this very personal journey of discovery to her roots—is also quite a modern construct. I don't mean in any sense to deny Morgan's "Aboriginality," nor her remarkable achievement here. But I think we need to question the implicit claims to some privileged authenticity that, in this case, may be unnecessary to the disclosures, and even mask the originality of her text.

These difficulties also point to a rather massive gap in the literature on modern Aboriginality: the place of European ancestors in these histories. For the generation of Sally's grandmother, the reasons may seem obvious (the same as those described in the novels of Xavier Herbert). The white fathers, although at times ambiguously motivated, in the end denied these children and any claims that their paternity might rightfully entail. By contrast, Sally's mother, indeed Sally herself, married more respectful whitefellas. Morgan glosses over her own relationship; she is more interesting and, as I have suggested, poignant, when describing her father and his weaknesses, but he remains an outsider. The syncretism of Morgan's philosophy and theology can be considered a reasonable product of her personal history. One only wishes that the duality of cultural heritage and its consequences had been more frankly described. What a great contribution such a treatment would be, and how much more successfully the contradictions of her own history might have been resolved!

But it is not Sally Morgan who invented the conventionalized denial of European influences and the practice of tracing only Aboriginal sources in such genealogies. A vulgar misreading of evolutionary theory is general, and deeply embedded in the Australian rationale. The confusion between cultural and biological transmission that underlies this misreading may also be at the core of modern racism. So the failure to pursue the matter strikes me as more than merely an undeveloped option.

The Songlines

Chatwin is no Aborigine, nor is it entirely clear what he is. British-born and -educated, he embodies a personal displacement associated with the 1960s, elevated here to an icon of the archetypal wanderer. *Songlines* continues a personal odyssey Chatwin first describes in his successful earlier travel books, beginning with *In Patagonia*. These books are credited with pioneering a new generation of travel-writing that has attracted not only considerable literary respect but some anthropological interest as well.[3]

In *Songlines* Chatwin attempts his most explicitly anthropological project, because he centers his attention on what he implies are the most primitive, exotic, alien, and thus authentically "real," beings: the Aborigines of Central Australia. This brings Chatwin to said region, after a series of world travels among nomads, to encounter the nomadic source. (At the risk of seeming pedantic, it's worth commenting that Chatwin identifies these other nomads as transhumance pastoralists while recognizing that Aborigines are, or were, hunter-gatherers; but he trivializes this difference by ignoring it, and insists on pursuing his analogies relentlessly.) In fact, the text mostly describes the people who now work for and surround these "true primitives"—gatekeepers mediating their contact with the outside world, people dubbed "the Aboriginal Industry," and whose capital, Alice Springs, is also Chatwin's home base in *Songlines*. We get some conflations of first-, second-, and third-hand knowledges as a result, but this is not the book's major problem. The difficulty of getting through these mediators to the "real Aborigines" does play into the conventions of "a difficult journey against great odds," except here the impediments are social as much as geographical.

The first half of the book provides accounts of various encounters and events, seen or reported to Chatwin in Alice Springs on his two-week journey "out bush." Some of the descriptions of house parties are quite acerbic and recognizable, as are lunches at a local Todd Street café. As anecdotal insights into an important and undocumented culture these have some value, and their criticisms of "ab-industry" characters are not completely unjustified. But what separates the good white folk from the bad? Mostly, Chatwin's identification of pretentiousness. Chatwin doesn't share his grounds for judgment with us; he is, ipso facto, the ultimate judge of this pretentiousness. Inasmuch as the second half of the book—jottings from Chatwin's journals and extensive quotes from the world's gurus—strikes me as the most pretentious padding I've yet encountered in a published work, I cannot accept Chatwin's evaluations here. Like Morgan, he constructs minibiographies of various (unpretentious) individuals encountered, so that

we do get to know a range of characters more extensively through time and space than the travelogue form normally allows. But these are not first-person transcriptions, and how Chatwin constructed such stories is not specified.

Although it takes up comparatively little space in the book and offers little detail, Chatwin's "peak experience" seems to have been his visit to the Cullen Outstation where he finally discovers the truly "authentic" Aborigines, the essential nomad, barely touched by civilization. He became stranded at Cullen by the rains for a couple of weeks, but is curiously silent about the "truth" he learned there. Most of his time seems to have been spent with another intriguing, good (presumably nonpretentious) whitefella adviser—a writer who shared many of Chatwin's interests. Together, they check out the remarkable stream of gorgeous blondes in faded cotton shifts who seem to populate that part of the world. But it is at this point that the narrative line collapses and we shift into a pastiche of locales, people, and memories from old diaries, losing any sense of time or place for the rest of the book.

For many of us, one difficulty with *Songlines* is that it is very close to being an ethnography and covers much the same ground in accounting for its Aboriginal subjects, as does a vast extant anthropological literature. In fact, *Songlines* raises some issues not unlike those Carlos Castaneda did over a generation ago about the line between ethnography and fiction. Two contrasts are evident, however. Castaneda styled himself a professional anthropologist and invited a formal disciplinary criticism, while Chatwin rejects the anthropological discourse, explicitly distancing himself from any such claims (and, along with Morgan, is rather dismissive of anthropology as a whole, despite or because of repeated references to his own training in the subject). In fact, Chatwin cites Strehlow (a politically curious choice of mentor), honoring him by turning him into a fictionalized historical character. But terms from Meggitt, Myers, Moyle, and probably other anthropologists pop into the text unreferenced (e.g., 56–57), indicating that Chatwin is a far more literate student than he admits. His reading must have stopped in the 1970s, however; he doesn't seem aware that many anthropologists themselves have lately problematized any absolute, determinate distinctions between ethnography and fiction. Among other results of a "reinventing" of anthropology[4] has been this reevaluation of the traveler's tale as a source of ethnographic insight as well, a reevaluation that surely has had its effect on both Chatwin and his readership, even if he dismisses this. Recent collections such as *Writing Culture: the Poetics and Politics of Ethnography* (Clifford and Marcus 1983) and *A Crack in the Mirror: Reflexive Perspectives in Anthropology* (Ruby 1983) devote

sustained attention to these issues, which may well have been triggered by the Castaneda debates as much as by postpositivist philosophy. The new travel writing conventionalizes the character of the author/adventurer as an amateur, a naïf, a nonspecialist, and this is one difference between the two genres as well as a likely reason why Chatwin underplays his own anthropological exposure. This also provides an additional contrast to Morgan's autobiographical persona; and perhaps certain differences in the sorts of truth and accountabilities in the books can be traced to these differences in authorial construction.

If I take more space to describe *Songlines* than *My Place*, it is not because it deserves more attention. Rather, it is so fragmented a book that it cannot be easily characterized and seems to require the critic to pick it off bit by bit:

> Why the inconsistent conflation and confusion of characters and places?
>
> What possible justification exists for describing the laws governing secrecy and then treading all over them (see 116)?
>
> Why the language of Rousseau ("carefree and open-minded," 21; "innocent sacrifices," 11; "the false fantasy of perfect symmetrical reciprocity," 57)?
>
> If a sense of place is so important to nomadic cosmology, why are the primary informants all displaced persons and not locals?

The result is finally a huge contradiction in Chatwin's own terms regarding nomadism.

By choosing the Dreaming Track (which he prefers to call "songlines," after Strehlow [1970]) as the central trope and explanatory metaphor for desert Aborigines, Chatwin might have contributed a legitimate interpretation, and even resolved the apparent contradiction between mobility and place that has proved so alien to European thinking and law, and that is so crucial to understanding contemporary Aboriginal claims to land. What these tracks demonstrate is a complex, utterly precise connection between person, knowledge, and place that is now known to be at the heart of Australian desert ontologies. The problem—and it is demonstrably a problem for Europeans, not at all for Aborigines—is how

these tracks mediate between local movement and an unimaginable stability (of history). As Chatwin's own "data" demonstrate, this is managed by the strictest attention to maintaining the connections between kin and place, and by restricting the circulation of associated knowledges. It is in this context that Chatwin's stylistic techniques of fragmentation, his purposive, if inconsistent confusion of sources, and his choice and construction of a harlequinade of informants and characters so clearly defeats his purpose and results in such confusions. Finally, we are forced to ask: Just what is this book about?

Oddly, a clue may be found in the bizarre meanderings of the journal fragments. These begin, not incidentally, just at the point of confrontation with the authentic nomad at Cullen Outstation. At this very intersection where we might expect a sustained portrayal of the situation, reaching the core of the experience, we shoot off in time and space through these utterly disconnected knowledges. It is not unlike the moment in the film *2001* when the astronaut, finally encountering the unknown and alien object, cannot land, but instead is propelled into a time-space warp in which the object is forgotten. But at least Kubrick's astronaut goes somewhere—a journey to the Self. In fact this may be what happens here as well, only Chatwin doesn't tell us, and probably doesn't know. The book merely dissolves into aether as its fragmented objects fly past at unimaginable speeds.

There is a bizarre insertion precisely at this point of encounter that must be more than accidental. Chatwin is running out of his favorite high-quality French notebooks ("carnets moleskines," if you simply must know). He tells a story of the search for more: "the owner of the papeterie said that vrai moleskine was getting harder and harder to find" (160). Finally, the bad news was delivered through an intermediary. The one last manufacturer had died. His heirs had sold the business. "She removed her spectacles and, almost with an air of mourning said, 'Le vrai moleskine n'est plus.'"

This intriguing tale launches us off into those notebooks, and, although the Australian narrative continues in fits and starts, we never again know just where or when in the world we are. But more, it is impossible to ignore the metonymic connection—witting or not—between "le vrai moleskine" and "le vrai sauvage." The connection is imprecise and probably insulting. It opens Chatwin to the charge of attempting to increase the value of the nomads, and thereby his account of them, by underscoring their rarity. These sentimentalisms make us suspect that the book is only about Chatwin, about his own rootlessness, his personal fragmentation, some reconstructed bohemian quest—which I can personally

identify with, even if I see no excuse for this projection onto desert Aborigines that inescapably results in their appropriation.

I suspect that *My Place* approaches what are perhaps exactly the same epistemological questions of truth, authenticity, and authority, but from nearly the opposite direction as does *Songlines*, which is what makes them interesting to compare. It might be argued that Chatwin's overly literary technique underscores the constructedness of the texts and acknowledges himself as the agent of fabrication. This might be preferred to Morgan's deceptively frank autobiographical style, which has the opposite effect; she implies an archaeology of preexistent truths, and her action is to uncover/encounter these as unmediated.

Sally Morgan eventually positions herself as the locus of Aboriginality (indeed, she discovers it in the very act of writing this book itself). She seeks knowledge, authority, and authorization almost exclusively from people to whom she can trace a direct consanguinial (or occasionally affinal) link. Chatwin's evidence by comparison is mostly hearsay, and he boldly fictionalizes his sources. His possible, but questionable, contribution may be that he finally succeeds in positioning himself—rather than the Aborigines—as "the other." Morgan's solution instead is to collapse subject/object distinctions and positions; alterity in her book is reserved for the white reader, or perhaps the line of mostly absent fathers.

Morgan's involvement may produce a more compelling authority and a more convincing authenticity than Chatwin's, but it likewise masks, perhaps even more successfully, the fundamental constructedness of the enterprise and associated questions of sources and consequences. More importantly, by employing these contrasting techniques of persona, both authors still succumb to an emphasis on character, a definition of the person, and his or her place in a story. The consequences for the surrounding landscape—in both cases designated as Aboriginal—deserve critical attention.

We need to inquire more closely than does either of these books into the nature of Aboriginal conceptions of personhood to discover whether the conventions of modern European autobiography are an appropriate way to package these stories, or whether they finally do violence to the very subjects they seek to describe. This question is probably applied more directly to Morgan's work, because Chatwin is admittedly a European; and once we realize that he remains at the center of the story, the main objections (other than literary or aesthetic ones) that can be raised concern his appropriation of sources, and his motives (Stephen Muecke has recently taken up these matters in an uncomplimentary review).[5]

This is not the place to enter into a survey of these issues of personhood—though Fred Myers's recent work should be noted, which goes back at least to Róheim for investigating Western Desert psychology. But the position taken by the current books is neither objective nor concrete, as would be implied if these were examples of the ethnographic genre. Instead, both authors and even their readerships undergo certain transformations of self in the reconceptualizations of identity these books describe. Aboriginality is emergent here, so that those who (either as subjects or readers) believe these books become defined by them as well. Many more people will read these texts than will ever encounter an Aborigine or an ethnography. The image of the Aboriginality constructed by them will have considerable popular force; indeed, *Songlines* has already found its way into land claims testimony. Nor can the label of narrative be invoked to deny accountability for this. The authors assert, and readers surely believe, that the purpose of the literary conventions employed here is to make a truer truth than documentary, or the academic texts they criticize.

It is interesting that both books contribute so directly to the discourses of modern "pan-Aboriginality," a recent social construction characterized by denying the local particularity of past (and many contemporary) societies, their languages and law. Even in Morgan, who is tracing her kin, the rigorous attention to classes and lineages that her relatives describe to her as linking people seems mostly ignored, in preference to the simplified "skin name," memorized and employed in the general way one might identify with an astrological sign. Chatwin notes, but then in his own account totally ignores, such local distinctions of the groups he encounters. He classes people on a single scale: authentic primitivism on the one hand, pretentious inauthenticity on the other. Thus he steers himself to the essential heart of nomadic darkness. He suggests something more audacious than Morgan's pan-Aboriginal society; he implies an equivalency of all nomads. This is a curious conflation of old uni/multilineal evolutionary debates and can't be taken quite seriously (although Muecke's not-so-different theory of "nomadology" derived from *A Thousand Plateaus* by Deleuze and Guattari might invite a similar criticism).[6]

Yet perhaps it is precisely the ability of *Songlines* and *My Place* to mediate philosophically and objectively incompatible positions to produce a satisfying narrative construction that is the source of their popularity. The masked contradictions of each authorial persona seem central to accomplishing this. The issues of traditionalism and change become much more accessible, indeed manageable, on these pages than anywhere else.

As might be implied, the issues raised in these "para-ethnographies" are not so very distant from issues within current anthropological discourse and theory. This is why I argue that *Songlines* and *My Place* should not be excluded from a disciplinary debate. Let me reiterate examples: To what extent do we now regard ethnography as a narrative, even literary form, and not just as an objective mode of scientific reportage? What is the self in any culture and how do characterological conventions affect cultural conceptions? What is a defensible position for the cultural subject and how are the relations of observer to observed to be themselves observed? And what are the responsibilities of inscriptive practices, the consequences of publishing folk traditions? As in the case of Chatwin, where must privacy, or secrecy, or sacredness be respected? Anthropological study now theorizes these very issues. By contrast, *Songlines* and *My Place* exemplify them, if in an implicit and sometimes inarticulate way. This is exactly why they require a critical reading to extract what may be their contribution to important debates, debates out of which these texts arise, even if they are not admitted.

My purpose in naming these texts para-ethnographies is starkly appropriative. I am impressed with how, in the field of psychology, the disciplinary academic establishment dealt with a whole range of unverifiable, irrational, irreplaceable, even invisible mental phenomena in which the public (and the popular press) admitted such an interest. At first, academic psychology denied these phenomena, at least partly in attempting to establish its own objectivist credentials. But their interest and relevance could not be denied. So psychology partitioned this area and called it parapsychology, but implying no special claims for the legitimacy of the phenomena so labeled. Indeed, researchers crossed over only at considerable risk (and comparatively few did so). The study never quite gained respectability, although the terms of the debate were defined, so that Shirley MacLaine can at least be discussed at annual APA meetings.

Certainly in the case of Chatwin, Morgan, and others, their disavowal of anthropology is neither wholly honest nor particularly accurate. They are very much in a dialogue with the profession. Some response is in order. By partitioning an area as para-ethnography, the examination of such texts can be undertaken without confusing our (or their) purpose. If so, a good deal of wasted ink could have been saved regarding Carlos Castaneda, or even Derek Freeman.[7]

Postscript: My Essay on Postmodernism

[1 9 8 7]

IN MADONNA'S recent videoclip "Open Your Heart," she performs as a stripper inside a room surrounded by spectator booths. The spectators presumably pay to view for a certain period of time; the blind on each window raises in turn; when the pay period is over, the blind descends. I hear there really are such facilities somewhere, one of the more bizarre variants of the commodification of desire predicted by Lenin as symptomatic of late capitalism. That citation may or may not interest Madonna. She probably would be more interested in what the set offers graphically to the audience for the clip, which partly functions to promote the recording of the song she is singing — for which such clips serve a complex advertising/market function. What the set offers that audience is a vehicle for densely packed narrative information outside of any narrative line. As each blind raises or lowers we glimpse a variety of male spectators, including an elderly degenerate, a set of twins in military school dress rapt in homo-romantic catatonia, a youngish school lad, an older mischievous schoolboy, a man furiously writing a note on the window that we never read, and so forth. The camera's point of view shifts back and forth from Madonna's view of them to their view of Madonna to a third, more distant perspective taking in both actress and spectator through the windows from both sides. Toward the end, Madonna breaks through the third wall by chastely kissing the young school lad, which effects a series of transformations. Madonna's hair goes from sleek to frazzled. Her arch black Frederick's-of-Hollywood stripper

outfit (with gold-tasseled teats) becomes a funky androgynous suit matching the schoolboy's. They are transported outside the theater. They dance together in a relaxed, jokey fashion down into a Hollywood studio sunset.

There is no simple gloss that can suggest a storyline for this videoclip. Such clips, I take it, are not meant to mean but to be, as William Carlos Williams had it, arguing against the reductionist tendency of poetry criticism. But maybe the formula is more aptly reversed here: this videoclip is only supposed to mean … without meaning anything. The stripper's lair and the spectators' windows provide an opportunity to juxtapose vignettes that invite narrative interest without providing specific narrative content. We sometimes used to use train compartments in films (or later, faces on the subway) to suggest something similar — every life is a story, but we can only guess at the details, plot, motivation, and so on. Film (or video) editing capitalizes on this phenomenon in that it encourages the putting together of images into a sequence for which the audience will assume meaningfulness, even if the sequence is arbitrary. The early Russian filmmakers saw their theoretical task as determining a proper ideologic to employ in the editing sequence, perhaps to counteract this tendency of editing to unmoor meanings. Later, intentionally in a film like *Last Year at Marienbad*, and perhaps earlier in B-grades, auteurs start to play with this responsibility to mean. But it is with television, and now the hybrid videoclip form, that something starts happening in which the literary bias of narrative is exploded and we get stories that exploit, rather than resist, the divorce of signifier and signified, image and narrative meaning, which moving picture (film or video) technology permits. Commercial television must have had a great influence here, because the effect of its economic rationale on the narrative format/sequence was profound. The insertion of irrelevant bits of advertising into the program narrative has now trained two generations of viewers to accept the deconstructive possibilities of audiovisual sequencing.

We are describing subjects that think about themselves in the presence of objects that think about themselves without any necessary presumption of a denotative imperative linking one to the other. We now have a label for this kind of activity: postmodernism. The very fact that it has been fifteen years since intellectual life has consented collectively to such categorization cannot be overlooked. I had assumed that with the demise of *Life* magazine — that *deus ex logo* whose business it was to wander the twentieth-century garden, Adamlike, dispensing names — we were terminally exhausted by such an enterprise. *Life's* last, baroque moments, which produced an orgy of "Pop," "Op," "hippy," "yippie," "teenybopper" neologisms, seemed to retire the title permanently. The appearance

of the feeble descriptor "yuppie" in the early 1980s stood more as a reminder of archaism than a serious revival. At the same time, we were observing the acceleration of nostalgia fetishism reach its logical limit where the present would collide with the immediate past to destroy the temporal framework and rule out any possibility of fashion. Maybe it is because what is happening in aesthetics right now denies fashion by appropriating its elements as components in new, but arbitrary relationships that aestheticians see the necessity to reassert their position by labeling what precisely resists denotation. Whatever postmodernism is, it isn't a thing, and the attempt to capture it has proved challenging to aesthetics in a very interesting way, requiring practitioners to operate on many more levels of description than was done in the past. But, as I think Madonna's videoclip asserts, the distinction between artist and critic has collapsed. The clip is as savvy a commentary on itself as any derivative reading, and is going to make a lot more money too (postmodernism, whatever it is, doesn't come cheap).

In this, my essay on postmodernism, I want to keep open the possibility that the label is inappropriate, that labeling itself has been rendered dumb, and that one has to hold it all at arm's length, accounting for the impulse to label as much as the label. This leaves me open to the accusation, I suspect, of being supremely postmodernist. This is because postmodernism, like Freudianism, which it has resuscitated, is a total system of explanation. (I dimly recall a 1950s cabaret song by Pete Seeger's The Weavers called "Dr. Freud," which had a refrain asserting that a telephone pole was only a telephone pole.) Because it describes a relationship between subject and object, rather than identifying particular subjects or objects, nearly anything could conceivably be positioned in a postmodernist discourse. Thus we have postmodernist objects (especially buildings), media (books, films, videoclips), but also dialogue and criticism. The boundaries between objects, between media, between actuality and representation, are, moreover, always subject to challenge. For example, Madonna on screen and Madonna in "real life" are commenting on each other in her videoclip, which was directed, as it happens, by her husband, film ingenue Sean Penn.

Madonna has built her personal and her screen image around the great movie star legends that became iconized in Marilyn Monroe. Upon achieving stardom, she even transformed her punky, New Wave look into something quite terrifyingly Monroesque. She suitably chose and married the hottest young Brando around, and manages to get headlines weekly over speculation about whether they're happy or divorcing. The fans are invited to care about this. But she is not Monroe. She is rather in that direct line from Monroe to Barbra

Streisand (in the 1960s) to Bette Midler (in the 1970s), who succeeded in achieving stardom by commenting on stardom. Streisand set that up as a competition, an aggressive appropriation; Midler made it a joke and parodied it; Madonna post-modernizes it, stripping it of meaning while hitting all the meaningful bases. We watch the videoclip looking for clues about the relationship between the director and the star. Instead, we get Madonna playing to a gallery of voyeurs. In passing, we can't help but notice suspiciously academic references to Lacan's essays about "the Gaze," Deleuze and Guattari's *Anti-Oedipus*, the feminist critique of woman's film image, and other citations too scholarly to be believed but too precise to dismiss. What we really want to perv on — Madonna's relationship to Sean — is not satisfied by any image explicit in the clip, but by the extratextual knowledge that he is behind the camera. This plays directly into the reflexive emphasis of the post-modern relationship and draws our attention to the extraordinary cleverness of the text that happens to anticipate my own reading list this week. But I am watching this on *Countdown*, hosted by an aging post-hippie moron, or I'm watching it on the screen at the drugged-out subteenage androgynous punk club, the Exchange, on Sydney's Oxford Street.[1] I am not watching it at a seminar by Fredric Jameson at Yale, or Jonathan Culler at Oxford. The honest critic must conclude, at this point, that he has put all that there; the text invites the critic to delude himself.

Andy Warhol became famous in the 1960s for saying that, in the new electronic age, everybody would be famous for five minutes (or ten, or fifteen ...). Never noted for his mathematics, Warhol's prediction may require a recalculation: if you take the number of radio and TV transmitters operating everywhere in the world and multiply this by the number of total broadcast hours each, and then divide by the total world population, the result might indicate that by, say, 1982, everybody, everywhere, had had their five minutes. The precise date when this happened, I submit, marks the beginning of the postmodernist moment. At that point, we were required to come to some new relationship between texts and audiences.

I hypothesize that this was accomplished by building a new form of expression that invited the audience into a space in the text created by distancing signifier from signified. In this new kind of room within the text, the reader/viewer is required to locate himself in order to search for meaning. The spatial metaphor implied here is quite intentional. Gore Vidal has his hero/heroine Myron/Myra Breckinridge actually falling into the television set. Truffaut translated Ray Bradbury's reactionary evaluation of stupefying participatory narrative into a huge wall-screen TV that immobilized Julie Christie in *Fahrenheit 451*.

Lévi-Strauss described the savage quality of modern media as "images which, while in transmission, can be grasped from within and without." The first stirrings of postmodernism were recognized not in media but in architecture. But I think that the text's invitation to the viewer to step in and write her own story (or write herself as a story) takes its clearest expression in electronic forms. Where the print media attempt to tackle their own equivalent, whether in Mills & Boon or Italo Calvino, the effect is more tortured, less ambiguous, and so less realized. And in architecture, too, postmodernism quickly proved to be a mere gestural appliqué capable of being overlaid on anything, a thousand pink-and-blue skyscraper variations on 1930s train stations upended.

In the postmodernist space, the activity of the audience is self-inscription. One is invited to create meaning in the text by writing oneself there. There is an extent to which this has always been true in all expressive media. In literary studies, we designate this "identification." The reader steers herself through the novel by identifying with certain characters or situations. So it could be argued there is nothing radical in postmodernist interpretative activity. But I would claim that the shift of emphasis signals a shift of activity. Texts that intend polysemy, that do not police meaning but instead invite it, do not encourage identification, a psychological response, but displacement, a spatial activity. For within the text, we displace the star. We look at the world from the star's perspective, and every text offers us fame. After all, it is only from here that we actually have a glimpse of Sean Penn, and can solve the gossip column dilemma that brought this videoclip to us, and us to it. From this perspective, I am encouraged to see Lacan and Freud and Lévi-Strauss behind the windows, gazing at me; or I can peer through the lens deeply into Sean's eyes and plead silently with him to save our marriage. The choice becomes mine. I have bought another five minutes' fame.

Notes

Foreword (Hebdige)

1. C. G. Jung, *Memories, Dreams, Reflections*, rec. and ed. Aniela Jaffe, trans. Richard and Clara Winston (New York: Random House, 1 9 6 5), **249–50**.

2. James Clifford, "On Ethnographic Allegory," in *Writing Culture: the Poetics and Politics of Ethnography*, ed. J. Clifford and G. E. Marcus (Berkeley: University of California Press, 1 9 8 6), **115**.

3. Eric's *Unbecoming: An AIDS Diary* (Sydney: EMPress, 1 9 9 0) includes a transcript of the notification he received from the Queensland branch of the Department of Immigration dated July 12, 1988 (less than a month before his death), detailing why, despite an offer of continuing employment at Griffiths University, his application for resident status had been turned down. While the assessing officer (J. Donnelly) acknowledges that "it is not anticipated that he [Eric Michaels] has more than 12 months to live," s/he also notes that he has let his overseas medical insurance lapse and that he "fails to meet the required health standards": "On balance ... I do not see that the factors weighing in favour of approval outweigh the possible health risks for the general community and the considerable public health costs which will accrue from the treatment given to Dr Michaels" (**163–7 4**).

Eric's last entry, written on August 10, closes with the news that the Immigration authorities have contacted one of his friends "asking for a report of my condition and whether I'm ready to travel." These are the last three sentences of the diary: "Even if it is resolved, the problem keeps me up at night, consumes what energy I have for writing and planning, hijacks all my agendas and otherwise completely overtakes these last days. That people willing to do this exist staggers me. That they represent the official arms of the State depresses me more than I can say, or think" (**186**).

4. Ibid., **3 2**.

5. "Constraints on Knowledge in an Economy of Oral Information," *Current Anthropology* 26/4 (1 9 8 5), **509**. In this article, Michaels is developing an alternative theory of information value against the "reductionist 'ecologism' " of Harris, Rappaport, Peterson, and Chagnon. But see also "Hollywood Iconography: a Warlpiri Reading" (chap. 5) for his critique of Walter Ong's *Orality and Literacy* (London: Methuen, 1 9 8 2).

6. Sol Worth and John Adair, *Through Navajo Eyes* (Bloomington: Indiana University Press, 1 9 7 3). For Eric's critique, see particularly "The Indigenous Languages of Video and Television in Central Australia," in *Visual Explorations of the World*, ed. J. Ruby and M. Taureg (Aachen: Rader Verlag, 1 9 8 7).

7. Edmund Carpenter, *Oh, What a Blow that Phantom Gave Me!* (Toronto: Bantam, 1 9 7 4). Eric Michaels's take on the ethics of photographing reluctant subjects "in the field" is indicative of how far his methodology and research priorities depart from standard professional documentary practice. In "A Primer of Restrictions on Picture-Taking in Traditional Areas of Aboriginal Australia" (chap. 1), he reverses the standard positions so that the focus shifts from the "superstitions" of the "childlike natives" to the anxieties and obligations of the infantilized ethno-documentarist, at sea in an impenetrable world ("From being a competent, valued adult member of your own culture, able to make sense of what's going on around you, you become an incompetent child"). In place of "panicked picture-taking," a familiar defensive tactic on the part of the "culture-shocked" photographer, Michaels observes that increasingly "the person behind the lens gives up certain responsibilities to the subjects," and asks: " 'What do you want photographed?' and 'How?' ... The photographer becomes a collaborator, even an employee, of the subjects, facilitating their objectives in representing themselves."

8. Oliver La Farge, "Higher Education," originally published in *The Saturday Evening Post* (M a r c h 3 1, 1 9 3 4); reprinted in *Yellow Sun, Bright Sky: The Indian Country Stories of Oliver La Farge*, ed. David L. Caffey (Abuquerque: University of New Mexico Press, 1 9 8 8), 61. La Farge's concern with the ethics of disclosure, with (American) aboriginal sovereignty and the functions of restricted knowledge in the preservation and empowerment of subordinated traditional enclaves anticipates Michaels's treatment of these themes. See especially "The Little Stone Man" and "The Ancient Strength" in the same volume, stories that might be said to explore contrasting research options into Pueblo Indian culture.

9. See "Hollywood Iconography: a Warlpiri Reading," chap. 5.

10. Ibid.

11. *Unbecoming*, 36. Michaels is referring here to his "vaguely marxist/zen/hippy economic idiolect." Raymond Williams's relation to Marxism was, of course, no less ambivalent and complicated than Eric's. Nonetheless, it is hard to imagine that Williams would have felt comfortable with Michaels's synthetic/syncretic mix, organized as it is around an emphatically Pacific spiritual axis ("zen/hippy").

12. See, for instance, Ien Ang, *Watching Dallas: Soap Opera and the Melodramatic Imagination* (London: Methuen, 1 9 8 5); "Wanted: Audiences: On the Politics of Empirical Audience Studies," in *Remote Control: Television Audiences and Cultural Power*, ed. Ellen Seiter (Boston: Routledge, 1 9 8 9); David Morley, *The "Nationwide" Audience* (London: BFI, 1 9 8 0), and *Family Television* (Boston: Routledge, 1 9 8 6); "Changing Paradigms in Audience Studies," in *Remote Control*; James Lull, *World Families Watch TV* (Beverly Hills, Calif.: Sage, 1 9 8 8) and "How Families Select Television Programs," in *Journal of Broadcasting* 26/4 (1 9 8 2).

13. Michaels, "Constraints on Knowledge," 510.

14. See "Bad Aboriginal Art," chap. 9. Michaels uses this term to refer to the system linking painter, dealer, and consumer/collector in which Aboriginal art circulates and acquires value, "authenticity," and so on: "... a *stochastic* system, neither determinate nor indeterminate, but one that nonetheless seeks description and deserves judgment (i.e., of the processes of production and circulation, but not of the product)."
 This esoteric adjective seems to fit Eric's system of writing, too, as does the next sentence: "Good Aboriginal art ... must indeed 'appeal to the assent of the other' and does not seek to convince."

15. George E. Marcus, "Contemporary Problems of Ethnography in the Modern World System," in *Writing Culture: the Poetics and Politics of Ethnography*, 166.

16. See Carlo Ginzburg, "Morelli, Freud, and Sherlock Holmes: Clues and Scientific Method," in *The Sign of Three: Dupin, Holmes, Peirce*, ed. Umberto Eco and Thomas A. Sebeok (Bloomington: Indiana University Press, 1 9 8 3). According to Carlo Ginzburg, the apparent contradiction between serendipity and scientific rigor is resolved once we acknowledge the existence of a subterranean "divinatory" or "conjectural" model of deductive science that is diametrically opposed to the Galilean criteria of scientific inference. Whereas Galilean science studies the typical rather than the exceptional, and tends "towards a general understanding of the workings of nature rather than particularistic, conjectural knowledge," this alternative tradition is anthropocentric, "born of experience of the concrete and individual" (98). Ginzburg finds a common genealogy for nineteenth-century detective fiction, psychoanalysis, and attribution methodologies in art connoisseurship in sources as diverse as paleontology, Voltaire's *Zadig*, Mesopotamian divination procedures, Galton's fingerprint identification system, traditional forms of weather prediction, Sufi philosophy, and the ancient Arab art of *firasa* — "the capacity to leap from the known to the unknown by inference (on the basis of clues)" (110). The distinction may throw some light on Eric Michaels's conversion of a sense of the irreducibility of the local into a rigorously (postmodern) analytic.

17. Meaghan Morris, "The Pirate's Fiancée," in *The Pirate's Fiancée: Feminism, Reading, Postmodernism* (London: Verso, 1 9 8 8), 53.

18. "Hollywood Iconography," chap. 5.

19. Roland Barthes, *Mythologies* (Frogmore, St. Albans: Paladin, 1 9 7 2), **12**.

20. "Aboriginal Content: Who's Got It—Who Needs It?", chap. 2 above.

21. "A Model of Teleported Texts (With Reference to Aboriginal Television)," *Continuum* 3/2 (1 9 9 0), **24**.

22. Ibid.

23. "Ask a Foolish Question: On the Methodologies of Cross-Cultural Media Research," *Australian Journal of Cultural Studies* 3/2 (1 9 8 5), **45, 49**.

24. "A Model of Teleported Texts," **10**.

25. Michaels's skepticism regarding "unpositioned knowledge" is most clearly articulated in the review articles, particularly his critique of Fred Myers's *Pintupi Country, Pintupi Self* (Washington, D.C.: Smithsonian/AIAS, 1 9 8 4) in "If 'All Anthropologists are Liars …'" (see chap. 7). His resistance to the bogus "solution" of labeling a mere consciousness of the limitations of such knowledge "reflexivity" is put with equal force in the following passage from chapter 7: "It must be admitted that in its short history [reflexivity] has proved capable of encouraging a false resolution: reflexive practices can be transformed into gestural motifs employed as rationales merely to keep us going (at least past the edge of Occam's Razor). This in turn may have resulted in far more dishonesty than positivist perspectives could ever have been accused of. Conversely, reflexivity can so decenter the cultural subject that ethnography becomes opaquely self-inscriptive. So the course is full of danger"

26. Ibid.

27. Eric Michaels, "Introduction: Electronic Primitives," in unpublished manuscript of "Aborigines, Information and Media: the Aboriginal Australian Encounter with Introduced Communications Technology" (Canberra: AIATSIS archives, 1 9 8 6), **2**. The sentence is worth quoting in full: "Part of my objective in describing the Aboriginal experience of new media is to explode this unfortunate image of such people as 'the other,' to indicate that the appearance of contradiction in Aboriginal access to electronic media is false, to demonstrate that Aboriginal Australians are people sophisticated in forms of communication which must be uniquely suited to electronic transmission, and that providing them an opportunity to teach us something about the coming information age may help clarify our contemporary confusion."

28. Clifford Geertz, *Works and Lives: The Anthropologist as Author* (Polity Press, 1 9 8 8), **138–146**.

29. Guy Brett, in a presentation given at a symposium on "The Politics of Images," organized by S. Naire and B. Ferguson at the Dia Foundation, New York, in November 1 9 9 0. At this point in his talk, Brett was referring to what is spiritually at stake in the exposure of non-Western art forms to the indifferent gaze of the market/international "community" of art lovers. See also G. Brett, *Through Our Own Eyes: Popular Art and Modern History* (GMP, 1 9 8 6). Though framed in different terms, the same oscillation between the will to show and to confound unearned access to "tribal" secrets has shaped elements of my work. See, for instance, "Subcultural Conflict and Criminal Performance in West London" (Occasional Paper, Centre for Contemporary Cultural Studies, University of Birmingham, 1 9 7 4); *Subculture: the Meaning of Style* (Boston: Methuen/Routledge, 1 9 7 9); *Hiding in the Light: On Images and Things* (Boston: Comedia/Routledge, 1 9 8 8).

30. Michael Taussig, "State Fetishism," in *The Nervous System* (Boston: Routledge, 1 9 9 2), **124**. The enframed caption reads: "This empty space is where I would liked [*sic*] to have presented Spencer and Gillen's drawing of the frog totem because it seems to me next to impossible to get the points about representation across without this amazing image. But my friend Professor Annette Hamilton, of Macquarie University, Sydney, tells me that to reproduce the illustration would be considered sacrilege by Aboriginal people—which vindicates not only the power of the design but of the prohibitions against its being seen, strenuously noted but not observed by Spencer and Gillen themselves." One of Eric Michaels's objections to *The Songlines* (in "Para-Ethnography," chap. 9 above) is that its author performs the same anomalous move (while claiming to enjoy a more authentic relation with Aboriginality than any "mere" anthropologist): "What possible justification exists for describing the laws governing secrecy and then treading all over them?"

31. *Unbecoming*, **32**.

32. "Constraints on Knowledge," **506**.

33. "A Model of Teleported Texts," **22**. The full quotation reads: "Violating speaking constraints and rights [in the traditional Aboriginal information economy] is treated as theft, and recognized to be highly subversive of the traditional gerontocratic structure. From these basic facts of information ownership flow the essential conditions governing Aboriginal expressive media. Modern mass media are based on a contrasting and subversive principle—that information is made to appear ostensibly free—TV program costs are hidden to the audience so that they can masquerade as freely accessible common property available to huge publics simultaneously."

34. For work on the relations between Dreamings/Dreamtime History, Aboriginal identity, and inscription practices, see, for instance, *Dreamings: the Art of Aboriginal Australia*, ed. P. Sutton (New York:

Viking, 1 9 8 8); N. Munn, *Warlbiri Iconography* (Ithaca, N.Y.: Cornell University Press); N. Baume, "The Interpretation of Dreamings: the Australian Aboriginal Acrylic Movement," *Art & Text* 33 (W i n t e r 1 9 8 9); M. J. Meggitt, *The Desert People* (Sydney: Angus & Robertson, 1 9 6 2); S. Muecke, "On Aboriginal Art and Nomadology," *Art & Text* 14 (1 9 8 4). Eric's focus on the Aboriginal economy of knowledge and on the apparent contradiction between stability and change, mobility and place in Western Desert ontologies bears comparison with the emphasis, in the anthropology of consumption, on the multiple communicative and mediating functions of object circulation systems (e.g., A. Appadurai). Approaches based, like Michaels's and Appadurai's, in dynamic and processual models of cultural adaptation and transmission challenge static, essentialist models of tradition, place, and ethnic/cultural identity by tracking the "social life of things" as they circulate through valorizing networks in physical and social space. For Michaels, the Dream Tracks are both ceremonial trade routes and complex kinship matrices that spatialize social identity (by braiding, as it were, blood-line and songline) to permit yet proscribe change and exchange. They therefore function to mediate between "local movement and an unimaginable stability of history." Appadurai's description of the Kula ring in the Massim group of islands off New Guinea suggests that there are more than merely formal parallels with the Australian system: "The term *keda* (road, route, path or track) is used in some Massim communities to describe the journey of these valuables (necklaces and armshells) from island to island. But keda also has a more diffuse set of meanings, referring to the more or less stable social, political and reciprocal links between men that constitute these paths. In the most abstract way, keda refers to the path (created through the exchange of these valuables) to wealth, power, and reputation for the men who handle these valuables.... Keda is thus a polysemic concept in which the circulation of objects, the making of memories and reputations, and the pursuit of social distinction through strategies of partnership all come together." See *The Social Life of Things: Commodities in Cultural Perspective*, ed. Arjun Appadurai (Cambridge: Cambridge University Press, 1 9 8 6), **1 8**. Also *The Kula: New Perspectives on Massim Exchange*, ed. J. W. Leach and E. Leach (Cambridge: Cambridge University Press, 1 9 8 3).

35. "Warrumungu: The Ruined Ritual," in unpublished manuscript of "Aborigines, Information and Media," **5**.

36. See *Magiciens de la terre* (Paris: Editions du Centre Pompidou, 1 9 8 9). Also J. Clifford, *The Predicament of Culture: Twentieth-Century Ethnography, Literature, and Art* (Cambridge, Mass.: Harvard University Press, 1 9 8 8); G. Brett, *Through Our Own Eyes* (GMP, 1 9 8 6); F. Pfeill, "Popular Expressions," in *Another Tale to Tell: Politics & Narrative in Postmodern Culture*

(London: Verso, 1 9 9 0); B. Jules-Rosette, The Messages of Tourist Art (London: Plenum, 1 9 8 4); P. Wollen, "Tourism, Language and Art," in *New Formations* 12 (W i n t e r 1 9 9 0).

37. Warlukurlangu Artists, *Yuendumu Doors/Kuruwarri* (Canberra: AIAS, 1 9 8 7), is the book in which Eric's "Western Desert Sandpainting and Postmodernism" (chap. 3) appeared.

38. "Bad Aboriginal Art" (chap. 7 above).

39. "Western Desert Sandpainting and Postmodernism" (chap. 3 above).

40. "If 'All Anthropologists are Liars …'" (chap. 7 above).

41. The phrase is James Clifford's. See contributions by J. Clifford, V. R. Dominguez and T. T. Minh-Ha, "Of Other Peoples: Beyond the Salvage Paradigm," in *Discussions in Contemporary Culture No. 1* (Dia Art Foundation, 1 9 8 7).

42. "Constraints on Knowledge," **5 1 0**.

43. *Unbecoming*, **33**. The mortuary taboo prohibiting the invocation of the name or exhibition of the image of the deceased is one of the Warlpiri's most powerful interdictions. Michaels discusses its impact on the Aboriginal uses of video at length in the present book. The inclusion of two photographs of Eric in *Unbecoming*—one on the back cover showing Eric looking like a young Clark Gable, and the other as a frontispiece ("reproduced by permission of the author") showing him in June 1988, stripped to the waist, covered in sores, sticking out a lesion-perforated tongue at the camera—is both terribly poignant and shockingly courageous, especially in the light of Eric's own remarks in his diary: "The contradiction [raised by not naming the dead] of course is that this all assures that a great deal of attention is actually directed toward the absence of this individual who we go to so much effort not to name. It is an elegant contradiction however, very useful within its cultural context. Not only did I feel required to take these prohibitions into account with respect to my writing and publishing, as well as the very interesting implications of literacy here, I discovered that the idea became very sensible to me. For some time I refused to look at pictures of [my lover] Rick, or of my mother, after they died, except surreptitiously" (**3 2**).

Introduction (Langton)

1. Title of prepublication draft of "The Cost of Video at Yuendumu" (Michaels and Japanangka 1 9 8 4) submitted to the Central Australian Aboriginal Media Association (CAAMA) during the Second Conference of the National Aboriginal and Islander Broadcasting Association, Alice Springs, O c t o b e r 2 3 – 2 6 , 1 9 8 3. Page numbers quoted below refer to this unpublished version (designated as 1 9 8 3 *).

2. *Jardiwarnpa* was directed and produced by Ned Lander and coproduced by Rachel Perkins. Ned Lander has directed or codirected, among others, *Dirt Cheap* (with Mark Clancy and David Hay), *Wrong Side of the Road* (with Graham Isaac), *Ballangari Video, Into the Mainstream* (with John Whitteron). Rachel Perkins, trained at CAAMA, is executive producer of the Aboriginal Television Unit at SBS-TV in Sydney.

3. I am indebted to Liz Fell, senior research officer at CIRCIT, Melbourne, and Michael Leigh, film archivist at the Australian Institute of Aboriginal and Torres Strait Islander Studies, Canberra, for their invaluable assistance of various kinds, including editing, argument, and suggestions. I am also indebted to the Australian Film Commission, which enabled me to write a larger paper ("Well, I heard it on the radio—and I saw it on the television: A Discussion Paper on the Politics and Aesthetics of Film and Video Making by and about Aborigines," forthcoming) on which the above is based.

A Note to the Reader

1. I.e., the Report of the Task Force on Aboriginal and Islander Broadcasting and Communications, published as *Out of the Silent Land*, ed. E. Willmot (Canberra: Australian Government Printing Service, 1 9 8 4).

Acknowledgements

1. See the Bibliography for chronology and publication details of Eric Michaels's written work. *Continuum* is an Australian journal of the media and is based at Murdoch University, Perth. Its special issue on Eric's work is called "Communication & Tradition: Essays after Eric Michaels," *Continuum* 3/2 (1 9 9 0), ed. by Tom O'Regan, and includes, in addition to Eric's own "Model of Tele-ported Texts," eight major surveys as well as biblio-graphic material. I am indebted to this issue for much of the latter included here. See, also, J. Ruby, "Eric Michaels: An Appreciation," *Visual Anthropology* 4 (1 9 9 1).

2. Eric Michaels's 1975–88 papers are archived in the AIATSIS Library in MS 2744, ten boxes (9 X 17 cm; 1 X 8 cm). A guide to their contents can be obtained from the Australian Institute of Aboriginal and Torres Strait Islander Studies, GPO Box 553, Canberra ACT 2601, Australia. See also the list of unpublished manuscripts contained in the aforementioned *Continuum* issue.

3. Recent anthologies to include Eric Michaels's work are *The Media Reader*, ed. M. Alvarado and J. O. Thompson (London: BFI, 1 9 9 0); *Australian Cultural Studies: A Reader*, ed. J. Frow and M. Morris (Sydney: Allen & Unwin, 1 9 9 3); and *Australian Ficto-Criticism — An Anthology*, ed. N. King, T. Miller, and S. Muecke (Wakefield Press, forthcoming).

4. Again, see the Bibliography. For description of the original publication sources and dates of each essay presented here, see the entries under Notes.

5. The publication of this work in the Art & Criticism Monograph Series was made possible by the generous support of Melbourne artist Juan Davila, Artspace in Sydney, and (for the second printing) the Australian Film Commission. Their role in assisting the wider dissemination of Eric's work is here gratefully acknowledged.

6. The dates in parentheses at the head of each chapter indicate the years in which they were composed or initiated, but not necessarily published. The idea is to periodize Eric's narrative so that the reader will be mindful of certain anachronisms (a case in point being the comment about Princess Di in chapter 1) or simply to help locate the sequence of events. Chapters 1 through 9 are thus presented in chronological order. This schema does not apply, however, to the Postscript ("My Essay on Postmodernism"), whose inclusion here is meant to provide a sense of Eric's wider cultural agenda.

7. A number of Eric's colleagues were invited to situate his work for an international readership at the same time as ensuring the involvement of locally informed material. All those who took the time to check through the manuscript are particularly to be thanked.

8. It should be noted that *Bad Aboriginal Art and Other Essays* is nothing other than a collection of Eric Michaels's most celebrated essays presented in the order and (except in rare instances) the way in which he wrote them. In other words, at the level of scholarship, veracity, and exposition, this book is entirely the product of his own work. A few mistakes, where noticed in the original sources, have been corrected, and there have been some slight editorial amendments in view of Eric's overall intention. But in the main, editorship has not been involved. My role has simply been to coordinate all this shared activity and to prepare the manuscript for publication. That said, any responsibility for errors that have been overlooked must lie with the author himself.

9. Nevertheless, I have interpolated some explanations of terms or points of interest throughout the text. To distinguish these asides from Eric's own, they are placed in square brackets.

10. See *Unbecoming: An AIDS Diary* (Sydney: EMPress, 1 9 9 0) for Eric's own psychologizing on the fate of his intellectual labors.

11. Of the 12 essays comprising the manuscript of "Aborigines, Information and Media," all but three have appeared elsewhere (with or without modification): "Introduction: Electronic Primitives" (mainly an introduction to Aboriginal Australia), "Warrumungu: The Ruined Ritual" (on information management and disclosure) and "Yap: How did you know we'd like TV" (a review of Dennis O'Rourke's film). A fourth review is

listed as "Women of the Sun" but it doesn't seem to have been written.

The three essays carried over into the present collection are "Western Desert Sandpainting and Postmodernism," "Hundreds Shot in Aboriginal Community: ABC makes TV Documentary at Yuendumu," and "Hollywood Iconography: A Warlpiri Reading."

1. A Primer of Restrictions on Picture-Taking in Traditional Areas of Aboriginal Australia

[This paper was commissioned in 1986 by Penny Taylor, Coordinator of the AIATSIS "After 200 Years" Photographic Project, as a briefing paper for photographers who were to work with remote Aboriginal communities documenting their lives. The results were published in *After 200 Years: Photographic Essays of Aboriginal and Islander Australia Today*, ed. Penny Taylor (Canberra: Aboriginal Studies Press, 1 9 8 8.)]

1. Because of the extensive cultural differences between Torres Strait Islanders and mainland Aborigines, including quite different attitudes toward photography, this essay restricts itself to the Aboriginal case in its particulars, although some of the theoretical principles may apply more broadly. Likewise, the topic of discussion here is traditional communities alone. I suspect, however, that there are some cultural continuities from the traditional that may apply to urban and town-based Aborigines and help explain certain attitudes toward images and information, for example, in considerations of privacy and authority. Yet explicit restrictions, such as prohibitions on images of the dead, do not seem to be observed among urban Aborigines whose values here conform more to the European model.

2. A fifth problem area, unauthorized speaking for another's business or country, was described in an early draft of the essay. It regards the important concern that the properly identified senior person be accorded primary authority for speaking about matters associated with their land or religious knowledge. For another to speak of these things without permission may be considered a breach of Aboriginal copyright as much as etiquette. The issue is omitted in this primer for simplicity's sake, because it seems to apply more to speaking and writing than to visual imagery, although it could apply to captioning and text in a photographic volume. Related issues are discussed elsewhere here concerning speaking rights and definitions of space.

2. Aboriginal Content: Who's Got It — Who Needs It?

1. This paper is a modified version of the keynote address at the Documentary Sessions of the Australian Screen Studies Association Conference held in Sydney, December 1986. I wish to thank the Australian Institute of Aboriginal Studies and the Torres Strait Islanders Media Association for supporting the studies on which this paper is based; Warlpiri Media Association and the Central Australian Aboriginal Media Association for their collaboration in this work; and John von Sturmer for his close reading and original suggestions for this paper.

2. The following work by film- and videomakers mentioned in the text is not by any means exhaustive of each artist's work. Rather, this is a selection of recent and/or representative work that I think confronts, implicitly or explicitly, the problematic of Aboriginal content and control in Australian media practice, as well as the precursors cited in French and American documentary.

Aboriginal Development Division, "Aboriginal Video Magazine 1–11," 1 9 8 2 – 8 7, VHS, 30–60 min., New Territories Dept. of Community Development.

Boyd, E., "Look Show 1–12," 1 9 8 3 – 8 7, 30–60 min., VHS, Alice Springs Education Centre.

CAAMA, "CAAMA Video Magazine," 1 9 8 4 – 8 7, 30–60 min., VHS, Alice Springs.

Cantrill, A. & C., *Grain of the Voice*, film. Documentation: *Cantrill's Filmnotes* 33 & 34 (1 9 8 0); and "The 1901 Cinematography of Walter Baldwin Spencer," ibid., 37 & 38 (1 9 8 2).

Coffey, E., *My Survival as an Aboriginal*, 1 9 7 9, 53 min., 16 mm., Good Gabah Productions, Sydney.

Dept. of Community Development, "The Miller Report," 1 9 8 6, 26 mins., VHS, Australian Commonwealth Government.

Dunlop, I., *Madarrpa Funeral at Gurka'wuy*, 1 9 7 9, 87.5 min., 16 mm., Film Australia, Sydney. Documentation: Morphy, H., *Journey to the Crocodile's Nest*, 1 9 8 5, AIAS, Canberra.

Ernabella Video, "Nganampa Tjukurpa Kanyioni (Keeping Our Story)," 1 9 8 5, VHS, 29 min., EV-TV, Ernabella, S.A.

Levy, Curtis, *Mourning for Mangatopi*, 1 9 7 5, 56 mins., 16 mm., AIAS, Canberra.

McDonald, Penny (Executive Producer), "Kamirra; Pina Yamirlipa Ngurrakurra," 1 9 8 6, Ngurrangka Video.

MacDougall, D. & J., *Sunny and the Dark Horse*, 1 9 8 6, 16 mm., AIAS, Canberra; also *Three Horsemen*, 1 9 8 2. Review: *Journal of American Folklore* 98 (1 9 8 5), **389**.

McKenzie, K., *Waiting for Harry*, 1 9 8 0, 57 min., 16 mm., AIAS, Canberra. Review: Goodale, J., *American Anthropologist* (1 9 8 4), **862**.

Mangels, A., *World Safari*, 1 9 8 5.

Morgan, A., and G. Bostock, *Lousy Little Sixpense*, 1 9 8 3, 54 min., 16 mm., Sixpence Productions, Sydney.

O'Rourke, D., *It Couldn't Be Fairer*, 1 9 8 5, 16 mm., 50 min., BBC/O'Rourke & Associates, Canberra.

Rouch, J., and E. Morin, *Chronique d'un été* (Chronicle of a Summer), 1 9 6 0, Argos Films, Musée de l'Homme. Documentation: *Studies in Visual Communication* 11, ed. S. Feld.

Stellar, W., "Fight Fire with Fire," *Open File*, 1 9 8 5, 28 min., 16 mm., ABC-TV, Sydney.

Strachan, C., and A. Cavadini, *Two Laws*, 1 9 8 2, 4 pts., 30 min. each, 16 mm., Sydney. Review: MacBean, J. R., "Two Laws for Australia, one White, one Black," *Film Quarterly* (S p r i n g 1 9 8 3).

Torres Strait Islanders Media Association, "Keriba Wakai (Our Voice)," 1 9 8 7, VHS, 30 min.

Yuendumu TV, "Australia's First Public Television," 1984, 38 min., VHS, Warlpiri Media Association, Yuendumu, N.T.

3. [Flamboyant producer and "star" of locally made TV adventure features of the Girl Friday-in-bikini / trusty dog school. Mangels is best known for his *World Safari* series of films.]

3. Western Desert Sandpainting and Postmodernism

1. [This essay was written as an afterword to a volume illustrating the Yuendumu doors.]

2. [The fifth Biennale of Sydney was titled "Private Symbol: Social Metaphor," directed by Leon Paroissien. Its main exhibition site was the Art Gallery of New South Wales, Sydney, A p r i l 1 1 t o J u n e 1 7 , 1 9 8 4.]

4. Hundreds Shot at Aboriginal Community: ABC Makes TV Documentary at Yuendumu

1. [Gore Hill is the Sydney suburb where ABC-TV has its headquarters.]

2. [See filmography, n. 2, in "Aboriginal Content: Who's Got It — Who Needs It?"]

3. [Bill Peach pioneered current affairs and documentary on ABC in the 1970s and 1980s.]

4. [Mike Willesee hosts a prime-time current affairs program on commercial television.]

5. [Andrew Peacock was a minister and later leader of the opposition party during the Hawke era, 1983–91.]

5. Hollywood Iconography: A Warlpiri Reading

1. This paper was presented at the Second International Television Studies Conference, British Film Institute, London, 1 9 8 6. My appreciation to the Australian Institute for Aboriginal Studies for funding to undertake this study.

2. Lévi-Strauss, *The Savage Mind* (Chicago: University of Chicago Press, 1 9 6 6), **267**; quoting de Musset.

6. For A Cultural Future: Francis Jupurrula Makes TV at Yuendumu

1. For a description of languages in the Central Australian satellite footprint, see B. Blake, "Case Marking in Australian Languages," Linguistic Series No. 23 (Canberra: Australian Institute of Aboriginal Studies, 1 9 7 7). Note: throughout my text I employ a more recent orthography for Warlpiri, developed by Ken Hale in association with Yuendumu linguists.

2. See J. Meggitt (1 9 6 2) for the classic description of Warlpiri kinship and social organization.

3. [Eric Michaels wrote *For a Cultural Future* for publication in the Art & Criticism Monograph Series, edited by Juan Davila and Paul Foss. Its first printing (Sydney: Artspace, 1 9 8 8) was made possible by a grant from the Visual Arts Board of the Australia Council, as well as by the kind assistance of Artspace, Sydney. Its second printing (Sydney and Melbourne: Art & Text Publications, 1 9 8 9) was made possible by a grant from the Australian Film Commission.]

4. [Some of these images illustrate this chapter.]

5. Translation by Francis Kelly and Mary Laughren.

6. [Then director of the ABC.]

7. If "All Anthropologists Are Liars . . ."

Published in *Canberra Anthropology* 10/1 (1 9 8 7), **44–62**. Part of a special report titled "Issues of representation, responsibility, and reflexive anthropology: the Pintubi case" (**35–73**) concerning the publication of Fred R. Myers's *Pintupi Country, Pintupi Self: Sentiment, Place, and Politics among Western Desert Aborigines* (Washington, D.C.: Smithsonian Institute Press; and Canberra: Australian Institute of Aboriginal Studies, 1 9 8 4). This report is made up of two review articles, Michaels's and another by Deborah Bird Rose ("Representing the Pintupi," **35–43**), and Myers's rejoinder ("Representing Whom? Privilege, Position, and Posturing," **62–73**). A slightly different version of Michaels's text appeared in *Mankind* 17 (1 9 8 7), **34–46**.

1. My choice of references to illustrate alternative critical positions cannot hope to do more than touch on what is an extensive and rapidly growing literature. Even the logic of my choices would take an additional essay to justify, so it seems best to consider them an arbitrary assortment.

2. Liberman's (1 9 8 2, 1 9 8 5) work on Western Desert discourse I think aims to satisfy these sorts of requirements. It is disappointing that Myers did not take the opportunity to make a critical comparison here.

3. The myopia of ethnographic form in this case causes Myers to devalue communicational distinctions the Pintupi themselves make — which I would claim were relevant "oral" contrasts worth exploring — between "showing" (*yuntininpa*), "giving" (*yunginpa*), and "teaching" (*nintinpa*) (**152**). Myers claims these are "to some extent equivalent concepts" (**152**), a position that I might challenge with respect to my own experience of their Warlpiri counterparts if the term "equivalent" were not so equivocal and Myers's intent so obviously dismissive.

4. Meggitt's structural reading of the Warlpiri cannot be offered as unproblematic evidence that these models are inherent in Warlpiri life and thought. One would have to deconstruct *Desert People* (1 9 6 2) to provide insight into the sources of these structures. Conclusions based on distinctions between Pintupi "negotiations" and Warlpiri "rules/rights," could prove to be an example of the effect of ethnographic inquiry, the discourse of the practitioner, even an effect of literacy on the Warlpiri.

8. Bad Aboriginal Art

1. Whether to classify Warlpiri people and their art as coming from the Western or Central Desert is somewhat more our problem than theirs. Because I am drawing some comparisons to work from the Kimberleys, and because I wish to imply some continuity of techniques, I will class the Warlpiri as "Western" here. In fact, there were once probably extensive continuities of some painting techniques throughout Australia. Certainly, that is the situation today: acrylic "dot paintings" are being produced in inner Sydney suburbs, north Queensland workshops, Singapore toweling mills, Japanese printing houses ... perhaps everywhere.

2. Susan Dermody (1 9 8 7) made this claim at the Power Institute's forum on the debate between postmodernism and cultural studies. Overseas guest Dick Hebdige would only admit that the debates on the subject were very advanced in Sydney. See Meaghan Morris's adroit management of this contradiction of displacement in her reading of *Crocodile Dundee*, "Tooth and Claw: Tales of Survival, and *Crocodile Dundee*," in *The Pirate's Fiancée: Feminism, Reading, Postmodernism* (London and New York: Verso, 1 9 8 8), **241–69**.

3. This text is an edited version of a paper delivered at the Department of Anthropology, University of Sydney, O c t o b e r 2 9, 1 9 8 7. I wish to thank John von Sturmer for his close reading and suggestions.

4. [A mythical mountain of gold in the interior reputedly found by Lasseter and then lost — the Australian equivalent of El Dorado.]

5. *The Northern Territory News* (S e p t e m b e r 1 2, 1 9 8 7) quotes Wanang Ngari administrator Mr. Leighton Leitch as saying that the two responsible elders were in Derby at the time and in fact were consulted from the beginning. Elsewhere, Mowarljarlai (1 9 8 7) implies they were on site supervising the work.

6. Bardon describes dots as having meaning, and diagrams one painting by Johnny Warrangula Tjaparula to indicate how differing dots contrast the signified topologies: sandgrass, sandhills, bush tucker (**26**). It is a beautiful painting, and the dotting technique is extremely effective; I have seen something similar in perhaps no more than a dozen other paintings. It may well be a specific convention that applies to a certain style. But it is in no way universal. I argue that, more generally, the dots are background and therefore may be manip-ulated for various effects without affecting the correct-ness of the painting from the painters' points of view.

7. At Yuendumu, we had a number of unscrupulous Europeans living there who sought to acquire personal collections — or fortunes — by offering immediate cash and other inducements (always a small fraction of what any canvas would eventually command), thus aborting the marketing process and depleting the local collective's supplies. Some painters resisted, but others needed money and this was a familiar mode of local exchange; after all, the paintings have to be considered each artist's property. But it was discovered that the tastes of these collectors were entirely predictable: kitsch on one hand, and the most neat, Papunya-looking examples on the other. We realized these sales represented a kind of weeding-out process resulting in a welcome petty-cash flow, and no direct action was taken. Eventually, such characters tend to leave the community, often chased by the law for other reasons, as happened here. Thus what came to market tended to be the more "Yuendumu" of the canvases. (Anyone who has worked in a contemporary Aboriginal settlement will recognize this kind of story, and this logic.)

8. The commercial "Christian" printers who set the color plates for the Yuendumu doors book objected to some of the graffiti included in the photographs and agreed to print the pictures only after airbrushing them out. Nobody has even noted this curious revision or

argued, as I might, that a desecration, perhaps equal to a mutilation of the Mona Lisa, has occurred.

9. [The following postscript to "Bad Aboriginal Art" appeared on the back cover of *Art & Text* 28 (1 9 8 8) and is included here as an interesting addendum to the essay's general thesis. A further discussion of this case of Aboriginal "censorship" can be found in Eric Michaels, *Unbecoming: An AIDS Diary* (Sydney: EMPress, 1 9 9 0), **101–4, 105–6.**]

"Since the early days of subway graffiti, there has been a code among the writers banning them from 'backgrounding' (also called 'going over' or 'crossing out') each other's pieces. This code also states that once a piece has been 'gone over' it is considered destroyed and becomes fair game for all other writers. Thus even the smallest cross-out can result in the eventual total elimination of a piece" (Craig Castleman, *Getting Up: Subway Graffiti in New York* (Cambridge, Mass.: MIT Press, 1 9 8 6).

"*Art & Text* wanted to use an image of one of the painted doors at Yuendumu for the cover of the issue. A dispute arose over this. I understand the issues 'backgrounding' raised here to be: 1) the sexual content of the graffiti; 2) the possible devaluation of the art work; and 3) the conceivable challenge to the authority of elder painters. But these are secular, public paintings, and it is unclear that they can be included under codes established to protect secret and sacred representations. This is more than a matter of simple appropriation.

"I chose to substitute my own photograph of an equivalent image (the first photo was taken by a third party) to resist any charges of censorship and to push these questions past the limits of available discourses that liberal silence has imposed. These are some of the very issues I consider in 'Bad Aboriginal Art.'

"Again from Castleman, graffiti 'writer' Blade warns other 'writers': 'I see you people like crossing out my pieces. If I see any more of my pieces crossed out, I will "Destroy All Pieces!" ' "

9. Para-Ethnography

1. Cf. D. Tedlock, *The Spoken Word and the Work of Interpretation* (Philadelphia: University of Pennsylvania Press, 1 9 8 3).

2. See William McGregor, "The Structure of Gooniyandi Narratives," *Australian Aboriginal Studies* 2 (1 9 8 7), **20–28**; and Eric Michaels, "The Indigenous Languages of Video and Television," in *Ethnographies of Visual Communication: Papers Selected from the International Visual Communications Conference,* ed. Jay Ruby (Göttingen: Rader Verlag, 1 9 8 7).

3. Cf. James Clifford and George Marcus, eds., *Writing Culture: the Poetics and Politics of Ethnography* (Berkeley: University of California Press, 1 9 8 6).

4. Cf. Dell Hymes, ed., *Reinventing Anthropology* (New York: Pantheon Books, 1 9 7 2).

5. Stephen Muecke, "Winding Path: The Ethics of Chatwin's Fiction," *The Age Monthly Review* (Melbourne, F e b r u a r y 1 9 8 8), **21–22**.

6. See K. Benterrak, S. Muecke, and P. Roe, *Reading the Country: Introduction to Nomadology* (Fremantle: Fremantle Arts Centre Press, 1 9 8 5).

7. [The reference is to Derek Freeman's *Margaret Mead and Samoa: the Making and Unmaking of an Anthropological Myth* (Cambridge, Mass.: Harvard University Press, 1 9 8 3).]

Postscript: My Essay on Postmodernism

1. [Oxford Street is the center of Sydney's homosexual community and focus of the annual Gay & Lesbian Mardi Gras parade. See Michaels, "Carnivale in Oxford St.", *New Theatre Australia* 5 (M a y – J u n e 1 9 8 8), **4–8**.]

Works Cited

Alexander, G. 1 9 8 7. "Slipzones: Text and Art." *Art & Text* 26 (September–November), **42–57**.

Australian Broadcasting Tribunal 1 9 8 6. *Decision on the Central Zone RCTS Licence.* Canberra: Australian Government Printing Service.

Bardon, G. 1 9 7 9. *Aboriginal Art of the Western Desert.* Adelaide: Rigby.

Bateson, G. 1 9 7 2. "Why Do Things Have Outlines?" *Steps to an Ecology of Mind.* New York: Ballantine.

———. 1 9 7 9. *Mind and Nature: A Necessary Unity.* New York: Dutton.

Baudrillard, J. 1 9 8 1. *For a Critique of the Political Economy of the Sign*, trans. C. Levin. St. Louis, Mo.: Telos Press.

Bell, D. 1 9 8 3. *Daughters of the Dreaming.* Sydney: McPhee Gribble/Allen & Unwin.

Benterrak, K., S. Muecke, and P. Roe. 1 9 8 4. *Reading the Country.* Fremantle, W.A.: Fremantle Arts Centre Press.

Berndt, R. M., and C. H. Berndt. 1 9 4 9. "Secular Figures of Northern Arnhem Land." *American Anthropologist* 19/2.

———. 1 9 5 0. "Aboriginal Art in Central-Western Northern Territory." *Meanjin* 9/3.

———. 1 9 6 4. *The World of the First Australians.* Sydney: Ure Smith.

Chatwin, B. 1 9 8 7. *The Songlines.* London: Jonathan Cape.

Clifford, J., and G. E. Marcus (eds.). 1 9 8 6. *Writing Culture: the Poetics and Politics of Ethnography.* Berkeley: University of California Press.

Coombs, H. C., M. Brandl, and W. Snowden. 1 9 8 3. *A Certain Heritage for and by Aboriginal Families in Australia.* Canberra: CRES.

Crocker, A. 1 9 8 7. "An Appreciation of the Work of the Pintubi Painter Charlie Tjararu Tjungurrayi." In *Charlie Tjararu Tjungurrayi — A Retrospective.* Orange City County.

Dermody, S. 1 9 8 7. "(What To Do) When the Going Gets Tough." In *Streetwise Flash Art* 6 (Power Institute of Fine Arts Occasional Paper, University of Sydney).

Dubinskas, F., and S. Traweek. 1 9 8 4. "Closer to the Ground: A Reinterpretation of Warlpiri Iconography." *Man* 19/1.

Foucault, M. 1 9 7 2. *The Archaeology of Knowledge*, trans. A. M. Sheridan Smith. London: Tavistock.

Geertz, C. 1 9 7 3. *The Interpretation of Cultures.* New York: Basic Books. 1 9 8 5. "Waddling In." *N.Y. Times Literary Supplement* (June 7), **6 2 3 – 2 4**.

Glenn, E. 1 9 6 3. "Walbiri and State Department Graphics." *American Anthropologist* 65: **1 1 1 3 – 3 5**.

Gödel, K. 1 9 6 2. *On Formally Undecidable Propositions of "Principia Mathematica" and Related Systems*, trans. B. Meltzer. Edinburgh: Oliver & Boyd.

Hale, K. 1 9 8 4. "Remarks on Creativity in Aboriginal Verse." In *Problems and Solutions*, ed. J. Kassler and J. Stubington. Sydney: Hale & Iremonger.

Havelock, E. 1 9 8 2. *The Literate Revolution in Greece and its Cultural Consequences.* Princeton, N.J.: Princeton University Press.

Honigmann, J. J. 1 9 7 6. "The Personal Approach in Cultural Anthropological Research." *Current Anthropology* 17: **2 4 3 – 5 0**.

Hymes, D. 1 9 6 8. "Linguistic Problems in Defining the Concept of Tribe." In *Essays on the Problem of Tribe*, ed. J. Helm. American Ethnological Society, **2 3 – 4 8**.

———. 1 9 7 2. *Reinventing Anthropology.* New York: Pantheon Books.

Jung, C. G. 1 9 6 5. *Memories, Dreams, Reflections.* Rec., ed. Aniela Jaffe, trans. Richard and Clara Winston. New York: Random House.

Kolig, E. 1 9 8 2. *The Silent Revolution.* Philadelphia: Institute for the Study of Human Issues.

Kuhn, T. 1 9 7 0. *The Structure of Scientific Revolutions.* Chicago: University of Chicago Press.

Langton, M. 1 9 8 1. "Urbanising Aborigines: The Social Scientist's Great Deception." *Social Alternatives* 2/2: **1 6 – 2 2**.

Lévi-Strauss, C. 1 9 5 5. *Tristes tropiques.* Paris: Plon.

———. 1 9 6 6. *The Savage Mind.* Chicago: University of Chicago Press.

Liberman, K. 1 9 8 2. "The Economy of Central Australian Aboriginal Expression: An Inspection from the Vantage of Merleau-Ponty and Derrida." *Semiotica* 40: **2 6 7 – 3 6 4**.

———. 1 9 8 5. *Understanding Interaction in Central Australia: An Ethnomethodological Study of Australian Aboriginal People.* Boston: Routledge & Kegan Paul.

Loveday, P., and P. Cook (eds.). 1 9 8 3. *Aboriginal Arts and Crafts and the Market.* Darwin: Australian National University, North Australian Research Unit Monograph.

Lukács, G. 1 9 5 0. *Studies in European Realism*, trans. E. Bone. London: Merlin Press.

Lyotard, J.-F., and J. Rogozinski. 1 9 8 7. "The Thought Police." Trans. J. Pefanis. *Art & Text* 26 (September–November).

Macherey, P. 1 9 7 8. *A Theory of Literary Production*, trans. G. Wall. London: Routledge & Kegan Paul.

McLuhan, M. 1 9 6 2. *The Gutenberg Galaxy.* Toronto: University of Toronto Press.

———. 1 9 6 4. *Understanding Media.* New York: McGraw-Hill.

Mead, M., and R. Métraux. 1 9 5 3. *The Study of Culture at a Distance.* Chicago: University of Chicago Press.

Megaw, V. 1 9 8 6. "Contemporary Aboriginal Art—Dreamtime Discipline or Alien Adulteration." In *Dot and Circle, a Retrospective Survey of the Aboriginal Acrylic Paintings of Central Australia*, ed. J. Maughan and J. Zimmer. Melbourne: Royal Melbourne Institute of Technology.

Meggitt, M. J. 1 9 6 2. *The Desert People: A Study of the Walbiri Aborigines of Central Australia.* Sydney: Angus & Robertson.

———. 1 9 6 6. *Gadjari among the Warlpiri Aborigines of Central Australia.* (Oceania Monographs 14). Sydney: University of Sydney Press.

Michaels, E. 1 9 8 5. "Constraints on Knowledge in an Economy of Oral Information." *Current Anthropology* 26/4: **5 0 5 – 1 0**.

———. 1 9 8 6. *The Aboriginal Invention of Television in Central Australia 1982–1986.* Canberra: Australian Institute of Aboriginal Studies.

———. 1 9 8 7 a. "Hollywood Iconography: a Warlpiri Reading." In *Television and Its Audience: International Research Perspectives*, ed. P. Drummond and R. Patterson. London: British Film Institute. (Included as chapter 5 in this volume.)

———. 1 9 8 7 b. "The Indigenous Languages of Video and Television." In *Visual Explorations of the World: Selected Proceedings of the International Visual Communication Conference*, ed. M. Taureg and J. Ruby. Aachen: Rader Verlag.

Michaels, E., and L. Japanangka Granites. 1 9 8 4. "The Cost of Video at Yuendumu." *Media Information Australia* 32: **1 7 – 2 5**.

Michaels, E., and F. Kelly. 1 9 8 4. "The Social Organisation of an Aboriginal Video Workplace." *Australian Aboriginal Studies* 1: **2 6 – 3 4**.

Morgan, S. 1 9 8 7. *My Place.* Fremantle, W.A.: Fremantle Arts Centre Press.

Morphy, H. 1 9 8 3. " 'Now you understand': An Analysis of the Way Yolngu Have Used Sacred Knowledge to Retain their Autonomy." In *Aborigines,*

Land and Land Rights, ed. N. Peterson and M. Langton. Canberra: Australian Institute of Aboriginal Studies.

Mowarljarlai, D., and C. Peck. 1 9 8 7. "Ngarinyin Cultural Continuity: A Project to Teach the Young People the Culture, Including the Repainting of Wandjina Rock Art Sites." *Australian Aboriginal Studies.*

Munn, N. D. 1 9 7 0. "The Transformation of Subjects into Objects in Warlpiri and Pitjantjatjara Myth." In *Australian Aboriginal Anthropology*, ed. R. Berndt. Nedlands, W.A.: University of Western Australia Press, **141–63**.

———. 1 9 7 3. *Walbiri Iconography*. Ithaca, N.Y.: Cornell University Press.

Myers, F. R. 1 9 8 0. "A Broken Code: Pintupi Political Theory and Contemporary Social Life." *Mankind* 12: **311–26**.

———. 1 9 8 2. "Always Ask: Resource Use and Land Ownership among Pintupi Aborigines of the Australian Western Desert." In *Resource Managers: North American and Australian Hunter-Gatherers*, ed. N. M. Williams and E. S. Hunn. Boulder, Co.: Westview Press, for the American Association for the Advancement of Science, **173–95**.

———. 1 9 8 4. *Pintupi Country, Pintupi Self: Sentiment, Place, and Politics among Western Desert Aborigines*. Washington, D.C.: Smithsonian Institute Press; and Canberra: Australian Institute of Aboriginal Studies.

———. 1 9 8 7. "Representing Whom? Privilege, Position, and Posturing." *Canberra Anthropology* 10/1: **62–73**.

Nash, D. 1 9 8 2. "An Etymological Note on Warlpiri Kurdungurlu." In *Languages of Kinship in Aboriginal Australia*, ed. J. Heath et al. Sydney: University of Sydney Press.

Nash, D., and R. Wintrob. 1 9 7 2. "The emergence of self-consciousness in ethnography." *Current Anthropology* 15: **527–42**.

Nathan, P., and D. Japanangka. 1 9 8 3. *Settle Down Country*. Malmsbury, Vic.: Kibble Books.

Ong, W. 1 9 8 2. *Orality and Literacy: The Technologizing of the Word*. London: Methuen.

Peterson, N. 1 9 6 9. "Secular and Ritual Links: Two Basic and Opposed Principles of Australian Social Organisation as Illustrated by Warlpiri Ethnography." *Mankind* 7/1: **27–35**.

———. 1 9 7 0. "Bulawandi: a Central Australian Ceremony for the Resolution of Conflict." In *Australian Aboriginal Anthropology*, ed. R. M. Berndt. Perth: University of Western Australian Press for the Australian Institute of Aboriginal Studies, **200–215**.

———. 1 9 7 6. *Tribes and Boundaries in Australia*. Atlantic Highlands, N.J.: Humanities Press.

Pike, A. 1 9 7 9. "An Ethnographic Film Conference." *Cantrill's Filmnotes* 29/3.

Ricoeur, P. 1 9 7 4. *The Conflict of Interpretations: Essays in Hermeneutics*, ed. D. Ihde. Evanston, Ill.: Northwestern University Press.

Róheim, G. 1 9 4 5. *The Eternal Ones of the Dream*. New York: International Universities Press.

Rose, D. B. 1 9 8 4. "The Saga of Captain Cook." *Australian Aboriginal Studies* 2.

———. 1 9 8 7. "Representing the Pintupi." (A review article of Fred R. Myers, *Pintupi Country, Pintupi Self*, 1 9 8 4.) *Canberra Anthropology* 10/1 (April), **35–43**.

Rosenthal, A. 1 9 7 1. *The New Documentary in Action*. Berkeley: University of California Press.

Ruby, J. (ed.). 1 9 8 3. *A Crack in the Mirror: Reflexive Perspectives in Anthropology*. Philadelphia: University of Pennsylvania Press.

Sapir, E. 1 9 2 1. *Language*. New York: Harcourt Brace.

Spencer, W. B., and F. J. Gillen. 1 9 0 4. *The Northern Tribes of Central Australia*. London: Macmillan.

Spurgeon, C. 1 9 8 9. "Challenging Technological Determinism: Aborigines, AUSSAT and Remote Australia." In *Australian Communications and the Public Sphere: Essays in Memory of Bill Bonney*, ed. Helen Wilson. South Melbourne, Vic.: Macmillan.

Stanner, W. E. H. 1 9 5 9. *On Aboriginal Religion*. Sydney: University of Sydney Press.

Strehlow, T. H. 1 9 7 0. "Geography and the Totemic Landscape." In *Australian Aboriginal Anthropology*, ed. R. Berndt. Nedlands, W.A.: University of Western Australia.

Task Force on Aboriginal and Islanders Broadcasting and Communications. 1 9 8 5. *Out of the Silent Land*, Canberra: AGPS.

Tedlock, D. 1 9 8 3. *The Spoken Word and the Work of Interpretation*. Philadelphia: University of Pennsylvania Press.

Ucko, P. (ed.). 1 9 7 7. *Form in Indigenous Art: Schematization in the Art of Aboriginal Australia and Pre-Historic Europe*. Canberra: Australian Institute of Aboriginal Studies.

Vaughan, D. 1 9 7 7. *Television Documentary Usage*. London: British Film Institute Monograph, no. 6.

von Sturmer, J. 1 9 8 2. "Talking with Aborigines." *AIAS Newsletter* 15.

Warlukurlangu Artists. 1 9 8 7. *Yuendumu Doors/ Kuruwarri*. Canberra: Australian Institute of Aboriginal Studies.

Whorf, B. 1 9 5 6. *Language, Thought and Reality*, ed. J. Carroll. Cambridge, Mass.: MIT Press.

Wild, S. 1 9 7 5. "Warlpiri Music and Dance in their Social and Cultural Nexus." Unpublished Ph.D. thesis, University of Indiana, Bloomington.

Willis, P. 1 9 8 0. "Patrons and Riders: Conflicting Roles and Hidden Objectives in an Aboriginal Development Programme at Kununurra (W.A.)." M.A. thesis, Australian National University.

Worth, S., and J. Adair. 1 9 7 3. *Through Navajo Eyes: An Exploration in Film Communication and Anthropology*. Bloomington: Indiana University Press.

Worth, S., and L. Gross. 1 9 7 4. "Symbolic Strategies." *Journal of Communication* 24: **2 7 - 3 9**.

A Bibliography of Eric Michaels

1 9 7 4. "The Family." In *Communitarian Societies*, ed. John Hostetler. New York: Holt, Rinehart & Winston.

1 9 7 9. "Ethnography and Visual Anthropology." In *Videthos*. An Exhibition Catalogue, Long Beach Museum of Art.

1 9 8 2. "How to Look at Us Looking at the Yanomami Looking at Us." In *A Crack in the Mirror: Reflexive Perspectives in Anthropology*, ed. Jay Ruby. Philadelphia: University of Pennsylvania Press.

1 9 8 4 a. (with Francis Jupurrurla Kelly). "The Social Organization of an Aboriginal Video Workplace." *Australian Aboriginal Studies* 1: **26–34**. Also in *Programme: 3rd International Video and Television Festival*, ed. M. Bongiovanni. Montbeliard: Centre d'Action Culturelle de Montbeliard (1986), **89–93**.

1 9 8 4 b. (with Leonard Japanangka Granites). "The Cost of Video at Yuendumu." *Media Information Australia* 32: **17–25**.

1 9 8 4 c. "Aboriginal Air Rights." *Media Information Australia* 34: **51–61**. Excerpted from a 1983 talk, "Aboriginal Australians and The New World Information Order." Presented at the Australian National University's Public Affairs Conference, "Aborigines and International Law."

1 9 8 4 d. "Hopes and Fears: the Application of International Examples to the Case of Aboriginal Telecommunications." In *Out of the Silent Land*, ed. E. Willmot. Canberra: Australian Government Printing Service.

1 9 8 5 a. "Constraints on Knowledge in an Economy of Oral Information." *Current Anthropology* 26: **505–10**.

1 9 8 5 b. "How Video Has Helped a Group of Aborigines in Australia." *Media Development* 32: **16–18**.

1 9 8 5 c. "Ask a Foolish Question: On the Methodologies of Cross-Cultural Media Research." *Australian Journal of Cultural Studies* 3/2: **45–59**.

1 9 8 5 d. "New Technologies in the Outback and Their Implication." *Media Information Australia* **38**.

1 9 8 6 a. *The Aboriginal Invention of Television in Central Australia 1982–1985*. Canberra: Australian Institute of Aboriginal Studies, Institute Report.

1 9 8 6 b. "The Impact of Television, Videos, and Satellites in Aboriginal Communities." In *Science and Technology for Aboriginal Development*, ed. Barney Foran and Bruce Walker, Project Report no. 3. Canberra: CSIRO.

1 9 8 7 a. "Aboriginal Content: Who's Got It—Who Needs It?" *Art & Text* 23 & 24: **58–78**. (Included in this volume.)

1 9 8 7 b. "Western Desert Sandpainting and Post-Modernism: A Postscript to Recent Acrylic Paintings by Senior Warlpiri Aborigines at Yuendumu." In Warlukurlangu Artists, *Yuendumu Doors/Kuruwarri*. Canberra: Australian Institute of Aboriginal Studies, **135–43**. (Included in this volume.)

1 9 8 7 c. "Response to Eric Willmot's review, 'Aboriginal Broadcasting in Remote Australia.'" *Media Information Australia* 43: **41–44**.

1 9 8 7 d. "My Essay on Postmodernism." *Art & Text* 25: **86–91**. (Included in this volume.)

1 9 8 7 e. "Hundreds Shot in Aboriginal Community: ABC makes TV documentary at Yuendumu." *Media Information Australia* 45: **7–17**. (Included in this volume.)

1 9 8 7 f. "Hollywood Iconography: a Warlpiri Reading." In *Television and Its Audience: International Research Perspectives*, ed. P. Drummond and R. Patterson. London: British Film Institute, **109–24**. (Included in this volume.)

1 9 8 7 g. "The Indigenous Languages of Video and Television." In *Visual Explorations of the World: Selected Proceedings of the International Visual Communication Conference*, ed. Martin Taureg and Jay Ruby. Aachen: Rader Verlag.

1 9 8 7 h. *For a Cultural Future: Francis Jupurrurla Makes TV at Yuendumu*. Art & Criticism Monograph Series, vol. 3. Sydney: Artspace (1st print.). Melbourne: Art & Text Publications, 1 9 8 9 (2nd print.). (Included in this volume.)

1 9 8 7 i. "The Last of the Nomads, the Last of the Ethnographies, Or, If 'All Anthropologists are Liars …'" A review of Fred Myers, *Pintupi Country, Pintupi Self. Mankind* 17/1: **34–46**. (Also published as "If 'All Anthropologists are Liars …'" in *Canberra Anthropology* 10/1: **44–64**.) (Included in this volume.)

1 9 8 7 j. "Aboriginal Air Rights Resuscitated." *Broadcast*, July, **16–17**.

1 9 8 8 a. "Bad Aboriginal Art." *Art & Text* 28: **59–72**. (Included in this volume.)

1 9 8 8 b. "Para-Ethnography." *Art & Text* 30: **42–51**. (Included in this volume.)

1 9 8 8 c. "Literacy—Electronics vs. Print: The Aboriginal Example." In *Proceedings of the Annual New England Social Science Seminars*, ed. Z. Klisch. London: Allen & Unwin.

1 9 8 8 d. "Carnivale in Oxford Street." *New Theatre Australia* 5: **4–8**.

1 9 8 9. "Postmodernism, Appropriation and Western Desert Acrylics." In *Postmodernism: A Consideration of the Appropriation of Aboriginal Imagery Forum Papers*, ed. Sue Cramer. Brisbane: Institute of Modern Art, **26–34**.

1 9 9 1 a. "A Primer of Restrictions on Picture-Taking in Traditional Areas of Aboriginal Australia." *Visual Anthropology* 4: **259–75**. (Included in this volume.)

1 9 9 1 b. "A Model of Teleported Texts (with Reference to Aboriginal Television)." *Visual Anthropology* 4: **301–23**. (Also published in Continuum 3/2, 1 9 9 0: **8–31**.)

1 9 9 1 c. *Unbecoming: An AIDS Diary*. Sydney: EMPress.

Index

Compiled by Eileen Quam and Theresa Wolner

Eric Michaels was an American ethnographer
and a theorist of visual arts, media studies, and broadcasting.
His published work has had an impact in various discursive sites
from aesthetics, policy analysis, through ethnographic filmmaking and anthropology
to technology studies. He is the author of
For a Cultural Future: Francis Jupurrurla Makes TV at Yuendumu (1987).